Practicing the Good:
Desire and Boredom
in Soviet Socialism

e-flux

Practicing the Good: Desire and Boredom in Soviet Socialism

Keti Chukhrov

Printed and Distributed by
the University of Minnesota Press

There is nothing new about the thesis that
the Absolute is identical to this world.*

—Giorgio Agamben, *The Coming Community*

* Giorgio Agamben, *The Coming Community*, trans. Michael Hardt
(Minneapolis: University of Minnesota Press, 1993).

CONTENTS

Part I
Political Economy

Part II
Sexuality

Part III
Aesthetics

Part IV
Philosophic Ontics of Communism

Foreword
Boris Groys

In recent decades it has often been said that we live after the end of the Cold War. However, one might describe this time as a transformation of the Cold War rather than as its end. From the Western point of view, the Cold War was primarily a conflict not between socialism and capitalism, but between Russia and the West. Not accidentally, Western Communist parties were seen as "Moscow's Hands." (That has not changed, by the way.) Moreover, today every critique of the West—be it from the left or from the right—is seen as serving the interests of Kremlin. In her book, Keti Chukhrov draws the attention of the reader to the fact that the thinkers of the Western Left (as examples, she mentions Alain Badiou and Étienne Balibar) are ready to recognize the Chinese Cultural Revolution and Maoism, but not the Soviet experience, as relevant for the contemporary Left. The reason for that is simple: the Maoist movement was anti-Soviet. Thus, in the context of the Cold War, it positioned China as part of the Western camp. And that was famously confirmed by the historical 1972 meeting between Nixon and Mao that definitively integrated Maoism into the American geopolitical sphere of power. Today the Western Left still wants to remain inside the West—and, thus, it is still defined by Cold War divides. One is ready to accept the "Other," but this Other has to come from the former Western colonies—and that means to be de facto already integrated into the West. The non-Western Other is not even the Other, but is simply nonexistent—if not an outright enemy.

This constellation is a result of a process of the regionalization and nationalization of Soviet Communism. It is easy to say that this process was initiated by Stalin as he proclaimed his program of building "socialism in one country." Actually, Stalin merely drew conclusions from the fact that the international revolution had failed. The communist idea became territorialized—following the trajectory of other universalist ideas of the past. Today one tends to speak about Islam as a regional culture, forgetting that Islam is, actually,

universalist. The same can be said about the Catholic and Protestant countries of the West. Christianity is a universal religion but it was historically territorialized in the West. In the same way, Soviet communism began to function as a synonym for Russian imperialism already during the Cold War—and it continues to function in the same way today. That is true for the Western perception of Russia, but it is also true for Russian self-perception. Today, Russia is a capitalist country with all the characteristics of contemporary oligarchic capitalism. But the Russian pro-Western, liberal opposition still sees all the problems of the country as caused not by its contemporary economic and social regime but, rather, by its culture produced in the "Soviet past." The slogan of the day that calls for overcoming the Soviet past reminds one of Soviet propaganda from the 1920s and its struggle against the remnants of the czarist past. This shows that the nationalization and culturalization of Soviet communism went full circle not only in the West, but also in Russia itself.

Keti Chukhrov's book is directed precisely against this nationalization of the Soviet experience as practiced in our time. She wants to rediscover the internationalist, universalist dimensions of Soviet ideology and experience. Indeed, Soviet society was the only historically existing non-capitalist society—a society beyond private property, a society in which the economic course and social life were defined not by private interests, but by a common political plan. There is no doubt that the Soviet ruling bureaucracy became increasingly corrupt—especially during the last decades of the Soviet Union—and, thus, the common good was increasingly subjected to the private interests of the ruling elite. At the end of this process, Soviet socialism was abolished by the elite that privatized the country. However, there is a difference between the corruption of rule and the rule itself—between indirect corruption by private interests and direct rule by these interests. This difference is at the heart of Chukhrov's book. She does not speak primarily about the corruption of Soviet rule as is fashionable today. Instead, she revisits and revives the uncorrupt dimensions and possibilities of this rule. And in this respect, her book is a substantial contribution to overcoming Cold War divides that still dominate thinking both in the West and in Russia.

INSTEAD OF AN INTRODUCTION

This book is not meant simply to revisit the communist past. Its aim, rather, is to witness to what extent certain zones where capitalism's domination is resisted—the zones of anti-capitalist critique, institutions of civil society, and theoretical provisions of emancipation or progress—are in fact permeated by an unconscious form of capitalism and thus unwittingly affirm the capitalist condition.

From this perspective, the political economy of historical socialism offers an indispensable *logical tool* that can map the paths of radical recomposition—and the radically different epistemological development—of such notions as labor, sexuality, power, gender, culture, unconsciousness, consciousness, reality, and the general, in socialist society and in Western thought respectively since the 1960s. The goal of applying this logical tool (political economy of historical socialism) is to see why the post-socialist retranslations of those aforementioned notions into "Western" emancipatory theories did not lead to more democracy, equality, or a desegregated society after 1989—either in the former West or the former East.

The role of historical socialism as a transitional phase to communism was dismissed as early as the 1960s by Louis Althusser, and was then further discredited during the Eurocommunist debate. Étienne Balibar reminds us of Althusser's stance, according to which socialism was merely a modernizing tendency within capitalism.[1] On the contrary, communism—which is more a form of social relations than a mode of production—is a tendency that surpasses merely social modernization. Following this logic, emancipatory movements resisting capitalism from *within it* are more communist than constructing and building communism in the conditions of socialism. If this is true, then it is not surprising that historical socialism is dismissed as an example of the communist experiment. Even Alain Badiou, in his 2010 book *The Communist Hypothesis*, refers to the Paris Commune, Mao, the Cultural Revolution in China, and 1968 as "evental sites" of communism without once mentioning the experience of the Soviets except for the revolutionary years of 1917–1922.

1. Étienne Balibar, "Althusser and 'Communism,'" *Crisis and Critique*, vol. 2, issue 2 (November 2015): 8–23.

Interestingly, in his 1880 essay *Socialism: Utopian and Scientific*, Friedrich Engels delineates the role of socialism in the construction of communism by emphasizing that socialism is not so much a preliminary phase of communism, but rather a systemic condition in which the forces of production become social wealth and are appropriated by the proletariat—first from the bourgeoisie, and then from the state. Socialism, then, is a scientific experiment undertaken to operate on surplus value as the core systemic element of the capitalist economy; hence, it is first and foremost a constructive research stage that is crucial for communism. Consequently, socialism merely represents the historical condition when the working class acts as a subject that has to socialize both the productive forces and relations of production so that they belong to society generally and not merely to one part of it. Hence, historical socialism is an indispensable experiment that, due to politico-economic turnover, manifests what happens to ontology, ontics, the principal epistemes of being, production, sociality, and culture when they remain without the surplus value economy and private property.

The book will not dwell on various standpoints concerning the fallaciousness of historical socialism. Nor is its task to search for the experiences in socialist culture that would be convertible into the global canons of art, culture, thought, politics, social movements, etc., as they evolved from the 1960s onward.

These two traps often materialize in attempts to integrate the former communist legacy into various post-communist emancipatory contexts: the one of contemporary art, of political theory, of Marxism, etc. Thus, my goal is not to prove, as in the many studies of "latent modernisms" within socialism, that the traits of "proper" modernity existed in the sociality, science, culture, art, and theory of historical socialism—and that therefore these legacies have the right to be integrated into the theoretical and social context of the emancipatory and progressive paradigms of "the West" or of global contemporaneity.

Such a stance would imply that what remains of the socialist experiment is only worthy of an archeological search for some hidden narrative that could neatly fit into contemporary critical thought and the global cultural context after the 1960s. This well-trodden approach stems from an assumption of historical socialism's

backwardness in comparison with developed capitalism. The capitalist economy defeated the socialist economy in the Cold War. This fact brought us to the general condition where the "Western Subject" happens to be the only subject of recognition and of universal judgment—even judgment over the impossibility of any universal judgment on behalf of the Western Subject.

Our claim, rather, is that even with its failures and drawbacks, a society that abolished private property is more advanced than any other existing social formation thus far.

In a 2012 essay entitled "Epistemological Gaps between the Former Soviet East and the 'Democratic' West," my aim was to reveal the epistemic divergences between emancipatory theories in Soviet Marxism and those recognized in "Western" capitalist thought and theory after 1945.[2] Even if I now emphasize such epistemic divergences between socialist and "capitalist" thought, I find it additionally productive to map and anchor such epistemic incompatibilities within the anti-capitalist philosophical and cultural narratives of continental thought itself. In this way, socialism could help expose the epistemic inconsistencies within anti-capitalist thinking in capitalist society. The divergence in this case would not be about the West and the East, but about the rupture between Marx and post-structuralism, between Hegel and Spinoza, universalism and post-colonialism, nominalist materialism and dialectics, object-oriented ontologies and idea-based universalisms and, in the end, between capitalism (even when it promotes a form of self-criticism) and socialism (even when it failed in the given historical period).

There are quite a number of unresolved epistemic inconsistencies that became explicit in continental thought before and after World War II. Just to briefly mention a few terrains and concepts:

Humanism: Frederich Nietzsche sees humanism as the main trait of bourgeois civilization and thus calls for its extinction. Marx, on the contrary, claims humanism as a still unattained state in the conditions of capitalism that could only be reached with the sublation of private

2. Keti Chukhrov, "Epistemological Gaps between the Former Soviet East and the 'Democratic' West," *e-flux journal*, no. 41 (January 2013), http://www.e-flux.com/journal/41/60226/epistemological-gaps-between-the-former-soviet-east-and-the-democratic-west/.

property. While Jean-Paul Sartre writes *Existentialism Is a Humanism* (1946), Althusser dismisses humanism as the Feuerbachian fallacy of early Marx (1965). In deconstruction (Derrida) or the works of Gilles Deleuze and Félix Guattari, the human and the historical become a-human and ahistorical.

Psychoanalysis: Jacques Lacan develops Freud's psychoanalysis; Deleuze and Guattari (and numerous other thinkers of gender theory, actor-network theory, and cognitivist studies) defy it.

Subject: Michel Foucault, Lacan, and later Slavoj Žižek and Badiou construct philosophies of the subject; the Spinozists—Guattari, Deleuze—reject even a political subject in the name of contingent forms of immanence and performative subjectivities. The further we go, the more confrontations emerge.

Reality: for Freud, reality is an illusion; for György Lukács it is the only mode of objectivity. For Theodor Adorno, and later, for the whole gamut of post-structuralists, a mimetic representation is a metaphysical essentialism; for Lukács, it is the only possibility of touching upon the worldly, the secular, and the evental.

Performativity: for Lukács, the accidentality of performativity is a return to archaic rituals, which causes alienation from the world. For many theorists of performance, from John Austin and Judith Butler up to Erika Fischer-Lichte, performativity is seen as an autopoetic presence of a body that defies mimicry and fictitiousness and brings forth social agency.

Consciousness: for Lukács and Cornelius Castoriadis, consciousness represents a breakthrough towards the emancipation of the oppressed—it is only through consciousness that the proletariat can construct itself as the class *for itself*. For psychoanalysis, by contrast, consciousness is but a repository of ideals and the instrument of control by the superego.

Labor: Lukács views labor as an indispensible condition of societal infrastructure and even of aesthetic production—for example he considers it a potentiality for de-alienating relations of production. Conversely, in post-operaism, labor conditions the insurmountable subsumption in capitalist production; thus it has to be sublated. Contemporary art practices posit the conceptual extinction of labor as a progressive step toward social emancipation.

INSTEAD OF
AN INTRODUCTION

Aesthetics: for Lukács, aesthetics realizes itself as the primary mode of humanism, which is a "must" for art. Needless to say, such a stance becomes quite anachronistic later, for example when Althusser denounces early Marx's humanism as ideology, or when works such as Jean-François Lyotard's *L'inhumaine* (1988) appear.

Indeed, if we address the connotations of such hyper-concepts as Enlightenment and modernity, the epistemic confusion will seem even graver. Does modernity reside in the nihilist and transgressive dismissal of Enlightenment as the instrumentalized mind (as posited by Nietzsche, later by Georges Bataille, Freud, Adorno, Derrida, Deleuze, and in general so many experiences of modernist art)? Or should modernity rather be regarded as persevering in Enlightenment, understood as the expanded universal common reason and civility (as Jürgen Habermas posited)?

When Habermas juxtaposes the decency of bourgeois culture and the anarchy and demonism of the cultural modernism that resisted it, he emphasizes that the traditionalism of Western bourgeois values and their radical rejection in Western modernism are two sides of the same coin, which in the end met in technocratic rationalization.[3] Modernism, in its protestant and often nihilist stance, was not able to accomplish a full-fledged political turn in sociality. It could neither eradicate the older cultural paradigms (e.g. completely dispense with religion and its institutions, which still function in contemporary democratic societies and are not abolished as they were in historical socialism), nor produce future worlds.[4]

In this case, Enlightenment as the project of modernity, on the one hand, and artistic modernism's extreme nihilism, on the other, do not go together. It is in this sense that modernism is the opposite condition of the avant-garde; it denounces the profanity of commercialized reality without any affirmative projections of its radical transformation.

One can then argue that Western modernity since the late nineteenth century has been contaminated by a strange aberration. In it,

3. Jürgen Habermas, *The Philosophical Discourse of Modernity*, trans. Frederick Lawrence (Cambridge, UK: Polity, 2015).
4. Unfortunately, we cannot touch upon Adorno and Horkheimer's most valuable observations on the controversies of Enlightenment.

the infrastructures and edifices of capitalist modernity and its insti-
tutions of enlightenment have been constantly undermined as the
"wrong," "bourgeois" modernity. This destructive mood was encour-
aged to become more vicious than the viciousness of capital itself.
It instigated forms of creative and political agency to function as the
nihilist backdrop to the instrumentalized reason of capitalist produc-
tion: fighting against alienation by means of a more extreme alienation.

The question would then be whether the transgressive and at
times decadent interventions of modernist nihilism into "bourgeois"
Enlightenment were meant as some sort of alter-enlightenment and
emancipation, or did they happen to be Enlightenment's and eman-
cipation's termination in a protest against it? One of the outcomes
of such a blurring of distinctions is the present condition: the ves-
tiges of radical modernism, being the legacy of contemporary art,
quite unconsciously and automatically become narratives for the
cultural education of the masses or tools for integrating third-world
cultural contexts into modernized and "civilized" life and production
in the present. However, what goes unnoticed is that this modern-
ist legacy was often explicitly and deliberately anti-social, decadent,
non-emancipatory, destructive, and at times meant even a violation
of life and menace to it. Here it suffices to mention Bataille's circle
or the activities of lettrism, Viennese actionism, and many other art
practices that bring the ideas of Enlightenment, emancipation, and
progress to a nihilist halt. These questions became truly confusing
with the activities of social engagement at the time of the second
avant-garde in the 1960s, which hijacked many ideas of the produc-
tivist and constructivist practices of the first Soviet avant-garde, and
thus created a mutated form that combined the decadent defiance
of emancipation characteristic of modernism, on the one hand, and
the protocols of social emancipatory progress initiated by the avant-
garde, on the other.

These mutations take place when modernist practices of sac-
rilege and skeptical disbelief in socioeconomic emancipation start
epitomizing the critique of modernity and are gradually treated
as contributions to progress. In this case, that which is criticized
and denounced as capitalism's vicious character is simultane-
ously desired and accepted as the condition of an albeit malicious

modernity without engaging any affirmative post-critical imaginaries of social emancipation. This is because such a post-critical condition could be at stake only after the October Revolution, i.e., in a post-capitalist sociality. Such an overlapping of repulsion and fascination with negativity and nihilism characterizes thought and creative practice from Charles Baudelaire to Bataille, and further on up to Guattari, or the accelerationist dystopia and post-humanist theories of the present. Foucault already demonstrated that the mapping of clinical phenomena can arouse desire for them. Similarly, in *Capitalism and Schizophrenia,* Deleuze and Guattari find capital monstrous, but at the same time a desirable terrain from which subversion and its emancipatory potential might stem. The acceptance of vicious capitalist contemporaneity is inevitable given the condition of the impossibility of its sublation. In other words, what has to be rejected is unconsciously approved. Certain undesirable conditions become exactly what is *de facto* desirable. As a result, the potentiality of affirmative social constructivism that could aim at expediency and progress becomes invaded with explicit modes of counter-enlightenment and counter-emancipation—applied paradoxically in the role of practices both emancipatory and enlightening.

A very important aspect of such an aberration lies in the following: the capitalist undercurrent of these emancipatory and critical theories functions not as a program to exit from capitalism, but rather as the radicalization of the impossibility of this exit. Consequently, the impossibility of terminating capitalism mutates into the bureaucracy of critical civility and is packaged in emancipatory, progressive lexicons. The planning and ideological framework is counter-capitalist, but the contents remain either nihilist, or reproduce the status quo of capitalist political economy and sociality in the form of its critique.

What thus goes unnoticed when we refer to critical and emancipatory theories in capitalist societies is that they persevere in subverting, intervening in, or even undermining the conditions of capitalism in a regime that ultimately affirms them. This is quite explicitly the case even in those theories where such an affirmation of the capitalist condition is not implied. While developing the lexicons of the critique of ontology and metaphysics, anti-capitalist critical theories within capitalism did not have the opportunity to experience and

practice sublated capitalist economics. In other words, such theories were unable to exert a critique of their own insufficient anti-capitalism. They were at a loss when analytically approaching their own involuntary and unknowing practice of capitalism. This is why the critical theory of capitalist societies is often unaware of its own contamination by the vocabularies and lexicons of capital on various levels.

Hence, historical socialism is exactly that "outside" from which one can see how the aberrations and fallacies in the critique of capitalist subsumption are overlooked by the token of their own entanglement in the logic of capital—by the token of being its indispensable part.

To cut it short, the irretrievable epistemological gaps in continental thought and culture are inscribed in the project of modernity—regardless of their Eastern or Western geopolitical manifestations. Yet it was exactly in the conditions of historical socialism that an explicit decision on this or that philosophical standpoint, a choice *in favor* or *against* certain philosophemes and aesthetic positions, was not solely a theoretical standpoint, but had to become a concrete tool to be practically applied in social production and confirm the chosen path of emancipation *in situ*.

What determined such choices in historical socialism? Were these choices dependent mainly on the instrumental decisions and guidelines of Party ideology and bureaucratic apparatuses? Or were these choices derived from the social infrastructure molded by the eradication of private property and the non-surplus value economy, which in fact generated new ontologies and epistemologies of socialism and hence affected the programmatic choice of this or that philosopheme? If we infer the latter—namely the application of a certain philosopheme while defying the other as the superstructure to concrete politico-economical operations—we have to acknowledge the following: certain critical, philosophical, and aesthetic positions had to be rejected, because they had become incompatible with the new realia of the socialist economy and production politically, socially, as well as epistemologically, and even *ontically*. Indeed, by claiming the *ontic* compatibility of the Soviet socialist economy and production with specific philosophic and aesthetic ideas, I mean that the political economy of deprivatization changes not only the

speculative, conceptual, and epistemological categories in the comprehension and interpretation of reality and its modes (i.e., ontology), but it also transforms the material factuality of existence, the thinghood of things themselves—i.e., even the ontic is contaminated by the communist condition. Thus, what might appear to be unsurpassable traits of being or of existence—e.g. social and ontological alienation, the split between mind and matter, the insurmountability of the division of labor—could turn out, after socialist revolution and under socialist economic conditions, to be rather the outcome of unabolished private property and various forms of economic subsumption and coercion.

We are dealing here, then, not only with the political and the social, but with the ontological, and, even more importantly, with the *ontic reconstitution* that was an inevitable consequence of the forceful erasure of the capitalist economy and its social and cultural features from social consciousness and hence from life and material production in historical socialism.

We are accustomed to thinking that various forms of suppression in socialist societies—constraints on sexuality, dispensing with certain tendencies in art and intellectual fields—can be mainly ascribed to the manipulative rule of the bureaucratic party machine. But could it be that what we, capitalist subjects, assess as unfreedoms and constraints are in fact derived from the inevitable exigencies of the socialist economic system?

In this light, a key area of analysis would therefore be to reconsider the "traditional" emancipatory concepts that undermine power and metaphysics—*sexuality*, *freedom*, *the unconscious*, *subversion*, *performativity*, etc.—in order to reassess their liberating validity. But simultaneously at stake then is an attempt to revisit the concepts traditionally interpreted since post-structuralism as metaphysical—for example, *the idea/the ideal*, *the general/the universal*, *the classical*, *metanoia*, *reality*—and try to reassert them as materialist notions. This needs to be done in order to observe how these seemingly metaphysical notions construct the body of sociality, how they function as the extensions of non-surplus economics, and to what extent they are essential to the production of a non-capitalist ontics. Such a reconstitution implies that the noumenal parameters—the ideal,

the general—occupy the physical body of things, simply becoming ontic, coinciding with matter. The infinite then exists in the body of the finite, while nonetheless preserving its qualities of infinity within finiteness, instigating the formation of a new philosophic discipline: materialist metaphysics.

According to the standard approach, the demise of historical socialism is predominantly explained by different aspects of false communism within concrete formations of historical socialism. I conversely assert that the decomposition of socialism was due to the excessive—to *too many parameters of communism*, which happened to be unimplementable for a variety of factors. An important methodological condition of the present book is the reliance on logical constructs rather than historiography. The primary stake in its four parts (1. *Political Economy*, 2. *Sexuality*, 3. *Aesthetics*, 4. *Philosophy*) is to detect how the concepts essential to the critique of capitalism—such as surplus value, desire, libidinality, alienation, labor, culture, language, sexuality, and production—evolve in socialist and capitalist environments respectively. But even more important is to articulate the concepts that formed Soviet socialist ethics and cultural politics, but which have been rejected by anti-capitalist critical thought since the 1960s. These notions are: the universal (*vseobshee*), de-alienation, metanoia, human resignation, the ideal, non-self being, the classical, realism, and others.

Part I

Political Economy

CHAPTER 1

ABERRATIONS IN
ANTI-CAPITALIST CRITIQUE:
Desiring Alienation

One of the syndromes of anti-capitalist critique of alienation, both in politics and aesthetics, has been a strange aberration inherent to the post-structuralist analysis of capitalist society. Foucault's *History of Sexuality*, Lyotard's *Libidinal Economy*, Deleuze and Guattari's *Capitalism and Schizophrenia*, Guattari's *The Machinic Unconscious*, and Butler's *The Psychic Life of Power* demonstrate this syndrome. In these cases, what is criticized is simultaneously desired and accepted as the condition of vicious contemporaneity. Thus, in the very act of repulsion there is a fascination with the repulsive. The unconscious acceptance of remorseless capitalist reality along with its fierce critique is inevitable in the conditions of the impossibility of its sublation. Therefore, the strategy for resisting alienation often resides in exaggerating and intensifying what is vicious. Consequently, radical tools of imagining or installing de-alienation are rejected as redemption. Such paradoxes are often manifested in contempt for the philosophical and artistic contexts of historical socialism. As Samo Tomšič argues in *The Labour of Enjoyment*, alienation should be managed rather than imagined as abolished, as the latter would only result in a compulsive and repressive de-alienation, and, further, would introduce new forms of alienation.[1] Research into Soviet Marxist thought (Ilyenkov, Vygotsky, Leontyev) in psychology, philosophy, and political economy reveals concrete cases of exerted de-alienation and its continuity with the politico-economic achievements of the October Revolution. These cases demonstrate that de-alienation is not a goal in itself, but rather the ontological effect of concrete epistemological and politico-economic turnovers and refurbishments.

I
ABERRATIONS IN ANTI-CAPITALIST CRITIQUE

Resisting alienation or "working through" it (Tomšič) in the conditions of capitalist economy tends to intensify or estrange the already existing traits of alienation. Even Brecht's *Verfremdung* (distanciation),

1. Samo Tomšič, *The Labour of Enjoyment: Towards a Critique of Libidinal Economy* (Berlin: August Verlag, 2019).

or the Russian formalists' *ostranenie* (defamiliarization), functions as a symptom of alienation rather than a counteraction to it, in that it does not in any way undermine its logic. It should be made clear from the very start that the term "de-alienating" does not imply any pretension of overcoming the primary, ontological alienation. I use the term "de-alienation" to refer to a social and politico-economic practice that deals with the abolition of private property, with surpassing the division of labor and surplus value extraction. However, I infer at the same time that certain aspects of ontology that appear to be natural conditions of the primary existential alienation inherent to being might turn out to be mere contortions of a capitalist politico-economic regime of privatization and of social and class segregation. Consequently, numerous features of alienation that are treated as inherent and ontologically prescribed in sociality, subject, language, thought, signification, and labor are actually contortions caused by concrete effects of the political economy and the politics of production.

In fact, when mapping the logic of capital, Marx does not ontologize the condition of surplus in it; for him, surplus value is mainly the disequilibrium between the forces of production and the relations of production. Conversely, in Deleuze and Guattari's *Capitalism and Schizophrenia* (1972), Lyotard's *Libidinal Economy* (1974), Foucault's *The History of Sexuality*, and Castoriadis's *The Imaginary Institution of Society*, surplus is, on the contrary, ontologized and seen as an innate force of the libidinal. In the aforementioned works, alienation acquires an insurmountable ambivalence. Foucault shows explicitly how the clinical control and inspection of sexual pathology generate sexuality. *Capitalism and Schizophrenia* epitomizes the Möbius condition in which capital itself represents creative subversion, which is both axiomatic/subjugating and liberating at the same time.[2] Desire in capitalism is generated by surplus economy, but this very desire can be subversively applied against the limits that hamper capitalism's creative and schizophrenic redundancies. Thus, the post-capitalist condition is sought within capitalism's productive resources and its

2. Such logic follows the Althusserian disposition about the interpolated subject, which is constructed as an emancipated unit simultaneous to being ideologically marked and subordinated.

semiology. But this anti-capitalist radical creativity is not itself un-alienated. On the contrary, it becomes even more uncanny and alien than the predictable modes of alienation. (Strivings toward the inhu-man, the machinic, or animalic mutations, which have all been seen in the last fifty years in post-structuralism, actor network theory, accelerationism, object-oriented materialisms, and post-humanist studies might be the consequence of such a yearning for enhancing the already existing modes of alienation.) As Guattari states in his *Machinic Unconscious* (1979), if we remove the existential status of a human being, as well as of living consciousness, then other ener-getic stratifications will acquire the potentiality for production.[3]

In his *Economic and Philosophic Manuscripts of 1844*, Marx stated the premises of alienation and the paths of its sublation, which were: the division of labor, its abstract character, class division, and private property. Marx's discovery was that the things that seem innate to human existence and social life—like trade, the division of various capacities among humans, and the need for exchanging them—are not a natural state of things, but are conditioned by private property. Thus, the division of capacities is not the motivation for exchange and trade, but rather the effect of exchange and trade instigated by the neces-sity to accumulate private property. Marx clearly posits the abolition of private property as the main provision for overcoming alienation. Such an abolition could restore the human condition and facilitate a conflation of the cognitive and sensuous parameters: of thinking and of objective reality. As Marx claims, production, grounded in private property, produces the urgency of need.[4] By consequence, man starts to function then as the impetus of artificially constructed, necessitated novelties, as the encourager of a new enjoyment; whereas, paradox-ically, the growth of necessities simultaneously generates a lack of necessities: it necessitates novelties in order to promote new forms of enjoyment.[5] (This is precisely what Lyotard revealed in his *Libidinal Economy*, where lack is crucial to the construction of desire.)

3. Félix Guattari, *The Machinic Unconscious*, trans. Taylor Adkins (Los Angeles: Semiotext(e), 2011), 33–57.
4. Karl Marx, "The Meaning of Human Requirements Where There is Private Property and in Socialism," in *Economic and Philosophic Manuscripts of 1844*, trans. Martin Milligan (Amherst, NY: Prometheus Books, 1988), 115–135.

This early work of Marx's does not provide any prognosis for *how* the sublation of alienation and private property could be implemented. Already in it, however—and much earlier than any of the works on desire and alienation that would appear in the 1960s—Marx determined how private property and its economy of surplus *estrange* things and humans, and exactly by this token make things desired as "urgent needs." Marx emphasizes that "estrangement is manifested not only in the fact that my means of life belong to someone else, that my desire is the inaccessible possession of another, but also in the fact that everything is itself something different from itself—that my activity is something else and that, finally (and this applies also to the capitalist), all is under [the sway] of inhuman power."[6]

In this argument, the way the objects of "my" labor can be detached from "me" makes their alienation and the labor that produces them dull and uninteresting. But the market, trade, exchange—exactly due to alienating detachment—turn those objects into a desired fetish. By this argumentation Marx already predicted the craving for various modes of alienation (including transhuman horizons), caused by alienation itself.

However, for Marx the attraction to the desired fetish object is not attractive, mysterious, or enigmatic: the commodity is always estranged, but its bizarreness is conditioned by the surplus value economy. Even though the fetish object might seem inhuman and mysteriously remote and longed for, its mystery is easily decodable within the logic of production. It is possible consequently to attain another state—one in which capitalism and its inhuman force of alienation might *not* be desired, despite their allure.[7]

In this argumentation Marx is ethically and epistemologically quite remote from what we witness in the most important works on alienation and desire, which appear in the 1960s and 1970s: Castoriadis's *The Imaginary Institution of Society*, Lyotard's *Libidinal Economy*, Guattari's *The Machinic Unconscious*, and Deleuze and Guattari's *Capitalism and Schizophrenia*. In those works, desire is constitutive of capitalist production and its surplus economy in

5. Ibid.
6. Ibid., 124.
7. Ibid., 121.

that it produces phantasms of fetishes, while it is at the same time grounded in deferral and lack, never saturating this phantasmatic greed. However, according to Lyotard, it is this very viciousness, this very pathological undercurrent of desire that is sought after, and not merely the illusionary fetishes contrived by it. Therefore, for Lyotard, resisting capitalism is stuck within the double-bind logic of the Möbius strip—wherein alienation can be surpassed only with even greater alienation. This is how we arrive at the aberration of mistaking aestheticized alienation for emancipation. The aberration in this case resides in treating libidinality as a sort of revolutionary force directed against the reigning order.

For Lyotard, representation, virtue, law, state, and authority confront the subversiveness of libidinality. Yet, he goes as far as to say that even the law, representation, "the great Zero," and "despotic rule" are also libidinally grounded and inscribed into the economy of desire. Thereby, power and its restrictiveness and even religion in its asceticism are libidinal, whereas desire in its own turn always faces the danger of turning into a dispositive.[8] Exteriority and interiority are fused in the Möbius logic; this implies that, while libidinality might be engaged in most despotic phantasms, it might also subvert from despotism too. In this way, it is not that evil and viciousness are chosen as the forms of protest against capital's domination (as in classical modernism), but the choice itself is to be deferred to make such modes as pain, tragedy, or virtue unviable. Aberration does not take place when viciousness supersedes virtue, since certain concrete representations of virtue are simply considered false (for example, when one claims that "truth" is despotic, etc.). But aberration takes place when even what is truly considered to be the "common good" happens to be permeated by a vicious or libidinal genealogy. In other words, the libidinality of desire can manifest itself elsewhere, even in something that is not functioning as desire, and the yearning that saturates it. Hence, non-libidinal phenomena—religion, law, justice, virtue—also become libidinal, are also the products and embodiments of alienation. Thereby, even what might have been de-alienated—by means

8. Jean-François Lyotard, *Libidinal Economy*, trans. Iain Hamilton Grant (London and New York: Continuum, 2005), 5–6.

of approximation to the relative de-alienatedness of the common good—in fact merely remains a libidinal fantasy. In short, what might have been de-alienated functions within the very logic of alienation as well. Consequently, what could have been a project of non-alienation is in no way able to exceed alienation.

The outcome of this condition is that what has to be achieved as social virtue can only be a false, disguised virtue, functioning as a repressing Signifier, in fact. On the other hand, what seems to be alienated, perverse, or uncanny, might not be that vicious if one were to supplement it with artistic intensity, and surmount it by means of greater perversity and estrangement.

The radical critique of capitalism since the 1970s thus provides a paradoxical example of aspiring to those features of counter-capitalism that have only intensified the alienating conditions of capitalism.

One of the most structured and logical manifestations of such a stance is found in Guattari's *The Machinic Unconscious*. In his critique of dominant semiology and its axiomatics, Guattari becomes a proponent of a-signifying flights from the rule of the Signifier.[9]

His logic is the following: capitalism resides in the force of abstraction, but what can subvert this regular abstraction is an even more enhanced, creatively produced, and a-signifying abstraction. Instead of articulating non-capitalist urgency in the abolition of private property—for example, overall equality of education, blurring the borders between privileged and unprivileged labor—the flight from capitalism might be sought in deviations from what functions as the universal, language, the system, power, etc. After claiming capitalism's schizophrenic creativity as insufficient, Guattari calls for the a-signifying creativity of primitive societies and indigenous communities: of magic, dangerous animalities, deviant facilities, and de-territorializing shifts. In this new, creative, a-signifying counter-structure, diagrams supersede *Gestalt* and *Umwelt*, assemblages stand for distinct semiotic essences, the labyrinth evades platonic exit from the cave, redundancy is juxtaposed to reduction, dissociation to composition, de-subjectivized non-genital libido takes over

9. Félix Guattari, *The Machinic Unconscious*, trans. Taylor Adkins (Los Angeles: Semiotext(e), 2011).

the familially-biased genital one, infantile mumbling and its metabolism takes over adult normality, event as occurrence surpasses substances, etc.

The problem in such apologia for redundancy and a-signification is that in them the modes representing the system—law, virtue, the universal, and language—are identified mainly with capitalism and criticized precisely as capitalism's features. (This remark is what is at stake in Althusser's argument as well, when he identifies the ruling class, the capitalist class, and the law.)[10] Meanwhile, the abovementioned categories do not necessarily embody something exclusively capitalist. Moreover, theoretically, in the case of defeated capitalism they might as well represent that very indispensable temporary dictatorship and the law of the subjugated class (proletariat) that Lenin insists on in his *The State and Revolution*. In this case, the law, the common good, and organization would on the contrary function as de-alienating forces. As a result, paradoxically, subversive deviation from the capitalist syntagmatic is entitled to operate as the only remedy against it, even though in fact such deviation only intensifies the already existing alienation of the capitalist semio-system. Furthermore, in this case, the conditions that might unify and hence potentially exert socialization and certain modes of de-alienation (conditions of the common good, and its social accessibility) are denounced and claimed to have a no less alienating character, just as every other feature of capitalism. In fact, the fear and mistrust of de-alienating social procedures arises from the fear of coercive equality. It is true that the October Revolution did not completely guarantee socioeconomic de-alienation; it had to be a long-term social practice that was never completed in the Soviet republics. However, what was facilitated by the October Revolution and what retained viability in its aftermath, notwithstanding Stalinism, was the *criminalization* of those provisions that Marx listed as alienating: private property, surplus economy, fetishized consumption, and thus, the ethics and aesthetics of libidinality. This simply meant an abrupt, overall, and hence coercive *criminalization* of certain forms of alienation on numerous

10. Louis Althusser, *On the Reproduction of Capitalism: Ideology and Ideological State Apparatuses* (London; New York: Verso, 2014).

levels—social, economic, and cultural. Therefore, it is truly a question of whether communism could be "a collective management of alienation" as Samo Tomšič suggests;[11] or whether this model—for the collective management of alienation—could only be regarded as a social democracy within capitalism. In fact, the abovementioned modes of de-alienation—abolition of private property, grounding production in use value, overall and abrupt equality in education—meant something quite harsh and unacceptable for the formerly privileged classes, insofar as it criminalized the otherwise "normal," alienated components of the capitalist political economy.

As we see from Guattari's arguments, alienation is not the primary cause of concern when deviating from the axiomatics of the capitalist system. On the contrary, at stake are the "normalizing" and the non-alienating functions of the law, of the common good, of organization. In other words, in fact what causes irritation with "the order" and "the law" is the capacity that would allow the law to restrict alienation, i.e., to de-alienate. This is because such redemptive de-alienation is only viewed on behalf of external powers—like God, the State, Religion, the Ideal, the Good, etc.—and is considered to be only an illusionary mode of de-alienation. In this way, it would be a false de-alienation that is only *pretending* to de-alienate, and by this token is alienating even more. (Religion is the classic case of such alienation, in that it pretends to represent non-alienatedness.) Consequently, deviation and subversion are used to fight the system, not because it is a vicious capitalist system, but they happen to fight precisely those potentialities of organization in the system and order that might have been the system's de-alienating potentialities. Thus, even when resisting alienation, these deviant moves function as an opportunity to additionally and excessively alienate. Surplus value—the embodiment of abstracted labor and alienation—can then inflate to the extreme and acquire creative potentiality. For Guattari, surplus value can be viewed as a redundancy, pregnant with new productive contingencies, capable of undermining the code. It generally

11. Samo Tomšič made this statement as an argument to the present chapter at the Historical Materialism conference in AUB, Beirut, on March 10, 2017, on a panel moderated by Ray Brassier. See also: Samo Tomšič, *The Capitalist Unconscious: Marx and Lacan* (London and New York: Verso, 2015).

becomes the force capable of surpassing the code and order, without which creativity is impossible. For example, the trans-territorial mode of rhizome ecology and its deviated reproduction is explained as the surplus value of code, in which surplus value acquires the force of the a-signifying shift, of the excess, surmounting code. Surplus value rejuvenates the rules of evolution and genetics, allowing biological territorialities to become redundancies and flights within the social assemblage.[12]

If Marx was attempting to bring abstraction back to its genesis from matter, to concreteness, in order to conjoin it to the sensuous dimension, here we see on the contrary an intensification of abstraction: the normative abstraction of the code should become abstract anxiety without the object. The same goes for dissociations (disseminations), which make capitalism creative; so that they should be enhanced further to surpass capitalism's systematic regularities. Let us remember the way that Deleuze treats the cave: instead of exiting it to return back afterwards in order to enlighten the other captives, one turns it into an endless labyrinth where there is no division between light and dark, and which one can never leave. In the beginning of *Libidinal Economy*, Lyotard refers to Plato's cave in a similar way: in this case, the actors who show the objects to the bound captives observing the shadows of those objects on the wall turn out to be the shadows themselves, and not actors at all. The cave then becomes the counter-universalist and nomadic totality.[13]

<div align="center">*
* *</div>

Another eloquent example of aberration and confusion in the search for paths of emancipation can be found in Castoriadis's argumentation in *The Imaginary Institution of Society*. His standpoint oscillates between orthodox Marxism, psychoanalysis, and post-structuralism. While Castoriadis declines a number of Marx's principal premises, he cannot fully accept the radical post-structuralist treatments of

12. Guattari, *The Machinic Unconscious*, 120–122.
13. Lyotard, *Libidinal Economy*, 12.

capitalism either. When it comes to Marx's exigency for the radical reconstruction of the social field, to the necessity of eradicating the conditions generating alienation, Castoriadis labels Marx's political economy as ideology: as extremist rationality and crypto-bureaucratic sociology. But when it comes to overtly soaring into the inhuman condition of hyperactive alienation á la Guattari, then Castoriadis pulls back and searches for classical social democratic remedies against alienation, such as participatory autonomy, individual autonomous consciousness, etc.

Castoriadis's critique of Marx is a good example of how the unconscious desire of a capitalist subject functions in evading communism. The main thing is to clearly posit (quite similarly to post-structuralism) that alienation is generated not merely by labor division and deprivation (i.e., not so much by economy and production), but also resides deeper in the social Unconscious, which speaks on behalf of the Imaginary. Capitalism's phantasmatic nature, as Castoriadis insists, epitomizes the condition of the Imaginary, which in its own turn is the site of the insurmountable power of the unconscious. But then, quite unlike the post-structuralists, having acknowledged the alienating power of the Imaginary and of the unconscious, having emphasized the power of the alien and the phantasmatic Otherness, he demands the agency of the Subject's autonomous *consciousness* and *conscious* decision-making as a counteraction to the rule of the unconscious phantasm. Here we confront a confusion: capitalism can be overcome by certain components of capitalism itself that evade alienation, since capitalism contains forms of agency that are beyond and counter to alienation. Among such types of agency, Castoriadis cites the autonomy of a conscious Subject and his/her de-alienating potentiality, which can turn the phantasmatic otherness into intersubjectivity, into the "con-substantiality" of autonomous individuals. By participating together in social life, these individuals could help conflate the agency of institutions with the agency of societal texture. Such civil agency would deprive the institutions of their sovereignty in favor of society. It would de-alienate the otherwise negative social context in which everything—the market, the systems, the institutes—alienate, turning social texture into hostile and alienated otherness. Yet, when the question arises about overall,

revolutionary methods of eradicating concrete forms of alienation caused by the capitalist political economy—in other words, eradicating that very phantasmatic Imaginary that speaks on behalf of the unconscious, or those very drives that blur reality by fictitious desires—then Castoriadis states that such eradication is forceful, violent, and leads to extreme rationalization and bureaucracy. In the end, it is exactly the insurmountable force of the Imaginary (i.e., precisely desire, alienation and its contingency) that becomes an irresistible, enchanting force that maintains capitalism—because its enchantment is stronger than any justice carried out in the name of equality or that of de-alienating measures (labeled as over-rationalized bureaucracy). According to this logic, even if it is important to develop types of agency for de-alienation in the midst of capitalist alienation, alienation will always prevail.

Striving towards an overt non-alienatedness would presuppose, as he claims, a violently contrived and artificial vision of being; it would construct only the fiction of the common good on behalf of the self-declared Subject claiming to be the master of history.[14]

By means of such arguments, Castoriadis dismisses Marx's contention in *The Economic and Philosophic Manuscripts of 1844* according to which the allure of the phantasm, and hence of the commodity, can be easily undone and disenchanted by abolishing the surplus value economy. For Castoriadis, political economy and labor stop being the main realm where the conditions of alienation and class division might be terminated and sublated. This is because alienation operates libidinally, namely it functions deeper than sociality—closer to the body, skin, the drives, and the unconscious yearnings where political economy cannot reach.[15]

The cause of alienation in this case is not derived from the economic deprivation that results from dispossessing the worker of humanity, as Marx would posit it. The cause of alienation is not the artificially generated poverty resulting from distilling the surplus value of everything. But alienation, as well as the libidinal undercurrent of capital, resides in the unconscious, and hence in the

14. Cornelius Castoriadis, *The Imaginary Institution of Society*, trans. Kathleen Blamey (Cambridge, UK and Malden, MA: Polity Press, 1987), 110–115.
15. Ibid., 132–135.

innateness of the phantasmatic of the Imaginary. In this way, the Imaginary and the unconscious are the sources of both alienation and creativity.[16]

Castoriadis criticizes Marx's economic determinism, which did not allow him to predict that capitalism contained the capacity to surpass the incoherence between productive forces and the relations of production. So that in the end, as Castoriadis claims, productive forces evolved without allowing the relations of production to collapse, quite contrary to Marx's predictions. This is why the social systems and public relations (relations of production) within capitalism are sustained, even when they lag behind the development of productive forces.[17]

In this logic, we can see how the force that escapes the over-rationalization and over-functionality of communism and the radical Marxist critique of political economy is exactly the Imaginary—the remainder that sustains such things as, for example, "the three thousand years of Christianity, the child's infantile mumbling, the shaman's sorcery, the power of mysterious magic" (Castoriadis)[18] and other inexplicable powers in human history.

Meanwhile, Marx's political and ethical standpoint resides in the premise that economic conditions motivate biopolitics, that *they are antecedent to the bond of political economy with the unconscious and the phantasm*, which for Castoriadis (as well as in poststructuralism and psychoanalysis in general) are considered prior to economic and social alienation.

In other words, judging by Castoriadis's argumentation, the Imaginary is the force of alienation and it embodies capitalism; but it is too powerful, creative, multifarious, to be surpassed by any severe presumption of equality or any radical, revolutionary transformation of economy and production. Thus what epitomizes capitalist alienation simultaneously contains the power to diversify it—to make it creative, subversive, and fascinating. On the one hand, Castoriadis's stance fits the disposition of all post-structuralist laudations of alienation as an inhuman condition that can be "worked through," enhanced, or

16. Ibid.
17. Ibid., 42–45.
18. Ibid.

radicalized. On the other hand, Castoriadis does not dare to make a further step towards accepting the "evil" of capitalism and its eternal "labyrinth," as Deleuze or Guattari do. He does not refer to revolutionary social lexicons insofar as it suffices for him to confine himself to reconsidering institutions—to retranslate them from the alienated and foreign lexicon of the Imaginary into the lexicon of the conscious decisionism of intersubjectively allied, autonomous citizens.

Hence the aberration—exactly that which is proclaimed as the vice to be abolished—becomes the ambivalent, omnipresent power and fascinating "otherness" of it. But it cannot be and maybe should not be surmounted, because its vicious traits (magic, alienation, surplus) might be too precious for humanity. Castoriadis appeals to the social consciousness of the autonomous, conscious individuals participating in civil work to control the Imaginary and its unconscious undercurrents. But along with his participatory program of resistance, he calls a society devoid of alienated social structure Marx's fantasy—a bureaucratic regime which would be similar to absolute knowledge and consciousness, bearing the pretension of making life fully cognizant.[19] There is yet another, more recent psychoanalytical analysis of alienation that insists on its insurmountability despite any social struggle. Being quite suspicious about any discreet methods of de-alientaion, Tomšič differentiates between two functions of alienation: capitalist exploitation, and the critical "working through" of various forms of alienation that he ascribes to psychoanalysis and Marxist critique. In this perspective, de-alienating methods of resisting alienation (such as attainment of use-value production in economy, communicative accord in speech, or "constructing future scenarios of a de-alienated social condition") should be suspended, as explicitly planned de-alienation can only be repressive and ultimately lead to new forms of alienation.[20] Meanwhile alienation cannot but be sustained as an important systemic condition marking the difference, split, and surplus in language, labor, thought, and value production; paradoxically it is the acceptance of alienation that then enables resisting the exploitative forms of alienation in social systems.

19. Ibid., 110–113.
20. Tomšič, *The Labor Of Enjoyment*, 123–137.

However, such resistance should be implemented without fantasies of an uncorrupt sociality, or of any authentic subjectivity.[21] Quite like Castoriadis, and just like Deleuze and Guattari, Lyotard claims that abolition of the libidinal drives of capitalist economy would abolish creativity, too; Tomšič argues that de-alienation in labor, language, and thought would imply their repressive regulation. It's another eloquent example of a psychoanalytical treatment of alienation which asserts that alienation in political economy has ontological grounding, and even though it is spread across sociality, its elimination would entail a collapse of the tools of its critique and mapping, especially when alienation reaches its utmost forms of exploitation.

Even if we agree with this critical potentiality of unsublatable alienation—as it would only presuppose a false illusion of sublation—the following problem remains: If there can be a productive management of alienation and an emancipatory "working through" alienation in the form of resisting its exploitative features, it means that this would diminish the extent of alienation. Then why not term the decrease of alienation as de-alienation, marking the direction of this emancipatory process? Moreover: If no abrupt and coercive forms of de-alienation are accepted, does it mean that radical forms of termination of exploitation in the history of political struggle and social emancipation—such as the abolition of slavery or serfdom, anticolonial struggles, the French Revolution, the October Revolution, the abolition of private property and of many other forms of inequality—were repressive, redemptive, and uncritical? If critique maintains exploitation, maybe this is why the socialist revolution abolishes the social conditions in which such critique claims its emancipatory agency and establishes new conditions, effectively de-ontologizing the previous forms of alienation and its critical management. The fact that the very episteme of alienation retains its conceptual vigor and appropriates the agency of emancipation, defying such agency in the term "de-alienation," confirms my initial allegation: the de-alienating components of the regime of the common good are unacceptable for capitalist subjectivity, even when such a subject perseveres in anti-capitalist critique.

21. Ibid., 122.

II
THE ALIENATING POWER OF THE GENERAL:
Language, Law, and the Common Good

I will now once more reconstruct the logic of aberration in anti-capitalist critique within the conditions of capitalism. Capitalism is understood as a suppressive social order, as long as it is a capitalist order; order then counts as repressive, as long as it is a capitalist order. However, the "wrongness" of the capitalist order is confused with the "wrongness" of order as such. In this case, it is not precisely capitalist order that is the condition to be censured, but any order starts to embody "the wrongness" of capital and its repressive domination. Consequently, a confusion follows: the centrifugal elements of capital (even though they are part and parcel of capital's logic) are seen through the prism of counter-capitalist emancipation, whereas the traits of any order as such—which might not necessarily represent a capitalist order—stand for capitalist subjugation and its modes of repression. The schizophrenic components of capital are then treated as flights from law and order. Order, law, and the Good are claimed to represent repressive capital a priori, although they might as well bear the potentiality to rather surpass capital, in case they organize power and law in favor of the exploited. Thus, order and law become "wrong" by definition. Whereas any mode of opposing them stands for emancipation and has to be discovered within capital itself. This is because it remains unheeded, that, in fact, law and order are detested not as traits of capital, but as traits that restrain the libidinality of desire and enjoyment. Nevertheless, the fact that desire epitomizes capital remains indiscreet. Rather than undermining capital, the resistant forces, in subverting law and the system, represent and enhance its alienating potentiality.

In that case, the subversive means that are sought to evade order, understood as the capitalist order, pertain to capitalist anthropology and its imaginaries. Then the question is: If "evil" comes from the *capitalist* social order, why is *any* order, law, or regime of the common good then treated as the innate falsity of order, "the big Zero," the Big

Other, whereas all divergences subverting law and order, even though they might be embodiments of capitalist conditions, become vicious but inevitable tools of resistance against the false virtue of order?

As a result of such an aberration, numerous anti-systemic forms of resistance pertaining to the lexicons of capital mistakenly acquire the status of "revolutionary" deviation, and stand in for liberation and freedom. Meanwhile the order that could have been virtuous if it had not been the order of an unjust society is proclaimed to be a force of authority and subjugation, since virtue and the Good can only falsely pretend to be virtuous, no matter what they stand for. Consequently, those exact capitalist distortions of the possibility for commonness and universality—distortions of the potential for the common good—acquire the role of resistance against the apparent fakeness of the Good (as virtue's only trait), and confront the Good, as the Good cannot but stand for suppression and bureaucracy.

Now, with all that said, let us look at the motives for resisting de-alienation—the motives for desiring alienation. Let us forget for a short time the word "communism," which contains so many symbolic connotations, and concentrate merely on communism's indispensable exigencies: overall equality, sublated desire, eradicated private property, and the abolition of the phantasmatic and libidinal realms of the Imaginary. Would such a world not appear to us capitalist subjects as quite an uncanny, barren land, populated by some sort of delibidinized angels, by Geist bio-robots, or neo-human titans?

Paradoxically, radical humanism and the non-alienated commons would seem inhuman and uncomfortable to a capitalist Subject. The economy of basic need would often contradict elementary comfort. The imagery of historical socialism with its ethics of modesty and anti-consumption might seem quite squalid and "estranging" for a capitalist Subject. Yet, paradoxically, it is precisely due to the de-alienation of labor and economy that the socialist material environment acquires the features of the absolutely un-owned, non-private objecthood, where anything is whoever's; and consequently, due to such radical de-privatization it seems "inhuman" and alien to a capitalist Subject, even when s/he is critical of capitalism. The capitalist Subject, even despite his/her counter-capitalist critique, would find

communist living conditions uncanny. This is because to adjust to the non-alienated commons one needs to get rid of the phantasms of "the desired" and "the attractive."

But the Subject of capitalism is anthropologically incapable of dismissing exactly those achievements of the capitalist everyday that, even despite anti-capitalist critique, remain part and parcel of life in capitalism. Stuck between the imaginaries of de-alienated sociality and the alienated Real of capitalism, the Subject of counter-capitalist critique chooses to apply the narrative of alienation to deal with the utter (alienated) reality of capitalism against capitalism's illusory imaginaries of comfort and progress. Consequently, anti-capitalist critical rhetoric within capitalism often relies on the narratives of extreme alienation as revolutionary imagery, insofar as such imagery inevitably stands for the Real of capitalism against "cozy" bourgeois islands of elegance and prosperity. Yet this critical Subject does not notice how in his/her everyday s/he unconsciously nourishes and consumes exactly that very illusion of the "un-alienated" prosperity within capitalism, which functions as welfare for the few. Quite often critics of capitalism, who detect alienating mechanisms within capitalist illusions of progress and call for further alienation with the aim of resistant critique, are unaware of the fact that they themselves are the beneficiaries of capitalism and active consumers of capitalism's privileges, and that it would be unbearable for them to restrict those privileges.

Let us refer in this connection to the rebuke Castoriadis made to Marx. In his argument, Castoriadis claims that if capitalism were reduced mainly to alienation, and did not also contain the modes *disguising* alienation, it would not survive very long. In the beginning of his *The Imaginary Institution of Society*, Castoriadis draws attention to an interesting paradox: capitalism does not wither away exactly because reification (and alienation) is exerted only partly in it; alienation leaves room for a certain amount of human creativity, comfort, and non-alienating forms of communication.[22] And, indeed, is commodity fetishism not aimed at producing and selling the phantasms of comfort, coziness, efficacy, high quality; in short, the phantasms

22. Castoriadis, in *The Imaginary Institution of Society*, 13–28.

of un-alienatedness? All of these can coexist with the phenomena of the harshest alienation, hardship, and deprivation.

This could be an argument against the claim about an inherent and absolute ontological insurmountability of alienation, and the redemptive artificiality of de-alienation, as Tomšič quite convincingly put it in his *The Labour of Enjoyment*. Alienation is as innate to being and its social extensions as the procedures of de-alienation, which in fact have always been the satellite of alienation in positing de-alienated commons in artworks, literature, political utopias, ancient ceremonies of hospitality, socioeconomic experiments, and the idea of communism, etc. In other words, de-alienation is not at all a totalitarian rule of "a master" or of a "sovereign" imposed over the contingency of life. Moreover, it is not confined to any historical period or social formation, e.g. Stalinism. It is part and parcel of the projections of the common good in the history of humanity that acquired politico-economic power in the conditions of post-revolutionary historical socialism. Yet, essential to de-alienation is that the projections of the common good—i.e., the idea of de-alienating certain forms of alienation causing suffering and exploitation—are not libidinally marked. The episteme of the common good dismisses libidinal self-love, aspiring for the political Eros of the non-self, of voluntary self-resignation. The epistemes of desire and the libidinal then are not vicious in themselves; they are simply unable to enter the economy of the common good, as they are stuck in the regime of narcissistic self-love and its various phantasmatic projections, and thereby foreclose *reality*.[23]

Thus, it is not surprising that even the capitalist economy produces those illusionary islands of sublated alienation, cherishing dreams about resolved antagonisms by means of expansion of consumption or proliferation of the images and sites of welfare.

Yet, according to Marxist logic, it is exactly those modes of capitalism that alleviate or disguise alienation that are derived from labor division and alienation. Paradoxically, reducing inequalities by means of a planned economy, which frees society, produces a very crude or

23. John Roberts, *Self-Love and the Love of Capitalism* (unpublished manuscript).

"poor" material culture that seems alien to the gaze of the capitalist subject; whereas free market economy is able to provide images of un-alienated, decent life, despite inflicting inequalities on society. Thus capitalism not only produces alienation, but is able to disguise it as well. For example, when purchasing or using commodities, very few people concentrate on what forms of coercion and exploitation stand behind an iPhone or a luxurious hotel interior.

In his "Converted Forms: On the Need for Irrational Expressions" (1972), Merab Mamardashvili brings forth the notion of "converted forms" from Marx's theory of surplus value, reminding us that what we treat as natural, substantial forms of being in language, psychology, economy, sociality, production, might be mere phantoms, abstract quasi-objects, which have to be unraveled as multilayered fetishist conversions.[24, 25] For example, the commodity form or capital serve as evidence of exactly this; they appear as naturally given objects, but behind them are concealed social forms and relations through which they have to be understood. In this case the surface structure pretends to be the ontological content. The mind perceives these objects automatically, without discerning that they have been converted from their real social contextualization. Let's refer to Mamardashvili himself:

> Converted forms regulate the system by replenishing the cut-off links and mediations, substituting for them a new relation that ensures the "life" of the system. The initial (real) relation here cannot be brought into being in its actual mode due to having been extracted from the given system of relationships or their blurring.[26]

Mamardashvili excellently demonstrates how these fetishized conversions pretend to hide the alienation that they in fact represent. Yet even more important is that, as he alleges, by means of dialectical

24. Merab Mamardashvili, "Converted Forms: On the Need for Irrational Expressions," *Stasis*, vol. 5, no. 2. (2017): 204–217.
25. Karl Marx, *Theories of Surplus Value, Part 1* [1861–63], ed. S. Ryazanskaya, trans. Renate Simpson (London: Lawrence & Wishart, 1969).
26. Merab Mamardashvili, "Converted Forms," 211.

analysis, both layers—the false de-alienation, and the relations of alienation—can be unwound when placed under the scrutiny of *self-consciousness*, which bears the potential capacity to disclose the alienated form of these chimeras of capitalist production.

*
* *

In post-structuralist thought, the syndrome of liberation from the Signifier is to unbind the bounded, to deviate from the established, and to fly in the face of the conventional. In this case, language—as a conventional structure—is seen as the representation of authority, rather than the vehicle of *social generality*. In capitalism, the primary view of societal structure is negative. What is given as the social realm existing prior to the "I" is considered a priori imposed by power and authority. Therefore, the subjectivity of an artistic or political agency has to dissociate and subvert anything that could have been historically or socially prescribed. Pathology is an inevitable component of such a society, since it needs the realm *beyond* the structure or organization in order to maintain this subverted, but still tamed, "beyond." Thus, instead of normalizing the pathology, this pathologized "beyond" is cherished and included in the system as the counteracting and divergent "beyond" within it.

In such sociality, the connection between hybridized individuals is not constructed in favor of affirmative mutual production. In this case, individuals consolidate mainly against any mode of a Big Other—authority, power, subjection, law, order, discipline, etc. They connect in order to direct themselves against external negative forces, rather than in favor of constituting the unified "each other." This was precisely why the young Marx viewed class as a problem: "separated individuals form a class only insofar as they have to carry on a common battle against another class; in other respects they are on hostile terms with each other as competitors."[27]

27. Karl Marx and Friedrich Engels, *Collected Works*, vol. 4 (London: Lawrence & Wishart, 1975–2004), 77.

Consolidation with other individuals is then possible, mainly against some suppressing powers, whereas every "other" to consolidate with—be it a suppressor or a subaltern—remains alien(ated).

As Boris Groys remarks, there is little room left in this negativist logic for productive politics. This leads mainly to the politicization of "the negative," whereas the politicization of the common good simply disappears. The active side in this case is not a politically motivated subject, but some external "demonic" force that always subjugates, hence one has to resist it with an even harsher demonism, or tame and moderate it (as Castoriadis claims) with forms of civil agencies. Virtue causes shame, but monstrosity and nihilism do not.[28] Hence, the principal element of struggle is in resistance rather than in social construction. In this confinement of social construction to the poetics of endless resistance, little capacity is left for self-critique (i.e., critique of the critique), or for constructive work on the de-alienation of the "other."

III
THE COMMUNIST DUTY TO DE-ALIENATE LANGUAGE

But what if the primary status quo that suppresses and subjugates is not the apparatus or the law, but the mutation (deviation) itself—the dissociation, the blur, the imprecision, the inarticulation, the mumbling, the insufficiently human, the irrational, the ever-childish—that already diverted from the light and clarity and which keeps one in the eternal obscurity of the "cave," where detachment and alienation from "the world" are absolute. In 1963 the Soviet psychologists Alexander Mesheriakov and Ivan Sokoljanski founded the Zagorsk Internat (boarding school) for deaf and blind children. They relied on the psychological school of Alexey Leontiev—a disciple of Lev Vygotsky—and were supported theoretically by the Marxist philosopher Evald Ilyenkov. Mesheriakov and Sokoljanski developed a special tactile signal system called dactilologia, which was developed

28. Boris Groys, "Consistent Atheism Makes Complaint Impossible," in *Raznoglasiya* [Dissent, journal of social and artistic critique], vol. 6 (2016): http://www.colta.ru/articles/raznoglasiya/11644

as an extension of typhlo-surdo-pedagogy (a specific methodology of teaching the deaf and blind). In his text "Where Does the Mind Come From" (1977), Ilyenkov wrote that "without pedagogical dedication these children would remain in the world where there is only matter, but not mind, spirit, psyche, consciousness, volition, thinking, speech, where there is no image and no idea of an outer world."[29]

The goal of the school's founders was not merely to develop the self-sufficiency of patients with hearing and seeing deficiencies by equipping students with minimal linguistic capacities via a special system of signification. They aimed to prove that pedagogy in the social context of communism was capable of constructing a full-fledged social subject with social consciousness, even despite having gravely impaired physiological and sensory capacities. This was an experiment in observing and detecting how consciousness and thinking are generated; how speech, language, and the capacity to connect material things and activity with concepts (and their linguistic forms) was conceived.

The initial psychophysical and social condition in this case was abnormality, pathology, permanent instability, and deviation. Yet the goal of pedagogy in this case was not to construct the survival or clinical protection of such divergence, but to prove that a full-fledged member of human society can emerge out of this total psychosomatic inability. In this case, it is exactly the de-alienated social and cultural environment that can become either the medium of radical emancipation, or, on the contrary, doom such students to social exclusion and a totally alienated existence. Such a pedagogical undertaking might have been viable only within the de-alienating conditions of socialist production, which had to guarantee the inclusion of the bio-physically deviant children into society as equal agents. What is important in this inclusion is that the psychic and linguistic deviations undergo explicit de-pathologizing; in this case it is the de-pathologizing of the initial pathology that happens to be emancipatory.

Let us now imagine that these "creatures" attain a minimal level of consciousness and comprehension due to someone's personal

29. Evald Ilyenkov, "Otkuda Beriotsa Um" [Where does the mind come from], in *Filosofia I Kul'tura* [Philosophy and culture] (Moscow: Politizdat, 1991), 30–43.

treatment in a clinic, remaining otherwise outcasts from the rest of the society. And if anyone takes care of them, these are private or familial undertakings of concrete individuals who can afford it; or this is a civil work of compassion, pity, and charity, condescendingly assisting such patients in survival. In such conditions, the resisting poetics on behalf of an individual alienated to this extreme could be imagined as a macabre Kafkaesque animalization, a monstrous zombie grimace, or a revenging exclusion. That would be a predictable logic of resistance against social normality and linguistic canon on the part of its deficient members in an alienated society, where "the other" cannot be inscribed into the ethics and poetics of de-alienating. Under capitalist conditions, civil solidarity with the "other" mainly implies taking into account each other's particularities and singular individual traits. But "the other" cannot be de-alienated merely by studying or integrating her particularities of existence and identity. De-alienation of the "other" can only take place as a radical decision to construct the common grounds that would abolish the watershed between the self and the other, the owned and the not owned. The subject in need of de-alienation is a fantastic subjectivity capable of producing a non-self out of one's own self and, due to such an act, providing the space for the other-determined commons.

It should be noted that for Vygotsky, as well as for Ilyenkov and Leontiev, language is a tool of generalization rather than a structure of signification that suppresses body, affects, etc. But such generality is not an act of alienating or abstracting as is the case in post-structuralism. A word accomplishes the function of generality in that it is the conceptual tool that is used merely in accord with "the others." A "word" is not just a signifier; it is not reduced merely to signifying form and meaning. It is an operation that already implies that it comes together with the notion (Vygotsky). But the notion in its own turn is something that is a generalized imprint of external, objective reality and the activity of labor. This means that language is not at all an autonomous realm abstained from reality and material life, as it is in post-structuralism and Lacanian psychoanalysis. Thus the ineffable and the unsaid are not mystified and substantialized as something irrational—but are just un-realized, non-conscious, or have not yet reached consciousness. The process of generalizing via concepts

does not impoverish reality and materiality or detach from it; on the contrary, it brings reality closer, since it posits it generally and objectively.[30] Even internalized inner speech and the production of thought are then the outcomes of socialization. Thereby inner speech is not the unconscious, or something innate and predominantly individual. When inner speech is refracted in a person it remains no less general than the external reality. This is what makes Vygotsky's treatment of language different from that of structuralism and post-structuralism. For Vygotsky, the word does not come without concept; moreover, the latter comes first, and the word then realizes, finishes the general dimension of sense.

As Vygotsky incessantly repeats, "the word is ready, when the concept is ready"—not the other way around—which is an explicitly anti-phenomenological and anti-Jacobsonian standpoint. This leads to important conclusions: not only is thought not different from external material reality ontognoseologically, but the word in turn is not separate and alienated from thought and hence from objective reality either. This stance enables Vygotsky to assert an anti-Cartesian dialectical entity of being, thought, and language (speech).

Ilyenkov compares such a disposition between language, reality, and consciousness to the actions of an artist making a portrait. The artist has a model (a person) in front of himself and a canvas (screen). The object to be depicted and the tableau depicting the object are the two phenomena extrinsic to the artist. Language, as Ilyenkov claims, plays the same role as the artist: by means of language one transposes empirical data onto the "screen" of social consciousness. Thus language paints reality on the screen of consciousness. It is this generalizing role of language that saves us from collapse into the type of contact with outer reality that would be conditioned by mere non-conscious behavioral reflexes.[31] According to Vygotsky, language as one of the carriers of thought transmits the

30. Lev Vygotsky, *Thought and Language*, trans. Eugenia Hanfmann and Gertrude Vakar, ed. Alex Kozulin (Cambridge, MA: The MIT Press, 1986).

31. Evald Ilyenkov, "Mechanism of Consciousness and Abstraction," in *Dialektica abstraktnogo I konkretnogo v nauchno-teoreticheskov mishlenii* [Dialectics of the abstract and the concrete in scientific and theoretical thought] (Moscow: Institute of Philosophy, Russian Academy of Sciences, 1960). See, in Russian: http://psylib.org.ua/books/ilyen01/index.htm.

automatic components of the unconscious into the consciousness that operates by intentions and decisions. Therefore, pedagogy, learning (culture) is always ahead of the psyche. Notions (which are the tools of generalization) are connected neither as immaterial abstract associations nor according to the structures of the perceived images, but as the outcomes of the relations of activity, labor, and their common dimension.

It is the other way around in post-structuralism, in which language is immaterial, incorporeal, and a systematized abstraction. It is rather in conflict with thinking and creative affectivity. Within such a logic, language is treated as the bureaucratized constancy that has the impact of the conventionalized and disciplinary *alienating* medium, detaching from matter, from body, from the Real, representing truth only falsely. Hence the search for subversiveness, which would evade the linguistic order, become bodily affective and reconsider the gendered body, or dissociate the linguistic order into counter-linguistic, counter-semiotic performative materiality. Thus, any artistic or creative gesture has to estrange language, alienate it further, or mutate it in order to get access to things and senses *beyond* it.

In the pedagogical methodology for the deaf and blind students at Zagorsk Internat, the strategy was precisely the opposite. The most crucial point was in fact a materialist premise, according to which both speech and language are not at all abstractions detached from the body, senses, gestures, and activity. On the other hand, body and senses and their materiality are not something nominalistically material in terms of being separate from the capacity for concept production. Language is merely the reflection and hence extension of activity and labor. Thus, consciousness is generated *by* and *in* activity. Language is the ideal (general) imprint of human activity and of labor that forms in their interaction with the material world. Leontiev writes in his *Activity and Consciousness*:

> Meanings refract the world in man's consciousness. The vehicle of meaning is language, but language is not the demiurge of meaning. Concealed behind linguistic meanings (values) are socially evolved modes of action (operations), in the process of which people change and cognize objective

reality. In other words, meanings are the linguistically transmuted and the materialized ideal form of the existence of the objective world, its properties, connections and relations revealed by aggregate social practice … [32]

As Leontiev argues, meanings are merely forms abstracted from living activity and labor. Despite becoming part of individual consciousness, such meanings nevertheless continue to imply the means, objective conditions, and results of actions and labor procedures: "regardless of the subjective motivation of the people's activity in which they are formed." Leontiev further explains as follows:

> At the early stages, when people participate in collective labor they still have common motives, meanings as phenomena of social consciousness and as phenomena of individual consciousness directly correspond to one another. But this relationship disintegrates along with the emergence of the social division of labor and of private property.[33]

Ilyenkov's standpoint was similar to Leontiev's position here in that there is little difference between thinking, language, and practical activity. Thinking is not passively perceiving and reproducing concepts while they are detached from activity, societal surroundings, and labor, but instead begins when the child starts to "move things" by means of notions (and notions can only be linguistically articulated). In other words, thinking becomes possible when a child first experiences translating actions into notions. Only after such a stage can one truly and consciously operate with concepts. Language (along with thought) then merely conceptualizes (endows with the ideal form) material and objective activities, including labor.

Experimental typhlo-surdo-pedagogy (founded by Leontiev, Alexander Mesheriakov, and Ivan Sokolyanski) confirmed that language is not an alienating abstraction but is a cognitive application

32. Alexey Leontiev, "Meaning," *Activity and Consciousness*, 1975. Available at: https://www.marxists.org/archive/leontev/works/activity-consciousness.pdf.
33. Ibid., 126–129.

of activity and of body and sensory experience. Ilyenkov, as well as Leontiev, insisted that thinking is acquired via the extension and translation of applied tools of activity and labor. If a hearing and seeing person hears and memorizes words and combines them with optical experience, the deaf and blind cannot perceive language by unmediated sensory means. For a person without access to either of those senses, meaning becomes translatable only via tactile, haptic contact with objects and by means of bodily acts. That's why linguistic forms are for the deaf and blind inseparable from manual moves and haptic experience. The principal metaphor of culture and language for Ilyenkov therefore became *the spoon*. For Ilyenkov, the use of a spoon as a tool of primary activity for deaf and blind children was already a cultural achievement. By learning to use the spoon the child already has access to the world of human thinking, the realm of language, and even the history of world culture. As soon as a deaf and blind child is able to use a spoon, the child's actions are no longer directed merely by biology, by the brain's morphology, but by the form and disposition of objects made by humans—and by the outer world and acting in it. Only then does the acquisition of speech become possible.[34] Experimental typhlo-surdo-pedagogy thus became an exemplary case of how the conceptual, linguistic, eidetic, and noumenal representation and communicative skills are inscribed already in the external material objecthood that the deaf and blind apply manually, haptically, and bodily for exerting speech acts and ratiocination.

American psychologists' method with the deaf and blind, described by William James, as in the case of Helen Keller, was precisely the opposite.[35] In this method the primary stage of successful edification consisted of mastering speech, words, and only afterwards the transition from repeating the words to a subsequent perception of the words via their being combined with certain sensory experiences. For example, Keller first learned, repeated, and memorized the word "water" and only afterwards understood that the word "water," as her teacher Anne Sullivan instructed

34. Ilyenkov, "Otkuda Beriotsa Um," 30–43.
35. Alexey Leontiev, *Activity and Consciousness*.

her, signified the liquid she felt in her hands. The signifier "water" then remained for Keller an abstract, autonomous, and detached correlation to a certain sensory experience, rather than a conceptual transmission of a concrete objective activity. In this case, the abstract word-form and its emission precede the activity that first generated the word as a concept. Consequently, consciousness as a mental and cognitive practice maintains its separation from sensory, practical, and sensuous practices. Consciousness remains internal, whereas sensuous contact with the world is external. Meanwhile, Leontiev, when commenting on the case of Keller, insisted that the success there was determined first and foremost by the zeal of the pedagogue Sullivan and her collaboration with Keller, rather than by the miracle of "recovery" due to the extraordinary mental capacities of a child.

Soviet psychology thus discovers and reveals a very important condition of social consciousness. Idealization, organization, dematerialization, generalization, universality, culture, and language are not the forms of abstraction. The procedures of generalization and ideation are not alienating; on the contrary, they emancipate a human being from obscurity and serve as unmediated and de-alienating access to the commons; of course, given that the common good already rules society.

Thus, the child devoid of the world and confined merely to body and brain morphology and doomed to darkness and silence—the creature with damaged senses—could develop his or her mind, despite the fact that the latter's development is impossible with collapsed senses. Yet it was the collective, the pedagogical effort, activity, and concreteness of labor that turned the utmost doom of estrangement and alienation into the de-alienating condition of the commons, by superseding the missing senses and allowing the dormant mind to generate speech and thought.

In his article "Where Does the Mind Come From," Ilyenkov describes how Alexander Suvorov (a pupil of the Internat for the blind and deaf, who later graduated from Moscow University and defended a PhD dissertation in psychology), when giving a speech before students, was asked the following question:

Your case contradicts the old premise of materialism, according to which all that gets into mind is necessarily developed and provided by senses. If your senses are damaged, how could your mind develop? How can you understand things even better than us, if you do not hear or see?

The question was transmitted to Alexander Suvorov via a tactile alphabet. And he pronounced into the microphone: "And why do you think that we do not hear and see? We see and hear by the eyes of all our friends, all people, all humankind."[36] This answer confirms the pedagogical method of Leontiev, Mesheriakov, and Sokolyanski, according to which neither sense, nor the mind or language, are derived from any subjective, or individual incentive, but are instead the outcome and construct of socialized forms of activity.

This concrete case in question—when extreme perceptive pathology finds its un-alienated access to the Universal—cannot be exemplary for the societies of historical socialism as a whole, since the Zagorsk pedagogical school never became a general state of affairs in any of the Soviet republics.

As the abovementioned example proves, however, in the conditions of the use-value economy the forms of generalization and conceptualization are not an abstraction, or an alienated metaphysics. On the contrary, they have the dimension of materiality and can be concomitant to body/matter as its unmediated access to the common good, even despite limited sensory capacities.

IV
"Historical Socialism was de facto Capitalism"

One of the most habitual arguments in denouncing the allegation about historical socialism's non-capitalism is in the claim that it was in fact a capitalist society—there were too many essential features of capitalism in its constructive core. This interpretation of Soviet

36. Ilyenkov, "Otkuda Beriotsa Um," 43.

socialism was most evident and articulate in Althusser's writing.[37] Since then this has become a more general interpretive trend, part of the prevailing status quo view of the versatile aspects of post-Stalinist socialist society. The latter is now seen as a simply fallacious and mistaken attempt to build a communist society.

Let us enumerate these arguments in order to then dispute them.

Argument 1 According to stereotypical interpretations—both from the right and from the left—socialism and its communist components were confined to the formal jargons of ideology and partocracy.

Étienne Balibar, in his "classic" oeuvre *On the Dictatorship of the Proletariat*, argues that socialism is simply a transition from capitalism to communism; that there is no such thing as the socialist mode of production (as against the capitalist and communist ones). Socialism is a continuation of class struggle headed by proletarian hegemony; it is rather a democratic transformation of capitalism than a new episteme and ontology of sociality and production.[38] Yet, as Balibar contends, the Soviet struggle against capitalism did not enable an inner critique of class antagonism, which inevitably emerged within historical socialism between different—the more and the less privileged—layers of society. According to Balibar, class struggle in the Soviet Union was reduced to the Stalinist purges of the peasantry and of the remaining prerevolutionary bourgeoisie, or to censorship against the surrounding capitalist countries. Consequently, Soviet socialism failed in its main task of persisting within class struggle; and hence not only does Soviet socialism have nothing to do with communism, it has never even been a form of socialism.

37. Louis Althusser, *Essays in Self-Criticism*, trans. Grahame Lock (London: NLB, 1976).
38. Étienne Balibar, *On the Dictatorship of Proletariat*, trans. Grahame Lock (London: NLB, 1977), 140–45.

Argument 2 The Soviet socialist political economy continued to be based on surplus value. The logic of such an assertion is the following: production of exchanged goods is commodity production; any commodity production generates value; hence, automatically, production of goods with value implies generation of added, surplus value. As Grahame Lock argues in his introduction to Althusser's *Essays in Self-Criticism*, to obtain surplus value one need not necessarily have a developed system of commerce and trade, but simply any form of trading commodities, whose consumption automatically implies the creation of value, i.e., economy, determined by "the law of value." Such a rudimentary commodity with exchange value is first and foremost human labor power. As long as labor is hired and remunerated, the capitalist condition cannot be considered cancelled.[39] The existence of wage labor in Soviet socialism confirms labor as an exchanged commodity; hence it confirms the logic of the law of value in socialism, producing in its own turn a surplus value. Consequently, historical socialism was de facto capitalism.

Following this line of argument, centralized state control and planning can also be regarded as a form of commodity circulation, because planning the economy and commodity production are compatible. Planning is nothing but bringing productive activity under control.[40] According to this logic, the socialist principle of the distribution of products according to needs does not preclude commodity exchange. For example, Antonio Negri suggests that planning and party institutions are equal to capitalist accumulation and privileged monopoly on the state's behalf. Consequently, Soviet society is regarded by him to be de facto capitalist, and only formally expresses the language of the communist ideal.[41]

39. Grahame Lock, "Introduction" in Louis Althusser's *Essays in Self-Criticism*, 18–19.
40. Paul Sweezy, *The Theory of Capitalist Development* (New York: Monthly Review Press, 1968), 53.
41. Antonio Negri, "Soviet: Within and beyond the 'Short Century,'" *South Atlantic Quarterly* 116, no. 4 (October 2017): 835–849.

Argument 3 The fact that qualified workers in the Soviet Union had higher incomes confirms that abolition of private property does not exclude the development of a privileged (capitalist) class.

Let us try to challenge these assertions.

Counterargument 1: "There was no class struggle in the Soviet Union."

Claiming that Soviet socialism dismissed class struggle is to consider struggle from the perspective of capitalist logic—as the resistance of the disenfranchised against the privileged classes, or as the critique of the capitalist features of economy that dominate society. But in historical socialism, a post-capitalist society, class struggle could not have the same form. In capitalism, anti-capitalist struggle tends to undermine the capitalist system, it revolts against that system. The system is grounded by inequality and hence is unfree. By consequence, the main syndrome of liberation is the resistance against this systemic subjugation. In socialism it is the other way around. It is the system that is determined by socioeconomic equality, and hence the system itself is even freer than mundane sociality. The system is oriented towards the common good much more than "ordinary life" and its particularities. Hence, sociality has to stretch towards the system rather than subvert it. For example, when the system of production and wage remuneration was equalizing the income of laborers of various skills in socialist countries, separate social groups or individuals (mainly from the "intelligentsia") were critical of such tendency since it was neutralizing the qualification of the work done and blocked any opportunity for additional surplus income. Contrary to stereotypical opinion that the socialist society was falsely socialist, since it was ruled by dogmatic imperatives of partocracy, I argue that the party is simply the organ responsible for the provisions of the common good. That said, the communist hypothesis is broader than the party—and it exceeds party organization as a system. As such, it is not the party that rules society, but the politico-economic and socio-ethical system—and the infrastructure and epistemes generated through this system. Historically

speaking, the party itself had to aspire towards the communist condition. Rather than to maintain that the party had usurped the ethics of communism for itself as an organization, it was often forced to claim its own deviations. The struggle then is not about transgressing the system, but in fitting the already established components of communism within socialism. In that sense, historical socialism, with its benefits, was nothing but a constant front line in every field against any traits of capitalism or fascination with it. In other words, the class struggle turned into a permanent vigilance in cultural politics, economics, and social life against capital. In fact, civil war was continued by other means in media, culture, and art. When numerous traits of communism already function in society, the consciousness of each citizen becomes the site of such a battle. In this case, class struggle evolves into a regime of self-critique and constant anti-capitalist self-censorship. To reiterate, the logical puzzle of Soviet socialism was that its political-economic systems contained more components of communism and a higher degree of socialism than everyday existence. If this were not the case, the economic infrastructure of the Soviet sociality would not generate so many shadow areas in production, trade, planning, etc., confirming the hidden human craving and desire for capitalist modes of life. The issue was not simply in rigid and inflexible networks of socialist production, but first and foremost in the incapacity to endure the severe experience of the non-surplus economy and of the rule of common good.

Thus, Balibar's view on historical socialism does not take into account the logical paradox that resides in the epistemological, ontological, and temporal inversion caused by the October Revolution. Even if it is true that socialism is an insufficient communism, this is not the case because communist components are too remote from socialism and are still to be achieved by its political economy and social infrastructure. On the contrary, communism *remains* remote because too many communist components have already been established in political economy, education, and the relations of production ahead of time. Moreover, there are human factors and certain drawbacks in production that make those communist components unimplementable. Hence, the inevitability of the socialist modality of

transition (resorting to the New Economic Policy [NEP] is a classic case to exemplify such an argument). Thus, the temporal paradox is not that socialism is a transitory stage after capitalism, and it thereby knows little of communism. Quite the contrary: precisely because the October Revolution achieves too many conditions of communism *ahead of time*, and precisely because the political and economic system happen to be more communist than life itself, does communism inevitably manifest itself in the guise of socialism.

The dictatorship of the proletariat then is an inner moral code. It subsists in the criminalization of any deviation from the principle of the common good and is not in need of continuing the classical anti-capitalist class antagonism between the less and the more privileged, so long as socialist revolution has already criminalized class antagonism and legally asserted the proletariat's dictatorship as law. In other words, the aporia of struggle for more communism after successful revolution lies not in further resistance against capital; after the socialist revolution, the dictatorship of the proletariat and class struggle are aimed at preserving and equipping the already achieved condition of a social classlessness. Which means that in this case the very logic and method of anti-capitalist struggle is modified.

Counterargument 2: "Soviet socialist economy was in fact also grounded in surplus value."

Indeed, nominally considered, the use value of products in Soviet socialism was not absolute; it implied some minimal added value. But such an addition cannot be considered a surplus value. To start with, one cannot claim that the goods produced as basic need items were commodities in the same sense as the commodities in capitalist society. This can be claimed not only because such surplus was very small in socialist production in comparison with capitalist production. But also, the sum added to a product's use value was preliminarily calculated to fit the basic income (which the Soviet salary actually was) and was *not subject* to market variations of prices and exchange rates. Another reason why the minimal addition to the cost of a product is not surplus value is that, surplus, as we know from the

post-Marxist analysis of libidinal undercurrents of capitalist economy (Lyotard, Castoriadis, Deleuze), is not simply conditioned by quantitative augmentation of income as an automatic trait of exchange and trade. On the contrary, the quantitative augmentation and increase of income (surplus) are conceived by desire and have a libidinal and phantasmatic source. For Soviet goods, the incentive for production was not a desire or phantasm; hence the tendency was in not extorting surplus from exchange, but rather the saturation of overall basic need and generation of de-privatized and demonetized sociality that would extinguish libidinal surplus both from imaginaries about consumption, as well as from the incentives and planning of production. Surplus, then, even if it is nominally added to a use value of goods, is not meant to be accumulated as capital, but is fixed to fit the item of basic need, which in its own turn has to be distributed according to universal basic income in a socialist society. Thus, Soviet socialist production evolved a production ethics of overall basic need, rather than the "law of value."

In this case, commodity production and planning cannot be considered compatible, since it was *not* the market that established prices for labor, as well as for consumer goods and services. This is to be contrasted to the capitalist economy where the market regulates prices insofar as relations of production are conditioned by the logic of private property and are built on it.

To reiterate, wages in the conditions of Soviet political economy were a distributed basic income with very small gradations. There was definitely a division of labor, but the difference in remuneration between different qualifications in labor was maximum 100 percent. (For example, 150 rubles as average compensation for any work; and 300–400 rubles for the most risky labor, for excellence in the Five Year Plan, or for remarkable achievements in science, art, production, and culture). On the other hand, in capitalist conditions such difference in wages is immense, which symbolically divides those who receive lower wages from those who receive higher wages. As a result, in capitalist society the qualitative and hence symbolic impact of the diversification of labor is immense and is practically beyond any quantification.

Part I 62

Counterargument 3: "Socialism never overcame the division of labor as it also applied the notions of qualified and unqualified work."

At stake in the capitalist division of labor is not merely the split between the mental and the manual, immaterial and material labor, but also the fact of privilege in one's right of hiring labor and extorting excessive income from it. This implies compelling those who are hired to hunt and compete for surplus income. Yet when the division of labor—socially and micropolitically—does not end in any considerable difference in remunerating labor, then labor cannot be considered to be bought and sold. On the contrary, it is programmed as organized production aimed at distribution of goods for overall social need and supply. In other words, the relations of production in Soviet socialism institutionally (and not simply juridically) excluded the possibility of any substantial priority of revenue and hence molded the economy according to such impossibility. Privileges in fact were deviations, which were unmistakably cherished by some members of the partocracy, but simultaneously they were forced to move underground, into the shadow economy. Labor, then, despite the cases of division, is not a personal activity in this case; it is not hired or supplied as commodity, but it is a general necessity for each person and has the function of social wealth.

What are the radical outcomes of such a condition? One's achievement in labor counts as common good for the benefit of society, and is not rewarded and distinguished in a monetized way. Exactly because excellence in knowledge production, culture, art, or technology were not receiving sufficiently diversified remuneration in the Soviet Union, members of the socialist "intelligentsia" formed an unofficial confrontation with the hegemonic position of the "proletariat." Yet this confrontation took place only as a marginal discourse, while the official hegemony belonged to the rhetoric of the "working class." To reiterate Marx's maxim from his *Critique of the Gotha Program*: "From each according to one's abilities, to each according to one's needs" in fact changes the ontology of labor, in that labor ceases to be an individual endeavor with individual interest for remuneration, but becomes a generic activity.

In this case, an achievement does not belong to an individual person engaged in a concrete activity, but is counted as common wealth, belonging to everyone. By consequence, not only does monetized surplus not accumulate with a proprietor and become private property, even the symbolic surplus of a given labor achievement can't be accumulated by its producer. This is why the Soviet Union had no need to institute a star system of celebrities. On the other hand, it instituted the system of the "heroes of socialist labor."

Later on I will show how the philosopher Ilyenkov proves that all labor is cultural and philosophic, and demonstrates that social wealth is not defined by value production (*Wertbildung*).

It must be kept in mind that if wealth in socialism can only be a common wealth, then the constraints of the basic need economy can be considered scant and squalid only from a capitalist perspective. Following such logic, what indeed seem to be images of poverty when viewed from a capitalist gaze might in fact be wealth in another, non-capitalist system, simply because wealth in the context of the commons and in the context of individual prosperity imaginaries, respectively, are drastically different ontic and ontological phenomena.

CHAPTER 2

THE POOR OBJECT OF THE SOVIET COMMON-WEALTH

I

When dealing with the reconsideration of the Soviet historical leg-acy in the context of contemporary theories of emancipation, one of the stereotypical approaches is to mainly locate the embodiments of historical socialism prior to Stalinism in the period of revolution-ary uprising and avant-garde practices in art and cultural politics.

Another stereotype is to integrate the Soviet socialism of a later, post-Stalinist period into global emancipatory experiences by means of discovering in it the latent canons of modernism and thus inscrib-ing it into the context of internationally acclaimed, non-Western modernisms.[1] The limitation of such an attitude is that whatever is worthy of interest in Soviet socialism should necessarily reproduce the poetics and politics of the 1910s and 20s. As a result of such a stance, the whole history of Soviet socialism is perceived as some kind of unrealized utopia judged from the perspective of the first years of the Soviet state. On the other hand, the Soviet political and social infrastructure only begins to truly fit the relations of produc-tion of socialist political economy by the mid-1950s.

This is the period when the elimination of private property had already become a stable feature of the economy and started to con-siderably affect both the means of production (productive forces) and the relations of production. The avant-garde object, despite its novelty or imaginaries of emancipation, remained a utopian projec-tion—put forth by artists without any real economic conditions to fit such projections. On the contrary, from the 1960s onwards, the Soviet material object was already generated by mass production and its socioeconomic conditions, for example by the planned econ-omy. It was no longer an aesthetic imaginary about the utilitarian object that would sublate capitalist attraction, as was the case in the conditions of avant-garde social engineering. Avant-garde artists and designers had to persuade their audience to accept the modesty and expediency of the material objects characteristic of socialist life.

1. In such a case even the aesthetics of antimodernist realism is often considered to be some sort of deviated modernist edifice, losing the strength of its critique of western bourgeois culture.

Whereas, a material object after the NEP was already produced in the economic system from which any surplus value was eliminated due to planning and the distributive economy. Avant-garde constructivists still operated according to the logic of desire, as if convincing the customer that s/he should desire in the object only its functional, expedient parameters—i.e., the desire that an object becomes a non-commodity. On the other hand, the post-Stalinist political economy already manifests how desire and its libidinal undercurrents were subtracted from the ethics and modes of Soviet socialist production and consumption.

Commenting on the functions of a constructivist object, Christina Kiaer writes:

> By suggesting that the constructivist object also makes a place for the workings of desire, I am claiming that constructivism included aspects of Benjamin's hope that a progressive political relation between private fantasies and collective goals could be articulated through the object.[2]

Kiaer is right when she emphasizes the ambiguity of the fascination that the early Soviet constructivists demonstrated when determining the formal merits and consumer habits of new socialist production. She claims that the modest but refurbished market production of the NEP—despite its regeneration of class differences—could contribute to modernization and could provide conditions for the utopian experiments of the constructivists much more than "war communism." On the contrary, "war communism" actually de-modernized production by way of economic shortages. The NEP in this case is considered to be a positive transitory stage to socialism.[3]

What seems to be an ambiguous and probably unknowingly pro-capitalist condition here is that the historians of the Soviet avant-garde sometimes approve of the market and consumption in Soviet production as alternatives to rigid socialist modes of political

2. Christina Kiaer, "Rodchenko in Paris," *October* 75 (Winter 1996): 21.
3. Christina Kiaer, *Imagine No Possessions: The Socialist Objects of Russian Constructivism* (Cambridge, MA: The MIT Press, 2005), 25–27.

economy. However, traits such as the market and consumption are typically posited negatively as elements of capitalist production. Yet, strangely, when these traits of moderate capitalism are traced in socialist societies, they are regarded as modernizing and progressive.[4]

According to Kiaer, the fact that the status of the market was inevitably reinstalled in socialist societies serves as proof that historical socialism could not but be defeated because of its forceful and non-democratic abolition of private property, which gradually led to the economy of scarcity and rigid distribution.

The ambiguous apology for the NEP's impact on early Soviet society among historians is due to the fact that the avant-garde constructivists were not yet free from certain components of the market economy and capitalist production. As Kiaer argues, along with claiming the anti-commodity features of an object, avant-garde artists aspired to have that very non-commodified object equivalent to the level of capitalism's advanced industrial production. As she puts it: "the ultimate test of Bolshevism [was] to provide the level of consumer abundance known in the West, but democratically (humanely), in a way that will foster the individual desires lodged in material objects for the benefit of the collective."[5]

In a nutshell, an avant-garde object always remained an aesthetic utopia: it took the form of anticipating possible future forms of production that never took place. The focus of constructivist and productionist artists was rather in their goal to effectuate the formal transformation of bourgeois objects into socialist ones. Nevertheless, such formal transformation was not yet dependent on socialist relations of production. On the contrary, post-Stalinist art and cultural production already stem, conversely, from the realities of the de-privatized, planned economy and its principles of distribution. This is why inscribing Soviet art—be it pre-Stalinist or post-Stalinist—into "world modernisms" might indeed be historically erroneous. Modernism's

4. Such an aberration is still very common now: researchers of the former socialist societies from "the capitalist West" are critical of exactly those traits of capitalist production in the West that they treat as achievements in the socialist or former socialist contexts.
5. Christina Kiaer, "Rodchenko in Paris," 21.

focus on innovations, its social agency, or conversely, the nihilist, reductive abstaining from the bourgeois social infrastructure embedded within it, is viable as a component of resistance only in a capitalist society. It has no agency and viability in the conditions of the absence of private property, or after the dismissal of surplus value and market logic from the economic exchange. Why, you may wonder? This is because "modernism" was a tool for disputing the means of modernization in capitalist society. Socialism's tools of modernization were entirely different. It in no way needed either the term "modernism," or its contents, because modernism was already anthropologically, aesthetically, and socially obsolete for a society without private property.

To reiterate, the preoccupation of constructivists with the formal issues of an object is due to the still unattained conditions of the relations of production grounded in the non-surplus economy, which crystalized to its full extent only by the late 1950s. Constructivists definitely tried to design a new socialist object, but such experimentation most likely cannot be called fully socialist, since it stemmed from constructing the anti-aesthetic object or an anti-commodity *aesthetically*. They could not predict the forms of functioning of the already de-commodified object in the economic infrastructure of the de-privatized relations of production. Only radically transformed relations of production, from which profit and surplus interest had been duly subtracted, could generate a full-fledged non-capitalist object.

In short, despite the fidelity of the early Soviet cultural politics to revolutionary events, Soviet society and its material culture attained what can be called a non-capitalist condition only by the late 1950s. This is because it is only by this time that the absence of private property and the surplus economy form the basis, while the superstructure of Soviet political economy on a more general scale permeated daily life, culture, science, and art. Thus the goals of the avant-garde constructivists—to sublate bourgeois aesthetics by engineering and accelerated industry, to redirect desire from the high culture of consumption towards social expediency and general interest—manifested itself in economics between the 1950s and 1970s, without any specific artistic design. It was a consequence of the relations of production conditioned by common use, use value, and general (basic) needs. In the 1970s the absence of surplus value in the distributive economy was

a matter of ardent discussions at the meetings of party committees. It was evident that in the global context the economy without profit might collapse. Nevertheless, the Soviet economy before Perestroika, even despite its efforts to attain at least some deviations from the planned economy, never managed to transform itself into a market economy. The discussions in the Politburo to expand the profit component of the planned economy are only a confirmation of the fact that the use value economy as the sign of socialist relations of production could not be refurbished into one of surplus economy without rejecting socialist ideology and the economy of planned distribution, for example without dismissing the de-privatized relations of production.

It is in this sense that Boris Groys and Vadim Mejuev call such relations of production post-economical. According to Groys, the post-economic condition is motivated by the verbalization of production—by the hegemony of the logos in communist society, the paradoxicality of "philosophic" logic and "idea" versus money.[6] As Mejuev explains, on the other hand, the cultural horizon of the everyday is the effect of freed time and common wealth.[7]

Thus, what was a *utopia* of de-commodified objecthood for the early Soviet avant-garde later became an intrinsic aspect of *everyday life*. By consequence, both artifacts and utilitarian objects acquired one principal trait: they were meant for *general* use. This implied that what was usually part of mundane life—e.g. consumption—had to cease being utilitarian or usable in terms of consumption; it had to construct the realm of a common project of communist life confined to basic need. This is really a strange paradox. Art becomes utilitarian, mundane, whereas life ceases to be usable and becomes "eternal," non-utilitarian. As Groys writes, only those commodities that fit "the idea about the communist future" could be produced in the conditions of Soviet socialism, and "the commodities not legitimized as socialist were not produced."[8]

6. Boris Groys, *The Communist Postscript*, trans. Thomas Ford (London and New York: Verso, 2010).

7. Vadim Mejuev, "Socialism as the Terrain of Culture," in *14 Texts of the Post-Soviet School of the Critical Marxism*, ed. Aleksandr Buzgalin and Vladimir Mironov (Moscow: Cultural Revolution, 2009), 113–164.

8. Groys, *Communist Postscript*, 12.

II

Now we can immediately dispute the abovementioned premises and claim that the experiences of historical socialism had nothing to do with either socialism proper, or furthermore, with communism. For example, Andrei Kolganov, historian of socialist economics, hesitates even to use the term "socialism" in reference to the Soviet experience.[9] He treats this experience as a social mutation in which forms of agency in true socialist politics were absent. However, he has to admit that despite such mutations, the absence of the "bourgeoisie" and the market economy enabled Soviet political economy to exert non-capitalist modes of production. Groys, even more so, argues that it is exactly due to historical communism's erroneous form and defeat that it cannot but repeat and remain a potentiality.[10]

It should also be emphasized that judgments about "true" communism are utopian, imaginary, and phantasmatic even when they rely on Marxist texts as communism's orthodoxy. These judgments are too often products of the capitalist imaginary, of productive efficiency, and prosperity. Meanwhile, the exigencies of social justice and equality might be quite incompatible with those of prosperity. The traits of social formation presupposed by communist production—undivided labor, collective production, the common-wealth principle of social co-habitation, equality in consumption and education, the collapse of the surplus economy and hence shrinking the libidinal undercurrents of desire—are traits that often appear to be violent, or even worse, boring to us capitalist subjects.

In short, what if communism is quite simply unbearable? Perhaps it is too dull for the human being conditioned to life in a capitalist era, and moreover, even coercive as it pushes forth this "boredom."

Let us proceed in a more gradual fashion with the following argument. In capitalism, the productive forces (technology and its efficacy, infrastructure, and logistics) are more advanced than the relations of production (forms of property, social interaction, superstructure,

9. Andrei Kolganov, *Chto Takoe Sozialism? Marxistskaya Versia* [What is socialism? The Marxist version] (Moscow: Librokom, 2015), 476–519.
10. Groys, *Communist Postscript*, 44–50.

institutions). This becomes clear if we look at any commodity object of late post-industrial production. For example, a luxury car is efficient, attractive; it represents the advanced achievements of technology and engineering. On the other hand, the relations of production (the social superstructure) in capitalist society are alienated, privatized, hybridized, etc. Therefore, the institutions of civil society, social critique, and micro-political activism are forced to maintain the forms of agency of democracy and potential for social continuity. In other words, the conflict between the productive forces and the relations of production in the conditions of capitalism is that the latter (the relations of production) lag behind advanced technology (the forces of production). In this case, the social structure of common interest, the common and un-monetized equal access to living conditions, to knowledge and culture are treated as technically, economically, and politically non-optimizable and redundant compared to technical ventures and the ameliorations of production. As Diedrich Diederichsen put it: in capitalism the free economy implies an unfree society, whereas in socialism unfree economy leads to freed sociality.[11]

From its early years, Soviet socialism was the hostage of an insurmountable incompatibility between productive forces and the relations of production. Yet, unlike this incompatibility in capitalist society, in socialism, the former (productive forces) lagged behind the latter (relations of production). And their correlation never attained any balance throughout the Soviet period. As Kolganov argues, with this absence of the development of productive forces, i.e., their immature condition, their industrial character could not fit the demands of constructing an advanced socialist society and its emancipated relations of production.[12] In other words, the entire socialist project was doomed to failure from the very start. What Kolganov puts forward here is the principal Marxist stance according to which only due to the proper development of the productive forces can the truly socialist relations of production be attained.

11. Paraphrased from a talk by Diedrich Diederichsen titled "Enlightened Globalism vs. Provincial Quasi-Socialist Localism," given on December 13, 2016 at NCCA, Moscow in the frame of the program *Theoretical Studies of Cultural Anthropology*.

12. Kolganov, *Chto Takoe Sozialism? Marxistskaya Versia*, 478–499.

In his introduction to *A Contribution to the Critique of Political Economy*, Marx writes:

> At a certain stage of development, the material productive forces of society come into conflict with the existing relations of production or—this merely expresses the same thing in legal terms—with the property relations within the framework of which they have operated hitherto. From forms of development of the productive forces these relations turn into their fetters. Then begins an era of social revolution. The changes in the economic foundation lead sooner or later to the transformation of the whole immense superstructure. …
>
> No social order is ever destroyed before all the productive forces for which it is sufficient have been developed, and new superior relations of production never replace older ones before the material conditions for their existence have matured within the framework of the old society.[13]

Here Marx explicitly writes that the obstacle for social development is the capitalist relations of production based on private property. The subjugating relations of production block and hamper the proper development of productive forces and this is what brings about social revolution. (Thus, in this passage Marx confirms that in capitalism, productive forces are much more advanced than the relations of production). The advancement of productive forces over the relations of production is a motivation to draw those relations up to a proper social level—de-privatized sociality—by means of revolution.

Castoriadis disputes exactly this premise in Marx.[14] To his mind Marx overestimates technology, economy, and production when he claims that the developed forces of production are the main condition that come into conflict with the capitalist relations of production. According to Castoriadis, the advancement of the forces of

13. Karl Marx, "Introduction," in *A Contribution to the Critique of Political Economy*, ed. Maurice Dobb (New York; International Publishers, 1970).
14. Castoriadis, *The Imaginary Institution of Society*, 13–28.

production over the relations of production paradoxically does not bring capitalism to anything other than a more developed capitalism.[15]

Yet, interestingly, what Castoriadis overlooks in this formula of interdependence between the productive forces and the relations of production is the fact that for Marx the proletariat and the idea of the commons have to take charge of the forces of production and direct them. Only then can they expand over the social infrastructure, refurbishing the relations of production.

What Marx implies is that social revolution is needed to guarantee the proper development of productive forces, which are halted by the "fetters" of the unemancipated relations of production; this automatically presupposes that the de-privatized relations of production would lead to the proper development of productive forces.

Yet what Marx did not predict is that a society based on equality with no private property might not necessarily become an incentive for the advancement of productive forces. This was the case with historical socialism. In other words: Can it be that in the conditions of socialist, de-privatized political economy, the criteria for what the developed productive forces mean in capitalist political economy would be modified and reinterpreted? What used to be considered the advancement and progress of productive forces in the conditions of capitalism would be looked upon otherwise in the conditions of socialism (with new, de-privatized relations of production). In other words, the development of productive forces would be assessed according to different coefficients. For example, this would not occur according to the degree of perfection attained in technical infrastructure and its embodiment in consumer goods production—refined textures, innovation of commodities and equipment, attractiveness of machinery and design. On the contrary, it would take place according to a shift in the perception and exertion of labor, human activity, knowledge, and the politico-economic infrastructure. If the functions of labor, technology, and knowledge are to be seen as distinct in socialism, then the tools that construct socialism's given

15. Ibid. Marx can still be critiqued here in terms of the contemporary conditions of production, which often do not allow the most exploited laborers cognitive and technical participation in advanced production as would be the case in the times of industrial capitalism.

infrastructure (i.e., productive forces) will also be seen differently. If a human laborer is a communist laborer, then labor will have the function of a generic social necessity and not the function of an individual means of survival. Consequently, the perspective and the goal of producing objects and the role of technology in socialist society would be different as well. In this case technical progress would not be an autonomous process of acceleration separated from the progress of social human relations and their development, as it usually is in the case of a capitalist society. In a socialist political economy, the advancement of productive forces could mean, for example, the institution, organization, and engagement of labor forces and labor tools for the general development of each and all. Of course, in this case the question arises as to what exactly could be meant by "development" in a communist society and for its members.

*

* *

The fact that the relations of production in the Soviet system—the superstructure, the institutions of society and culture—were ahead of the level reached by technology (the forces of production) brought about an aporetic situation and caused various mutations in the social system and production. In short, the technical forces that served as a material basis for the already attained social and economic ethics of common-wealth were not sufficiently developed. Despite industrial and military mobilization in the Stalinist and post-Stalinist years, breakthroughs in science and cosmotechnics, and the inscription of post-industrial technical know-how into daily life, retail production, and consumption were quite limited. These mutations attest to the material culture of Soviet society and determined the conceptual, cultural, ethical, and social texture of that society.

The consequence of this situation is the following: when the relations of production happen to be ahead of the forces of production, there is no motivation for further technical augmentation, since social constellations already fit the demands of what technical progress headed by the proletariat had to accomplish—de-privatization, competition in labor achievements instead of market competition,

elimination of surplus profits, etc. As a result, what we have is the stagnation of industry within the conditions of attained socialist "ideals." In other words, the social "ideal" that had to be achieved in the long run with the help of the gradual and persistent development of society was accomplished without technological perfection. Even if there were numerous cases of material inefficiency, the social "ideal" became the everyday reality—it was in no way a utopia. As a result of this mutation, a sinister disquieting confusion between the mature socialist consciousness and the immature material textures manifested itself in technological belatedness; it was expressed in the "poverty" of Soviet production and the social environment, as well as the low quality and unattractive interfaces of consumer goods. On the other hand, it can certainly be said that in capitalist society, access to high quality consumer goods is not a universal condition for each member. Such access is only possible due to the ranking of products according to privileged and underprivileged social groups and the way a specific product is consumed. Indeed, diversification of production and consumption is possible under capitalist conditions due to the explicit discrimination present in production and consumption.

In short, when the social goal that aspires to common wealth is implemented without due engagement of productive forces, we get a paradoxical, aporetic condition: a produced object is not a commodity, its production is motivated by the common cause, use value, and general need in the society of collective wealth. Such an object represents and confirms social justice and commonly owned wealth, insofar as it is conceived in general planning, but it is "poor" and plain in terms of its textures, design, and technical implementation.[16]

16. Interestingly, what has often been emphasized in this connection are the high standards of Soviet military industry despite the inefficiency of consumer goods. Harley D. Balzer comments on this in his book *Soviet Science on the Edge of Reform*, when he writes: "There also exists a definite Soviet style of design, and a style of integrating design into the production process. Too often, these styles have been mistaken for a complete lack of attention to design, when in fact they are important aspects of Soviet technical performance. Soviet products often appear to be poorly finished and clumsy. But key components of such products as aircraft function reasonably well. Consumer goods are another matter. Here again, style is a key. Soviet designers do not 'waste' resources on appearance or unnecessary touches. And

Nikolay Panitkov, *Vo Vsem*, 1988. Cooking pot, color photo, rope, cardboard.
24×24×15 cm. Courtesy of the MANI Museum Collection.

Erik Bulatov, *Idu*, 1975. Oil on canvas. 230 × 230 cm. © 2020 Artists Rights
Society (ARS), New York / ADAGP, Paris.

Such mutations triggered shadow economies and various abnormalities within consumption in socialist economies. On the other hand, it should be noted that the drawbacks of industrial and post-industrial development and shortages in supply of goods were superseded in historical socialism by cultural production, by universal free education, inventions in theoretical science, made up for the lacunas in technological acceleration and in the supply of consumer goods.

III

With all that being said, the trickiest question is the following: If the forces of production had been mature enough for the socialist relations of production, would these forces not then have been able to develop further in the conditions of the absence of a surplus economy? Are the elimination of private property and the collapse of libidinally oriented production not restraints on accelerated technological progress by definition?

Could it be that even with duly developed forces of production the use value economy could only gradually and inevitably bring about similar effects as the planned economy? Such effects would be the elimination of phantasm from production and trade, the shrinking of diversification and sophistication of goods, the simplification

they generally prefer an incremental approach, building on basic systems rather than redesigning an entire item. They also tend to shun the American proclivity for including the latest technology in a system. They are more likely to rely on proven (even if older) subsystems, integrating only those changes needed to guarantee the necessary performance characteristics. ... One example is Soviet reliance on large booster rockets due to their inability to achieve the precision Americans relied upon in downsizing launch systems. When faced with the task of launching very heavy payloads for their space projects, the Soviets' 'dinosaur' launchers proved to be highly effective. ... The Soviets' inability to produce advanced computers has led them to develop highly sophisticated input-output systems and advanced techniques of parallel processing, thus placing them in a good position to develop coprocessing technologies. While suited to many of the goals of initial industrialization, these characteristics are exacting an increasingly high price in the age of information and high technology." Harley D. Balzer, *Soviet Science on the Edge of Reform* (San Francisco and London: Westview Press, 1989), 154–155.

of the quality of retail goods, abolition of the private realm, sublation of authorship in art and cultural production, suppression of consumption, and the refinement of technologies redundant in daily life and the material environment. From the point of view of libidinally constructed capitalist consciousness, the modes of non-alienation brought about by the absence of private property and superseded by *common wealth* would result in boredom and hardship. However, in the framework of socialism the same conditions might have been experienced as the plenitude of life, as full-fledged activity and production. The Soviet filmography is an extremely valuable document that manifests these controversial effects of anti-capitalist living conditions based on use value. Regardless of form or content, its facticity is important as it shows how Soviet citizens inhabit the social realm—one full of limitations, and shortages of various kinds—as if it were abundant and prosperous.

In our contemporary imaginaries of emancipation, we often envisage the commons and communism as an extension of various freedoms and creative prosperity: opened up by contingency, an extended field of uncontrolled enjoyment, immanent, devoid of ideology and the rigidity of reason, a playground for transgression, an imaginary that estranges and exceeds habitual reality and, lastly, a utopia of accelerated forms of technological progress. But maybe such imaginaries about the commons and emancipation are often part and parcel of capitalism's dream of social justice and creative liberties. In fact, if we had to make a radical decision about non-capitalist modes of economic production in favor of equality, non-alienation, and the overall socialization of property, this would cause us extreme discomfort. We actually do not want changes in the homeostatic conditions that happen to be capitalist. This reluctance of ours is often unconscious and can nevertheless be concomitant to our own ardent anti-capitalist rhetoric.

A capitalist Subject desires alienation. Alienation—the combination of libidinal striving and libidinal lack—is able to phantasmatically construct the Subject's Other—which is not the other person but a narcissistic realization of the estranged phantasm of the "I," of its imagined otherness. This act of constructing the *other* alienated "ego" is libidinally grounded, narcissistic, and therefore irresistible.

We are actually unable to subtract our desire from consumption despite our critique of it. The world without commodities and their diversification would seem gray and repressive. Nevertheless, the need for a commodity is one of the forms of the inevitable and unconscious desire for alienation; this is because it is an alienation—in economy, labor division, and production—that instigates a libidinal bond with the desired object. This is equally true the other way around: libidinal striving in economy, exchange, and consumption ends up with alienated forms of labor. Moreover, one desires when one experiences lack. That is why, along with desiring an object, one desires the lack that makes that very craving for the object possible.

De-commodified and de-alienated labor and the use value economy change such dispositions in political economy and in material objecthood. The main effect of this is that the Idea is not external to material substance; it is not something suspended over the immanence of objecthood or matter, or torn from it. The common and the general are not delegated to the superego, spirit, or high reason. The de-commodified, non-alienated economy is itself already able to embody the general (the conceptual, the ideal, the universal). Groys is in no way ironic when he says that it was only those objects that could have been produced in the Soviet society that developed the meaning of communism: i.e., the objects that bear the conceptual meaning of communism and by the token of such noumenal character happen to be "philosophic."

In the non-surplus economy, any object, which is no longer a commodity, let us say a car, represents just the "carness" of a car, or the table becomes the "tableness" of a table. Therefore, various brands, types, or peculiarities of a "car," that might attract desire or contrive it, are superfluous. Convergence of the idea and the object (of the signifier with the signified) is thus the kernel of communist production and stems from the logic of the non-alienated economy of non-surplus value. The object of communist production is not a commodity generated out of specificity of attraction or desire, but it is a thing that satisfies a general/basic need without advancing the unique particularities that are very much emphasized in a commodity.

In this case, idea and concept are not torn away from matter, suspended over it, or separated from a "body," as is the case with

the platonic split between the object and its ideal. On the contrary, the concrete body and object are already conceptualized in the communist agenda, operating as ideated phenomena: that is to say they are material noumena, whereas the idea in its own turn is not valued or applied without being embodied in things, without being embodied in concrete activity.

IV

It is interesting how the condition of an object that is conceptual—i.e., an object already constructed by an idea, and at the same time remaining merely a thing of basic need—revealed itself even in nonconformist art practices, such as Moscow Conceptualism. The latter bears the strong imprint of a socialist economy in its creative topologies and trajectories, and, voluntarily or not, it reveals the logic of the anti-libidinal socialist economy. It is important to keep this in mind, because traditionally, researchers investigating Moscow Conceptualism have regarded Soviet sociality as the hostile "Big Other," in relation to which the conceptualists formed a hermetic dissident island of deconstructive interpretations. This is the stance that Ekaterina Degot disputed in her 2005 article "Moscow Communist Conceptualism."[17] According to Degot, even though the conceptualist artists would never refer to themselves as communists, we should keep in mind the objective, socialist economic conditions in which they produced their work.[18]

In regular capitalist society, where the capitalist character of labor, production, and consumption causes alienation, all idealistic projections are either unconscious or imaginary. In the Soviet socialist world, on the contrary, the most emphatic realizations of ethical deeds or *idealist* expectations in labor relations or in social spaces are

17. Ekaterina Degot, "Moscow Communist Conceptualism," in *Moscow Conceptualism*, ed. Ekaterina Degot and Vadim Zakharov (Moscow: Izdatelistvo WAM, 2005), 7–11.
18. According to Degot, defining "communist" features include the absence of a market and the self-organization of artistic and contemplative communication, in which the audience is posited as potential thinkers and artists, rather than mere consumers.

Odessa, Ukraine: Producers watch a backstage rehearsal of a marionette
show in the theater. 1982 Photo: © Ian Berry/Magnum Photos.

Odessa, Ukraine: The crowd spills into the water on a crowded beach, 1982.
Photo: © Ian Berry/Magnum Photos.

implemented and performed in concrete *reality*, while the consuming dreams and the commercial luxury of capitalism, by contrast, occur as imaginary abstractions or ousted illusions—as something almost sublime. Moscow Conceptualism finds itself in the social environment of production and communication where strange, absurd, and philosophical practices lose their quality of being something transcendental and become part and parcel of everyday normality.

As Groys writes in "Romantic Conceptualism," Moscow Conceptualism, unlike Western conceptualism, preserves a striving for the metaphysical dimension—the so-called other world. But this otherness is not something esoteric.[19] It simply asserts the insufficiency of empirical immediacy and the fact that art is a medium to grasp something other than art. The Soviet Union could then be seen as the objectified "fruit" of German classical philosophy—seen as the Romantic variant of Hegelianism. Each member of this society combines the extremity of collective consciousness with the extremity of loneliness, not knowing pleasure: they are surrounded only by symbolic things—or, we could say, conceptual, ideated, generalized objects.[20]

This is what makes Moscow Conceptualism different from Western conceptualism's academism, which is permanently focused on re-questioning the limits of art itself. If Western conceptualism takes objects from reality and turns them into art (which is still a modernist paradigm), Moscow Conceptualism steps into Soviet socialist reality which itself is a readymade conceptual artwork.

In the text accounting for his *Earth Works*, Andrei Monastyrski explains how the surface of a conceptual work, its "demonstrational sign field" (images and their textual commentaries), becomes transparent for "the expository sign field" (social reality). The expository sign field, as opposed to the demonstrational field, does not belong to the artist but to the state, and its objectivity practically knows no boundaries: "apartment walls and studios, museums, factories,

19. Boris Groys, "Romantic Conceptualism," in *Total Enlightenment: Conceptual Art in Moscow*, 1960–1990, ed. Boris Groys (Ostfildern: Hatje Cantz, 2008), 316–22.
20. Andrei Monastyrski, "VDNH: the Capital of the World; Schizoanalysis," [VDNH: stoliza mira; shizoanalizis]. Available at: http://conceptualism.letov.ru/Andrey-Monastyrsky-VDNH.html.

institutions, the earth that is owned by collective and state-run farms (*kolkhoz, sovkhoz*), roads—in short, everything, including water resources and airspace."[21]

The state here means not so much a state apparatus, but rather the permeation of life with the civic duties of a communalized sociality. Hence, the outer social space, as well as both its ideocratic contents and material objectivity (which are inseparable), are seen as the initiators that the conceptual work cannot do without. According to Monastyrski, Ilya Kabakov was able to achieve a powerful aesthetic effect on the level of formal structure only because his works were synergistically connected to the structural changes taking place at the level of the "governmental" sign field. His works are defined as governmental not because they are about the governing power apparatus, but because the artist searched within them for a broader meta-social dimension and grasped how the construction of the spaces of existence are accomplished, including how not only art's but "life's social necessities" evolved, implicating a "huge number of people and organizations."[22] This involved the coincidence of the dimensions of the social, the artistic, the conceptual, and the ontological. As Monastyrski argues, in Kabakov's work the "demonstration field of an artwork" (let's recall the blank spaces in Kabakov's drawings and the documentation of Monastyrski's actions) remains empty because eventality progresses on a broader scale than that of the artwork.

Moscow Conceptualism not only deconstructed but also, whether voluntarily or involuntarily, reconstructed Soviet socialist anthropology and ethics. In its classical period, Moscow Conceptualism dealt with the already conceptualized social surroundings, since anti-libidinal and de-alienated social spaces happened to be already conceptual, if we understand the term "conceptual" as synonymous with the eidetic. When a regular capitalist consumer object becomes an artistic readymade, it has to be reconceptualized—either in terms of its seductive components or in terms of its profane character of mass circulation. This is the case

21. Ibid.
22. Ibid.

with Andy Warhol's readymades or Jeff Koons's inflated commodity objects. The Soviet consumer object—whether clothes, underwear, furniture, and so forth—is already conceptual before its introduction into the space of art. It is conceptual because it belongs to the eidetic realm. Of course, Soviet consumer goods were also consumed, they also possessed functions and utilitarian values. But the experience of using things in the Soviet social space is devoid of libidinal pleasure. For example, if one has furniture, it has to be some eidetic piece of furniture, any furniture that serves its functions and its concept—if we regard the meaning of the word "concept" as defining why and how something had been conceived in the first place. An eidetic piece of furniture is completely free of decorative details that could allude to phantasmatic desire in relation to the image of the furniture, surpassing its most ascetic and minimalist use and purpose. The same concerns the room, the house, and articles of clothing.

Anton von Webern, in an explication of his understanding of *Fasslichkeit* (clarity/comprehensibility), which for him is the main feature of a work of art, says that an artwork is first and foremost conceived as a principle, as a concept. An everyday object such as pincers may be beautiful or ugly, big or small, new or old, but the idea of pincers must coincide with what they do—pincers are just those things that perform the proper function. The ideal pincers simply perform the minimal function of squeezing. This is when the thing can be seen as eidos, the eidetic, or the conceptual machine.[23] Translated into Marxist terms, these could be things with use value only, which in fact the Soviet commodity was. This is why, upon viewing the films of the 1960s, 70s, and even 80s, what was then merely the material objecthood of the natural everyday appears today to be a conceptually and artistically constructed space—some kind of total installation.

69. Anton von Webern, *Lekzii o Musike* [Lectures on music], trans. V.G. Shnitke (Moscow: Muzika, 1975).

V

A non-surplus economy is thus one of the principal causes enabling the general or even the sublime to occupy everyday life. This does not presuppose an ideology imposed from above. Such conjecture overturns the criticism of many researchers that communist ideology and the economy of scarcity in historical socialism had been the utopian program of the party bureaucracy forcefully applied in industry and production.

In a commodity, it is the surplus and the abstraction that are reified and materialized. Similarly, the modernist object reifies abstraction and transcendentality, but ignores the objecthood of reality. The commodity is material, but its materiality is a reified abstraction. In it abstraction is materialized, but the use value of an object is not generalized, and hence not socialized. Such materialized abstractions are sovereign. Whereas in the object based on use value, matter converges with the idea; matter needs and conflates with a concept. Thus, the general, as well as the idea, then reside in the matter and the object, and in no way are they confined to the pure mind and its specific applications.

CHAPTER 3

TOO MUCH SOCIALISM:
The Non-Cinema of the Soviet Film

*A communist is a human being of inner necessities
and not of external incentives.* [1]

—Protagonist in *The Days of Surgeon Mishkin*

I
WHY SOVIET FILM WAS NON-CINEMATIC

The main corpus of Soviet film is usually considered an extension of the socialist realist canon. Hence even after the demise of socialist realism between the early 1960s and late 80s, film production is still inscribed into the poetics of extended socialist realism—a second-rate art commissioned by the party program that has no artistic value whatsoever. Among the pieces that might have acquired artistic merit and might have gained international acclaim are only those films that had been explicitly denounced by Soviet censorship, had been held back from distribution after being released, or, having been released, bore the imprint of being anti-Soviet or non-official. The makers of such internationally acknowledged films are well known against the grey mass of "mediocre" Soviet film-production: Andrei Tarkovsky, Sergei Parajanov, Kira Muratova, Otar Iosseliani.

It is not my goal to dispute the artistic merits or historical importance of the aforementioned filmmakers. Nor is it my aim to criticize the provisions of socialist realism either, or to justify "B" Soviet film production in search of any latent artistic merit. The reason we refer to filmic material of 1960s and 70s is not simply to show that the films of the 60s continued the avant-garde activity of political engineering socialist society. Nor is it my objective to witness how certain components of socialist production appear years later (in film after the Thaw) as fallacies or incompatibilities of socialism. Rather the aim is to redirect this material to us, present subjects of capitalism, in order to trace unconscious capitalism in contemporary anti-capitalist reasoning.

1. A statement made by the protagonist of the film *The Days of Surgeon Mishkin*, directed by Vadim Zobin (Moscow: Ekran Film Studios, 1976).

The majority of such film production complied merely with basic standards for filming, without any specifications in favor of any unique cinematic language. Such aesthetic poverty served the goal of constructing the social and ethical agenda of "communist conscious-ness" by means of each concrete film. This filmic material reveals not only the extent of mutations in historical socialism; it also implicitly highlights what in contemporary, global, progressive critical theory remains an inevitable component of capitalist production, while being treated as a feature of communization and emancipation. In other words, the B-film in the Soviet Union catalyzes both conditions—the mutations within historical socialism, and the unconscious capital-ism in contemporary anti-capitalist critical theory. In this sense, Soviet film, belonging to the period of so-called "mature" socialism, could serve as a litmus test to show what in the contemporary discourse on emancipation is still permeated by capitalist modes of production and fallaciously treated as emancipatory, and what in historical social-ism happened to be a disastrous failure of economy and production.

But first and foremost, this filmic material clearly shows how it happened that the economic and social conditions of historical socialism turned out to be unimplementable. This is not only because they were applied in a corrupt way (by token of being insufficiently socialist), but also, on the contrary, because the socialist measures of eradicating the principal components of capitalist production were too extreme in their socialist agenda. Quite simply, socialism failed because it contained *too much socialism*, more socialism than could have been exerted with the existing productive forces.

The social structure of such a society might make us, its contem-porary viewers, exclaim: *no, the materiality of basic need with its quest for regulated common interest cannot be what communism could aspire for as its goal of emancipation. This artificially organized non-alienated-ness and prescribed equality restricts imaginaries of desire, initiative, and liberty by artificially constructed common need; and hence non-alienatedness in it is just a redemptive act of repression.*

From the outside, such a society causes panic as it cancels desire and freedom as the mode of social development and aspi-ration. Consequently, what needs to be examined is: (1) To what extent such negative reaction to this filmic material might occur as

a consequence of our capitalist unconscious? And: (2) What were those mechanisms in economy, production, and life that made the inhabitants of the socialist infrastructure treat it as an ethical and political achievement?

As mentioned above, what is unique in each film is not its cinematic poetics and aesthetics, but rather an ethical treatment of a certain social conflict. The large majority of industrial film-dramas are actually logical exercises in finding the proper solution to various modes of drawbacks and fallacies hampering communism—economic, technical, ethical, and social. The main visual tools in these films are quite similar and are not diversified cinematically; whereas, in terms of an ethical conflict each piece is a unique case of the dialectical treatment of a given social problem, which is analyzed in a sort of *trial* that investigates the circumstances hampering approximation to communist sociality.

Referring to the social realia as they are given in the films of the 1960s and 70s, one can witness how the eradication of various aspects of capitalist production generated a very specific material culture, economy, ethical conduct, and set of power constellations that produced a controversial societal construct: on the one hand, the disappearance of those attractions of life that in capitalist society support the phantasms of desire; and on the other hand, a constant conflict between individual desire and the necessity of the commons. The distributive planned economy and production was confined to basic need and almost automatically fostered an invasion of the mundane by the universal (the general).

Interestingly, if we were to compare the discursive paradigm of the psychoanalytical correlation between patient and analyst with the conflicts constructing Soviet film in the 1960s and 70s (the conflict between the collective aspiration toward the commons and individual inabilities to conform to it), we would have to say that in these films the analyst's position is substituted by judgment from society and its ideological organs (institutions). This is why self-analysis within the ethics of the common cause turns into self-judgment and entails a metanoiacal turnover of consciousness. Self-critique is a procedure quite different from psychoanalysis in that it precipitates such change of the self, which in its own turn should be inseparable

from the changes in external circumstances and conditions. In this case the social dimension is sought not only in the external context, but it also has to be discovered in oneself as the personal ability to expand one's interests to the dimension of the non-self being. In addition to the critique of external circumstances in society, the self-critical Subject internalizes the social drawbacks in the regime of severe self-denouncement. Thus, the ethics of non-individual interest intertwines with the transformation of consciousness, which leaves almost no room for sovereign individual desire.

The main function of a socialist film is quite far from exerting innovative aesthetic methodologies; its main goal rather is finding out how the already established non-capitalist modes of production can be fully incarnated and inscribed into the texture of social production. In psychoanalysis, such an act is known as the internalization of the extra-individual phenomena—the universal, the ideal, the Big Other, the superego, which controls drives and desires. The invasion of the psyche by ideology implements a traumatic intrusion of sublimity into the unconscious. In this case, the common cause simply occupies the place of libidinal desire: forcefully molding everyday life, behavior, communication, and the psychic body. Hence, the social and the general tasks exerted by the social infrastructure occur to be just a set of prompted and imposed commands.

Meanwhile, the Marxist formula "social being determines consciousness" implies that there is no primary isolation of an individual body from the social framework; hence social infrastructure, language, culture and the set of ideas and collective activity are always antecedent to an individual and broader than him or her. The idea (the ideal, concept) and the thing (body, immanent empirical realia) are not confronted with each other as the abstract against the concrete, the general against the specific. Bodies can exert ideas and be them. This is not because some authority from above imposed the idea, but because the body can only be active and productive as an idea: without it, it is mere dead materiality. Non-privatized materiality presupposes that the general, the universal, is not any idealist aspiration, but an effect of the use value economy. In *The Communist Postscript*, Boris Groys provides evidence for how the elimination of a monetary economy asserts a logic of philosophical semantics for

all elements of reality within such a society. In this case any object becomes a logical, speculative, and philosophical unit. Philosophical language and dialectical logic sublate economy and its interests: this principle leads to treating reality and any of its components—material or immaterial—in general terms.[2]

This is why conflict in Soviet film narrative turns around the tension between the already achieved condition of the commons and personal aspiration.

However, as already stated above, the mutations that such films manifest in this clash of the personal and the common consists not—as traditionally thought—in a lack of communism but, on the contrary, in its excessive abundance. The reason for the collapse of historical socialism lies not in the falseness of the system itself, not in the gap between the genuine socialist necessities of true communism and the bureaucratic hypocrisy of the imposed social infrastructure. On the contrary, the mutation happens because the social infrastructure and its systemic construction already contain *too much socialism*—more socialism than human life, people, and even bureaucratic institutions could exert in their mundane existence, labor, and activity. That is why very often the critical demand, characteristic of Soviet film, consisted not so much in evading party rigidity for the sake of more liberty, but quite the contrary: critique lay in the demand to exert almost super-human ethical deeds posited by the de-privatized social systems and infrastructure.

Lukács extensively discussed that consciousness becomes self-consciousness only as proletarian consciousness—i.e., as class-consciousness.[3] However, when relations of production are already socialist without productive forces matching their development, the motivation for further technical maturation is paralyzed. This is because relations of production have already been tailored to the political demands of socialism, prior to any further technical progress guided by the proletariat.

2. Boris Groys, *The Communist Postscript*, 66–77.
3. Georg Lukács, "Class Consciousness," in *History and Class Consciousness: Studies in Marxist Dialectics*, trans. Rodney Livingstone (Cambridge, MA: The MIT Press, 1971), 47–83.

This paradox—of the relations of production already acquiring a post-economic condition ahead of technology in terms of social and humanitarian ethics—has already been touched upon. To repeat again, even though the elements of state monopoly and control over the economy were evident in socialist production, this does not presuppose any similarity of historical socialism with capitalist production.[4] This is first and foremost the case, because the Soviet economy was not dependent on the market, its competition, or surplus value gains. The state fulfilled the function of forced but still equalized distribution and general planning, crediting the privileged zones in science, culture, construction, and armament. Secondly, the Soviet Union was never a national state, but the organ responsible for the trans- and international influence of the Communist party. Thus, the issue lay rather in expanding the power of communist ideology over economy rather than in monopolizing production by extracting surplus value from it. In other words, even despite the Soviet state's control over production, such traits of its economy as the absence of a market, the collapse of surplus value, and the basic need principle of the distributive planned economy allow us to dismiss the idea of the identification of state monopoly with capitalist production: the interference of the socialist state into the economy differs from the regular national state's engagement in the economy in capitalist countries and economies, when the state takes up the bridles of regulating the "free" market.[5]

4. It was actually Lenin himself who as early as 1917, in his brochure "The Impending Catastrophe and How to Combat it," claimed that state monopoly was a transitory but inevitable condition for socialism. In "Can We Go Forward If We Fear Advancing Towards Socialism?" Lenin writes: "But because state-monopoly capitalism is a complete *material* preparation for socialism, the *threshold* of socialism, a rung on the ladder of history between which and the rung called socialism *there are no intermediate rungs*." V. I. Lenin, "The Impending Catastrophe and How to Combat It: Can We Go Forward If We Fear To Advance Towards Socialism." Available at: https://www.marxists.org/archive/lenin/works/1917/ichtci/11.htm.
 As Lenin argues here, in the conditions of proletarian dictatorship, even when the State has a monopoly over the economy, the social agent is not capitalism, but rather a streamlined system of social accountability, control, and regulation over private capital, aimed at the quicker development of the material basis for socialism.
5. Mariana Mazzucato, *The Entrepreneurial State: Debunking Public vs. Private Myths* (New York: Anthem Press, 2013).

According to Lenin, in the conditions of the proletarian dicta-torship, state monopoly lies in regulating *defense* against capitalist economy, while at the same time it creates the economic conditions for socialist production. But it has to be repeated that the Soviet state had to be neither a national state, nor an empire. It had to be the social construction subservient to the party as to the organ rul-ing and constituting the agency of communism. Thus, the nominal ownership of resources by such a State is not in privatizing those resources but in organizing, distributing, and socializing them and the results of production—according to the presumptions of the com-mon good. Even without the complete eviction of surplus economy, the state nevertheless is not focused on gaining surplus value. The party exceeds the state and instigates the latter to exert the social-ist economy as its principal goal.

However, in situations in which the social goal of aspiring for "the general" stumbles over the inefficiently developed productive forces, the social cause has to be attained otherwise—by means of a concrete personal metanoiac deed, serving as an ethical example of personally implemented communist duty.

The main bulk of film production from the 1960s and 70s was in constant transmission on TV and had a broad mass audience while being treated by the cultural elite as an artistically unimportant dog-matic ballast. Now, three decades later, even the scripts of those films seem literally *fantastic*, almost science fiction. They reveal the extent to which "the most advanced society" was in fact modest and poor in terms of its living conditions. But at the same time they show how this society managed to shift the understanding of wealth into the realm of the common good and thus attained a specific social vision: what now looks like a reality that was full of squalor was in fact perceived by its protagonists as economic plenitude liberated from the vices of capitalism.

II
METANOIA OF THE COMMUNIST SELF-CRITIQUE

I propose three principal modes that Soviet film catalyzes in the abovementioned discrepancy between the excess of socialism and the effort to conform to it. These modes would be: (1) metanoia, (2) halo, i.e., aureole (Agamben), and (3) non-alienation.

Metanoia is a radical change of consciousness that overturns the pace of everyday life and the order of one's thoughts; it shifts life in a converse direction. In Soviet film and drama of the 1960s and 70s, metanoia is often used as a dramatic device. It is shown as an event, which has to turn delusion, perplexion, and passivity into ethical agency and confirm in the consciousness of a protagonist civil and ontological commitment to the communist project and an exemplary involvement in it. Larisa Shepitko uses this tool of overturned consciousness in all her films.

The main character of her film *Wings* (Mosfilm, 1966), a female pilot named Nadezhda, is a World War II hero who, when de-mobilized, becomes the director of a professional training school in a provincial town. The plot is not dynamic at all. Nadezhda lost her boyfriend in the war, who was also a pilot. As a member of the war generation, she is undereducated, and ashamed of it. The entire film is about her attempt to accomplish a deed that would result in the further advancement of the commons. Yet her daily life only consists of her routine, bureaucratic role as a school director. The film depicts how the social enthusiasm for building a new society decreases with the gradual forgetting of the trauma of World War II, with only a remote melancholy to fill the ensuing space. When compared to her daughter's interest in private life, Nadezhda's social work at the school seems quite extraordinary. But in comparison with her war past—her former proximity to the novelties of industry and technology, to the production prospects constructing the new society—her work at the school seems uninteresting. For the protagonists of Shepitko's films, the process of shrinking away from previously-held enthusiasm for building communism becomes a personal tragedy. This is the moment when the heroine succumbs to

metanoia. At the end of the film, she deserts the school, goes to the aerodrome, gets into a plane without any permission, and flies away, leaving the spectators wondering whether she survives or not, since it's likely that after many years she has lost her piloting skills.

In another of Shepitko's films, *You and I* (Mosfilm, 1971), Peter, a physician and scientist who is performing an important experiment in neurobiology, is offered a job to work as a therapist at the Russian Embassy in Sweden. Both he and his wife have the opportunity to enjoy the consumer privileges of capitalism. Peter quits his laboratory and leaves it under the charge of his principal colleague, who later also quits to become a successful bureaucrat. The film centers on the protagonist agonizing over his choice for personal comfort. It focuses on Peter's attempt to return to science: not just to restore the material equipment of his scientific experimentation, but to reinvigorate his belief in living and acting in the name of a common cause that might be uncomfortable from the individualist perspective of private life.

Peter returns to Moscow from Sweden, goes to the railway station and without any luggage at all jumps onto the first long-distance train he sees. During his trip, he mingles with the moving crowds, the masses of people, mostly industrial workers travelling throughout the country. He understands that striving for the "commonness" inherent in each personality is something that he lacked in the privacy of his family life. He finds work as a doctor and surgeon in a very remote region in the north where a large construction project is underway. Interestingly, the film does not show Peter's decision to return to his scientific occupation in concrete steps, but rather focuses on the inward ethical transformation which ultimately gives rise to that act. It is only after dissolving into common needs that the protagonist can regain interest in his scientific work. Shepitko here brings forth the idea that it is predominantly the supersession of an individual interest by social consciousness, and not just technocratic development, that leads to true social progress.

In Gleb Panfilov's *I Ask for the Floor* (Lenfilm, 1975), the chairman of a provincial city committee (the mayor), Elizaveta Uvarova, is completely immersed in the project of modernizing her town. Her present goal is to implement the construction of a new bridge. Parallel to

Larisa Shepitko, *Wings*, 1966. Film. 85 min., black & white film, 1.33:1.
Courtesy of Mosfilms, Russia.

Larisa Shepitko, *You and Me* [Ty i ya], 1971. 1h 37min. Courtesy of Mosfilms, Russia.

Larisa Shepitko, *You and Me* [Ty i ya], 1971. 1h 37min. Courtesy of Mosfilms, Russia.

Sergey Mikaelian, *Love By Request* [*Vlyublyon po sobstvennomu zhelaniyu*], 1982. 89 mins. Lenfilm, Russia.

this, she is engaged in other construction projects, planning housing, distribution of apartments, and even the cultural life of the city. This B-film recycles one of the numerous Soviet plots about honest communist bureaucrats. The unique moment in each of these films is usually the concrete situation of exerting the act of self-resignation in the name of a common cause in the most complex conditions. As mentioned above, there is nothing attractive in these cinematic pieces in terms of extraordinariness of narrative. Nevertheless, certain circumstances of life and production bring the protagonist to some extreme decision, so that in the midst of ordinary mundaneness the narrative achieves the heights of a tragedy. The teenage son of Elizaveta eventually kills himself while playing with a gun that belonged to his mother when she was a sport shooter. However, to her colleagues' surprise, Elizaveta appears in her cabinet right after the funeral, not even taking leave for the ritual of mourning—conduct that emphasizes her grief even more and manifests her attempt to ignore it as an act of a stoic resilience.

In Sergei Mikaelyan's *Premium* (Lenfilm, 1974, after A. Gelman's play *The Protocol of One Session*) the moment of self-exposure and metanoiac self-trial takes place in even more trivial conditions. The script is a logical dilemma rather than a narrative. The workers of a "construction trust" receive a premium for overfulfilling the production plan (each worker gets an extra seventy rubles, amounting at that time to one hundred US dollars). Eventually, one of the brigades, headed by a worker named Vassily Potapov, refuses to accept this money; its members insist that the overfulfillment claim is invalid, since the rate of plan had been reduced the year before. The issue is later debated at the party committee session, where the brigadier Potapov presents his investigation of the deliberately reduced plan and its economic undercurrent. According to his research into constant idle stays of production at various brigades, the dishonest party leaders reduced the plan so that it could have been easily overfulfilled. Gradually, it becomes evident that those idle stays took place not only because of a poor supply of construction materials, but also due to bad organization and coordination between various sections of the constructing process. Because the "objective reason" behind reducing the plan (a lack of supply) was false, Potapov's brigade

decides that the premium for the forged overfulfillment (amounting to 37,000 rubles for the whole brigade) has to be returned to the state. The main conflict evolves between Potapov and the secretary of the party committee, Lev Solomakhin, who supports Potapov's suggestion, and the head of the trust who opportunistically asserts that the workers' rejection of monetary award would be absurd. At the moment when all members of the party committee support the withdrawal of the premium, information arrives that half of Potapov's brigade unexpectedly changed their minds and accepted the money. Defeated, the honest worker leaves the room. But meanwhile the party committee and even the head of the trust vote for the withdrawal of premium; the premium has to be returned to the State as proof of the fallacious plan and its false overfulfillment. This plot is a confirmation of the fact that although the distributive economy was conditioned by basic need, which became an ethical and aesthetic rule in the Soviet Union, such political economy was not the only condition for the shortages in product supply. Shortages and inconsistencies of production were often the consequences of inefficient organization. And since such inefficiencies had to be concealed from party and society alike, the leaders of production often had to falsify numbers, results, or invent other forgeries to appear successful in socialist competition.

Consequently, the trial initiated by an ordinary worker with excellent economic and logical analysis of the flaws of production proves that the system contained enough resources for adjusting the relations of production to the means of production, i.e., sufficient resources for socialism, but that it was the human factor that hampered the proper realization of those resources. The trial manifests how an imprecision in calculation and organization, or merely natural and inevitable opportunism, undermines and corrupts the infrastructure of production. The socialist system tacitly implied that the human consciousness engaged in it should have already been communist in terms of being devoid of private interest. But the trouble with the distributive economy and socialist competition was that they required impeccable honesty, complete clarity, and total transparency in their communication and organization. The realities of production manifest to what extent the planned economy obliges

the worker to put aside casualties and traits of character, personal life, or its conditions, in order to constantly correspond to the social and economic infrastructure adjusted to the common good and its objectives (which are not at all welfare). Meanwhile, the capacity for seeing all phenomena in general terms is not always possible in "normal" life. Therefore, the slightest deviation from the plan, or negligence when such a violation occurs, undermines the social system; it is only self-trial that can then turn its agents back to the communist perspective.

In such a self-trial, the bureaucratic problem and its analysis acquire the scale of a universal drama. In *Premium*, the information that the workers initially rejected the money, but later accepted it, is shown as a tragedy of the brigadier, whose belief in the solidarity of his brigade is shaken and for whom the precision of his calculations becomes futile. It is clear that all the abovementioned vicissitudes of socialist production and its critique could be translated into the lexicon of optimization in post-Fordist production. Interestingly, however, the debate on optimizing the functional efficacy of production or liquidating its errors is rarely confined in socialist rhetoric to technological pragmatism. As many would assume, such self-critique is much more ideological and didactic. However, along with economic analysis and didacticism this self-critique in the framework of production exerts a philosophic thinking—some sort of over- or supra-consciousness and its logical machine—that happens to be the outcome of the pro-communist relations of production. The philosophic dimension presupposes that the Subject of thought, of speculation and decision is a non-self—it is the mind that departs from the needs of the generalized non-self and not of the needs of the individual self (the stance that does not annul the personality). Thereby, the ethical and logical argumentation standing behind even the most trivial issues of production or economy always puts at stake the philosophic demand for the general. Only in being a philosopher, can one take responsibility for the common cause that is above personal concerns.

This is why the contemporary viewer of these films is so absolutely astonished by them insofar as, already at the level of a fabula, the mundane, the routine, and the sublime overlap. The administrative trifle can acquire the scale of a universal problem. Or, on the

contrary, the sublime dimension can constitute the mundane life completely. For example, in Ilya Averbach's *Fantasies of Faryatiev* (Lenfilm, 1979, after the play by Alla Sokolova) the protagonist researches through scientific means the transfer of human civilization to the planet of absolute common good, universal virtue, and disinterested conduct.

From the point of view of the aesthetics of attraction on which the cinematic language is grounded, it is impossible to keep a viewer's interest on a plot about the supply of cement to a construction enterprise; on the narration about inexact calculations in industry; or on a story about what happens after a married couple working at the construction trust gets a new, one-room, separate apartment (*Ksenia, Fedor's Beloved Wife*, Lenfilm, 1974). Such stories can only be part of bureaucratic sessions, debates on organization and management, or make up the body of sociological statistics. Nevertheless, exactly these trivial components of organization acquire the scale of dramatized conflict, and by reenacting the micro-social problem in the magnifying glass of metanoiac transformation a protagonist scans the social, political, and ethical needs of communism.

III
HALO (AUREOLE)

Chapter XIII of Giorgio Agamben's *The Coming Community* is titled "Halos." In it he describes a specific mode of reality in which the world becomes completely different and new, without any nominal change of its empirical conditions whatsoever. In this world to come, "everything will be as it is now, but a little different." Things are "otherwise" in it, even though they remain as they are. Agamben claims such a condition is aporetic, and quoting Saint Thomas, defines it as the "halo." Agamben writes:

> The halo is this supplement added to perfection—something like the vibration of that which is perfect, the glow at its edges. ... The halo is not a *quid*, a property or an essence that is added to beatitude: it is an absolutely

inessential supplement. One can think of the halo, in this sense, as a zone in which possibility and reality, potentiality and actuality, become indistinguishable. The being that has reached its end, that has consumed all of its possibilities, thus receives as a gift a supplemental possibility. This imperceptible trembling of the finite that makes its limits indeterminate and allows it to blend, to make itself whatever, is the tiny displacement that everything must accomplish in the messianic world. Its beatitude is that of a potentiality that comes only after the act, of matter that does not remain beneath the form, but surrounds it with a halo.[6]

(Interestingly and oddly, matter here is able to exceed the constraints of form, "surround" it as aureole, and to acquire new meaning despite nominal formal limits; i.e., form starts to depend on the capacity of matter to produce the aureole of new meaning.)

In a certain sense the communist perspective allows its material reality to acquire such a halo, such an aureole. It completely reconfigures perceptive, sensitive, and cognitive habits, becoming a truly new topology, ontology, ontic, and anthropology. The films of the 1960s and 70s show how such a halo effect works within socialist "reality."

(The reason a regular documentary could not serve for such testimony is that documentaries generally lack the element of a dramatic protagonist exerting an ethical act and embodying an idea of the common in a concrete situation, i.e., they lack the Subject of a concrete deed.)

In any other—non-communist—context, the same things would be seen otherwise: as poor, inefficient, badly designed, unattractive, raw, cheap, and tasteless. But the effect of the halo shifts everything in accordance with the ethics of the common, which affects the material surrounding so that it literally, "already on the ontic level," becomes both basic and perfect at the same time. The reality of basic need then is treated as the plenitude that is completely sufficient.

6. Giorgio Agamben, *The Coming Community*, trans. Michael Hardt (Minneapolis: University of Minnesota Press, 2003), 53–59.

There is no yearning for any better reality; the common good is already attained and the drawbacks are nothing but temporary and casual deviations. The viewer who is outside such a perspective sees the same reality differently. For example, in the abovementioned film *I Ask for the Floor*, the head of the city committee passionately tells the French delegation about achievements in construction work, and is full of enthusiasm to now launch the construction of a new bridge. Meanwhile one of the members of the "foreign" delegation wonders how such a plain-looking and poorly dressed woman could be the mayor of the city. The effect of the halo (aureole), tuned by a communist gaze, falls apart with the intrusion of capitalist economy. An encounter with the Western, capitalist gaze was a huge source of trauma for the socialist Subject. It undermined the aureole inside this isolated universe of equality (equality conditioned by common poverty, as many would insist).

Interestingly, Sergei Gerasimov's films—such as *To Love a Human* (Gorky Film Studio, 1972) and *Journalist* (Mosfilm, 1967)—are rare cases of considering this critical Western gaze. Gerasimov uses filmic elements as well as design to make the plain Soviet material reality seem neat and "cool." In the abovementioned two films he deliberately includes the encounter of the privileged Soviet intelligentsia with their Western colleagues. Soviet architects meet their French colleagues in *To Love a Human*. In *The Journalist*, a young student is sent to the US as a journalist after graduating from the Moscow University of Foreign Affairs. In both cases the members of the Soviet cultural elite are at first slightly tempted and fascinated by the consumer abundance and communicative easiness of capitalism. But soon they discover capitalism's genuine "face" and dismiss it once and for all. The neat interiors of Gerasimov's films then are meant to serve as proof that the Soviets actually can afford what the capitalist West is appreciated for—material welfare, well designed interiors, the elegant manners of the intelligentsia; yet in addition to welfare, socialism achieved the overall condition of the common good. And even though the capitalist welfare society is more advanced in many fields, including its technology and consumption, it does not possess the principal achievement: a new humankind with communist consciousness.

<center>*</center>
<center>* *</center>

But what is this slight something with which the reality is permeated under the influence of halo (aureole)? As Agamben mentions, "its beatitude is that of … matter that does not remain beneath the form, but surrounds it (the form) with a halo."[7] So a halo is not a metaphysical extra-corporeal "divine" complement by which things are endowed as a result of some mental or psychedelic procedure. It is merely a quality of matter itself, it is the same as matter nominally, but is nevertheless capable of changing its hypostasis, meaning, impact—while remaining the same in form and constitution. ("The being that has reached its end, that has consumed all of its possibilities, thus receives as a gift a supplemental possibility".)[8]

The socialist political economy produces such a gaze, such a function of halo, so that the poor socialist materiality appears in its conditions as pleroma and sets the "reality" as already satisfactory, "beautiful," and virtuous, when perfection is already felt as attained, although it is not nominally or empirically there. In this case things are free from Lacanian lack, since the machine of libido is turned off. There is enough of everything, everything is full, even if it is nominally subject to shortage.

However, if in the case of Agamben the glow caused by the halo is to make reality messianic, in the case of communism this "glow" of halo and its plenitude is conditioned and motivated by the prism of the common cause. Collective consciousness is not merely the result of coercive collectivization, but collectivization is the consequence of treating the world philosophically, i.e., in general terms, without particular interest. This is why the metanoiac and parrhesiastic self-resignation of the protagonists in the abovementioned films seems insane and often silly. Paradoxically, such a protagonist does not desire something as an envisaged future imaginary, but, on the contrary, should teach himself/herself to *need* what is *already*

7. Agamben, *The Coming Community*, 53.
8. Ibid.

available to him/her by virtue of the already-attained socialism. The goal of communism in such conditions was not to achieve yet non-existent communist components of life, but quite the contrary—*to learn to need and aspire to the already existing ones*.

Not that what is available is necessarily already a communist ideal, but it is more likely that if the socialist system supplies something, it is—already in all its material haecceity—more socialist, more proper, more general, than individual phantasmatic dreams and desires. Thus, along with attaining the dimension of the non-desire providing the state of plenitude, a halo guarantees that one stops to crave and desire, attaining bliss with whatever is at hand, and sees reality due to such aureole as plenitude. One does not any more desire tastier food in, let us say, a luxurious restaurant imagining oneself in a tuxedo with an attractive lady. Instead, one has the urge to intensely search for the heroes' tombs of the Second World War, or imagines an improvement of the Kolkhoz production, etc.

In Sergey Mikaelyan's *Love By Request* (1982) the protagonist, Igor Bragin, is a locksmith in a factory. He is handsome, charming, and successful with women. However, since he is just a regular factory worker, women do not stay with him for very long. Bragin is unhappy with his routine work at the factory, and craves something more creative and romantic. It seems that with his good looks and background in sports he could have been more successful—a better apartment, a beautiful girlfriend, a better working position, more prestigious friends, etc. Eventually, he strikes up a comradeship with a young lady—a plump, very friendly and diligent librarian, Vera Silkova. In his leisure time he frequents discos and travels as a tourist; Vera searches for the tombs of deceased soldiers from World War II and organizes trips for the dead's families to visit their graves. To cut it short, the film ends with Igor Bragin falling in love with Vera Silkova the librarian and understanding the higher mission of his (seemingly routine) labor. But this happens not because his female comrade turned into a beauty as the result of exercise, new outfits, etc.—which would have been the case in a Hollywood film. Bragin likewise becomes enthusiastic about his job not because he managed to get a better position at the factory, but because he falls in love and manages to discern in Vera a new person by viewing his

life through another prism. Similarly, he suddenly sees in his job a goal that is already accessible then and there and not as any imaginary future utopia, and reaffirms himself not as a dependent worker, but as part of the general project of the common good. Such a change of perspective, when things remain the same—they remain finite, transitory, inefficient, but nonetheless they suddenly overturn their meaning and functionality and appear as infinite, eternal, and ideal—is the effect of a halo, the aureole. The protagonist of the film, Igor Bragin, thus learns to need and find perfect what was already at hand instead of chasing nonexistent future imaginaries. The film achieves this turnover not visually, i.e., technically, but rather logically, and semantically, i.e., metanoically.

IV
THE UNBEARABLE SQUALOR OF NON-ALIENATION

A capitalist subject revisiting the abovementioned corpus of socialist film production reacts not only with boredom; but also experiences an uneasiness caused by *squalor* [9] and pity for "this kind" of communism. Such a reaction is not merely based in empathy for "squalid" living conditions, but rather in the perception that the inhabitants of this "world" are completely unaware of the extent of their squalidness, and are in fact basically content with how things are. This basic satis-faction with already existent socialism is present, even despite what its subjects might be constantly preoccupied with: solving the issues of social injustice and deviations from communism. What seems truly uncanny in a such state of affairs is the absence of real evil—of real danger, risk, intrigue, resistance, temptation, seduction, subversion: the absence of various vicious situations; in general, the absence and impossibility of hubris; the absence of struggle against some true "evil" or, on the contrary, an intentional demonic choice of it.

The squalor is even more obvious when we cannot be sure that what is treated as social virtue, emancipation, and happiness is valid at all. For a capitalist subject the already attained good cannot be

9. As in a *reaction* to poverty that looks extremely meagre and ascetic.

real; it would imply stagnation. But that which for a capitalist subject stands for a misfortune—negligence to one's body and desires, the rule of social harmony, collectivity deprived of personal privacy—is treated here as the only necessary point of departure. What for "capitalist" consciousness is desirable as a liberating, resistant, anticapitalist imaginary—searching for true enjoyment uncontrolled by any authority, liberties of body and its performative subversiveness—becomes a matter of severe self-critique and eradication in the society of real socialism.

The film then has to show how, when a person inevitably deviates from this already established socialist "harmony," the metanoiac shift compels that person to get back to that "harmony" again. In Shepitko's *You and I*, Peter, who has a laboratory for his experiments and is working to invent a new means of fighting cancer, also has communist comrades and collaborators who are utter allies. Despite this already attained social good, he suddenly "deviates" towards "normal" bourgeois life in Sweden, becoming a private doctor for Soviet diplomats. It is only after the existential and metanoiac over-turning of consciousness that he returns to the previously attained state of being an inventor and scientist.

*
*　*

But how can these sexless, flawless, sinless near angels, boring titans and machines of logic, who sublated personal interests, drives and desires, who treat life and its conditions as a communist eternity, deny that their bliss was artificial? How can the characters depicted in these films ignore that their sublated libidinal drives were the result of coercive restraint, that their material poverty and shabby interiors were a contradiction to their communist confidence, and that all their voluntary decision of utmost de-privatization and de-alienation might have been the outcome of being brainwashed—if not by an external authority like a party, then at least by a fallacious idea of communism? What can be more squalid and miserable than the collectivity of communalized consciousness, the sociality of political Eros dispensing with the frontiers between the private and the

public, the sociality that cannot strive further and achieve more than it has already attained, because it is already a "paradise"?

The main illusion of capitalist subjectivity in perceiving this legacy is that certain types of contradiction in it are ignored. What is contradictory and what evolves as a civil resistance in socialist society is simply not recognized and acknowledged by capitalist subjectivity. The main reason for this is the logical condition of de-alienating ethics. When sociality is de-alienated, virtue confronts virtue, rather than evil. The struggle is not between evil and good, or evil and an even bigger monstrosity, which as an emancipatory hubris would surpass the "regular," "official" evil. At stake instead is the argument between two standpoints, or the two stages of virtue and the dialectical clash between them. What does it mean that evil is absent? "Evil" cannot be sublated until a human being exists and confronts death, entropy, and social injustice.

Yet, despite all those malign ontical, ontological, and social conditions—ecological catastrophes, violations, corruption, crime, fraud and forgeries, shadow economies and ethical injustices, etc.—all those vicissitudes are treated merely as temporary drawbacks, minute "sins" in the otherwise proto-communist sociality. They are only a temporary termination of virtue, even if these terminations are very frequent. In other words, "evil" does not have its ontology, its poetics, and its *"part maudit"* charm. It might have occurred as an accident, a predicate, but it might not have any agency, nor can it enter into any relation with the common good. Another aspect is pain, grievance, and suffering. Metanoical searching and de-alienating gestures abound in true suffering. But this suffering is never private nor individualized: nothing that is inflicted on an individual and his personal life, death, or activity can be experienced as painful or tragic. Clichés of individual grievance such as unrequited love, death, or disease are not a condition for grief in a proto-communist society. Only the collapse and destruction of the continuity of the common can be tragic. Hence most tragic characters in Soviet literature and film, starting from Ostrovsky's Korchagin (*How the Steel Was Tempered*, 1934) and Platonov's Chagataev (*Soul*, 1934), up to the communist bureaucrats or the freaks of communist honesty from the B-films, suffer only from their own or their comrades' insufficient aptitude to the communist condition.

In capitalism, "evil" composes society. To evade "evil" would merely be unrealistic and naïve. Protestant agency, then, is often located in extrapolating "evil," in exceeding the evil of capitalism itself with a far more excessive demonism, infernality, or nihilism (see Chapter 1, "On Aberration"). Vice, then, becomes not a predicate to a certain condition of the good, but a subject of ontology, or even its horizon. General horror or the uncanniness of capitalist reality is part and parcel of the art and literature of modernism starting from Romanticism up to Kafka and beyond, in film and contemporary art. But even more important is that the "bad," the "uncanny," is then resisted not by "the good," but by "the worse"; and then often "the worse" acquires the parameters of emancipation from "the bad." As a result, law, legislation, justice, and order in capitalist society acquire the status of a false "good," which has to be denounced on behalf of the realness of "bad," or on behalf of the excessiveness of the revolutionary, infernal "worse." Therefore, in capitalist film production and literature, crime, alienation, violence, sexuality, subversion, transgression, destruction, macabre surrealism, etc. (be it an entertainment or a critical art product)—i.e., generally viciousness—are endowed both with strong libidinal power and with emancipating potentiality. Such subversive choices of maligned forces standing for emancipation can be understood if we imagine that the lumpen sociality criticized by Marx in *The Eighteenth Brumaire of Louis Bonaparte* is already an achieved condition of emancipation. Then, indulging in bohemian lumpenness, or persisting in carnivalesque demonization of lumpen living conditions, would stand for emancipatory resistance. Let us imagine that the conditions of lumpenness have been renamed as already having achieved emancipation: just because lumpenness cannot be helped, and therefore its agents would merely seek the social recognition of their devastated condition as if it were their social right to represent this devastation as their political achievement or as a social destiny that has to be respected. And since they—the lumpens and decadent bohemians—should have social rights, they, instead of overcoming their lumpenized state, would simply persist further in the condition of lumpenness with pride, and would label it political agency. In this case the consequences of devastation would simply

be mistaken for the traits of surpassing and overcoming the devastation itself. In this case decadence has to stand for such a vicious form of "emancipation."

Conversely, from a communist perspective: even despite catastrophic contradictions, the primacy of the attained virtue is indisputable. Interestingly, even though the plots of Andrei Platonov's novels might demonstrate the harshest atrocities and hardships, they are presented by the author as the tragedy of communism. All misfortunes are in this case the consequence of being unprepared for communism, rather than serving as testimonies against it. In socialist conditions, vice is a casual and temporary deviation within the framework of the already established common good.

<p style="text-align:center">*
* *</p>

But where does this feeling of squalor towards socialist reality that one confronts when watching Soviet B-films of the 1960s and 70s—that mixture of pity and repulsion—arise from? Can it be that the procedure of de-alienation itself is squalid, because when de-alienation is coercive and treated as attained, it seems to be nothing but a false consciousness of the "idiots" of communism? Or is it the conflation of poverty and equality that causes the feeling of squalor? How are the concepts of squalor, "poverty in equality," and de-alienation connected?

The mere idea of non-alienated sociality cannot cause repulsion; on the contrary, it appears to be a utopian horizon, or the logical condition of social justice. The image of poverty, too, causes empathy and generates solidarity, rather than repulsion. Repulsion and squalor as the reactions of a capitalist Subject to de-alienation might be in the conflation of these two—of non-alienated harmony *despite* poverty. It might seem that the sequence here is the following: the coercive social obligation about inevitable "poverty *in* equality," the artificial social harmony imposed on all citizens, entails artificially constructed de-alienation, treatment of a political economy of basic need as if it were satisfactory. But in fact, the sequence is the opposite. It is the de-privatized political economy and sociality that trigger

the inevitability of "equality in poverty" and its normalization. After de-privatization, poverty is no longer poverty.

Although the de-alienating effect of eradicated private property does not end the division of labor completely, it constructs new constellations between the Subject and "the other." As we remember from Althusser's "Ideology and Ideological State Apparatuses," the Subject is constructed by the negativity of "the other"—"the other" being apparatuses, authority, another Subject. Emancipation of the self is thus inseparable from the Subject, from the constant suspicion towards "the other."

In the conditions of non-alienatedness, the role of "the other" is transformed: s/he is a priori acquitted of both being the (Big) other that subjugates and controls, and of being the (oppressed) other that needs emancipation. This new social construction causes epistemological and anthropological change in the phantasmatic economy of the Subject, in whom the boundaries between the self and nonself, between the owned and not owned, between personal and common, private and general, are erased. In *The Philosophic and Economic Manuscripts of 1844* Marx differentiates between the logic of "having," which is grounded in private property, and the logic of the generic condition of human sociality. Dispensing with the logic of "having" refurbishes the role of "the other." "Having" instigates the social division of a Subject from "the others." But if everyone has the same "little lot" and it is merely the basic kit of living, "the other" cannot be an intruder into one's living space, but s/he constructs together with "me" communalized living, in which the products of labor are redistributed. In this way, the insufficiencies of welfare are merely superseded by common goals. The de-privatized economy and relations of production that allow for the condition of poverty—of the commonly distributed insufficiency of *welfare*—are nevertheless treated as an attained non-alienated good.

Then, what makes the socialist forms of de-alienation repellent and unbearable for a capitalist subject is *the erasure of the difference between poverty and welfare*. Such indifference to personal property and ownership is no longer conditioned by deprivation or shortage and hence it is not experienced as a shortage or as poverty. Yet what makes this situation abnormal for a capitalist Subject is that

the nominal conditions of such poverty simply do not differ from welfare in socialism. The goal of Soviet socialism was neither in attaining true common welfare, nor in dismissing it as a condition of bourgeois sociality, but rather it was in changing the hitherto existing attitude to what welfare is and the very experience of it. In proto-communist socialist societies, welfare and lack of personal property (poverty) lose their differentiating markers. Hence the attitude toward poverty as if it were plenitude (pleroma).

Part II

Sexuality

CHAPTER 4

GENDER AND ITS
SOCIAL PARADIGMS

When it comes to researching the issues of gender in former socialist societies, one soon stumbles upon a stereotype common in the post-Cold-War era: that the lexicons of emancipation in formerly socialist societies could be the same as those in the "West" if only they could be considered separate from ideological regulations imposed on those societies by their bureaucratic apparatuses. Such an approach leads to the search for latent narratives of gender difference and hidden sexualities amidst an otherwise coercively desexualized totalitarian culture: implicit gender manifestations, underground feminisms, and clandestine representations of sexuality are sought out in the "forbidden" unofficial culture and shadow economy. This stance prevailed in "Eastern" cultural studies and curatorial projects in the aftermath of 1989. As Branislav Dimitrijevic has argued, the early post-communist agents of art and culture were afraid that "the West" might detect some inherent inerasable communism in the already post-socialist "bodies," "liberated" from communist ideology.[1] Hence post-socialist art had to prove that even if its "body" could be related to communism, this was only in the context of struggle against party ideology; otherwise socialist body politics of resistance and gender subversion applied the same lexicons as the "conventional" body of Western democracy. The body and power dispositions of historical socialism and its aftermath have thus often been seen through the prism of post-industrial capitalist production based on the surplus economy (the libidinal economy of desire) where the dispositions of body and power function otherwise than in the conditions of distributive de-privatized economy.

This is why, in addition to the application of "classical" theoretical references to research of gender and sexuality (Foucault, Lacan, Deleuze, Butler, Kristeva, Braidotti), it is important to take into account the conditions of the socialist non-libidinal, planned economy in retrospectively analyzing gender composition in classless society. In this case we would have to deal not merely with the ideological divergences between two social systems—disciplinary/

1. Branislav Dimitrijević and Branislava Anđelković, "The Body, Ideology, Masculinity, and Some Blind Spots in Post-Communism," in *Gender Check: A Reader: Art and Gender in Eastern Europe since the 1960s*, eds. Bojana Pejic and Erste Foundation (Cologne: Walter Koenig Verlag, 2010).

totalitarian versus post-disciplinary/liberal democratic—but with the fact that under each system the paradigms of economy and production produce specific compositions of social life and its biopolitical regulations, gender constitution included.

Interestingly, most theoretical frameworks we look towards when it comes to the social analysis of gender construction and representation—Foucault, Freud, Lacan, Deleuze, Butler—underestimate the economic aspect. It was only in Jean-François Lyotard's *Libidinal Economy* (1974) that surplus value as the principal feature of capitalist economics was tied to the libidinal dimension of capitalist production and the economy of desire and enjoyment. It follows that if surplus value is expelled from economics it disappears from the production of pleasure and enjoyment. It is no surprise, then, that the constitution of gender changes immediately and drastically with the shift from the non-libidinal economies of socialism towards the primitive accumulation of the late socialist and early post-socialist periods.

To show why the traditional theories of gender are not fully applicable to former socialist societies, it is sufficient to dwell on one paradox of Judith Butler's theory of gender composition, itself very much influenced by Althusser's theory of the Subject and Foucault's theory of sexuality.[2,3] According to this paradoxical logic, the subject is subjugating itself by virtue of creating itself. A similar logic goes for desire and sexuality: without the control of desire one cannot acquire and forge that very desire; without clinical surveillance of sexuality, one cannot acquire the lexicons of sexual enjoyment (Foucault).

The same goes, in a way, for the notion of "the social": it is the site that subordinates the individual, yet it is at the same time the playground on which to display acts of emancipation. It is because of such an ambivalence to the social field that Butler emphasizes the double-bind genealogy of the Subject and searches for the remainder of social space free from subjugation by "apparatuses" (and social

2. Louis Althusser, "Ideology and Ideological State Apparatuses," in *Lenin and Philosophy and Other Essays*, trans. Ben Brewster (London: New Left Books, 1971), 127–188.
3. Michel Foucault, *The History of Sexuality, Volume 1: An Introduction*, trans. Robert Hurley (London: Penguin, 1976).

institutions broadly).[4] For Butler, such a free remainder is the gendered body and its psychic dimension that sustains and functions as the minimal but genuine agency capable of evading and subverting the biopolitics of social control.

This means that it is only in the realm of the psyche and in the subversions of the *individual* body that one is able to resist the power discourse. But the question then remains how to extend such solipsistic resistance, residing in the frame of the "clinic" into the broader commons. As theorized by Butler, the notion of gender bears the imprint of such clinical solitariness in its genealogy. Gender's genealogy is the two-fold process of subjugation and emancipatory yearning, but according to Butler, this yearning is generated as a result of an [or, the] "initial loss" of the Other, and is due to narcissistic internalization of such loss (i.e., its acceptance). This is why gender is a category of crisis and bears the seal of social melancholy. In *The Psychic Life of Power*, Judith Butler (following Freud) notes that by not admitting the experience of grief and its elevation to the pitch of mourning, the melancholic individual divides the corporeal and the ideal and separates the general from the individual.

As Butler writes, in melancholy not only is the Other, or the ideal, lost from consciousness, but also the very social world in which this loss took place. So "the melancholic gender" not only internalizes the lost object (the ideal), but shifts the whole configuration of the social world into the individual psyche.[5] Then the main act of freedom for such a body is to expose itself—its chief transformative potentiality being to provoke power by often narcissistically aestheticizing such exposures and taking them for freedom. However, this subversion and remaining freedom from apparatuses is often confined to bare life, i.e., gender as the free subversive remainder happens to be clinical, as stated above. Thus gender is a clinical category, marking the crisis of liberty and compelled therefore to perform its own *libertarian* performance.

If that is so, if the resistant agency of gender difference is only negatively related to sociality, what then makes such a disposition socially productive?

4. Judith Butler, *The Psychic Life of Power* (Stanford: Stanford University Press, 1997), 31–62.
5. Ibid., 178–187.

Although Butler tries to reconnect the melancholic individual with the Other in the social stratum, such an attempt, as she describes it, remains speculative and insufficiently active. Society is the realm of Others, the realm that had not been invented by "me," the realm where "the Other" is either alien or is lacking—as against "my" psychic life and gender composition, within which the imaginary "Other" can be internalized, tamed, or discarded.[6] This is why the "Big Other," the ideal, the common, are regarded by the self as certain symbolic impositions, which colonize the psyche that, in turn, resists such "colonization."

Thus we return to the ideal of sociality as a double-bind category, the realm where one can enact the performance of freedom, but at the same time it remains the site of coercion and alienation, by the token of it being external and alien to the individual. Social critique, therefore, does not construct the common zone between the individual and sociality; rather it allows the individual to expand the sites of critical conduct or subcultural subversions within the sociality that remains otherwise alienated. The chief transformative potentiality of such a body is to provoke power by performative and subversive exposures of its trauma (the trauma caused by the confrontation with ideology and its apparatuses), and to treat such exposures as liberating.

Paradoxical as it seems, the productiveness of sociality is thus recuperated when the solipsistic and resistant gendered body, freed from social surveillance, is then exposed in that very social context to confirm the emancipatory agency of both, of its solipsistic escapism and its subversive intervention into the otherwise alienated social context.[7]

It is in this "negative" sense that gender and psyche can be considered to be socially productive. The emancipatory demand in this case is not that society should integrate and normalize subversiveness, but rather that it should allow for the performance of subversiveness and pathology within a special, legally delimited site, separate from the accepted conventions of normality. In other words, in its primary disposition, the social sphere is alien to the gendered individual and her gender performance. The right to subversive

6. Ibid., 132–150.
7. André Lepecki, *Exhausting Dance* (Abingdon: Routledge, 2006).

deviation and abnormality as the main trait of emancipation, rather than normalization of the hitherto non-normal parameters, arises from this alienated mode of society.

Conversely, in works by Marx and subsequent Marxist thinkers, such as Lev Vygotsky, Evald Ilyenkov, Alexey Leontiev, Georg Lukács, Valentin Voloshinov, and others, the realm of sociality is not a priori marked by regulation or subjugation.[8,9] What comes prior to "me" as the diachrony of society created by "others," is not necessarily considered to be an ideological imposition that coercively attaches the ego to something that exceeds it—family, state, culture, law, social apparatuses. On the contrary, sociality as something that is beyond "me" amplifies and constructs the subject; it is only via the social genesis that the subject's consciousness might be posited. The realm of sociality is thus not the site where an inevitable loss of "others" is demonstrated and emancipation is posited as the enhanced territory of such a demonstration of loss; it is in the priority of the common cause for any citizen, regardless of gender differences.

In the landscapes of Soviet sociality, the idea of communism is placed not in the superego as some transcendental abstraction, but it is materialized in the body and reproduced within everyday life and confirmed in interhuman, collective spaces. The body is the idea, and the idea can only be a body.

The result of taking such a stance is that where one expects gendered bodies and those reduced to bare life or the traumas of the psyche, one stumbles into the idea or the ideal. In this case we find no fixation on loss, we find no melancholy of an individual. The problem of such a society is not lack, in the Freudian sense, but rather the tragedy of excess of "the acquired" communism. Mere life is already a subversion in relation to the communist condition.

The Subject's consciousness, then, is but a reflection of the objective world; the Subject, in this case, can only be constructed out of social objectivity. Consequently, the permeation of the signs and elements of sociality into the realm of "me" is not implied as an

8. Lev Vygotsky, *Thought and Language*, trans. Eugenia Hanfmann and Gertrude Vakar, ed. Alex Kozulin (Cambridge, MA: The MIT Press, 1986).
9. Valentin Voloshinov, *Marxism and the Philosophy of Language*, trans. Ladislav Matejka and I.R. Titunik (New York: Seminar Press, 1973).

obstacle to certain countercultural or counter-social freedoms, but on the contrary, such signs of the common and the objective can only free the Subject from the captivity of her solipsistic privacy.

Exploring why these things work so differently in capitalist and non-capitalist societies enables an understanding of the differences in disposition between power and liberation and power and resistance in capitalist and socialist societies respectively.

The stereotypical attitude toward socialist power is that it is just a classical disciplinary society with an authoritarian center, personified government, and indoctrinated masses, who otherwise could potentially be normal consumers and free, creative, middle class citizens. Such a stance does not duly describe the socialist society.

In the Soviet state, the power lies not just in management, administration, and governance, as in the post-disciplinary liberal or neoliberal state.

The ultimate power is delegated to the idea, and the idea belongs to all. So, the power belongs, let's say, to the idea of communism. As for the government, the governing power is just operating and mediating the idea. But the government (or even the party) can never be identified completely with the idea. Moreover, the government is often suspected of being a perverse and an insufficiently communist government.

In *To Denounce and Display Hypocrisy*, Oleg Kharkhordin makes a distinction between the Western paradigms of surveillance and supervision on the one hand, and the ones characteristic to the Orthodox church, and later to post-revolutionary Soviet Russia, on the other.[10] In the first case, the paradigm of supervision is Bentham's panopticon, in which each culprit or patient is in his transparent room, observed by the "eye" of a Big Brother. But as Kharkordin proves, Big Brother is not the Soviet power paradigm at all. Moreover, the Stalinist paradigm is not surveillance but rather putting to shame (*pozorit'*). And the aim is not to exclude the ill, the insane, or the corrupt person but to transform him/her through his/her conscience, supra-consciousness, and belief, and instigate his/her own decision in becoming adequate to communism, in being converted into it, etc.

10. Oleg Kharkhordin, *To Denounce and Display Hypocrisy* (St. Petersburg: European University, 2002), 230–355.

Those who put to shame and instruct are not supervisors, though, but one's equals—brethren, comrades. The disposition then is not the "eye" watching "me," but the brethren surrounding "me" in rebuke for "my" betrayal of communism and persuading "me" to convert. Those who instruct (the brethren) form *the circle*; the untrue communist is in the middle. This was the practice in Makarenko school.[11] (Kharkhordin mentions the same models in Orthodox monasteries.) So the direction here is not to get away from or subvert the power, but the fact that it is too difficult to be faithful to the idea. The governing structures of communist sociality are themselves so shaky, unstable, and potentially perverted in relation to the idea of communism, that one's primary goal is to attempt to constantly improve in performing the concrete act of fidelity to communism, showing that one's life and the communist idea coincide.

Consequently, the struggling effort is in the act of manifesting faithfulness to the communist idea—striving to adhere to it, rather than subvert it.

It was this conception of sociality that served as the paradigm for the socialist system with an abolished surplus economy. As a result of de-privatization, the social sphere had to inevitably sublate its alienated genesis. Gender could then be applied in terms of equalized neutrality rather than difference, and function as a virtue of the common, rather than "a trouble" (Butler).

Interestingly, in the years immediately following the October Revolution, the first experiments with gender and sexuality overtly undermined the binary identification of gender difference. In this program of emancipation, it was not that a woman could be empowered and man's phallic power deconstructed. It was that maleness and femaleness had to be sublated as biosocial identities in favor of the political commons. If any social or gender conduct hitherto considered to be abnormal was to be inscribed into such a generalized

11. Anton Makarenko (1888-1939), a Russian and Soviet educator, pedagogue and writer, who elaborated the methodology of upbringing children in self-governing collectives and introduced the concept of productive labor into the educational system. In the aftermath of the Russian Revolution he established self-supporting orphanages for street children including juvenile delinquents. His main opus is *The Pedagogical Poem* (1925-35), a novel in three parts.

social field, then what had been deviant, vulnerable, or traumatic had to acquire affirmative social markers, integrating them into the broader projection of the commons. As it is widely known, the early Soviet socialist society was highly friendly to the normalization of gender difference in the frame of the socialist citizenship. This was mainly because it was not gender identity that constructed the political Subject, but rather the communist consciousness, which could incorporate any variations of gender or race.

Although such normalization didn't in fact fully happen in the socialist states, owing to the patriarchal re-genderization of society under Stalin, the non-libidinal economy nevertheless generated the disposition according to which the *social* markers of gender always prevailed over the *biological* or *sexual* ones, and neutralized them (Jerebkina).[12]

In the logic of the libidinal, capitalist economy, however, deviation is extrapolated in order to produce surplus pleasure, and such production is instigated by the lack of the commons. Deviation or subversion then remain diverted from sociality, simultaneously permitted as the performance of legitimized clinical pathology, constituted in the regimes of subcultures, or the sites of identity production.

12. Irina Jerebkina, *Gendernie 1990-e, ili Falosa ne suchestvuet* [Gender in the 1990s, or the phallus does not Exist] (Saint Petersburg: Aleteia, 2003).

CHAPTER 5

SEXUALITY IN A
NON-LIBIDINAL ECONOMY

Boris Mikhailov, *Untitled*, from the series *Suzi and Others*, 1960s. C-print.
Courtesy of the estate of Boris Mikhailov/Vita Mikhailov.

I

Historical socialist societies were usually severely criticized for their restrictions on sexual freedom. At the same time, the undergrounds of these same socialist societies were researched for manifestations of the sexuality that was supposedly suppressed because of ideological control. Researchers tried to discover the concealed practices of sexual liberation and subversive behavior, which would enable them to confirm that the free expression of sexuality automatically subverts the authoritarian apparatus in totalitarian societies.

Usually, sexuality stands for freedom and emancipation. However, this stereotype ignores numerous contradictions in the concept of sexuality: representation of sexuality is not a guarantee for emancipation. Foucault attributed the notion of sexuality to the emergence of bourgeois society. He located the origin of sexuality in the discourses that regulated health, clinical deviation, and medical care.

In the section called "Scientia Sexualis" in the first volume of *The History of Sexuality*, Foucault examines a very important stage in the history of Western European culture and science: when sexuality replaced the culture of Amor and Eros.[1] Sexuality didn't so much bring with it bodily freedom from restrictions; rather, it introduced a language of scientific, juridical, medical, and psychical description— a language where perversion, punishment, analysis, knowledge, and pleasure are intertwined. The same language that maps and controls sexuality generates its seductive and subversive power. Thus, the superseding of Eros by individual sexuality goes hand in hand with the birth of bourgeois society; the aristocratic poetics of amorous sentiment were replaced by analytical stratification and the control of health, pleasure, and disease.

If we now turn to Deleuze's treatment of the unconscious, we see that according to him, the unconscious is devoid of any psychoanalytical background and is dissipated on the surfaces of the social. The productive force of the unconscious is divorced from

1. Michel Foucault, *The History of Sexuality, Volume 1: An Introduction*, trans. Robert Hurley (London: Penguin, 1976).

personal pleasure, but still resides in the realm of desire and its libid-
inality. The dimension of the libidinality of desire is ambivalent. It is
far from being exclusively emancipatory. Desire stands for emanci-
pation, but it is also permeated by the libidinal economy. What does
this mean? Jean-François Lyotard's research on libidinal economy
can be of help here.[2] Lyotard exposes the libidinal complements to
monetary exchange and the economy. Capitalism and its economy
totalize life and production in the regime of alienated externality, but
our critique of it doesn't situate us beyond such externality, because
our impulses and desires are unconsciously inscribed in the produc-
tion of this alienated externality. We might think that we can resist the
logic of capitalist production, but our libidinal pulsions happen to be
in tune with this economy: we are unconsciously invested in it, and
this is manifest in various forms of our behavior, labor, leisure, com-
munication, exchange, and production. The macabre dimension of
this argument is that according to Lyotard, the critique of capitalism
itself is not at all free from the pulsions and desires that produce the
capitalist condition. The libidinality scattered over the social body of
capitalism permeates anything produced under its regime—includ-
ing anti-capitalist critique.

One can decipher to what extent capitalism is part and parcel of
life by looking at the way *jouissance* (enjoyment) and phantasms circu-
late within the framework of production and exchange. Lyotard sees
in capitalism "the return, but unaffirmed and unrecognized, of what
it rejects—libidinal intensity in the heart of neutralized exchanges."[3]
The nature of spending money, of exchange and production, reveals
the way libido works. But it also confirms that capitalism is libidinally
desired, even if it might be theoretically and conceptually denounced.

According to Lyotard, what we regard as creative intensity or
subversive desire ultimately becomes currency and exchange. It's not
that we necessarily desire commerce; rather, we long for the surplus
attraction or estrangement that accompanies material culture and
artistic production. Desire constructed via surplus is intertwined with
surplus value, and hence with an economy molded via surpluses of

2. Jean-François Lyotard, *Libidinal Economy*, trans. Iain Hamilton Grant"
(London: Continuum, 2004).
3. Ibid., 87.

various kinds—phantasmatic, sexual, libidinal, financial. That makes capitalism's power stronger, but also reveals that *jouissance* is not necessarily liberatory. Individually experienced pleasure or pulsion may be inseparable from the desire for power and domination.[4]

Although he mainly discusses capitalist production, Lyotard nevertheless extends this libidinal logic to any society, even to the symbolic order—religious acts, martyrology, and sacrifice. This means that even ostensibly non-libidinal acts, such as sacrificial deeds prompted by ethical or political convictions, can be approached from the point of view of libidinal drives and can be interpreted as transgressive realizations of enjoyment.

Such a totalizing attitude towards the instinctive and affective was also characteristic for Deleuze and Foucault. Although these authors uncovered the ambivalent character of the unconscious and sexuality, they nevertheless reserved a subversive, emancipatory role for them. Certain components of capitalism were simultaneously its oblique subverters. To deprive the economy of its libidinal resource would imply the termination and castration of desire altogether. Getting rid of the vicious part of libidinality would also get rid of its potential for creative fervor, since in a libidinal economy, creativity can only develop parallel to libidinal drives. Thus, capitalist alienation can be fiercely criticized, but it nevertheless remains unconsciously seductive to its critics.

II

But what if a society rids itself of the tempting form of a commodity, of surplus value, and grounds economy on competition in production and distribution according to the necessities constructed by delibidinized habits of consuming?

In the work of Soviet Marxist philosophers and psychologists, especially Voloshinov and Lev Vygotsky, one comes across an unconcealed mistrust of the role of the unconscious and the pleasure principle. In his book *Myshlenie i Rech (Thought and Language)* (1934),

4. Ibid., 94–145.

Vygotsky criticizes Jean Piaget for his Freudian interpretation of the infant psyche.[5] Piaget points to the psyches of children under the age of seven as an example of the autonomy of a child's syncretic thinking, its "autistic" fixation on the satisfaction of desires and pleasures. Piaget interprets this feature as the mode of the unconscious as such. This stage of infancy represents the psychic condition directed to individual pleasure and detached from culture and reality. All social, logical, and generalizing functions emerge later.

Contrary to the way the pleasure principle is treated in the theory of the unconscious, Vygotsky often paraphrases *pleasure* as *necessity* (*potrebnost'*) and inscribes it into the social and collective dimension. Generally speaking, in works of Soviet philosophy in which the impact of the unconscious, pleasure, libidinality, and individual psychology was debated (works by, for example, Ilyenkov and Voloshinov), the emphasis was always on the fact that social functions precede the instincts and hence the regimes of the unconscious. For example, Vygotsky insists that before the "autistic" period, the child is already inscribed into sociality; even the egocentric syncretic modes of speech and thinking are part of a more complex developmental teleology. Within the framework of such a teleology, the individual's pleasure, desire, and satisfaction are complements to the broader demands of the social, even at a very early stage. By contrast, in Piaget's system and in psychoanalysis, the principle of pleasure, the libidinal, and their drive precede objective reality, and are incompatible alterities in relation to consciousness.

Vygotsky's critical claim against psychoanalysis is that it turns the pleasure principle into an autonomous vital resource (*primum movens*, as Vygotsky put it), when it could have just remained a biologically auxiliary condition. Vygotsky insists that the attachment or detachment of a child to the implementation of social procedures is dependent on the social conditions of his or her upbringing—on whether the child is raised in the family or in broader collectivities. This presupposes the acquisition of cultural and social habits by

5. Lev Vygotsky, *Thought and Language*, trans. Eugenia Hanfmann and Gertrude Vakar, ed. Alex Kozulin (Cambridge, MA: The MIT Press, 1986), 12-58.

way of collectivity, rather than via the nuclear family. It means that even when a child is confined to the father-mother nucleus, he or she acquires qualities general for humanity and society, since these qualities have been constructed diachronically over the course of human history. From this standpoint—a standpoint that obsessed Soviet Marxist philosophy—so-called polymorphous sexuality and the whole set of sexual perversions ascribed to the child by psychoanalysis can be regarded as superfluous. Perversions and sexuality can be ascribed to the child only if they unfold via the linguistic articulation and registration of them—which the child, at least in the pre-oedipal (or even oedipal) stage, is not able to do. Such registration happens in psychoanalysis only retroactively, when the child becomes an adult.

When Piaget makes pleasure autonomous and detaches it from logic and reality, he places pleasure (which Vygotsky calls the satisfaction of needs) prior to the child's later socializing adjustment to reality. By contrast, Vygotsky insists that the satisfaction of needs (which Piaget calls the regime of pleasure) cannot be divorced from the social adaptation to reality.

According to Vygotsky, pleasure is not just about receiving pleasure; rather, it is inserted into a more complex teleological set of references to reality. The logic of those teleological bonds with reality is diametrically opposed to the logic of libidinal economy that characterizes capitalist society. Socialist "reality" is already delibidinized (which does not at all mean that it is de-eroticized). Desire and pleasure can only be understood as necessities to be implemented. Here the gap between the need for pleasure and the necessity for common values is minimized. A society in which production tries to attain the conditions of use value rids itself of the surplus economy—both in desire, as well as in consuming and communication. However, the rejection of surplus doesn't at all imply the termination of the extreme, the intense, and the excessive. On the contrary, excessive action is manifested elsewhere—in labor, ethical deeds, social responsibility, art, and culture. It becomes the zeal and toil of dedication rather than pleasure or *jouissance*.

Thus, under the conditions of an economy aimed at use value, desire stops being libidinal. By contrast, in Lyotard's case, libidinality is extended to all acts, even symbolically motivated ones like sacrifice, the sublime, and love.

III

Lyotard expertly describes the way the commodity form permeates bodies and their impulses. This is why the critique of the commodity cannot overthrow the regime of capital and the libidinal economy: because the body, the unconscious, and desire remain aroused by the commodity. This does not, of course, take place in a straightforward way. The point here is that the commodity form is constructed so that it serves and extends the phantasmatic drives of the unconscious. If we now turn to Piaget's infantile pleasure principle (as criticized by Vygotsky), we find the idea that pleasure can only be satisfied through the deformation of reality and its reduction to the ego's drive for pleasure. Egocentric phantasms prevail over reality, such that the "autistic" thought aimed at pleasure never deals with "truth" or "the real."

But Vygotsky, along with many other Soviet thinkers, tried to prove that the satisfaction of desire should not be opposed to the adjustment of reality. Necessity can be realized in the domain of reality, not counter to it, as Piaget claims. Even the "autistic" thought can be a part of a child's broader thinking. Similarly, there is no abstract thought without a relation to reality, to concreteness. Both the unconscious and the speculative or logical regimes are part and parcel of reality. Desire is tied to reality rather than to phantasms; it functions within the regime of (socially grounded) necessity. According to Vygotsky, detaching pleasure and needs from the accommodation to reality would endow them with metaphysical import, which would in turn completely detach the realistic principle and "realistic thinking" (the opposite of autism and its pleasure principle) from needs (when needs function as pleasures and abide with the realm of the phantasmatic).[6] In this situation, both realms—of "pure thinking" and pleasure—would be deprived of reality altogether.[7]

6. With the phrase "realistic thinking," Vygotsky refers to thought that is not "autistic" and self-referential—thought that is counter-individualistic and tied to reality.
7. Lev Vygotsky, *Thought and Language*.

For Vygotsky and his Soviet colleagues, pleasure is described as a need to be satisfied. This means that pleasure is not epistemologically separate from necessity. It also implies the non-libidinality of an economy based on necessity and its unmediated satisfaction (this unmediatedness is actually the quality of use value). By contrast, in a libidinal economy, pleasure, even when it is satisfied, is embedded in the diversification of modes of mediation—mediation between the drives and their satisfaction. It is precisely this gap that is phantasmatic and that produces the surplus.

IV

Historically, in socialist countries, extensive underground and shadow economies developed to conform to the standards of alluring commodities from abroad. Western researchers often ask why the governments of these socialist countries didn't try to satisfy this demand in commodities themselves. Wouldn't it have been profitable for the socialist economies to satisfy this desire for beauty, technical sophistication, success, and fashion *officially*, without criminalizing the areas of commerce and consumption? Perhaps, they may speculate, there was some ideological imperative to keep the whole spectrum of production, trade, and services *plain* enough to evade the attractiveness generated by a surplus economy—attractiveness that first takes the form of a phantasm, and is then embodied in a commodity. According to Andrey Kolganov, a researcher of the Soviet economy, there was never any deliberate social engineering through unreliable services or intentionally unattractive and poorly designed commodities. Rather, this situation was the consequence of a planned economy that did not so much aim to satisfy individual, specific demands; it was constructed to satisfy basic shared (and hence general) necessities. Commodities were radically de-personified. Paradoxically, this de-personified, de-privatized material culture met the demand for socioeconomic de-alienation among individuals, who no longer had any imagination about personal privacy or individualized space and hence did not need it much if not teased by media images from "the West."

In this economy, the object became the tautological realization of its idea—as if it were possible to imagine the "chairness" of the chair or to wear the "coatness" of the coat. Interestingly, this applied even to food, which had to be healthy, but deprived of any specific gourmet features, meaning that one had to eat the "cheesiness" of cheese—i.e., it being one kind of it and not the varieties of. This asceticism was not predesigned ideologically. The delibidinized commodity was just a consequence of the planned economy. This quality was manifested in a number of works by Moscow Conceptualists. To designate this anti-commodity condition, Ekaterina Degot used a term invented by Boris Arvatov: "the object as comrade." This referred to the de-commodified and thus delibidinized quality of objects produced under socialism.[8]

The non-libidinal conditions of production implied an economy that was not economical, that did not aim at economic growth: economy and production had to be subordinated to social and cultural criteria.

Here we encounter an interesting paradox. The society that tried to de-alienate social relations produced extremely unattractive commodities and artifacts of material culture (which even compelled the Moscow Conceptualists to invent a concept for a Soviet-produced object: *Plokhaya Vesh*—bad thing). By contrast, the society in which production was by definition based on alienated labor and social relations generated commodities that aroused intimacy, desire, fascination, and comfort—i.e., attitudes towards the alienated commodity-object that frame it as something lovable and unique. The de-alienated anti-commodity was too general, too abstract, since it was the embodiment of the idea of a basic need, whereas the alienated capitalist commodity acquired the qualities of an "unalienated," desired thing. The socialist "object as comrade" was bad and undesired, as if proving that in a new society based on equality, desire should be unimportant altogether.

Later, the unattractiveness of Soviet material culture was characterized by its critics as the embodiment of inhuman, abstract mass production. But maybe the fact was that objects that were produced

8. Ekaterina Degot, "Ot Tovara k Tovarishu" [From commodity to comrade: on the aesthetics of a nonmarket subject] *Logos* 5/6, (2004), http://www.ruthenia.ru/logos/number/2000_5_6/2000_5-6_04.htm.

unattractively and badly didn't at all annul the principle according to which precisely the generalized, communalized object that doesn't meet the demands of personal taste or phantasmatic desire is able to de-alienate production, labor, and social communication among its users (former consumers).

Thus, the unattractiveness of Soviet goods was not the ideological imperative of the Party. Rather, it was the consequence of economic shortages that resulted from the demand for equal distribution for all. Modesty and asceticism were an inevitable consequence of social equality. By contrast, under capitalism and its forms of sexualization, the unconscious Oedipal sexuality is guaranteed by "nice things" (commodities of quality), which shape personal imaginaries. Without the fetishism of commodities, it would be impossible to design any constructs or languages of sexuality. In his book *The Capitalist Unconscious*, Samo Tomšič insightfully compares consumption with encyclopedic knowledge of commodities and a buyer with a value-scientist.[9]

It's worth reiterating that according to a widely held belief, sexuality during historical socialism was suppressed by authoritarian restrictions on various freedoms. But, the argument goes, since sexuality is the epitome of liberation, and since sexuality can never be detached from from any society, sexuality was always at least latently embedded in any (even totalitarian) society as the potential for freedom—freedom from prejudices, power, control, and so forth. However, judging by statistical data, the rate of sexual intercourse under socialism may have been even higher than under capitalism.[10]

When we identify sexuality with freedom on the one hand, and with sexual intercourse on the other, one thing is overlooked: sexuality is not the same as statistics about sexual relations. If we accept this, then ignoring sexuality does not mean the end of sex. Libidinal drive, pleasure, and sexuality are not directly connected to the practice of genital

9. Samo Tomšič, *The Capitalist Unconscious* (London; New York: Verso, 2013), 30.
10. See the documentary *Liebte der Osten anders?: Sex im geteilten Deutschland* [Do communists have better sex?: Sex in divided Germany], directed by André Meier (2006; Germany: Mitteldeutscher Rundfunk).

intercourse. Aaron Schuster, in his foreword to Andrei Platonov's pamphlet "Antisexus," emphasizes this feature—namely, the incongruence between genital sexuality and the libidinal drives as theorized in Freud's interpretation of the libido.[11] Schuster first comments on Stanisław Lem's novel *Sexplosion*, in which the extinction of genital function due to the drug "Nosex" only shifts desire into the oral drive, i.e., perversion. Then he quotes Freud from *Civilization and Its Discontents*:

> Sometimes one seems to perceive that it is not only the pressure of civilization but something in the nature of the function [of libido] itself which denies us full satisfaction and urges us along other paths.[12]

In other words, Freudian interpretation (and many other interpretations that follow Freud) presents the libido as a negative drive that results from the fact that genital intercourse is not necessarily supposed to stand for sexuality or libidinality. Sexuality is the semiological surplus. In the quotation above, Freud describes the surplus element, that very "other path," which constructs desire and pleasure and nourishes the economy of libidinality. Sexuality and libidinal pulsion can be present in things not connected semantically with sex at all, and vice versa: genital intercourse can be deprived of the languages and semiologies of sexuality altogether.

V

The economy of use value eliminated sexuality in socialist culture, and it was superseded by the languages of enthusiasm, zeal, and amorousness. But why couldn't the rhetoric of enthusiasm and amorousness accommodate the languages of sexuality? We know from Foucault that the languages of sexuality are generated to control sexual life, and that together with the clinical function, they turn sexuality into surplus

102. Aaron Schuster, "Sex and Antisex," *Cabinet*, no. 51, (2013).
103. Sigmund Freud, "Civilization and Its Discontents," in *The Standard Edition of the Complete Psychological Works of Sigmund Freud*, vol. 21, trans. James Strachey (London: Hogarth, 1955), 105.

pleasure. By the same token, the unconscious as a language had been constructed to grasp what is beyond consciousness and did so rather with the aim to treat psychic deviations, than to establish the unconscious as an autonomous realm given its own ontology. However, over the course of the history of psychoanalytic and post-psychoanalytic thought, what used to be the symptoms of a disease in the realm of the unconscious became the vocabulary for creative, nonrational, and hence liberating forms of behavior, production, and communication. The Soviet mistrust of the unconscious was never a mistrust of its clinical, therapeutic, and research function. Rather, it was a mistrust of a certain dominant ideology of the unconscious in which all drives are reduced to suppressed enjoyment, acquire the autonomous status of an a priori principle, and thereby take on emancipatory potentialities.

In Lyotard's interpretation of pleasure, the totalizing impact of the libidinal and the unconscious and its surplus appears as a macabre force. However, the evacuation of the libidinal surplus is impossible, since it is impossible to terminate the pleasure principle. Therefore, the viciousness of the libidinal economy should be intensified to make it appear even more vicious, so that an unimaginable or inhuman *jouissance* will subvert or transgress the imaginable pleasure. This would mean that, even when pleasure becomes a vice that might be ousted in favor of religion, love, ideology, or any sacrificial procedure, the pleasure principle and the surplus economy are sustained. According to this logic, a saint is in a way potentially a subject of libidinal desire. But a resisting worker is also a subservient subject of libidinal drive. Every political economy is libidinal, since any excess can only be libidinal. Hence, the sublime also belongs to the category of unattained *jouissance*, since it is something imagined at the phantasmatic level. The question then is to what extent the shift away from capitalist production leads to the termination of surplus value extraction in production and obscures its libidinal dimension.

Within the framework of psychoanalysis, phenomena related to the superego—the ideal, love, death, the ethical deed—become so unattainable that they acquire either a repressive and censuring function, or they are only approached through the regime of transgression. Such a regime converts these conscious phenomena into individualized *jouissance*, thus drawing them too

into the realm of the unconscious and turning them into drives. The characteristics of a non-libidinal economy described earlier suggests that in the Soviet context, this constellation functioned differently. Here, sublime phenomena are not regarded as the superego's counteraction against pleasures and freedom, nor as transgressive acts that inscribe them into the pleasure principle in a twisted way. Instead, all the sublime phenomena that are usually symbolic—death, idea, love, solidarity, ethical deeds—become part and body of objective mundane reality. Such a disposition changes the form and constellation of desire, the role of sexuality, and the attitude towards reality. Along with such a change, the dichotomy according to which freedom, desire, and drives belong to the unconscious, while the superego and consciousness belong to power, ideology, and apparatuses that censure the unconscious, is also sublated.

If in capitalism even the sublime acquires libidinal qualities, in socialism the object that equals its use value tends to cease to seduce or tempt. In addition, the idea (e.g., the idea of communism) is not something remote, imaginary, or phantasmatic—not the voice of the "Big Other"—but it instead becomes an exchangeable, regular, concrete, everyday condition. The further distancing (alienation) of already alienated phenomena is the aesthetic device of capitalist society. By contrast, in socialist society sublime and unimaginable phenomena pervade the everyday as if they were common, habitual, and even unremarkable things.

What happens to sexuality under such conditions? Sexual intercourse is of course present, but it becomes one of the modes of communication within the framework of existential necessity—be it love, friendship, or even just physiological need. That is, it is inscribed into the more general framework, so that the elements of sexuality do not acquire any *surplus charm* that would make them seductive in a specific way. Therefore, it is not necessary to represent or circulate sexuality's sovereign images as the simulacra of desire, separate from their tie to existential or ontic necessity. Sexuality is just one of the modes of social production, amorous attachment, and communication: it doesn't have an autonomous value or a seductive allure. It is inscribed into the collective Eros, presupposing joy and zeal rather than enjoyment (*jouissance*).

The way Andrei Platonov depicts sexual intercourse in his novella *Djan* is interesting. In the midst of their exodus, the starving people treat sex as a basic necessity, in the same way they treat sleep and nourishment. This necessity isn't framed as an alternative to love or the sublime. The sublime is not detached from the mundane, but is implanted into matter and bodies, even when these bodies are on the verge of physical collapse. For example, the random intercourse of a son with his mother in the harsh conditions of survival has nothing to do with incestual trauma, but is mere saturation of basic need. Likewise, in Platonov's short story "The River Potudan," when Nikita, the husband of Ljuba, first has sexual intercourse with her after hesitating to do so for a long time, Platonov describes it as a "poor and inevitable pleasure, from which Nikita didn't acquire more joy than he hitherto experienced with Ljuba without it."[13]

It is traditionally thought that Platonov's writing was confined to the sexual part of love relationships. He is often juxtaposed with Alexandra Kollontai's anti-puritanical standpoint. According to Aaron Schuster:

> Platonov and Kollontai condense two separate strands of sexual theorizing that equally belong to the revolutionary project and express its emancipatory aspirations: on the one hand, a male-dominated ethic of sacrifice in the service of constructing another world, and on the other, the invention of a new "love-comradeship" based on pleasure, equality and solidarity, to replace intimate relations dominated by the bourgeois property form.[14]

However, Platonov's novels, while teeming with sex scenes, are either completely devoid of the phantasm of libidinality, or depict the libidinal features characteristic of sexuality as the squalor of a lonely individual unable to overcome his dependence on drives. And Alexandra Kollontai's manifesto *Sexual Relations and the Class*

13. Andrei Platonov, "The River Potudan," in *Soul and Other Stories*, trans. Robert and Elizabeth Chandler with Angela Livingstone (New York: New York Review Books Classics, 2008).
14. Aaron Schuster, "Sex and Antisex."

Struggle, which is considered to be an open declaration of sexual liberation, does not at all contradict the non-libidinal form of Eros.[15] Kollontai's criticism of the bourgeois family nucleus is fallaciously regarded as a simple legitimizing of free sex, when her claim is in fact more complex and demanding than that.

Although the political means that were needed for achieving the goals stated in Kollontai's manifesto remain quite vague, its futurological motivation is clearly articulated. Kollontai calls for the convergence of comradeship and political Eros, which would modify the logic of individualized sexual communication. If the collective were motivated by de-alienated production and social relations, then sex and love relationships would stem from political Eros rather than from an individual's demand to get pleasure from another individual. Kollontai's quest for freedom in sex does not so much legitimize what might be regarded as sexual liberation; rather, it calls for creating new terms of friendly solidarity, which can only come about after the creation of new economic and social conditions. According to Kollontai, the same bourgeois society that makes an individual feel solitary and alienated also provokes him to seek another individual "soul," to privatize that "other soul," and thus ground love in the imposition of obligations on another person. Kollontai insists that the abolition of private property would eliminate the privatizing attitude towards the "other" in love relationships. But only in a communist economy would it be possible to transform love relationships and sexual intercourse from "blind physical" acts into a "creative principle." Her manifesto is not so much an apologia for free sex as it is an appeal to transform society so that it acquires a sense of solidarity, which would in turn have a transformative impact on the human psyche. However, this change in the human psyche can only take place as a consequence of the abolition of private property and the transformation of social and economic relations. Thus, the destruction of marriage and the family nucleus is not aimed at liberalizing sexual relations, but rather at constructing the potential for anti-bourgeois consciousness. It is aimed at producing a society of

15. Alexandra Kollontai, "Sexual Relations and the Class Struggle," in *Alexandra Kollontai: Selected Writings*, trans. Alix Holt (New York: W.W. Norton, 1977).

common interest that supersedes individual desire. New modes of non-privatized sexuality and changes in gender dispositions are subsequent to this social and political transformation, not vice versa.

Kollontai's program—quite in tune with Platonov's communist sexuality—is aimed at reducing the libidinal and seductive complement to sexuality, so that sexuality stops being seductive and mysterious.

The problem, however, is that the loss of the libidinal phantasm of desire would be much scarier and more repressive than any puritan restriction on concrete sexual relations. Under capitalism, the cessation of libidinal striving seems impossible. This is why even legalized sexual services fail to become just services or a form of therapy: they are compelled to engage the surplus imagery of seduction.

CHAPTER 6

THE COST OF SEXUALITY

Any drive drives back not forth.
—Lev Vygotsky

I

That sexuality is libidinally biased and hence inscribed into a broader context of libidinal economy is obvious, so the question follows: If socioeconomic production is functioning without surplus value, and hence happens to be non-libidinal, would this conjecture make it possible to dispense with sexuality in such a delibidinized society altogether? These questions arise as long as sexuality is not reducible to any statistics of sexual intercourse, but is rather conditioned by various modes of surplus: in desire, in economic production, in language.

The argument against such an assumption could be that the Soviet socialist economy was to a considerable extent also capitalist, only on behalf of a state; so that it always contained a libidinal dimension, which was merely coercively and artificially suppressed. Another argument against this initial assumption could be that sexuality, desire, pleasure, and the unconscious are universal components in the construction of a subject in general. If they thereby happen to be suppressed, they manifest themselves obliquely in some other—not necessarily sexual—experience or its physical implementation—in social practice, ideology, culture, etc.

Both of these arguments seem to be doubtful. The distributive economy—whether functioning well or badly—was grounded in use value. This is why the commodity in Soviet social space didn't fit into the phantasmatic image of a libidinal desire. Apart from being *phantasmatically* imagined, desire has to be materially embodied: it needs to be produced, it needs to come into its being and manifest itself as a product, and consequently as a commodity into which phantasms and desires are inscribed. This implies that the economy and production should fit into the material realization of such a phantasm.

Sexuality for Foucault was a clinical category, for Freud a psychic one, for Lacan it was linguistic. But in all these cases one point

is overlooked. Sexuality, being the kernel of desire, cannot but construct itself via implementing its imaginaries *materially*— which makes it inevitably concomitant to the economy and to the types of production at hand.

For both Lacan and Deleuze, social infrastructure is permeated by libidinality and sexuality; the unconscious is a construction of such sociality. Nevertheless, missing in their research is the possibility of the evacuation of all libidinal parameters as the possible result of the sublation of the libidinal economy. In other words, if the type of economic production is not supplying the possibility to generate imaginaries of sexuality and the material sources to implement them, the question would then be: Is sexuality being acted out at all?

Bearing in mind this standpoint, the second argument regarding the all-encompassing universality of sexuality might be discarded, to make the assumption that the latency of sexuality in Soviet society (the absence of libidinally-biased images in media, social space, art; the censorship of issues of sexuality against narratives of love) was not just the outcome of bureaucratic restrictions, but stemmed from the specific social and economic modes of production.[1]

II

Andrei Platonov's short pamphlet "The Anti-Sexus" is an interesting example to trace the biopolitics of de-sexualization as it evolved in the conditions of Soviet sociality.[2] The pamphlet was written as a mock advertisement for a device providing

1. Interestingly, the Soviet artist Boris Mikhailov—who has been working with issues of gender and body since the early 1960s—said he could only photograph a naked Soviet body endowed with any sexuality at the end of the 1980s. Boris Mikhailov, *Suzi et Cetera* (Cologne: Walther Koenig, 2007).
2. Andrei Platonov, "The Anti-Sexus," trans. Anne O. Fisher, *Cabinet*, no. 51 (Fall 2013), 48-53.

coital service, produced in France and mainly distributed in capitalist countries. This machine of sexual satisfaction's ultimate biopolitical function varies, from regulating sexual life in marriage to the evacuation of sexuality from relationships in favor of friendship and enthusiastic labor and production—and up to the overall extinction of prostitution; or even to such functions that makes marriage obsolete in order to increase workers' productivity in factories. In other words, the Anti-Sexus is meant to automate and in the end dispense with humanity's libidinal striving, as well as with the troubles of the unconscious, by supplying a universal device of quick mechanic sexual satisfaction. Although the text is written on behalf of a Western, Fordist company, it implicitly refers to the biopolitics of sexuality in early Soviet society with a plan to drastically reframe the ethical, ideological, psychic, and physiological map not only of a concrete Soviet society, but of human existence in general.

Yet, what the Anti-Sexus device aims to remove from life and communication is not so much sex, but rather sexuality: libidinality, desire—the drive. It is not meant to remove the function of sexual intercourse—the nominal implementation of the sexual act is preserved in the application of this device. What is obliterated is precisely the yearning, the libidinal, the surplus element, the elusive "something." Genital satisfaction as opposed to sexuality does not necessarily reside in desire—it is implemented as an immediate, bio-physiological need. Applying the Anti-Sexus device for such stimulation enables people to get rid of the troublesome realm of desire. Tearing libidinal drives away from the realm of physiological necessities helps to shift focus on to social activity by *directly satisfying genital needs*.

<p style="text-align:center">*
* *</p>

This mischievous and ambivalent pamphlet could be read in two registers—as a grotesque irony and as a straightforward message, tacitly implying that the society from which sexuality is expelled already exists and in it there are certain reasons to regard sexuality, the libidinal desire, and the unconscious as the obsolete sides of social life.

Another question arising from this text is whether this Anti-Sexus machine is a masturbation device or not. It nominally functions as a tool of self-satisfaction. However, what hampers this device from being a masturbation tool is its compulsory and open representation in public space. The Anti-Sexus device proclaims publicly-observed sexual satisfaction as a necessity, which thereby loses its libidinal aureole and becomes a mere social function.

<div align="center">III</div>

If we look at the works of Lev Vygotsky, Valentin Voloshinov, the short manifestos by Andrei Platonov, and at the later research of Evald Ilyenkov, we can see that their vocabularies of social emancipation are grounded on the notion of consciousness rather than the unconscious, consequently marking a watershed between psychoanalysis and Marxist thought.[3] In his well-known and highly disputed work *Freudianism* (1976), Voloshinov juxtaposes Psychoanalysis and Marxism. According to his conclusions, consciousness is always a social and never an individual matter.[4] In Ilyenkov's "Dialectics of the Abstract and the Concrete," consciousness can only take the form of social consciousness too.[5] Consciousness in this case ceases to be the capacity of individual introspection, or to be the function of transcendental reflection, but is the screen of sociality and its general dimension.

In his "Analysis of Consciousness in the Works of Marx," Mamardashvili writes that Marx's approach to economic phenomena does not infer psychic operations:

3. Some texts by Valentin Voloshinov referring to the issues of psychoanalysis have been ascribed to Mikhail Bakhtin and published under his name. Makhlin V. Peshkov, ed., *Bakhtin pod Maskoy* [Bakhtin behind the mask], (Moscow: Labyrinth, 2000).
4. Valentin Voloshinov, *Freudianism: A Marxist Critique*, eds. I. R. Titunik and Neal H. Bruss, trans. I. R. Titunik (New York: Academic Press, 1976).
5. Evald Ilyenkov, "Dialectica Abstractnogo I Concretnogo" [Dialectics of the abstract and the concrete], in *Filosofiia i Kultura* (Moscow: Izdatelstvo Politicheskoy Literatury, 1991), 276–294.

(Marx) constructed his research so that already in the point of departure he had to deal with the systems, functioning and realized via consciousness. These were for him the social and economic systems. Hence it became possible to consider consciousness as the function, as the attribute of the social system, deducing its contents and form from the intersections and differentiations in the system and not from the simple reflection of the object in the subject's perception.[6]

So it follows that consciousness should be analyzed according to how various labor, exchange, organizational, or other social phenomena are to appear as the transformed state of crystalized social relations. Thus consciousness itself functions as the objectified realia to which the individual is expanded. As Mamardashvili writes, "For Marx it is not projection that is the product of consciousness, but consciousness is the reverse appropriation of that projection and objectification, realized and completely independent of an individual, and 'working' in the social system," and further:

Marx deduces consciousness not from the unmediated contents of separate objects, transmitted via affecting the sensitivity into consciousness, but from the correlation between the data in the system, from their place and differentiation in those relations. The separate objects are here the deposits and thickenings of the system, they are the manifestation of the certain aspects of a broader structure and interrelation.[7]

Marx defines those social "thickenings" of objects as the objective thinking forms characterizing the historically given social modes of production. It is obvious that in this argument of Mamardashvili's, "the social consciousness" stands for the dimension of the universal (generalization). Thus social data and consciousness are synonymous

6. Merab Mamardashvili, "Analis soznaniya v rabotakh Marxa" [Analysis of consciousness in works by Marx], in *Voprosi Filosofii* 6 (1968), 14–25, http://psylib.org.ua/books/_mamar01.htm. My translation.
7. Ibid.

terms; then it is not the unconscious that correlates with external reality. The criticism of psychoanalysis instigated by Vygotsky and Voloshinov posits that the unconscious has its role, but it cannot be substantialized. To claim that the psyche and sexuality are independent realms impenetrable by consciousness was an exaggeration, as Voloshinov argues in *Freudianism*. But the motivation for such a stance was not so much in disputing the existence of the unconscious and its psychoanalytical treatment, but rather a political and ideological claim asserting that the unconscious and psychoanalysis are insufficient to duly exert a social function. The unconscious was understood as a realm unable to attain the dimension of the general, and to truly imply social (common) interest. The unconscious elements were inferred just as something non-conscious, or not-yet-conscious, hence they didn't have to be regarded as an autonomous sphere of the psyche; since treating them within a framework of the psyche and by means of the psychoanalytical method would distance them from "objective reality." If this is so, body and physiology should not necessarily be considered within the prism of psyche, but rather remain in the context of the materialistic realm of biology. This is because biology and physiology are transcribed more easily and directly into the social (and hence economically biased terms) than into the psychic ones, subject to psychoanalytical treatment. In this case the psychoanalytical treatment of the unconscious, sexuality, and psyche become the forced libidinization of all forms of life, its subjection to the pleasure principle.

In his short text "But a Human Has One Soul," Platonov writes:

> The primary function in the life of a man was not thought, not consciousness, but the sexual drive—the striving to reproduce life, the first clash with death, with the wish of immortality and eternity.
> We live at the time when sex is devoured by thought. The dark and beautiful passion is expelled from life due to consciousness. Philosophy of the proletariat discovered consciousness and it supports the struggle of consciousness with the ancient, but still living beast. In this struggle resides the sense of the revolution nurturing the spirit of humanity.

Bourgeoisie gave birth to the proletariat, sexuality (*pol*[8])-generated consciousness. Sexuality is the soul of the bourgeoisie, consciousness is the soul of the proletariat. The bourgeoisie and sex completed their task in life—they should be abolished.[9]

Interestingly, in 1925 when Vygotsky and Luria wrote a complimentary foreword to Freud's "Beyond the Pleasure Principle,"[10] their main argument in Freud's defense was that in his description of the realm beyond pleasure, Freud managed to emphasize the impact of pure biology and evade psyche. For the Soviet Marxists, psyche was some kind of euphemism for spiritualism. What they approved of in this work of Freud's is how the psyche is exceeded by broader biological procedures and is thus considered to be part of a larger realm of biological phenomena. Vygotsky claims that Freud's *todestrieb* (death drive) overcomes the libidinal principle of drive, unraveling in it a materialistic, biological angle.[11]

The reason the biological forces are preferable to psychic ones in the works of both Vygotsky and Voloshinov is due to, as they put it, the "conservative" tendencies of biology. The fact that biological phenomena are able to be directly affected by the outward, non-individual forces of the material and social environment enables social life to be inscribed into the general dimension of history. In other words, the only forces able to transform our biological dimension are social ones, and they are more applicable to the body and its physiology than to the psyche and its libidinal genealogy. So, these Soviet thinkers could only approve of Freud if his treatment of psyche can be translated into the combination of two tendencies: the conservative-biological and the

8. It is more appropriate to translate пол (sex) as gender, rather than sexuality.
9. Andrei Platonov, "No Odna Dusha u Cheloveka" [But a man has one soul], in *Gosudartvenny Zitel* [State resident], (Moscow: Sovetsky Pisatel, 1988), 531–33. My translation.
10. Lev Vygotsky and Alexander Luria, "Foreword to Freud's 'Beyond the Pleasure Principle'," in *Psikhologia Bessoznatel'nogo* [Psychology of the unconscious], (Moscow: Prosveshenie, 1990), 29–37.
11. Ibid.

progressive-sociological—the two tendencies that could construct a dialectics of societal development.

Voloshinov's argument in *Freudianism* is similar—it unfolds in favor of biology due to its fusibility with social infrastructure. He interprets psychoanalysis as an artificial transposition of biological issues into a psychic context. According to Voloshinov, in psychoanalysis the contents of classical subjective psychology were molded into the newly and artificially montaged terrain of the psyche, sexuality, and the unconscious.[12] According to Freud, all organic, biological aspects are beyond psychology. Nowhere in its methodology does psychoanalysis demonstrate the impact of the somatic on the psychic. Freud is not interested in providing the material stimuli of sexual intercourse, in exploring how the material stimuli of sexuality get into the psyche.[13]

In Freud's work on sexuality, both its social and physiological parameters are superseded by the psyche and are thus deprived of physical, somatic, and hence materialist impacts, which would enable them to be more directly dependent on social and economic factors. The reduction of sexuality to a biological dimension would enable it to be redirected to the sphere of the genital and its innervations, which is actually anti-sexual and applies to sex only as to material necessity—without libidinal undercurrents, or the troublesomeness of individual psyche and its traumatic bond with familial and personal biographies.

According to Voloshinov, Freud is not interested in any material functions of the somatic, but rather by its subjective impact on psyche; i.e., he is trying to determine this impact from within psychic life itself. What is important for Freud, as Voloshinov argues, is the reflection of the somatic in the "soul," or psyche, no matter what these somatic phenomena might be beyond the psyche. Voloshinov dismisses Freud's theory of erogenous zones, since Freud does not provide any physiology of these zones or the functional work exercised by them; he is preoccupied only with the subjective psychic equivalents of these zones and their place in the psychoanalytically-determined libido. In *Freudianism*, Voloshinov writes:

12. Voloshinov, *Freudianism*, 65–75.
13. Ibid., 95.

Freud makes no provision for a physiological theory of the erogenous zones, he takes no stock whatever of the chemistry or their physiological relationship with other parts of the body. It is only their psychical equivalents that he subjects to analysis and investigation, that is, he focuses attention on the role played by subjective presentations and desires, associated with the erogenous zones, in the psychical life of a human individual and from that individual's inner, introspective point of view. ... The internal secretion of the sex glands, its influence on the operation and form of other organs, its relationship with the constitution of the body—all these processes, detectable in the external material world, are left completely undefined by Freud. How the role of an erogenous zone in the material composition of the body connects with the role it plays in the subjective psyche, taken in isolation, is a question for which Freud provides us no answer. As a result, we are presented with a kind of duplication of erogenous zones: what happens with erogenous zones in the psyche becomes something completely separate and independent of what happens with them psychically, chemically, and biologically in the material organism.[14]

Voloshinov is insisting here that the body and organism should not be inscribed complementarily into the realm of psyche and sexuality, so as to make the objective body endowed with the innermost and psychically complex drives and imaginary associations, thus generating some sort of introspective imaginary of that body. Voloshinov is calling for the following: psyche should complement the objective body and be inscribed into the objective social surrounding. This premise is very important in understanding not only Andrei Platonov's anthropology, but more generally for interpreting the ethics of numerous cultural, artistic, and political phenomena of Soviet socialism with its mistrust of desire and pleasure.

14. Ibid., 71.

*

* *

One of Voloshinov's principal rebukes is that the unconscious is in fact conscious. He insists that the work of the unconscious is not as contingent or mechanical as Freud would claim it to be. We can interpret the unconscious only as some force that acquires certain form and contents only after going through consciousness, which Freud projects afterwards onto the unconscious. Voloshinov's rebuke to Freud was that his "unconscious" inherits too many parameters of subjective psychology, which in fact treats the psyche as formed via consciousness, but then Freud relabels these parameters of consciousness as the unconscious. This is the reason Voloshinov disputes the necessity to derive a separate realm for the functioning of desires and phantasmatic imaginaries.[15] From his point of view, it would be more appropriate to allege that something unconscious (as an attribute) acquires certain specific forms and is mapped by means of entering the consciousness with the aim of inner self-observation, introspection. In other words, we can interpret the unconscious as a force that acquires certain form and content only after going through conscious procedures, so that the unconscious can only be considered as one of the functions of consciousness and not the other way around—as in psychoanalysis—when consciousness is just the imaginariness of reality serving as just a material to unravel the unconscious.

(Interestingly, according to Marx, eliminating private property is not a *desire* of the proletariat; by eradicating private property the proletariat merely reveals the necessity of a society, its core principle: commons without private ownership, which the proletariat merely mediates and embodies).

What is crucial in Voloshinov's arguments in the critique of psychoanalysis is that consciousness and the unconscious are not for him two ontological or ontic alternatives, two different psychic substances or material forces. These are just two aspects of

15. Ibid.

consciousness, and their juxtaposition or the critical priority of the unconscious over the consciousness reveals ideological choices. For Voloshinov consciousness and the unconscious are simply the official (formed by the ruling class) and non-official (de-socialized from class ideology) forms of sociality—the external and internal forms of speech; consciousness (and language as its tool) in this case is nothing but an imprint of broader sociality. Consequently, the separation and autonomization of the parameters of the unconscious and of the internal speech takes place when the social system is decomposed and the ruling class and its ideology (external, official speech) undergo disorientation and regress. Individuation of the unconscious as the internal speech is the symptom of de-socialization and hybridization of an individual. Thus, the language of the unconscious is an effect of mere detachment from the language of the ruling ideology and it happens to be the form of the regression and degradation of ruling class and ideology.

Thus, according to Voloshinov, the discourse of psyche, in this case, regresses into the form of the unconscious, in other words into the unofficial consciousness.

What is the outcome of this radical argument? First of all, if the ruling ideology is communist, and the socioeconomic system functions without surplus value and private property, then the split of consciousness into the official and unofficial layers is not at stake and the discrepancies between the external (official) and internal (unofficial) speech are minimized. If the ruling ideology, conversely, is capitalist, if sociality is alienated and the ruling class is the bourgeoisie, then isolation of the de-socialized individual's internal speech into the unconscious is inevitable, but it is not the only outcome; the revolutionary alternative to psychoanalytic discourse would be that the language opposing the hostile official ideology, instead of being squeezed and internalized into the patient's psyche and the parole of the unconscious, could externalize into that of struggle. Only then could such an exodus from the official ideology, in case it is regarded as hostile, have a social future. Hence, not all modes of human behavior in the conditions of social crisis and in confrontation to hostile hegemonic ideology have to necessarily degrade into internal, unofficial speech. An important conclusion can be drawn from Voloshinov's

argument: that first and foremost, there is no social or linguistic experience without ideology, and secondly—that there are progressive and regressive forms of ideology.

As Voloshinov writes in his *Marxism and the Philosophy of Language*, "word is external, not internal, there is nothing unexpressed in it"; ideology is social, the psyche is individual, consequently psyche follows the ideological sign, not the other way around. Therefore, inner speech cannot solve the issue of the collective, of the social and political, simply because it does not depart from *the other*. The capacity of the gaze on oneself on behalf of the other is what constructs consciousness. And if we put forth the primacy of the other, then the domain of psychic analysis becomes unimportant, as the split between the internal and external is neutralized.[16]

(The process of generalizing via concepts does not impoverish reality and materiality or detach from it; on the contrary, it brings reality closer, since it posits it as a general overview.[17] Linguistic generality by means of hooking a thing in notion is the principal means to access reality, but not because reality is linguistic, rather because reality is inexistent without noumenality.)

<p style="text-align:center">*</p>
<p style="text-align:center">* *</p>

Lacan's treatment of consciousness is of course quite different. In his seminars on the "I," Lacan explicitly states that the system of consciousness didn't fit into Freud's theory.[18] He further explains that the "I" that is inscribed into being, in reality (social context) does not coincide with the "I" of the subject of the unconscious. The "I" of the social context is imaginary, illusionary, until it becomes the "I" of the unconscious. The unconscious is definitely inter-subjective and dispersed, but nevertheless its analytical sphere is confined to the analysis of a subject.

16. Valentin Voloshinov, *Marxism and the Philosophy of Language*, 19–21.
17. Lev Vygotsky, *Thought and Language*, 12-58.
18. Jacques Lacan, "Ja v Teorii Freuda i v Technike Psychoanalysa" [The ego in Freud's theory and in the technique of psychoanalysis] in *Seminars*, vol. 2 (Moscow: Gnosis, 2009), 155–162.

Actually, Lacan eliminated even those remainders of conscious-
ness that were still present in Freud. The way he rephrased Freud's
statement "*Wo Es war, soll Ich werden*"—"Where *It* was the I should
appear"—in his seminars on the "I" is well known. Instead of the
German *Es*, for the *It*, Lacan put an S: The Subject. As a result of this
shift, the unconscious expands to incorporate all the functions of lan-
guage, as well as the symbolic instruments constructing the Subject.
On the other hand, such a substitution means that the incommen-
surability and diversity of the unconscious can be superseded by
a symbolical and monolithic category of the Subject, which in its
own turn remains ever the Subject of the unconscious. As all the
categories formerly exceeding the unconscious but influenced by it—
such as the subject, the I, the reality, the Symbolic, the language, the
superego, reside now in the realm of the unconscious. The principle
of reality acquires in it the impact of an illusion; whereas all catego-
ries claiming the sublime remain ever empty and unfulfilled. But also,
all the categories that were dealing with the non-individual and inter-
subjective—like "the other," the symbolic, the language, reality—are
no longer dealing with any human activity residing in reality, because
reality is merely the imaginary illusion of the "I."

It should also be mentioned that the unconscious is constructed
by desire, and as Lacan has explicitly claimed many times in the sem-
inars of the "I," desire has nothing to do with consciousness. Lacan
actually emphasizes the fact that Freud treated consciousness either
as a filter of reality, that is, as the instrument of its perception, or as
the self-reflective Cartesian machine that failed to be efficient. Thus,
in psychoanalysis, the "I" is not cognized in a frame of consciousness.
This is the conjecture that brings a specific consequence: namely,
that it is the unconscious that is able to deal with inter-subjectivity
and objective realia, whereas consciousness is only meant for indi-
vidual introspection that remains imaginary. However, despite the
broadened scope that the unconscious acquires in psychoanalysis in
comparison with consciousness, the focus of analysis is always the
subject biased by desire. In other words, for Lacan it is exactly the
consciousness that is limited and remains individual, whereas the
unconscious is inter-subjective and permeated with the clamor of
reality, being in its own turn the repository of desire and the symbolic.

The problem with such an extrapolation of the unconscious is that any discourse of the nominally "other," or the ideal, or the general becomes the rule of the superego, which, in its own turn, is, on the one hand, trapped in the unconscious and, on the other hand, is inseparable from the ego. By the same token, / is always the other; but the other as an alienated self, not actually a living "other" (being). There is not a real "other human being" in the extrapolated unconscious, which therefore inevitably becomes the endless analysis of the unsurmountable *blankness* of a Subject.

In Soviet Marxist psychology and philosophy it was the other way around. Consciousness had nothing to do with introspection; it was the assemblage of objectively-grounded social phenomena. And last but not least, consciousness is the form of the voluntary demand for the general, for the objective. The subject thus is not in need of studying itself, but is constructing the objective.

Socialist consciousness and even class consciousness are seen as a product of class interests, but they are inscribed as well in the developmental logic of the overall (diachronic) contents of previous human thought and culture and its contradictions. It is not human beings that reflect reality, but reality that is reflected in human consciousness. The unconscious therefore becomes insufficient to reflect reality. The unconscious elements are an indispensable part of our behavior, our affects, reflexes, desires, and drives. But the drives function in their orbit; they might not have access where the consciousness functions. Reality needs consciousness to be transmitted in all its objective force.

Lukács follows this direction in his definitions of class consciousness. For him it is not the sum of individuals that think. Lukács defines the origin of class consciousness as consciousness about the historically conditioned struggle in the period when capitalism emerges. The dimension of class is crucial for Lukács because it is only the proletariat that can realize itself as a class for itself and thus generate consciousness.[19]

19. Georg Lukács, "Class Consciousness," in *History and Class Consciousness*, trans. R. Livingstone (Cambridge, MA: MIT Press, 1971), 46–83.

SEXUALITY

The bourgeoisie cannot realize itself as a class. It can only perceive life on the level of individual consciousness, which is not consciousness at all. As Lukács puts it, consciousness of the bourgeoisie is economically conditioned; which means that it is a "false consciousness" or rather a higher form of the unconsciousness. So Lukács explicitly associates unconsciousness with the underdeveloped consciousness, which is not able to achieve the dimension of the general because of individually grounded (economic) interests. Only the theory and practice of the proletariat can draw the unconscious development of capital up to the level of social consciousness. Lukács even claims that consciousness, with its social and class genealogy, is no longer at all a psychological reality.

The debate against desire and enjoyment amongst the theorists of Soviet psychology and philosophy—Voloshinov, Vygotsky, Leontiev, Ilyenkov—resided in the conjecture that along with subjective self-introspection as the realm of desires, imaginaries, and emotions, there is an objective dimension of human activity, conditioned by outward experience, and in it desire is not a prevailing component at all. Objective experience has to rely on completely different material components of behavior, which have very little to do with desires, emotions, and imaginaries (phantasms). Desire in its own turn is engendered by libidinal economy; hence, the privileged role of the unconscious that brings forth the dimension of the libidinal as a feature of capitalist production. To further emphasize: what is not envisioned in psychoanalysis is the question of *what could happen if, by the token of the evacuation of libidinal economy, the function and the toil of desire and its libidinality expires*.

So it is only in the light of subjective self-consciousness that the map of our psychic life seems to be the struggle and trouble of libidinally-biased desires and imaginaries. Self-introspection cannot be the source for objective motives of life and social or class struggle. Such an argument leads us as far as to assert the extreme dimension of the general, or the radical idea of *the non-self*. In this case it is not the impact of sexuality that influences the social or linguistic realm (as is the case with Lacan)—when the social infrastructure is permeated with the pleasure principle and libidinality—but the opposite: the general, social consciousness, and the idea occupy

the body—physiologically preserving functions of sex merely as a reflex, which would not be an exercise for any sexuality. Then, communist society would be the society that would not need any Anti-Sexus device whatsoever. Simply because it would turn the biological necessity of genital functions into an indispensable part of sociality. It would dispense with sexuality in favor of the dialectics between direct physical (genital) needs and social goals.

IV

When we put to doubt all kinds of liberalisms and their libertarian and permissive rhetoric; when we, consequently, claim that liberalism is no less embedded in ideology than any authoritarian society of historical socialism, we imply that by the same token (since liberalism is also an ideology) societies of historical communism might have been no less "liberal" despite their authoritarian infrastructure.[20] If we follow such an argument, then liberalism would function as ideology, whereas idea and ideology, in their own turn, would be considered as something cracked and differentiated. We would not then be so intimidated by the symbolic dimension of the idea (and ideology), since it would also be evolving in the regime of difference and deviation. But what we endeavor to assume in reference to Platonov and Soviet cultural ethics would be the converse logic.

It is not that sexuality can be extended into the zone of the social or the zone of the sublime, nonetheless preserving its libidinal character so that the social ideal stays inevitably permeated by the "other paths" of libidinality—the argument discussed by Aaron Schuster in his explication of the libidinal.[21] On the contrary, the sublime, the delibidinized,

20. This logic is often applied in Slavoj Žižek's arguments in his numerous presentations. In his conversations he often mentions that the embodiments of disciplinary regimes—the Soviet army, or jail—for example, were organized as deviations, as corrupt forms of rule, whereas the permissiveness of liberal society might exert ideology. This leads to the assertion that ideology is biased by deviation and liberal permissiveness—by ideological rigidity.
21. In his comment on Platonov's pamphlet "The Anti-Sexus," Aaron Schuster emphasizes this feature, namely, the incongruence between genital sexuality and the libidinal drives as theorized in Freud's interpretation of the libido. Aaron Schuster, "Sex and Antisex," *Cabinet*, no. 51 (2013): 41–47.

invades material and immanent bodies and things, exerting the dimension of generality, noumenality, and the idea, which the body as a material object cannot often endure. It is not that sexuality and the libidinal become dematerialized in ideology, but the idea gets materialized in a body. This is why death is never tragic to Platonov; because the death of the body is not experienced as the end. It is interesting that while in Western modernism there are so many metaphors of living corpses, of the dead who are bodily alive, in Soviet prose even when the body is on the verge of survival, life and struggle still go on. This is because life resides in the idea of communism, rather than in the finite body. But such an idea of infinity is embodied in human bodies, being finite, concrete. Hence, what can really be tragic is the lack of communism and its non-implementability in the finite life of finite people.

If we take Platonov's *Chevengur*, *The Foundation Pit*, *Soul*, or *Happy Moscow*, we see that sex is not banished or limited by any imperative in them. Sex is the material function of the body that is always present. Its difference from sexuality is just that it functions as a simple necessity in the midst of an extremely poor life, where the imaginaries and phantasms of desire are substituted by the toil of "building" communism—without any surplus economy and its elements, that is, without the libidinality that would construct itself as sexuality.

In *Happy Moscow*, the chief protagonist, Moskva [Moscow] Chestnova, says:

–"I've just worked it out—why it is that people's lives together are so bad. It's bad because it's impossible to unite through love. I've tried so many times, but nothing ever comes of it—nothing but some kind of mere delight. You were with me just now—and what did you feel? Something astonishing? Something wonderful? Or nothing much?"
–"Nothing much," agreed Semyon Sartorius.
–"My skin always feels cold afterward," pronounced Moscow. "Love cannot be communism. I've thought and thought and I've seen that it just can't. One probably should love—and I will love. But it's like eating food—it's just a necessity, it's not the main life."

Sartorius was hurt that his love, gathered during the course of a whole life, should perish unanswered the first time. But he understood Moscow's excruciating thought: that the very best of feelings lies in the cultivation of another human being, in sharing the burden and happiness of a second, unknown life, and that the love which comes with embraces brings only a childlike, blissful joy, and does nothing to solve the task of drawing people into the mystery of a mutual existence.[22]

This passage is reminiscent of Voloshinov's claims that self-consciousness can only be a reflection of class consciousness, since realizing oneself is only possible via the glance of another representative of one's class; any personal, linguistic, or intimate reaction can stem only from objective roots of non-self being.[23]

VI

Let us now return to the role of property in the context of sexuality and repeat that sexuality is rather dependent on the impact of property and commodity stratification than on its traumatic or perverse undercurrents: this aspect is somehow underestimated in psychoanalysis. Following our assumptions made just now, it is sexuality that cannot be constituted without capitalist production and without surplus economy: it is but the consequence of the libidinality of desire and of its fusion with phantasmatic imaginaries. Sexuality and desire should have a backup, which has to be materially designed and embodied as the concrete phantasmatic program of desire. The extremity of the shortage economy which was the "normal" condition for socialism does not produce enough surplus in economy, and hence in imaginaries, in commodity production, and in production itself. The fact that a thing, an object, is produced via its use

22. Andrei Platonov, *Happy Moscow,* trans. Robert and Elizabeth Chandler (New York: New York Review Books Classics, 2012), 53.
23. Valentin Voloshinov, *Freudianism: A Marxist Critique*, 17–29.

value, refutes the phantasmatic parameters of things and bodies, reducing commodities to their crude utilitarian function—the general necessity—removing from them the surplus of attractiveness. In such conditions the very form of commodity distribution has to de facto eliminate the possibility of libidinal desire and sexuality, since they are but a satellite of surplus economy.

<p style="text-align:center">*</p>
<p style="text-align:center">* *</p>

If we look at the zones of poor life in the framework of a capitalist economy, we can observe a condition obscenely manifested in post-socialist economies of primitive accumulation. In them, the component of surplus within the economy is either too innovative to automatically permeate social production, or not materially implementable. If in the spheres of a non-profit socialist economy sexuality is constructed without a libidinal surplus, in the impoverished zones of the already capitalist, but still primitive surplus economy, the phantasm of libidinally-biased enjoyment is already there; yet it cannot be easily achieved because it is still too "expensive." This is because sex in the conditions where it has not yet become the proper "language" of sexuality (sexuality understood as discourse in the Foucauldian sense) is often used as currency to pay for the future material embodiment of attractive phantasmatic images. In the conditions of an impoverished but already capitalist economy, sexuality as the realm of libidinal pleasure is still remote. But what is achievable or accessible is the striving towards such pleasure—the quest to either acquire the attractiveness of the libidinally desired body, or to become such a body—that is impossible without the culture of consumption and commodification. Hence the bond between prostitution, impoverishment, and the commodity lexicons of attractivity: for the poor the attractivity lexicons can be accessed only through the economy of prostitution; a "poor" person then has no commodity or labor form to supply or sell, except for one's gendered body. Prostitution in this case is chosen as a social practice not only as a means of earning, or a path of perverse desire, but as the primary point of access to the hitherto inaccessible commodity

culture and certain desirable modes of consumption constructing the phantasmatic body of attractivity, the body that could be desired. Interestingly, in the Soviet Union, already in the period of its gradual demise, even the young ladies from "decent" Soviet families, endowed with higher education and employment, dreamed of becoming so-called "currency *putanes*" and working at Intourist hotels.[24] This would enable them to date foreign men, be paid in currency that afforded them access to commodities only available in shops which accepted currencies from foreign citizens in the Soviet Union, and also gain them access to clandestine sites where fascinating images of capitalist consumption, luxury, and enjoyment made the dream about the sumptuous and "sexy" West come true. But this would also mean becoming a "Western," sexuated body—like the ones in the commercials, advertisements, pin-up pictures, and Hollywood films—and ultimately entering into the enchanting realm of libidinal desire.

Interestingly, it is exactly in the conditions of a poor economy that the commodity items are at stake (as in Pasolini's movies *Mamma Roma*, 1962, or *Accattone*, 1961). For the impoverished woman, sex as such (often in the mode of prostitution) does not yet embody any desire or sexual pleasure. Sex is simply a measure of exchange to acquire the phantasmatic object of desire that haunts the imagination. And desire is rather focused on the quest to acquire certain objects of property. The same could be said about the early post-Soviet socioeconomic situation. Here phantasmatic imaginaries are confined to prosperity and feminine attractiveness, identified with material goods and luxury commodities. Early post-soviet material life is already motivated by a libidinal economy, but its "sexualization," and hence proper libidinization, took place later. The traumatic object of desire in it is not yet that of sexual pleasure and enjoyment, but rather the acquisition of novel items of imaginary private property, of "fantastic" commodities. These imaginary items are already able to unleash libidinal desire, but a fully constructed sexuality has not yet emerged as the result of their consumption.

24. See *Intergirl* (*Interdevochka*). Directed by Pyotr Todorovsky (1989; Soviet Union: Mosfilm).

This is why after the demise of authoritarian socialism one confronts so many examples of sexual abuse and victimization instead of encountering feminist agency and sexual freedom. Sexuality on such a transitory stage functions as a currency exchange rather than as lust, or enjoyment. To repeat once more, desire in such cases is conditioned by the quest for property accumulation and not sexual desire. Those who have only recently come out of the social context of use value are not yet able to properly exercise their libidinality.

As a comparison I would like to briefly refer to the plot of *Nymphomaniac*, a film by Lars von Trier. Desire functions here as pure surplus; it has an absolutely phantasmatic character and is detached from basic physical necessity. This is why it cannot saturate physical need even in the smallest degree. Yet it is this phantasmatically projected attractiveness of sexuality that gears desire, while simultaneously not being able to saturate it. Such a phantasm, such desire, is of course completely detached from a social context. However, it is precisely in a society determined by consumption and commodity fetishism that we will not witness any articulate existential demand for a commodity, or direct obsession with it in everyday life. This is because in the conditions of a developed libidinal economy, when there is no social experience of scarcity, a commodity stops being an existential necessity. A commodity is then not a basic need, but rather a variation of phantasmatic desire. Consequently, the more freedom of consumption there is, the more the surplus form of an economy is *concealed*; what comes to the foreground are mainly phantasmatic imaginaries, only obliquely referring to the commodity-oriented character of life and production.

The protagonist of von Trier's *Nymphomaniac* would not even question what stylistic, economic, monetary, or physiological parameters construct the image of her sexuality and the phantasmatic stages of her libidinal striving—namely, she would not question what those surplus value parameters that construct her transgressive sexuality are. The issue here is not the prosperity of a concrete individual, namely the protagonist in von Trier's film, but a simple formula: when one still exists in the economy of consumer shortages and basic need, sexuality functions as a crude, delibidinized necessity rather than as an imaginary about sexual pleasure.

CHAPTER 7

ON ANTI-LIBIDINAL RESIGNATION

I would like to dwell on one mysterious episode in Pier Paolo Pasolini's *Theorem* (1968). The poetics and ethics of this episode undermine the mythic plot of Oedipus on which psychoanalysis hinges its obsession with the libidinal self.

The plot of the film is very well known: a strange visitor appears in the mansion of a factory owner and his family, and quickly becomes the source of sexual desire for almost every family member, including the maid. The scene I refer to is the following: as the guest sits and reads outside the mansion, the maid (Emilia), who is mowing the lawn, tries to attract his attention. When she fails to attract his interest, she rushes into the house and back outside several times. After numerous, vain attempts to interest him, she goes back into the house again and opens the gas in the kitchen to attempt suicide. The guest follows her, tears away the gas hose, and puts her to bed in the adjacent room. What follows is an awkward and bizarre erotic scene in which Emilia manifests longing and shame at the same time. This reference, though, is not so much about the film itself, but rather the text of Pasolini's script.

It reads as follows, in a chapter of *Theorem* entitled "The Sacred Sex of the Guest":

> There is also a fine thread of irony in the way he deals with her, in his unsurprised patience. It is as if the woman's madness, her weakness, the sudden collapse of all resistance and therefore of any dignity—the collapse of the whole world of duties—awoke in him merely a kind of loving compassion, precisely of delicate maternal caring.
>
> This attitude of his and the expression in his eyes, which seemed to say, "It's nothing serious!" became still more marked when Emilia (flattered by his acts of tenderness—and blindly obedient to her instinct, which now was unrestrained) almost mechanically, with a kind of inspiration more mystical than hysterical, pulled her skirt up above her knees.
>
> This seems to be the only way she has—without awareness and without words or, by now, without shame—of declaring herself, of offering the boy something as a supplicant. And precisely because it is tremendous it also has a certain purity and an animalistic humility.

Then the guest—still with a protective maternal air that is sweetly ironical—pulls down her skirt a little as if to defend that shame she has forgotten and which on the contrary is everything to her. Then he caresses her face.

Emilia weeps from shame—but it is not a case of that special kind of weeping which is the outburst that comes, in a childish way, when the crisis is already subsiding, consoled.

He dries her tears with his fingers.

She kisses the fingers that are caressing her with the respect and humility of a dog or of a daughter kissing her father's hands.

Nothing stands in the way of their love and the guest lays himself on top of the woman's body, accepting her desire to be possessed by him. [1]

The subtlety of this episode is in the weird mutation between Emilia's libidinal drive and the guest's non-libidinal grace—between her desire and his mercy, her shame and squalor, and the guest's benevolence ("loving compassion," as Pasolini himself puts it). What kind of "delicate maternal caring" can at all be implied in a person who first and foremost arouses an enigmatic sexual desire in all the film's characters? How can it be that the guest feels himself to be "a mother," and displays a mother's level of care for another person, and at the same time submits himself to the same person's irresistible lust for him? In playing the libidinal role of a lover and getting involved in sexual intercourse, the guest simultaneously emanates anything but drive, anything but sexually marked desire. According to the script, the guest, despite experiencing motherly pity and tenderness, care and consolation for the maid who is seized by desire, still yields to her drive, while he himself experiences only benevolent empathy. In this case, by conforming to the role of a lover—while he experiences zero desire and drive—the guest performs a recession of the self, or even demonstrates its absence. Then the paradoxical "motherly care" exerted by the guest, regardless of his gender, resides

1. Pier Paolo Pasolini, "The Sacred Sex of the Guest," in *Theorem* [1968], trans. Stuart Hood (London: Quartet Books, 1992), 20.

paradoxically in that very sexual yielding of his to the irresistible libid-inal desire of some sort of "child" who is expecting him to play the role of a lover, while the guest himself is merely observing this desir-ing "child" benevolently, as the child's mother. In other words, he conforms to this act of sexuation not as a lover, but rather in formally playing the "lover," only to sooth the child's irresistible sexual longing. "The motherhood" here lies in allowing the other to use "you" sex-ually, but at the same time to benevolently conceal one's own being beyond desire, despite yielding to the other's desire.

This is what constructs benevolent and disinterested empathy: it is as if Jocasta knew that the person who appeared at Thebes was her son, but nonetheless deliberately played the role of his wife, pre-tending to be unaware of who it was; as if she allowed her marriage with Oedipus to happen from her perspective as a mother and out of some mischievous and subversive delibidinized quietist benevo-lence for her son's lust. This is exactly the potentiality that Freud disregards: namely, yielding to the other's libidinal interest but exert-ing this yielding only out of concealed anti-libidinal submission to the other's libidinality; as if a mother were giving her libidinal self as a toy to a naughty and inconsiderate child who cannot resist desire.

In Pasolini's script, such non-libidinal benevolence haunts every protagonist in the end. It invades every person (all the members of the family) that had been hitherto seized by desire for the attractive guest. I have already mentioned the mutation on the part of the guest—he doesn't act out of his own desire, but yields to the maid's desire with "motherly" compassion and mercy. Yet in the end, Emilia's desire happens to be mutated, transformed, and finally recedes. Initially, she is obsessed by libidinal desire and cannot resist it, but as soon as the non-desiring guest yields to her desire with his benevolence, she cannot but witness the double-bind condition of his generous act: on the one hand, there is the guest's de facto and nominally exerted sex-ual involvement, but on the other, his submission to Emilia is nothing but non-libidinal mercy and pity for her lust, performed as a libidinal role only formally. This instigates Emilia to go on with her desire, but at the same time, to feel shame for experiencing nothing but desire, nothing but longing that needs an immediate saturation. As we wit-ness later, in the end the guest's benevolent, non-libidinal, and even

slightly condescending empathy for Emilia transforms her lust, and recodes it into something else. One might argue here that this shift of desire on the part of the maid to a weird confusion between childish shame and sexual drive—shame not because Emilia's desire is forbidden, but, on the contrary, because it is generously and gracefully saturated by the guest—is nothing but a sublimation, which does not qualitatively annul the condition of libidinality.

Such an argument would be wrong. We would assume that this act of self-resignation on the part of the guest delibidinizes the maid. Doesn't Oedipus himself implement a non-libidinal act at the end of the myth? To illustrate the power of the libidinal, Freud chooses the myth of Oedipus, in which Laius prefers to get rid of the child to evade the prophecy of his own eventual murder; by doing so, he chooses his own safety as well as the safety of his kingdom. In psychoanalysis, this myth about self-preservation epitomizes the human condition (sexuality being at the crust of the human condition).

Meanwhile, there are myths based on the non-libidinal and resignatory act—Antigone rejects her affair with Hippolytus and prefers self-resignation in the name of her care for her brother, which exceeds self-preservation. When Medea's position as a mother and a wife is destroyed by Jason's libidinal desire for Creusa, she defies and rejects her position as a mother, since it failed to compete with her and her husband's libidinal roles. Or even Orpheus: after returning from Hades without Euridice, he becomes a solitary singer, a de-individualized part of the general universe. These myths are about the collapse of a desire, collapse of a drive in favor of the self-resigning Eros. The edifice of psychoanalysis is questioned precisely by this benevolent consent to satisfy somebody's desire without any recollection of one's own interest and without experiencing any desire at all. It is here that libidinality and Eros become opposed to one another. Let's remember what happens to each character in *Theorem* who confronts the "motherly performance" of the weird guest. They get thwarted from the realm of desire; i.e., after a lesson in delibinization they learn not to desire, they voluntarily initiate self-resignation and self-deprivation. The factory owner gives the factory away and ends up naked in the desert; the daughter collapses in catatonic fit; and Emilia, the maid, mentioned above, ceases to eat, the villagers

believe she is a saint who can cure the ill. Later, her self-resignation extends to such an extreme that she voluntarily terminates her life by burying herself in a pit, which then, according to Pasolini's metaphoric poetics, generates a spring. Self-resignation might resemble the death drive, but it is not. Jerzy Grotowski calls such a fusion of shame and self-resignation *caritas*.[2]

2. (Lat). Unconditional love for all. Jerzy Grotowski, *Towards the Poor Theatre*, ed. Eugenio Barba (Abingdon: Routledge, 2002).

Part III

Aesthetics

CHAPTER 8

THREE COMPONENTS OF REALISM:
Sensuousness, De-alienation,
Human Resignation

And only then [when electric light becomes the engine of production] will the confluence of humanity into one physical creature take place, and art, as it is understood nowadays, will become redundant; this is because art is merely a corrective of revolutionary matter applied to reactionary consciousness; but in communism matter and consciousness will be one.

—Andrei Platonov, *Light and Socialism*, 1923 (my translation)

I
CONTEMPORARY ART AND
THE MOMENT OF ACTUALIZATION

In *Aesthetics*, Hegel declared the demise of art due to its intellectualization, theorizing, abstraction, and detachment from matter and from the dimension of the sensuous. This was because in art truth could only be claimed via sensuous means, but art ceased to be capable of transmitting the true via sensuousness (*Sinnlichkeit*). The utmost goal for Hegel was the Absolute Spirit; hence, he did not see the demise of art as something fatal, as long as there could be other, philosophical, non-artistic modes of involvement with truth procedures. Hegel shrewdly predicted the sublation of art's sensuous merits in favor of abstracted scientific or philosophical notions, since (philosophic) notions became better transmitters of truth. Aesthetics could easily be sublated in favor of truth articulated in philosophy. Although Romanticism's tendency towards abstraction terminated with a lengthy period of realist art in the mid-nineteenth century, art entered the twentieth century with an explicit determination to abstract and theorize. In fact, modern art had been "art after (or instead of) philosophy" much earlier than Joseph Kosuth proclaimed it as such.

Meanwhile Marx, unlike Hegel, did not think that science or theory could touch upon reality any better than art's sensuous means would. According to Marx's rendering of his aesthetic aspirations in *The Holy Family*, logical thinking was not the only goal of history, as Hegel would insist. Marx also emphasized the necessity of the sensuous and material formation of nature and development of the

productive forces of humankind. In relation to this goal, all else—conceptual thinking, logic, and art—were simply the means, not goals in themselves. A human being in this case affirms him/herself not only via thinking, but also via all senses and capacities.

Nevertheless, we all know what happens in modernism: on the one hand, there is the recurrence of the conceptual, theoretical, and speculative values of art; and on the other, the development of affective, physiological, unconscious, and irrational practices which, although they belong to the sensations, still develop "under the gaze of theory"—as Boris Groys states in one of his texts.[1] This means that both cognitive and sensuous aspects of art are viable for contemporaneity, but they happen to be *separated*. Moreover, when affective or empirical phenomena are presented in artistic practice—be it the body, subversion, or forms of life—this practice derives from certain conceptual or theoretical standpoints, at least implicitly. Groys accounts for this in the aforementioned text: contemporary art detaches itself from the rationalism of the Enlightenment; but despite that, it remains a theoretical, cognitive, and highly conceptualized practice as opposed to art's sensuous parameters.

In socialist philosophy and aesthetic theory of the 1960s and 70s (in works by Ilyenkov, Davidov, and Lifshitz), the sublation of art by philosophy and theory that Hegel described was explained by the emergence of capital and the spread of bourgeois interests and economy. Notions, concepts, and speculative parameters are detatched from the world because the capitalist economy and capitalist production do not provide adequate correlations to concepts. And hence it is only natural that, since the 1840s, it was the revolutionary, postromantic discourse that brought back the capacity to reclaim realism and the dimension of the sensuous in art (Courbet's work or late nineteenth century realist literature being the embodiments of such a recurrence). When using the word "sensuous," it is important to keep in mind that this does not refer to feeling, emotion, the performance of something transgressive, an affect, or something sensual rather than intellectual. For Hegel, "the sensuous" means *embodying*

1. Boris Groys, "Under the Gaze of Theory," *e-flux journal*, 35 (May 2012). Available at: https://www.e-flux.com/journal/35/68389/under-the-gaze-of-theory/.

the idea or the concept—i.e., the convergence of the conceptual parameters with the material ones, the meeting of a notion or idea with the matter of a thing.

There are innumerable examples of lived experiences in performance and actionism to reclaim contemporary art's sensual merits. Yet to repeat again, life experiences in contemporary art remain in the frame of the theoretical mind. Art "ends" for Hegel because its own essential message is constructed and produced by the theoretical mind, but in the case of contemporary art this is not even an idea, or the mind in Hegel's sense—it is rather speculation, a conceptual gimmick, or theory.

However, it should be noted that modernist, avant-garde, and conceptual art practices weren't reduced to raw theory; along with the inevitable theorizing, they also deplored such a condition and subverted the inevitable totality of theory into an extreme *negative* gesture, into the radical moment of actualization—a critical moment that philosopher Valery Podoroga defines as *kairos*.[2]

It is in this moment of *kairos* that the episteme of a modernist and contemporary artwork resided. The moment is negative because it has to do with the collapse of perception and of the hermeneutically-biased capacity to understand. But by means of certain, almost impossible, cognitive leaps, understanding and misunderstanding coincide in a certain kind of "happy" supra-cognitive, paradoxical moment. Such gaps of conceptual nonsense were crucial for Dadaism. In this moment of *kairos*, theory is halted by a certain nonsense or absurdity, molding the theoretical conjecture into a conceptual paradox.

Actually, the reason contemporary art excelled over all other artistic genres and media and appropriated the right to be called "art" (we do not call film, theater, music, or poetry "art" anymore) is that

2. "The importance of *kairos* is in the fact that it actualizes time, casting it away from habitual paths. But even more important is its instantaneity, which defines the moment of actualization—always explosive and sudden, opening the rupture, the breach in the world. This happens even when *kairos* breaks forth to us via complex form or via artificial obstacles. *Kairos* is interesting by its dubiousness: as the occasion, and as the act-instant, as the principle of actualization of an artistic gesture." Valery Podoroga, *Kairos: A Crucial Moment* (Moscow: Grundrisse Publishers, 2013), 12.

Portrait of Mikhail Lifshitz (1943–45). Photograph. Photographer unknown.
Copyright Anna Pichikyan.

it *compressed* the realization of artistic contents, of an artwork and its impact, into this supra-cognitive moment, that is conceptual and nonsensical at the same time—sometimes reified, sometimes not. Modernist as well as contemporary artwork is instantaneous and momentary, no matter how long it lasts. It is not based on perception, but on a heuristic grasping of that very *conceptual* instant—be it articulated via material form, conceptual statement, affective experience, transgressive act, or speculative rumination.

However, while the conceptual paradigm in art emphasizes the impact of the cognitive, semantic, and intellectual components and tears away from any sensuous contact with reality, the conceptual procedure in it is still not an idea, since contemporary art's episteme is not philosophy, but post-philosophy—art *after* philosophy.

In her book *The Originality of the Avant-Garde and Other Modernist Myths*, Rosalind Krauss makes an attempt to discover a specific semiotic paradigm that defines conceptual thinking and its dimension of paradoxicality.[3] She refers to the semiotic category of the index. The index represents not a mimetic but a dynamic correlation of two elements, of two signs, or of a sign and an object—as with a pointing finger, or the trace of a bullet in a window.

The index is not in need of symbolizing or conjuring a resemblance. No matter what the conceptual work concentrates on—pure text, documentations, interventions, ready-mades—the prevalence of index semiology makes it a simple machine that always preserves the gap between the two correlated elements. What is important in the indexicality of a conceptual work is this disjunctive gap, despite the act of correlation. In other words, in a conceptual work the third element—symbol, idea—that otherwise would symbolize or lubricate these two—is absent. This means that in conceptualism the idea is turned into a speculative proposition, paradoxical in its tautological literalness, that is rather closer to language philosophy than to the idea in dialectics. Such a semantic disjunctive gap which produces the failure of interpretation is that very specific moment, interval, hiatus, *kairos*, that matters for modernist as well as contemporary

3. Rosalind E. Krauss, *The Originality of the Avant-Garde and Other Modernist Myths* (Cambridge, MA: MIT Press, 1985).

art—the moment of actualization when understanding is impossible and consciousness makes an impossible cognitive leap to grasp the otherwise cognitively ungraspable gap. This leads to the collapse of temporality that used to be indispensable to the sensuous perception of an artwork in favor of that very negative *instant of suspended perception*, which acquires a conceptual relevance.

The conceptual intensity of modern, contemporary, as well conceptualist art proper, resides in the speculation that circles this gap. But when art dispenses itself with this negative moment, then nothing remains in it but theoretical genealogy, positivist sociology, and cognitive routine—conditions that are neither sensuous, nor philosophic or conceptual, but make art become part and parcel of contemporary cognitive capital.

As for socially engaged, quasi-avant-garde art practices, their dealing with social engagement nowadays could often be claimed as formalist, since social and political phenomena are often rendered in them in a detached and sensuously uninvolved way—even when its producers do not recognize such a level of estranged un-involvement. Moreover, politically engaged works often retain their power due to that very negative modernist "trick" in them (that very instant of *kairos*), which the artists often conceal and do not acknowledge, or do not realize in their optimist civil belief in "improving society" through art. (The classic case of such de facto modernist negativity, which in a social context proclaims itself as a socially engaged art practice but in fact is grounded in the conceptual "gimmick," is the work of Artur Żmijewski.)

Thus, autonomous art is digestible and democratized, whereas committed art often reproduces the political agenda tautologically or formally: it neither further *alienates* the already existing social and economic alienation as Lyotard demanded (because it doesn't tend to reside in the Adornian modernist paradigm anymore), but it is not able to *de-alienate* either, because that would require the act of metanoia—overturning one's life and fate by means of getting involved in what happened in "reality."

While continuing its self-determination by the theoretical mind, art dispenses more and more with the conceptual instant of *kairos* mentioned above. At the same time, in the absence of a general

program of social and economic de-privatization, practices that stand today for the continuation of emancipatory, engaged aesthetics in contemporary art become part and parcel of cognitive capitalism's modes of production. Meanwhile, the speeds of circulation and modes of logistics for contemporary capitalist economy and technical progress are in fact more subversive, cognitively legible, creative, and even paradoxical than art's interventions into it. So, when following the cognitive path art cannot but be subordinate to cognitive capitalism's accelerative stream. Art that is based either on intervening within social infrastructures or generating machines of intelligence lags behind contemporary economics and technology, because capitalist economics is even more creative and cognitively advanced than art in terms of both generating infrastructures and then subverting them. It excels over artistic practices exactly in those fields of speculation and abstraction that art appropriated as its own when it got rid of sensuousness and metanoia, but also when it chose to *disregard even its own negative modernist and conceptual genealogy too*.

If it is not possible to revisit pre-modernist components at all (these components being: non-alienation, realism, "human resignation," sensuousness), and if, on the other hand, the abovementioned radical paradoxical moment of *kairos* is removed from contemporary art practices too, then art dissolves into various modes of creative activity, whereas capital in its own turn becomes more and more speculative and artistic. Therefore, today the watershed would be not so much between art's political commitment versus art's autonomy, but rather between the episteme of contemporary art and the sensuous rendering of an event that modernist and contemporary art voluntarily discarded long ago.

<div align="center">

II
THE GENEALOGY OF ANTI-MODERNISM
IN SOVIET SOCIALISM

</div>

Let's now refer to the former socialist interpretation of certain issues of Hegel's aesthetics, accounting for why sensuousness (*Sinnlichkeit*) was still regarded then as indispensable for art.

In his work "Aesthetics of Hegel and Contemporaneity," Mikhail Lifshitz, an apologist for realism, defines art as "the sensuous consciousness of truth"; only in that case the truthfulness of art derives not from "the artist's consciousness, but from a lively sense of reality."[4]

A realist act, as Lifshitz understands it, would be not so much in naturalistically documenting or depicting something—for example depicting the denigrated or the oppressed—but rather in sensuous involvement in that life.

Sensuous involvement would not necessarily mean nominal presence in any problem zone. It is not so much about any empirical sharing of certain experiences or rendering them; it is rather about the evental encounter with the phenomena or with the happened (with the event) which changes the producer in the course of a metanoic transformation that is imprinted both on the producer and afterwards on his/her art piece.

Realist art never refers to itself. It happens to be artistic only in order to become no more and no less than the *means* by which to touch upon life. It doesn't need to reflect on itself. The big paradox here is that modernist art, which is addicted to its own self-abolition, is permanently preoccupied with itself. Whereas realist art, which actually makes use of explicitly artistic (non-naturalistic, non-documentary, gnomic) means, never overtly shows that it is artistic; its preoccupation is mainly in setting a genetic bond (umbilical cord) with reality. Realist art articulates and reveals the event extrinsic to itself, and only thereafter becomes a work of art, while modernism, and often, even the avant-garde, are constructed in terms of themselves being their own event—the event residing in their own languages, media, methodologies, or activist procedures.

Alienation was a trait of capitalism long before the emergence of modernist art, and the question that socialist aesthetics asked was why a realist artist would make an effort to search for art's de-alienating potentialities despite harsh, alienating conditions; whereas the modernist artist rejected the potentiality of non-alienated experience, claiming such effort futile in the midst of alienated life and the division

4. Mikhail Lifshitz, "Aesthetics of Hegel and Contemporaneity," in *On Hegel* (Moscow: Grundrisse, 2012), 185–249.

of labor. Constructing modes of non-alienation in conditions of social and economic alienation would be regarded in modernist or contemporary art as kitschy, uncritical, and redemptive.

Yet, even when de-alienation is not socially and economically possible, in realist art it has to evolve sensuously, in other words artistically. It is clear that existence can never be de-alienated. But claiming non-alienation does not at all lubricate social or ontological ruptures and contradictions. The argument of the alter(anti)-modernist theory that developed in the frame of socialist ethics was that regardless of capitalist economy, the possibility of non-alienation retains a relevance for art, although it might require immense ethical effort in the conditions of capitalism.[5]

For Hegel, the human being expresses him/herself in the objective world, and returns to him/herself on another level; i.e., for him/her the objective world and its alienation is to be sublated by the Subject's self-consciousness. The sublation of alienation is the sublation of the objectified world by means of spiritualization, by means of turning the world into a phenomenon of mind and spirit. According to Yuri Davydov, in order to sublate alienation Hegel has to bring the outer world into harmony with the truthfulness of the inner world. Marx, on the contrary, brings the inner world into accordance with sensuous contact with the objective world; sensuousness is equal to objectification. Abstraction, the abstraction of a notion without sensuousness, is not valuable. Logical categories are only the "money of spirit" that can acquire real meaning only via the sensuous appropriation of the world by man.[6] This is because for Marx, thinking is not the sole and main form of human activity. The primary activity is labor. Division of labor and private property are the grounds for various modes of alienation. In this case, alienation cannot be sublated solely via mind, speculative process, or abstract thinking; abstract thinking is not able to overcome the division of labor and the rule of private property. The dialectical movement does not reside merely

5. Generally speaking, sensuousness in art is about the existence of other human beings, whereas the negative moment of *kairos* touched on above is about reified concepts.
6. Yuri Davydov, *Trud i Iskusstvo* [Labor and art] (Moscow: Astrel, 2008), 7–100.

in the thought of reality, but in the dialectical development of reality itself—in the historical process.

The issue to be disputed here is the following: If reality is estranged, alienated, and is capitalist, wouldn't it be unrealistic to project its non-alienated alternatives? It is here that Lifshitz's argument appears at work. According to Lifshitz, even in the midst of harsh alienation there remains a necessity and possibility to envisage non-alienated social constellations. The realist artist intervenes sensuously, exactly into the gap between alienated reality and the potentiality of non-alienated-ness. So it follows that realist art historically produced by nominal members of the bourgeoisie is paradoxically able to be less bourgeois than contemporary counter-capitalist critique—in cases where such critique clings to alienation as the sole imaginary, and refutes the modes of sensuous involvement in reality to reveal its potentialities of non-alienation.

Lifshitz regarded sovereign artistic acts of resistance, transgression, épatage, and criticism in modernism—and taken further in contemporary art—as arbitrary gestures that were merely the flipside of bourgeois consciousness. The truly non-bourgeois standpoint would entail experiencing and observing the objective features of life and heightening them to the generic dimension. Lifshitz's argument was that modernist art arises from a critique of alienation and of alienated society, but its methods actually bring alienation to its extreme—a disposition precisely described in the works of Adorno and Lyotard.[7] For example, Adorno sees the development of art as a revolutionary dialectic of a Subject who generates the project of Enlightenment, but then has to abstain from it, rejecting this false Enlightenment that turned into optimized ratiocination and the cultural industries. For Adorno, the artist is a revolutionary—whether Beethoven or Alban Berg—who looks back at the history of art by means of its negative annihilation. The artist uses art to form the antithesis of profane and alienated reality. Without this radical methodological arrogance in relation to history, in relation to reality, there can be no art in modernism.

7. See Adorno's *Aesthetic Theory* (1970), and Lyotard's *Libidinal Economy* (1974) and *The Inhuman* (1988).

Opposing alienation with a more extreme form of negativity became a focal point of contemporary art's praxis of resistance, but this blocked out any effort to imagine or compose the situations, existences, and societal constructions that might have escaped the logic of alienation. By intensifying alienation, the artist protests against bourgeois society only to confirm and support the logic of its existence. Lifshitz's belief was that art is able to transcend social alienation despite capitalism, whenever it attempts to exercise a trans-class consciousness, rather than merely provoke or tease an alienated society with anarchic or "transgressive" imagery, and thus tautologically reproduce the uncanniness of alienation wrapped in the packaging of protest. Lifshitz's view here is crucially linked to the ethical premises of "human resignation." This term is juxtaposed with the protesting gesturalism of modernist and contemporary art; with this phrase, Lifshitz characterizes art's attempt to grasp the real.

IV
HUMAN RESIGNATION AS ETHICAL EDIFICE

The term "human resignation" first appears in a letter from Lifshitz to Friedlender, and is borrowed from the writings of the Russian literary critic Vissarion Belinsky. In the context of the 1960s, with its critique of humanism, militant politics, and art, this term sounds like quietism with regard to revolutionary hubris in art, culture, even politics.

With this term, Lifshitz wishes to critique "the pride and arrogance of the bourgeois-democratic finite consciousness" that rises up against certain phenomena with the aim of resolving the contradictions, but without observing the true complexity of the circumstances. This acknowledgment of a relative incapacity to resolve the deep contradictions of life depends not on the weakness of our mind, but stems from the actual state of affairs. Resignation in this case does not imply abstaining from battle; it presupposes instead the existential, ontological, and empirical comprehension and acceptance of the contradictions inherent in the real—rather than supplanting them with personal desires, biography, methods, traumas, etc. This attitude presupposes an act of modest withdrawal,

even humility. Human resignation leads to a strange understanding that when individual personality recedes, reality is then revealed, and that reality cannot be reconstructed or changed unless there is an effort to both cognitively grasp and sensuously experience it.

In his letter to Friedlender, Lifshitz writes:

> History is not directly dependent on the pretensions of our unsatisfied little consciousness, while each participates in it as contributor to social labor and the struggle. The more independent reality is from our claims and pretensions and the more the mind becomes its inherent element, the freer we are—both in a philosophical and in an artistic sense.[8]

What Lifshitz means here is that the truth in art can never be consciously planned or implied, but nor is it a product of the uncontrolled unconscious. In art intention recedes in the face of the effectuation of reality. The artistic image (*hudozhestvenniy obraz*) deals directly with reality, and often does so contrary to the producer's intentions.[9] As he incessantly repeats, the truth is not in the head, it is in the world. Andrei Rublev nominally painted icons and depicted the sanctity of holy figures, but in fact he revealed something that Lifshitz called "disinterested benevolence" in human nature generally, thus revealing the sensuously transmitted epiphenomena of objective existence instead of simply establishing a canon of the sacred. In his personal beliefs, Dostoevsky often demonstrated conservative attitudes not supportive of revolutionary movements; but, paradoxically, the record of reality in his novels displays a great deal of fascination with the revolutionary situation. The objective constructs of life undermine and break through the prejudices of a concrete author and are ultimately stronger than them.

8. Mikhail Lifshitz, "O Pushkine: Pismo Fridlenderu" [On Pushkin: letter to Friedlander], Moscow, April 8, 1938. Originally published in *Pushkinist*, no. 1 (1989), 403–414. Available, in Russian, at: www.gutov.ru/lifshitz/mesotes/pismo-pushkin.htm.
9. Mikhail Lifshitz, "Argument o realisme" [Arguments on realism], in *Mifologia Drevnjaa I Sovremennaya* [Ancient and contemporary mythology] (Moscow: Iskusstvo, 1980), 498–545.

AESTHETICS 191

Interestingly Lifshitz was doing his own research on the myth at exactly the moment when the myth was being analyzed and researched in structuralism.[10] The socialist aesthetician called for a poetics of the myth at a time when it was either being deconstructed in semiotics and integrated into the edifice of the universal invariants of structuralism, or was praised as a return to a proto-culture and a new pre-linguistic savageness (in artistic practices). The reason Lifshitz was so interested in myth, despite all its symbolism and allegories, was because it preserved the ideal and sublime categories in a non-Kantian sense (i.e., when the sublime is not necessarily detached from reality). In this case the sublime is, on the contrary, revealed within the everyday and the real, something that Lifshitz defines as "gnomic."[11] By "gnomic," Lifshitz means a non-straightforward, non-naturalistic, artistic, oblique, aphoristic means of dealing with reality. This explains his interest in icon painting, which he declares as even more realistic than realist portraits of the nineteenth century. Another reason for referring to myth lies in its capacity to comprehend and gain insight into reality rather than operate with it. Lifshitz was interested in the role of personality, of a Subject in myth, who is able to lessen personal, individual sovereignty in the face of greater objectivities. Here, a human being demonstrates humility and modesty in relation to nature, life, and the world. Lifshitz writes:

> Human beings remain part of the material world and success comes to them due to *reservation*, which is the outcome of materialism as edifice, subsisting in the logic of objective independence of reality.[12]

To engage in revolutionary procedures, one does not necessarily need to imitate images or actions affiliated with the way that the revolutionary spirit is imagined, but rather to face the cruel data of life and carry it through the mind and senses. If the artist depicts

10. Ibid., 122–27.
11. *Greek*, a tense used to express general truths, or applied for sententious or aphoristic sayings.
12. Mikhail Lifshitz, "Ancient World, Mythology, Aesthetic Edifice," in *Ancient and Contemporary Mythology*, 122–27.

nothing but certain statements of protest, then this protest might well be emulated as a mere stylistics of protest, a mere performance of the spirit of protest that finds satisfaction in itself and glosses over the contradictions.

For this reason, Lifshitz defines "revolution" not in terms of an individualistic or romanticized breakthrough of sovereignty, and not as the act of a protesting subjectivity rising up against history, but as an act revealing the rules of objective historical development. He writes: "Revolution is lightning, interrupting the quantitative potential line with the appearance of *actual infinity*. It confronts the consciousness with what exceeds its limits and gives a human being an understanding of his deeds."[13] For a realist artist, the rupture between the artistic act, or work, with reality and its contradictions remains irresolvable. On the one hand, the artist endeavors to bridge this gap (rather than to aestheticize or demonize it) but, on the other, s/he is always aware that the gap cannot be bridged. The ethical act inherent in "human resignation" marks not only what is to be done, but also what has happened. It gives priority to the expression of the event, and does not proclaim the supremacy of a particular artistic method as the pivot of historical development, or a high point in the history of art. Instead, in realist art (or "classical" art, as Lifshitz would put it), this *modesty* is the starting point. Despite emancipatory or critical convictions, a contemporary (avant-garde, modernist, post-modernist) artist exposes a personal strategy with pre-packaged and resolved concepts, with utter self-confidence, and with an awareness that the work encompasses a whole range of problems of contemporaneity. In the framework of this strategy it is forbidden to doubt the validity of one's own activity or artistic methodology, even when the artist claims the complete negation of art as a strategy in itself. In this latter case an artwork stands for the whole institution of art and even the totality of art history.

The realist artist, by contrast, considers his or her own artistic activity by ousting and disregarding it, and remaining quite aware of *the futility* of using artistic means to address reality. That is because event and reality always exceed the work of art. But, nonetheless, only an artwork is able to reflect the event.

13. Ibid., 134.

*

* *

Thus the term "human resignation," which for Lifshitz was a para-phrase or synonym to Hegel's notion of "*Sinnlichkeit*," was aimed at disputing the modes and lexicons of emancipation exercised by avant-garde's constructivist wing and to cast doubt on its exag-geration of the roles of biopolitics and social engineering. In constructivist practices the issues of organization, systemic arrange-ment, or biopolitical management prevailed over the very procedures of life or reality. Even though the avant-garde made its own attempt to merge art with life when disputing modernism's nihilism and her-meticism, it instead often rather superseded life with organizational and engineering practices, substituting life by creative production, but without first taking the time to see what life itself might have actually consisted of.

It may seem that within the range of such elements as artistic subjectivity, artistic method, and forms of life, the avant-garde man-aged to cling to the latter—reality. Yet the aim of avant-garde strategy was to occupy, invade, and intervene in reality, rather than to examine it. In the avant-garde, issues of organization, or biopolitical engineer-ing, took over the ontological issues of existence.

In the logic of constructivism: exploitation, injustice, and dis-crimination have to be eradicated by recoding and reorganizing them, rather than reflecting, living through, observing, or studying them.

As a result, reality was often mistaken for the project of con-structing that very reality. In the projectivism of construction and modernization, constructivism and productivism superseded the temporality of a given reality with the technical reorganization of the social surroundings, as if it were a matter in the hands of a demi-urge; so that reality itself became no more than infrastructure or an art practice. (Boris Groys wrote prolifically on this topic in his 1987 book *The Total Art of Stalinism*.) Here we confront a strange para-dox, much discussed in the prose of Andrei Platonov, who belonged to the avant-garde's Proletkult wing and then shifted to anti-Stalin-ist Soviet realism in the 1920s.

In his novels, Platonov depicts precisely the inconsistencies of confining life to constructivism and engineering. People who engineer and construct consist of flesh, of various yearnings, exhaustion, loneliness, and anguish, of fear of mechanized labor, and of the senselessness of existence. As a result, it transpires that the real is not a construction at all, but a painful convergence of a communist project and frail bodies, exhausted by labor. And all of this is not seen as merely a demiurgic project undertaken by artists, engineers, and inventors: the objective processes of life tragically surpass the projected plan and the technology of its implementation.

Platonov's works abound in engineers and inventors who reorganize social space and create new machines. But, strangely, even when "the machine" is constructed, the inventors find that they lack the significance necessary to exceed the functionality of the construction:

Voshchev found himself in space, with only the horizon before him and the feel of the wind against his downbent face.

But soon he felt doubt in his own life and the weakness of a body without truth. He was unable to keep treading the road for long and he sat down on the edge of a ditch, not knowing the precise construction of the whole world and where it was he should aim for.[14]

"You said you knew everything in the world," said Voshchev. "But all you do is dig and sleep! I'd be better off on my own— begging my way around the collective farms. Without truth I simply feel ashamed to live.[15]

"Do not people lose in their feeling for their own life when construction projects gain?" Voshchev hesitated to believe. "A human being puts together a building—and comes apart himself. And who is going to exist?"[16]

14. Andrei Platonov, *The Foundation Pit*, trans. Robert Chandler, Elizabeth Chandler, and Olga Meerson (New York: New York Review Books Classics, 2009), 4.
15. Ibid., 34.
16. Andrei Platonov, *The Foundation Pit*, trans. Thomas P. Whitney (Ann Arbor: Ardis Publishers, 1973), 13.

If Lifshitz dismissed constructivist aesthetics because of its obsession with biopolitics, he disregarded Proletkult aesthetics (theoretically rendered by Vladimir Friche) as no more than vulgar sociology.[17] As is well known, the Proletkult proclaimed proletarian art to be the representation of "proletarian consciousness," thus treating the general category of class consciousness as the narrow, self-sufficient presentation and documentation of the problems characteristic of one's own specific social milieu. This latter logic meant restricting oneself to only representing the social issues of one particular social group. It implied that only an aristocrat could account for an aristocratic milieu, while only a proletarian could reproduce the true life of the working class. Lifshitz refutes this by referring to nineteenth-century Russian literature, with examples of members of the aristocracy (Tolstoy) or the bourgeoisie (Dostoevsky) being able to study and sense the life of the peasantry, the working class, or the underclass, and believing that conversely, a writer of proletarian social origin—an artist nominally belonging to the working class—might be able to perceive (socially as well as existentially) and accurately render the lives of other social groups, no matter how hostile this artist's attitude to them might be. Only such an approach can be truly general. Realism presupposes a capacity to experience and reflect social roles other than one's own.

Class consciousness in this context means not only the self-presentation of one class in revolt—let's say the self-presentation by a proletarian artist of a proletarian consciousness—but the capacity for, let's say, a proletarian artist to observe society in all its social diversity and contradictions, to ultimately dispense with class consciousness altogether. As we remember, for Lukács, class consciousness of the proletariat stands for the generalness of consciousness; it is not the self-consciousness of only one layer of society, but rather the universal capacity of a proletariat to exceed its captivation and subjugation exactly by inferring an overall view and knowledge of social contradictions.

The decision within Soviet cultural politics to re-evaluate the realist merits of "world art" (*mirovoe iskusstvo*) departs from this

17. Vladimir Friche, *Sociology of Art* (Moscow: Urss, 2010).

standpoint. The goal of such a decision was to shift "classical" heritage into a context that would annul the class genesis of this art, and thereby reconstitute the history of world art within the context of a classless society. Such a reading implied that art as such, even though it might have existed within the harsh conditions of class society or might have been produced nominally by the bourgeoisie, by definition realizes itself as a necessity of the classless society and by this token happens to be potentially proto-communist.

CHAPTER 9

WHY "CLASSICAL" ART IS MORE COMMUNIST THAN ANY OTHER MODE OF ART

*Therefore art in its parabolic reality—the reality that is
ideal, tragic, and comic—draws knowledge to absolute truth,
to the plenitude of life, to dialectics.*[1]

*Even the most humiliating and controversial situation cannot
humiliate the generic forces of humanity. They are limitless.
And let the artist reveal the magic of the true in this piece of real
world, and not amidst the sublime halls of Valhalla.*[2]

—Mikhail Lifshitz

We generally consider the term "classical" to refer to something related to the past, something pre-modern, and hence anti-contemporary. It is habitual to think that various periods of "classical" art merely mark the vestiges of bourgeois culture and of disciplinary society. The main stereotypes associated with the concept of the classical are: order, the system, and the inviolability and consistency of an aesthetic canon. The predictable structure of a classical form, even despite endowing it with the versatility of its contents—as shown by Walter Benjamin, or Theodor W. Adorno—becomes technologically and stylistically outdated as a medium; consequently, it cannot correspond to modern means and forces of production, or modern forms of sensitivity. The epistemes of the classical—mirroring, reflecting, realism, mimesis, and catharsis—are dismissed as obsolete means of creative production, as anachronisms of artistic media.

I will try to map the paradigm of "the classical" in order to show what those social and civilizational changes in capitalist modernity were, that made it inevitable to reject the poetics of "the classical."

1. Mikhail Lifshitz, *What is the Classical?* (Moscow: Iskusstvo XXI, 2004), 401.
2. Mikhail Lifshitz, "Aesthetics of Hegel," in *On Hegel* (Moscow: Grundrisse, 2011), 172.

I
REALISM IS ILLUSIONISM

Due to his insistent apologia for "the classical," Mikhail Lifshitz was located among the adepts of conservative aesthetics, of kitsch, of the dismissal of the emancipatory contexts of modernism and the avant-garde. Nevertheless, what Lifshitz termed "the classical" (*klassika*) is not confined either to form, to the canon, or to a set of constant rules. It is an episteme surpassing any cultural, historiographical, or aesthetic premises, or even any political and economic institution.

Let us start from the principal rebuke contra realism, which consists of the idea that realist literature or art in no way accesses the real or reality, but rather mimetically contrives the fictitious illusion of reality. For example, contemporary theories often define themselves as realisms or materialisms (speculative realism, new materialism, object oriented ontologies). However, within them, reality is treated as a pure nominal presence of elemental aggregations; matter is viewed irrespective of history or of a subject. As a result, the notions of the abstract and the concrete (the real) mutate: what is treated as real or material happens to be the data traced and inspected by techno-scientific research. This elemental, positivist "factography" is called realist, but happens to be abstract and formal.

Contrary to this stance, according to Mikhail Lifshitz's aesthetic theory, art attains reality via fictitiousness. Indeed, illusion and fictitiousness do not contradict the capacity to grasp reality. Lifshitz called art's exigency in fictitiousness "gnomics." Gnomics presupposes the poetics of the conditionality (*uslovnost*) that constructs the mode of reality exactly due to the "illusion." We know that very often in the avant-garde and in today's documentary practices, a mere document, piece of evidence, or an act of witnessing the situation stands in for a realistic alternative to formalism and abstraction. However, from the point of view of Lukács and Lifshitz, this straightforward "factography" is nothing but abstract nominalism. The "classical" paradigm, on the contrary, needs a composed structure; its overcharged complexity and construction seems to be contrived, to be fictitiously sensuous: fictitiously painful, or uncanny, beautiful, horrible, or truthful.

Yet, as Lifshitz insists, it is exactly the parabolic, gnomic, and fictitious *composition* that can deal with reality. But how can it be that the composed structure is more realistic, more sensuously engaged and emphatic than direct contact with the fact, with the affect, with the reflexes of repulsion, pain, horror, violence, etc.? Or, how does it happen that conditionality (*uslovnost*)—the gnomic dimension—does not turn into an estranged, distanced abstraction, but, on the contrary, functions as an approximation of the real?

The reason for this is that the gnomic parameters, as Lifshitz claims, are able to comprise the problem in its general (universal) sense. Reality can be touched upon only as a generalized reality, which implies the necessity of the mimetic and the fictitious, rather than the factographic. As Lifshitz writes in his *What Is the Classical?*, an excessively precise factographic rendering can only provide the nominalistic, naturalistic depiction of one singular, separate section, and not of generalness, of infinity.[3] The fictitiousness of art enables a revealing of the general dimension and infinity of contents, exceeding the particularity of the factographic.[4] To attain a general overview of reality, certain attributes and components of life need to be blurred. On the level of nominal factuality (vulgar materiality), one can only grasp the unreduced, boundless totality—"the skin of Jonathan Swift's giant." This skin is formless and boundless, so that one can see the details of the skin, but might not know what and whose skin it is. On the contrary, to truly grasp reality one needs the supra-factual reality (*nedeystvitelnaya deystivitellnost'*).

If there is no second, invented, fictitious reality, which is at the same time tied umbilically to the "first," real one, this first *real* reality cannot be mirrored or reflected. It can neither be seen or understood: neither transmitted or grasped in its breadth. In a recent article, "The Aesthetics of Singularity," Frederic Jameson makes a similar observation with regard to contemporary art objecthood.[5] He deplores the condition of total tautological presence of "a thing/object" in

3. Mikhail Lifshitz, *What Is the Classical?* (Moscow: Iskusstvo XXI, 2004), 350–415, 351.
4. Ibid., 356.
5. Frederic Jameson, "The Aesthetics of Singularity," in *New Left Review*, no. 92 (March–April 2015): 101–132, 122.

contemporary art objecthood, when it is unable to refer to or reflect any thing in reality other than itself.

If modernism aspired to abstraction and formalism for the sake of transcendentality, one confronts in the ideology of nominalism merely the exposure of the physicality of particles. According to Thomas Metzinger, transcendentality is just a self-preservation reflex of the human species in relation to the externality of space and time, developed as the "self-model" within the neuro-biophysical system or neuromatrix of that species. Yet this self-model of a human species is not the real self but merely a "created avatar"; it is the outcome of a specific aggregation of molecular dynamics. Metzinger defies the achievements of phenomenology, which attempted to analyze not only perception, but also the very modes of consciousness that make perception function. Moreover, his theses, according to which a human species can see, for example, a flower, but cannot see *how* s/he sees it, dismisses the whole legacy of modernist art and theory.[6] We can turn back to Rosalind Krauss basing her theory of the optical unconscious exactly on the capacity to visualize the representational system of vision and optics (hence of perception), and not simply of figures and images. According to Krauss, precisely the visualization of the grid as the system of seeing instigated the modernist choice for abstraction and geometry.[7] It proved that formalization and representation of transcendentalities could be embodied and depicted. This act of reified introspection of the way space, time, or sound are perceived was crucial for modernism and its quest to transform sensuousness into abstracted speculation.

Thus the obsession with material techno-scientific facticity in post-philosophies is even more abstract than the abstraction of modernist formalism.

As Lifshitz puts it, iconoclasm in contemporary art can be explained by the fact that the capacity to access reality via generalization is lost; while at the same time the emphatic and sensuous rupture with the material world seems to be insurmountable and at

6. Thomas Metzinger, *Being No One: Self-Model Theory of Subjectivity* (Cambridge, MA: The MIT Press, 2003).
7. Rosalind E. Krauss, *The Optical Unconscious* (Cambridge, MA: The MIT Press, 1993).

times uncanny.[8] Fear of reality, which happens to increase estrangement from it, makes its alienatedness even more tangible. The consciousness that confronts reality merely in its elemental, nominal (abstract) presence or in the form of abstracted data—without the tools of generalization—can only be horrified by it. And thereby such a consciousness searches either for a complete escape from reality, or indulges in transmitting the totalized, elemental presence of this uncanny, boundless, nominal materiality. Hence the dismissal of the "fake" illusion and fictitiousness of obsolete "realisms" in favor of the "truthfulness" of alienation and nothing but the factual details exposed to the "zoomed" gaze.

Lukács's argument at the beginning of *The Specificity of the Aesthetic* (vol. 2) is identical to that of Lifshitz in its critique of the operational and elemental treatment of reality as opposed to mimetic mirroring.[9]

Lukács insists, in a similar fashion as Lifshitz, that the more obliquely, the more gnomically art gets involved with reality, the more it can witness what happened in it. Direct *extasis* or direct performative reaction—something that characterizes, for example, magic rituals—is merely an affect. As for mimetic reflection (отражение/ *otrajenie*), the more framed and completed it is within an artwork, the more it approaches and comes into contact with reality. So, the more one relies on the "second," *mimetic* reality, the more one deals with reality. Mimesis treats reality via its mirroring, whereas in magic and in affect, whatever the magic or ritual may represent becomes part of the reality itself, invading it and operating in it. That is why the artistic dimension—the artwork, its framed construction in relation to reality—is a more truthful rendering of reality than any direct, affective, naturalistic reproduction or reenactment of it. Even more so, direct affective reaction and nominal reproduction bring transcendence to reality, make it mystical, alienated, and exterior to the world. As Lukács puts it, affect is outside and external to reality and it is not inside reality. Paradoxically, this external "outsidedness" is inhuman, whereas art's mimetic "insidedness" is de-alienating and human.

8. Mikhail Lifshitz, *What is the Classical?*, 352.
9. Georg Lukács, *Die Eigenart des Ästhetischen*, Band. 2 (Berlin; Weimar: Aufbau Verlag, 1981).

Hence *extasis* and mimesis are the two counteracting approaches to artistic creation: i.e., pure affect, or the mere reaction to pain, is as abstract as a notion. Exactly such phenomena, however, constructed the edifice of contemporary art, and they either represent subjectivity without any objectivity, (i.e., subjectivity without reality), or factography and objecthood without Subject. This is why Lukács and, for example, Erich Auerbach or Edward Said, treat mimetic distance as the dimension of the human. Direct presence is spiritualistic; it engages in "sorcery." No surprise, then, that post-human aesthetics gets closer and closer to occultism. Occultism is technocratic, random, and mechanistic.

The dimension of fictitiousness and conditionality marks a very important divergence in today's nominal materialisms (speculative realism, actor-network theory, or object oriented ontologies) from realism in its pre-modernist sense.

And truly: distance enables us to observe better what is inside, what is "on stage," what is "in the picture." Whereas when we intrude on the imagery and the picture, we become part of the ritual, of the ceremony, which in fact intervenes in reality, but by virtue of doing so, paradoxically remains beyond it. Thus, when invading reality with the medium of affect or ritual, we are even more alienated and estranged from where we intervene. We perform the rite, submerge in it, not being aware of *what* is produced, and thus delegate the performed to another, alien force—a nihilist nothing, divinities, nature, God, the factography of affect itself, etc. Such an act, as Lukács argues, makes the produced thing external, outward, inhuman, and not of this world. On the other hand, fictitious optics composes "the insidedness," the in-this-worldliness—inscribing it into the dimension of "the human." "The aesthetic" is thus human. Pure *extasis* is horrifying and uncanny. Yet it is not that having confronted it, one can change anything in this outer-wordly uncanniness; one can only aestheticize or document it without true cognition or sensuous involvement. Even Nietzsche, in *The Birth of Tragedy*, insists that tragedy has nothing to do with the crude ritual; it can only be implemented via "aesthetic play." Meanwhile, in shamanism the goal is not cognition, or even play, but contact, plugging into "another world." The collapse into total immanence is the path to transcendence, to the irreal.

This is why reality should be approached, as both Lifshitz and Lukács assume, via "illusionary," supra-real reality (*nedeystvitelnaya deystvitelnost'*). This is to evade the total nominalism of the fact, which in its restricted empiricism remains abstract. Without the generalized, universal vision of what happened "there," there is no possibility to transmit contents, to acquire the enlarged perspective of what occurred, and this is the reason for constructing an "unreal" reality.[10]

The "illusion" or fictitiousness is not at all a matter of individual fantasy. Instead it stems from the acknowledgment of the individual subject's limitedness in comparison to the breadth of the objective world. But since it is impossible to comprise the entire fullness of the world's phenomena in narrative, in an image, or any other message, it is necessary *to compose* that very repeated, mimetic reality, the "imagery of reality" (*hoduzhestvenny obraz realnosti*). "Imagery" (*hoduzhestvenny obraz*) is not merely a visual image or the constellation of images, and is equally viable for literature, drama, music, and poetry. The imagery of reality, due to its gnomic, parabolic character, is capable of referring to reality universally, ideally, generally, because otherwise one can only refer to a smaller particle of reality as its nominal object, dissected fact, or phenomenon. The empirical, naturalistic documentation merely extracts from reality its particle, instead of manifesting the infiniteness of the event. As Lifshitz puts it, it is in the "typization," in the blur, in making things typical and general that schematism is sublated. As Lifshitz writes:

> The labor of composed reality is the matter of ultimate and higher necessity, it is the matter of the artist's reaction to the imperfection of his own subjectivity, which does not dare in its modesty to celebrate the victory of its (this subjectivity's) imperfection over the world of reality.[11]

10. Mikhail Lifshitz, *What is the Classical?*, 370.
11. Ibid.

II
THE "ZEALOUS SELFLESSNESS" OF COMPOSITION[12]

Contemporary art indulges in two extremes—one already touched upon above, which is a naturalistic "factography" mistaken for realism and materialism. But the other extreme also applies abstraction and generalizing speculation, raving with the theoretical, scientific, or cybernetic application of facts and data. This is when the world is observed externally, quasi-theoretically, and speculatively instead of being explored sensuously. In this case, all current problems—ecology, post-colonial oppression, natural sciences, political resistance, migration, violence, military surveillance, gender issues, etc., are under inspection, while art guarantees some kind of quasi-theoretical narrative and quasi-gnoseology of anything. In this case the stated problem remains merely an observation, whereas any mimetic concreteness—the "substantial contents amplifying a man"—that very umbilical cord that ties the artistic subject to reality, is considered fictitious and outdated.[13] As a result, we get either pure facticity, or detached, abstracted, speculative statements on whatever: war, ecology, bio-physics, labor, precarity, technological mutations, surveillance, migration, etc. Both cases are embodiments of abstract formalism; i.e., both scientific abstract speculation and naturalist and hyper-real collapse into matter—collapse into the "skin of a giant" (Lifshitz)—and become the same non-human, abstracted empiricism, speculative nominalism, or alienated materiality.

In his preface to Hegel's *Aesthetics*, Lifshitz writes:

The idea and the ideal should not be seen abstractly but amidst the center of the historical reality where the intensity of life is approaching its accomplishment.[14]

12. "Zealous selflessness" is my translation of a term from Andrei Platonov's *Chevengur*. In Russian, the phrase is Усердная беззаветность, or *Userdnaya bezzavetnost*.
13. Mikhail Lifshitz, *What is the Classical?*, 225.
14. Mikhail Lifshitz, "Foreword to Hegel's Aesthetics," in *On Hegel* (Moscow: Grundrisse, 2011), 107–108.

In this connection it is important to differentiate between the poetics of the conditional, the generalized, and the typicized, as in "classical" composition on the one hand, and on the other hand the abstraction of the detached investigations, research, and observations characteristic of contemporary art. If the conditionality of a realist composition is not a nominal documented reality, or if it is not an intrusion into reality to attain its supersession, if it is merely another, second, mimetically repeated fictitious reality, then it *has to be composed*.

In his notes on "the classical," Lifshitz mentions the indispensability of composition. He does not unpack the notion fully, yet he defines composition ethically—as the effort of emancipation on behalf of an artistic subject. He writes:

> A human in primitive society reproduces a phenomenon as such, not its semblance and apparition. With the growth of conditionality, of fictitiousness, the dimension of composition grows too.[15]

We shall have to reveal what makes this tool—composition—not merely a form or an aesthetic method, but a specific, emancipatory, ethical treatment of reality. We are used to identifying composition with a construction, with an organized structure, with an engineered montage or at times with automated contingency (for example in the case of serialism in music). Composition is typically understood as something that has been composed this way or that in order to comply with certain canons necessitated by a certain predetermined knowledge, craft, or artifice. Composition stands for the conflation of certain formal prescriptions and unique traits in a concrete artwork: figure, background, linear perspective, reverse perspective, theme and thematic development, culmination, resolution, coda, etc. All these are certain assignments of structure and order added to the methodology of the development of form. Composition implies that all components of it are prescribed, prepared, they cannot be improvised; it is based on the score, the

15. Mikhail Lifshitz, *What is the Classical?*, 361.

composed text—its original is inviolable. All the nuances and details of this unique construction should in the end bring about some harmonized whole—some sort of *chef d'oeuvres*.

It is clear that this type of composing belongs to the industrial era. The crisis of the industrial mode of production and the development of technology caused a split between the cognitive and sensuous parameters in art, something already evident in romanticism, to be fully articulated in modernism.

For example, in any affective or ecstatic performance, and generally in pure affect or in a conceptual art gesture, there can be no composition. In psychedelic modes of inspiration—caused by specific experiences, alcohol, drugs, psychic derangement—inspiration is also combined with affectation and *élan*, but without resorting to any means of composition.

Meanwhile the conditionality and obliqueness of mirroring, its compositional generality, does not at all distantiate or estrange our experience. Composition is not some remote aesthetic order externally imposed on a certain genuine materiality or document of a real story. No, composition is neither a canon nor a structure; it takes place as a sensuously evolved mimetic syndrome. Artistic imagery (*hudozhestvenny obraz*) is a sort of mimetic mania that reflects the concrete, irreversible umbilical connection of its bearer with reality. And it is this connection that instigates play and composition. It is by means of this mania that the unbearable and ungraspable dose of reality is comprehended with the help of oblique and gnomic tools. This grasp of reality by means of twisting it into a composed alter-reality reminds one much more of a deed, of a specific zeal. It needs two components—vulnerable overtness and exposure to objective surroundings—*the "I" in the passive voice* and a gnomic labor in search of the most precise path of conditionality to transmit this umbilical connection with reality. The artistic subject is then self-vulnerated almost in a masochistic way, undergoing an imprint of reality and becoming inevitably doomed in its mediation of it. In other words, capacity and readiness for composition presuppose a selfless dedication to objectivity in all its insurmountability, the ability to selflessly (беззаветно/*bezzavetno*, in Platonov) face reality in general terms as a principal starting point or perspective.

Valery Podoroga defines such mimetic transformation (mania) an anthropogram—the chiasmus conflating the subject and objective reality. A certain mode of behavior of a fictitious character, an anthropogram is something not rationally prescribed by an author in a preliminary projection of composition, but it evolves as a tacit mimetic maniacal map, a landscape in which choreography, plastics, mimics, ethics, and speech and stuttering are displayed in the composition of a piece.[16] This mimetic mania of the anthropogram can be traced in an artwork only a posteriori, as the author cannot be fully aware of it. However, according to Podoroga, this tacit mimetic map defines the plastic eventality of a literary piece. A mimetic mania for Platonov, for example, would be a "eunuch of the soul," for Dostoyevsky "a man without skin"—a man of extreme vulnerability for whom anything that can happen is like an electric shock. For Kafka, the anthropogram would be an act of bending the head, since any door is lower than one's height. It is interesting, meanwhile, that in Kafka's text such a detail as the size of a door might not even be mentioned. But the logic of the created mimetic and plastic fictitious "landscape" enables one to see those movements taking place with a certain specific choreography. These are the mimetic anthropograms, the descriptions of which, however, are absent within the nominal text of the piece itself. Hence, Podoroga reveals a mimetic mania not in the nominal structure of the text, but shows this mania as the composed body of an artwork and artistic imagery (*hudozhestvenni obraz*), which surpasses the text. Thus, artistic imagery is not given nominally as the image of a concrete thing or a human being; it inhabits the ineffable compositional organics of the artwork itself, producing its *body* (*Telo*).

The passive voice of plastic overtness is not meant in the sense of straightforward suffering or some sort of empathy, but as the self-resignation of an ego in favor of imprinting the objective world on itself. The resignation of the ego is necessary in order to be able to resonate with reality, to accept *plastic indentation* from it. Art imagery, then, is not a construct; it is the composed body into which the

16. See Valery Podoroga, *Anthropogrammes* (St Petersburg: European University, 2017)

syndromatic mania of an artist evolved after the imprint and indentation that reality inflicted upon the artist.

To be able to plug into reality, one thus has to resign from the self (let us remember "human resignation") and be ready to transpose oneself into the "passive voice." The sensuous bond with reality can only be acquired in the "passive voice." It is then not "me" who intervenes in reality, but it is reality that intervenes in "me." Thereby the syndrome of *a passive voice*.

Such an ethical syndrome presupposes the utmost modesty, but at the same time extreme courage exactly by virtue of residing in humility. This syndrome can be traced in literature and drama from the Renaissance up to modernism, or in the entire corpus of so-called "classical" music after Dutch polyphony, i.e., from the sixteenth century up to serialism (even Viennese new music still can be considered a specimen of such overt selflessness). Resignation thus would imply the refusal to protect one's ego. On the one hand, this sounds like Tolstovian acquiescence. Yet it is exactly such "zealous selflessness" as the form of radical and maniacal anti-egoism that facilitates the regime of the other-determined non-self being. This exposes the "I" to undergoing the imprint of reality and thus twisting one's "I" into the passive voice.

But despite and along with such a "masochist" condition, along with the appropriation of pain and reacting to it, one has to simultaneously maintain the procedure of composition. The passionate plunge into the passive voice, the condition of being seized by the event, should paradoxically entail the capacity to witness one's involvement from outside of this entangled position and generate the mimetic excess of composition in addition to such maniacal entanglements with reality. This presupposes titanic efforts. In such a role the artist is a sort of martyr, and art is then rather an act of martyrdom. Composition has nothing to do, then, with merely the engineered construction of a piece. It is not a scheme or a structure, but an extreme and deliberate vulneration, which despite and along with it, is able to invent the oblique, gnomic, hieroglyphic modes of transmitting "the first" reality into "the second," fictitious one. Then the opus—a classical work of art—is not at all an investment in any imaginary aesthetic perpetuity in terms of something being eternal as an aesthetic

or cultural value. Composition then asserts infinity within and despite existential mortality and profanity. This is because reality can only be grasped as a conditional and generalized entity, as material ideality.

*

* *

To recall, one of the primary modes of dismissing composition in the history of art has been by means of the concept: the conceptual act in art discards any need for composition. In a readymade there can be no composition.

For example, John Cage's *4'33"* can be seen both as the limit of composition and the utmost emptied shell of the composed form. However, it can also be regarded as an act of complete dismissal of composition (not simply as an act of transcending music, as some sort of zero degree of music, as Diedrich Diederichsen put it, but already a conceptual contemporary art piece).

The dismissal of composition as well as the shift to post-industrial production was generated by a specific attitude toward labor in the post-industrial era. *4'33"* is an excellent example of non-labor—a composition of non-composition. This piece is in a way a critique of labor in the post-industrial era, when all labor is defined as subsumed, abstract, and susceptible to division. Consequently, composition is defined as being dependent in a way on the acquisition of excellence in some craft: it requires an enormous amount of time for the development of skills which many will never have. At the same time denial of the labor that produces an artwork gives an artist incredible freedom in that the imagined, the fictitious—that very gnomic generalized conditionality of reality—is not to be composed any longer. The labor of mimesis is painstaking work that can be dismissed altogether.

In his *Letters on the Aesthetic Education of Man* (1795), Friedrich Schiller (and Jacques Rancière follows him in it) defines the role of aesthetics as an escape from the necessity of labor towards *play*, towards the free place of "neither ... nor" (neither consumption, nor the complete transcendence of the divine or sublime divinity).

However, Lukács criticizes precisely Schiller's removal of labor from artistic production. He emphasizes that both the work of

thought and the work of imagination, as well as the methods of constructing artworks, are inseparable from labor—even if it is a labor of creation. By divorcing labor from aesthetics as Schiller does, Lukács claims that a wrong interpretation arises of artistic production being something detached from work.[17] However, the main fallacy, so it seems, with both Schiller and later Rancière, is that by ignoring labor in art, there is a reluctance to consider the diligence of mimesis as the labor inherent in composition. This arises from viewing art mainly via the dimension of perception and reception, rather than conception and production.

Returning to the ethical and aesthetic rejection of labor in art, it is important to take note of two aspects: (1) In the contemporary work of art, let us say in a conceptual artwork, the labor of production at times equals the moment of conjecture, a guess, a mental game, or a concept being made. And these actions of the mind are not considered labor. Such an approach is both right and wrong. It is right, because we associate labor mainly with a time-consuming effort, both material and immaterial. And it is also wrong, because the capacity for thought or operations of the mind are inseparable from labor. In other words, from the point of view of materialist dialectics, the human mind evolves from labor and is its extension both historically and anthropologically. Hence, labor is inscribed even in a momentous guess or a paradox generated in the act of thought.

Yet, labor is posited as absent from the conceptual work of art in the sense in which within it there is no need for sensuous engagement with the event. Within it consciousness does not dirty or dissipate itself in reality, in order to produce another, "second" conditional reality.

Another aspect to be heeded here is that even when we have a certain piece of contemporary art production—*not necessarily conceptual art biased on the work of the mind* but, for example, complex installations, serial music pieces, narrative documents—which in fact seems to be constructed even in a more complex way than any classical artwork, this does not mean that it is *composed*, that it is a

17. Georg Lukács, *The Specificity of the Aesthetic*, vol. 2 (Berlin; Weimar: Aufbau Verlag, 1987).

composition. Why? The answer first and foremost is because for such an art object, the primary thing is either contingency, "a throw of the dice," or, on the contrary, a completely prescribed design.

III
THE PASSIVE VOICE IN "CLASSICAL" COMPOSITION

Let us set out here for a bit of distance. To begin with, I refer to one of the important aesthetic conditions brought up in the critique and in the reconsideration of the metaphysical legacy of European thought, which late post-structuralist thinking initiated—with Jean-Luc Nancy, Philippe Lacoue-Labarthe, and in part, Jacques Derrida. This critique was often directed against the Nietzschean and Wagnerian paradigms of theater, performativity, and musicality.

This was another strike against Wagner, following in Adorno's footsteps, before apologia for the composer's work appeared on the intellectual scene in recent works by Badiou, Žižek, and Groys.

The principal assumption underlying the interpretation that Lacoue-Labarthe put forward is the following: the more form attempts to reveal sublime content, the more it tries to mimetically assemble the evental, the more it evades the truthful and the sublime and falls into the trap of kitsch.[18] According to Lacoue-Labarthe and Nancy, form cannot be an entity, an opus; it has to cease being composed as a continuity, and should rather become a fragment, a residue, and a splinter.

Thus the claim that one can transmit the truthfulness of things in language, image, sound, music, or melody is fake and illusionary, and hence classical art is fictitious and metaphysical in its self-deception. This is because it only pretends to transmit the entire picture of certain events as truthful, but it is in fact unable to do so. The efforts of so-called classical aesthetics to access truthfulness by compositional means and artistic imagery are then considered chimera and hence false. Counteraction to this fictitious tradition of mimesis was therefore nothing but a refusal to transmit any content whatsoever; it

18. Philippe Lacoue-Labarthe, *Musica Ficta: Figures of Wagner* (Stanford: Stanford University Press, 1994), and *The Subject of Philosophy* (Minneapolis: University of Minnesota Press, 1993).

implied a retreat to forms that refused any transmission of the event, or exertion of a cathartic act. Such apophatic modesty implies an utterly artistic, poetic, and philosophic honesty.

It is only logical that Nancy, Lacoue-Labarthe, and Derrida, even without knowing much about contemporary art or theories of conceptualism, in fact reached some kind of quasi-Kosuthian stance, where art was superseded by a certain kind of quasi-theory—a condition that transformed art into a post-philosophy. In this conjecture the poetic, the melodic, the figurated, and the imaginary had to give way to the prosaic, fragmented—to the deranged series of sounds, to deconstructed non-images, speculations, or even apophatic stuttering that mutes voices and shuts out pictures.

Lacoue-Labarthe's theory derives from the counter-aesthetic standpoint of the speculative, quasi-philosophical subject of German Romanticism and the further supersession of poetry with speculative prose as the principal paradigmatic shift towards modernity, as embodied by Hölderlin. Of course, for the French authors of deconstruction that angle of modernism, which derived from overt Promethean hubris—when the subject confronts the entire world in its negative and melancholic solitariness—was also unacceptable. Deconstruction had to deconstruct both objectivity (materiality, reality) and subjectivity. Yet what was important for deconstruction was the twofold, total apophaticism: not only restraint from the world and reality, but also restraint from the sprawling hubris of the subject. Derrida, Nancy, and Lacoue-Labarthe (but also Adorno) described this model in their critique of Nietzsche and Wagner when they appealed to deconstructive speculation instead of the performative splendor of the subject's hubris and sovereignty.

Thus, the authors of deconstruction (Derrida, Nancy, Lacoue-Labarthe) dismiss the modernist brand of hubris as empty pathos; only those modernist pieces which demonstrate radical apophatic retreat deserve their attention. However, for the deconstructionists, an artist's belief in their ability to reflect or mirror reality remains an even greater arrogance.

In the classical paradigm things are the opposite. What matters is the claim for the utmostness of the message, even despite a message's inaccessibility.

We all remember McLuhan's motto, according to which the medium is the message. Such an approach automatically presupposes that so-called realistic (classical) art counts on catching the fish in the net—i.e., it preserves the task of dealing with the true and retains the pretension of transmitting the message rather than superseding it with the medium. Such (realistic) art is (as is any other kind of art) merely a stylistic medium; and styles and media become obsolete.

Yet the extremity of realism lies in retaining the obsession with the *what*. This *what* is to be transmitted only as the general, common, fictitious, and conditional: i.e., with the utmost "zealous selflessness" asserted in the labor of composing. To repeat, the point is not only in having the courage to undergo the imprint of the world on oneself (simultaneously transmitting one's "I" into the passive voice). One has to additionally run the labor of composing—so as not only to become seized by the world's objectivity, but also to return to the world all its imagery in all its generality, and to do so in and by the very act of composing: the double bind process that requires both extreme vulnerability and passivity of the ego, and excessive labor and zeal.

Meanwhile any contemporary artist might argue that s/he deals precisely with reality—with reflecting and analyzing it. No one produces abstract fine art forms except for commercial artists and designers. And indeed, isn't everyone busy researching the problems and conflict zones of our contemporaneity—from the migration crisis and wars to macroeconomics and digital novelties? Yet, if we look more closely, we see that despite the sometimes macabre materials that one can encounter in any given art practice, the artist herself/himself generally remains in relative safety and *ataraxia* (indifference). S/he is involved in research and investigation intellectually, psychically, or even corporeally. But the sensuously (in the Hegelian sense) produced umbilical connection with reality is absent. "Sensuous" in this case implies Hegel's parameter of the classical. In his introduction to *Aesthetics*, Hegel defines the classical art of antiquity (and the Renaissance) as one in which the idea and its sensuous configuration are shaped in accordance with one another. They are conflated. In such art, the idea does not hover over materiality as in Romanticism. Moreover, it is only due to the sensuous peculiarity of the content that an idea or spirit acquires concretization. As Hegel argues, in the art

of the classical period spirit appears sensuously and in its body; simply because it is by means of sensuous embodiment that the spiritual can be manifested as "the truly inner self," and not as abstraction.[19]

On the other hand, many researchers treat the aspect of sensuousness in Hegel's aesthetics as quite dubious. The reason for this is that, on the one hand, Hegel claims aesthetics as the principal tool that art possesses for bringing about truth; on the other hand, Hegel himself declares this tool obsolete and delegates truth mainly to the speculative methods of philosophy. So, the question arises to whether sensuousness as art's means to bring truth into being, and art itself as involved in truth, was ever an apt gnoseological tool for Hegel. Is this not the very the reason he declared art redundant? Art can then also be interpreted in Hegel's system as the reifying contradiction in spirit, or even as its degradation.

Mikhail Lifshitz emphasizes exactly this issue when he touches upon the function of the sensuousness in art in his *Aesthetics of Hegel*.[20] As he argues, it is true that Hegelian sensuousness is definitely a descent of spirit and of idea into reality and a contradiction to the idea. But, as Lifshitz insists, for Hegel this descent of the spiritual and the conceptual into sensuous objecthood is inevitable in the cycle of an idea. The *highest* has to inevitably descend to the *lowest*, and the *lowest* must ascend to the *highest*, to the ideal. But this process is formed as one dialectical body so that it is not only the spirit that needs the object, but an object as well that needs ideation, concept, and spirit.

The pleroma (mesotes) of the classical aesthetic form as the convergence of the conceptual and the material, nevertheless, is not simply a balance between extremes, a secure pre-established harmony. Hegel gives Christ as an example of the spirit's *concrete* incarnation: in him the abstract (spirit, logos) and the concrete (body, matter) converge. Yet this convergence takes place not as a mechanic combination, but due to the voluntary sacrifice of God (of the highest) by means of the fatal and inevitable descent to the most painful, to the lowest, most miserable, or uncanny. A similar condition is played

19. G. W. F. Hegel, *Aesthetics: Lectures on Fine Art*, vol. 1, trans. T.M. Knox (Oxford: Oxford University Press, 1988), 73–77.
20. Mikhail Lifshitz, "Estetika Gegelja I Sovremennost," in *O Gegele* (Moscow: Grundrisse, 2012) 153–185, 172.

out in the myth of Orpheus, in which his becoming a poet is preceded by his descent to Hades. Dante does the same: he descends into the inferno before he starts to compose. The descent of an idea into the real is a fate that cannot be evaded when one has to question the truthful. Such a descent has the function of a sacrificial quest or even martyrdom. However, the downfall into the sensuous is not the sole moment in the cycle of the idea. The "lower" is, in its own turn, able to evolve and confirm itself as the ideated and the ideal, despite and within its finiteness and degradation. This is exactly why, in a work of art, as Hegel shows, the most wretched, oppressed, or the most miserable situations of life are able to manifest themselves as ideal, and do so despite their factual wretchedness and simultaneously with it. Classical art contains this emancipatory de-alienating power, functioning within and despite alienation and oppression. Hegel writes:

> The beggar boys of Murillo (in the Central Gallery at Munich) are excellent too. Abstractly considered, the subject-matter here too is drawn from "vulgar nature": the mother picks lice out of the head of one of the boys while he quietly munches his bread; on a similar picture two other boys, ragged and poor, are eating melon and grapes. But in this poverty and semi-nakedness what precisely shines forth within and without is nothing but complete absence of care and concern—a Dervish could not have less—in the full feeling of their well-being and delight in life. This freedom from care for external things and the inner freedom made visible outwardly is what the Concept of the Ideal requires. ... We see that they have no wider interests and aims, yet not at all because of stupidity; rather do they squat on the ground content and serene, almost like the gods of Olympus; they do nothing, they say nothing; but they are people all of one piece without any surliness or discontent; and since they possess this foundation of all excellence, we have the idea that anything may come of these youths.[21]

21. G. W. F. Hegel, *Aesthetics: Lectures on Fine Art*, 170.

*

* *

Sensuousness does not reside in the internalization of the world by a subject; or vice versa, in an overall mechanical immersion of a subject in the object, the thing. It resides instead in the specific contact with the event, with the objectivity of the world, possibly due to the ethics of the non-self being.

It is important to note that on the one hand, reality can be mirrored by the subject due to self-resignation, i.e., due to the subject's shift into the passive voice. But at the same time, while remaining in this passivity one is to conceive and *compose* the second mirrored reality in all its conditionality, fictionality, and generality. Yet such a stance does not presuppose any dismissal of subjectivity, it can only generate it.[22] Moreover, exactly such an "idiotic" subject generated by the human resignation's regime of the passive voice is able to feel and act as though alienation had been sublated despite subordination and alienation. This capacity is not at all an idealistic fantasy, or ignorance; it is rather a courageous and self-forgetful ability to compose the impossible "communist condition" within the existing non-communist reality.

To conclude: "the classical" (the realist) in art is communist exactly in the sense that it can conceive the "ideal" situation and "ideal" subjectivity in the midst of and despite the most deplorable conditions. Yet, this capacity has nothing to do with phantasy or idealism. Rather it resides in the perseverance to retain the minimal extent of de-alienatedness in the conditions of the harshest alienation. Then the goal is not only to claim social resistance in art, but to become and to *sensuously* compose "the body" and "the subject" of the future reality without alienation; in other words, to sensuously strain oneself in order to embody the untimely and premature communist condition even in the midst of communism's complete absence.

22. Let us quote Mikhail Lifshitz: "We are all the more personal when we submerge ourselves in pure facts and objects. And conversely: we become true subjects when we fully grasp objectivity." Lifshitz, *What Is the Classical?*, 359. My translation.

Part IV

Philosophic Ontics
of Communism

CHAPTER 10

ON THE GENERIC HUMANISM
OF LABOR AND CULTURE

I
DISCONTENTS WITH CULTURE

Modernism and the avant-garde treated culture as a deadlock, as civilizational homeostasis, as an obstacle to lively artistic processes, to the development of thought, or more so, to political agency. Modernism and both avant-gardes (in the 1910s and 20s, and the 60s)—although in different ways—tended to juxtapose culture, as the static repository of creative, technological, or cognitive achievements, with creativity. Art and culture in this case had been considered extreme opposites—culture was something established, whereas art was a practice that subverts or exceeds that establishment. This split epitomized the Copernican turn in modernism and its critique of the project of Enlightenment. (Needless to say, this discussion focuses on the extent to which culture was condemned and confronted by thought beginning with Nietzsche.) Culture could never meet the demands of novelty—in art, science, and thinking. It was something that hampered revolutionary change, and was thus an obstacle to the historical process that could only be understood via revolutionary procedures. The principal claims of Adorno's aesthetic theory are termination of the hegemony of culture and liberation of art from cultural history in order to make a leap into the revolutionary history of radical artistic gestures. For Adorno, culture is industry, factory, and commodity. Or, even if culture is not commodified, it is subservient to bourgeois tastes: or we could say that it functions either according to established rules of valorization or according to the pleasure principle. Culture as concept and as social habit becomes synonymous with the bourgeois class. According to avant-garde aesthetics—both of the Russian avant-garde, as well as the second wave in the 1960s—culture had become an embodiment of elitism, and of the consequences of the division of labor that had to be sublated. Therefore, any cultural politics in the conditions of an avant-garde would have to deal with the eradication of "old" culture and the invention of completely new means of production—thus removing this term from use altogether. The supersession of the obsolete notion of culture by the notion of production was put

at stake in the works of early Soviet productionists and members of the Proletkult. This line also found its continuation in the works of Benjamin.[1]

We see how modernisms and the avant-gardes courageously transfer pre-modernist art to the historical archive. And although premodernist art goes on to circulate as industry, it is considered "dead" in terms of contemporary creative needs and goals. In fact, in modernism and the avant-gardes alike, the work of art had to hide its cultural genesis. The less an artwork was embedded in cultural references, the more it was art.[2]

Keeping in mind this rejection of culture in modernism and the avant-gardes, Boris Groys emphasizes in numerous works how the avant-garde/modernist artists—even despite their reductionism—often paid apophatic tribute to "previous culture." They rejected culture not because they did not appreciate it, but because they

1. O. Brick, B. Arvatov, S. Tretyakov, N. Tarabukin, A. Bogdanov, V. Pletnev, and others.

2. One of the rare examples of keeping the notion of culture within the aesthetics of modernism can be found in Ezra Pound's attempt. Although his idea of culture was borrowed from colonial anthropology, and although he even invented a neologism for culture via a new spelling—*kulchur*—he nevertheless attempted to preserve this notion as viable, thus differentiating the dead culture from the active function of *kulchur*. Interestingly, his idea of "kulchur" overlaps with the anti-universalist, pluriversal interpretations of culture in present decolonial studies. In his *Guide to Kulchur* (1938), Pound quotes his favorite artist, Henri Gaudier-Brzeska, the sculptor who sees culture not as the repository of human achievements, or of valuable aestheticized objects, but in the repetition of certain movements or gestures that characterize this or that gestalt. For example, Gaudier observes various cultures via thier adaptation of one specific form—the sphere. In Assyria, the sphere becomes horizontal; in Canaan, it is squeezed into the ellipsis; in China, the sphere is disregarded altogether; in Africa, it is stretched to become a cylinder or conus—the cubists crystallize it. In this case *kulchur* is not secondary in relation to art, but on the contrary a unique work of art reflects the greater event of cultural *paideia*—a cultural move molding the paradigm of a cultural act in its various aspects. A work of art then loses its supreme value and factual importance since its eventality resides in a certain configuration of unique conduct when treating things by a certain collectivity—be it love, friendship, or economy. Such *paideia*, or cultural setting, generates large processes, tendencies and attitudes—like Provençal poetry affected by grace and courtesy or a line in eighteenth century drawing, which Pound claims to be affected by the economy of usury, or a metaphor in Chinese poetry affected by ideogrammatic, non-phonological writing, etc. See Ezra Pound, *Guide to Kulchur* (Cambridge, MA: New Directions, 1970).

PHILOSOPHIC ONTICS
OF COMMUNISM

225

had to first dispense with it to then preserve at least the ineffable remainder of it. This was done in order to feel its impact again, because of being unable to experience it in its former intensity and novelty. Therefore, the modernist and avant-garde negation of culture can also be seen as a decision to self-punish for such atrophy. In other words, the previously experienced intensity of culture was lost. Because of the transformation of art and culture into uniform industry and consumption, it became impossible to share even this lost intensity. Such a reductionist pathos might then be manifested as sacrificial rejection and as a desperate extermination of culture.

According to this logic, the necessity to eradicate culture is based on the following condition: exactly those who preserve the riches of culture dismiss it because of its commodification and industrialization; culture becomes consumed by the masses, or/ and misused by the bourgeoisie in order to legitimate elitist connoisseurship. For example, Arnold Schoenberg, Alban Berg, and Anton von Webern—composers of the New Viennese school who gave up the previous form of musical harmony in their system of composition altogether, were nevertheless devoted to the history of polyphony dating back to the fifteenth century. They considered themselves to be the successors of the Netherlandish polyphonic school and traced the history of its development back to Gustav Mahler.[3]

However, in a similar respect to Adorno's cultural sociology, they had to reject both the populist acceptance of culture and its heritage, as well as false elitism—thus ousting culture from their horizon and deploring its end. What we confront here is a mimesis of nothingness,

3. The composers of the so-called Netherlandish School originated in the fifteenth and sixteenth centuries and formed five generations. Most of these musicians were born in the so-called "Low countries," in the Burgundian provinces of Flanders, Brabant, and Limburg, and wrote ecclesiastical choral music for the cathedrals and churches in Antwerp, Bruges, and Ghent. Quite a number of musicians gradually moved to the courts of Italy, Spain, Germany, and France, as well as other parts of Europe, so that by the end of the sixteenth century the focal point of the Western music world had moved from the "Low countries" to Italy. Renowned members of the Netherlandish polyphonic school include Guillaume Dufay, Alexander Agricola, Johannes Ockeghem, Jacob Obrecht, Heinrich Isaac, Josquin Des Prez, Orlando de Lassus, and many others.

a mimesis of the ineffable and the impossible. The logic of Adornian negative mimesis had to bring art's genealogy to a zero point. This nullification is an oblique mode of experiencing awe before cultural history and art. And the fact that Adorno ignored the Copernican rupture between pre-modernist and modernist art, and rather considered all art previous to modernism in terms of a negative, retroactive conceptual revolution, confirms this apophatic veneration of culture. Adorno's premise of the negative revolution in art was that a true work of art has to undermine whatever comes prior to this work; otherwise it is not viable as an artistic phenomenon. Adorno extrapolated this logic to every form of art, whether modernist or pre-modernist. In other words, if we preserve negative historicist continuity in the Adornian sense, then the whole history of art should be regarded as a set of ruptures. But if we assume that modernism brings with it a Copernican turn between the premodernist and modernist standpoints, then all culture has to be dismissed as a relic of obsolete creative activity and thought. So, Adorno's negativism is quite retroactive and even preserves the possibility of mimesis, only this is the mimesis of apophatic silencing.

The constructivist and productivist wings of the Russian and early Soviet avant-garde share in modernism's idea of withered culture, but invent strategies of estrangement that could construct a new world full of novelty and fresh perspectives. Therefore, the question for the Russian avant-garde artists was how to estrange and defamiliarize art so that it never became "classical" or cultural again. The avant-garde's standpoint was that in the conditions of life-building (*jizhnestroenie*), art would constantly revolutionize itself without piling up cultural values.

In both cases—the modernist apophatic dialectics of the rejection-preservation of imaginary culture, as well as the avant-garde cultural politics based on radical novelty—the main premise was that culture is something sacral, valuable, and comprehensible mainly for connoisseurs.

II
THE NECESSITY OF CULTURE FOR ART

As is well known, Lunacharsky and Lenin's Soviet cultural politics rehabilitated the notions of world culture and "classical" art. Their standpoint was that it was mainly the bourgeoisie and cultural elite that treated culture as a withered repository of artifacts. The rising working class, on the contrary, acquired access to the riches of art, science, and culture of the world only after the revolution. Moreover, in the post-revolutionary, classless society, world culture, which had been historically (for the most part) only accessible to the ruling elites, became a universal inheritance for everyone. In other words, world culture had to be reassessed from a completely different standpoint than the anti-bourgeois resistance against culture that had persisted under the conditions of capitalism.

These issues became even more important in the 1960s and 1970s with the confrontation between non-conformist underground art, which claimed its origins in the modernist tradition, and the lexicon and methodology of so-called "official" "socialist" art, for which the goal was not so much methodological innovation, but rather reappropriation of the whole history of art, science, and philosophy from the perspective of socialist ethics.

The kernel of Soviet aesthetics as opposed to modernist aesthetics was that art without embeddedness in culture cannot be artistic enough, as it cannot get rid of individual sovereignty: without the cultural horizon art lacks generality. This is because culture is not at all a material specimen of an aesthetic or ethnographic activity of different periods and different regions; culture is anything that is de facto produced by means of labor for non-individual use and hence acquires a general and generic dimension, along with having a material form.

Ilya Kabakov remarks on a very important trait characteristic of the Soviet experience of world culture. In the Soviet experience, culture relies on the question "why," rather than the modernist question "how."[4]

4. Ilya Kabakov, *60-e, 70-e zapiski o neofizialnoy jizni v Moskve* [1960s, 1970s: Notes on Unofficial Life in Moscow] (Moscow: NLO, 2008), 52, 178.

Cultural integrity, as Kabakov insists, stems from regarding culture as something that is inevitably produced and inherited by humanity universally; it is a generic human necessity. According to Kabakov, an intellectual involved in culture is not an elitist, but is the one who takes care and sacrifices his sovereignty.[5] It may be useful to quote his perspective at some length:

> But here we run into difficulties in response to the question "why": I am either a free individual, or a medium, a servant, an "envoy" like in the work of Daniil Kharms, an intermediary of something that I cannot grasp. Then the answer to the question "why" might look like this: I am fulfilling a mission that is many times larger than my small life. Someone needed me to be born. In some cases, this might be an answer that is entirely cultured. It might be the reproduction of a gene, of an uninterrupted line. ... Behind my back there is something that cared about my existence and made sense of it. Not about me physically, but about the meaning of my everyday activity. I am a representative of an infinite cultural process that was there before me.[6]

Boris Groys brings forth a similar argument in his early text "Poetry, Culture, and Death in the City of Moscow":

> In his work, an artist activates forces that transcend in their power and impact his own individual goals. It is the extent of his understanding of culture, within which he works, that determines to what extent the impact of those forces happen to be beneficial for his own creation and fate. ... In these forces and not in the soul of an artist one has to search for the clue for the fact that the great artworks exceed their creator, reader or spectator. ... From which point of view do we inspect the mortality of our own "ego"? From the point of view of culture.[7]

5. Ibid.
6. Ibid.
7. Boris Groys, "Poetry, Culture, and Death in the City of Moscow," in *Early Texts: 1976–1990* (Moscow: Ad Marginem Press, 2017), 122.

PHILOSOPHIC ONTICS
OF COMMUNISM

The diachronic dimension of culture is not at all about traditionalist cultural continuity, but about the fact that what precedes the birth of a human being and what one encounters with it can only be the items of labor and culture, and not of raw nature. In this sense, culture is everything that was made by the preceding generations by means of labor. Culture is something that antedates each separate human being, is prior to him/her. Cultural diachronics is not about tradition and respect for it, but deals instead with the fact that culture is something a human being encounters as s/he is born. In this sense one is born into culture, not nature. Culture is the inevitability conditioned by human existence, which evolves by means of various modes of labor. Therefore, it is not about the veneration of objects, but about the irreversibility of labor in the evolution of matter. It is something that exceeds "me" in producing and constructing this world. Thus, we come to something quite paradoxical: If culture is first and foremost labor, then any mode of labor is cultural by definition. How can this be?

Before answering this question, let us consider two very important assaults against culture. One comes from Freud, and the other from post-structuralism. In each of them, the political lexicon of emancipation is counter to both culture and labor.

In Freud's programmatic 1930 text "Civilization and its Discontents," culture epitomizes the censorship of desire and drive; it functions as repression against them. It is seen as the genealogy and history of human achievement, but gained at the expense of dispensing with enjoyment. While emphasizing that culture is collective, Freud considers its social dimension as a negative trait imposed on an individual psyche and its desire by a collective. Collectivity is seen as a negative force that forms various sorts of taboos confronting the individual. Culture has nothing to do with emancipation; it is a set of constraints, since it counteracts desire, drive, and sexuality. In this case culture as the generalizing and universalizing institution either suppresses the drive, or sublimates it.

In post-structuralism (Lacan, Deleuze, Guattari, Derrida, and Foucault), the criticism of culture is complemented by the critique of language and its metaphysical, idealist dimension. Post-structuralism believed that there exist possibilities to evade the grids of structure and the constraints of culture. Language is the embodiment of

rationality, of structural invariants, and universalia, and hence of cultural restrictions. In his "Of Grammatology," Derrida attempted to deconstruct the conditions of phonological values of language, to blur the role of the signifier and effectuate this by means of permanent difference and deferral in the procedure of *l'ecriture*.

For Deleuze and Guattari, too, what matters is the alternative set of semiological constellations that would cancel the hegemony of the signifier. In his *Chaosmosis: An Ethico-Aesthetic Paradigm* (1992), Guattari talks about "a-signifying semiological dimensions that trigger informational sign machines and that function in parallel or independently of the fact that they produce and convey significations and denotation and thus escape from strictly linguistic axiomatics."[8] Guattari deplores that in the end even the a-signifying economy of language has been reduced to the linguistic, significational economy of language.[9]

Hence what we can trace in Deleuze and Guattari, and further in Virno, is an attempt to separate the psychosomatic or bio-reflexological components and their autonomous creative and emancipatory power from linguistic signification—an act that would posit emancipation as liberation from both culture and language. In all of these cases, culture seems to be regarded as an obstacle hampering access to the unthinkable or the unimaginable, the ineffable, to the Real—i.e., access to something truly material that can only produce the conditions for political or creative subversion.[10]

8. Félix Guattari, *Chaosmosis: An Ethico-aesthetic Paradigm*, trans. Paul Bains and Julian Pefanis (Bloomington: Indiana University Press, 1995), 4.
9. Ibid., 33–57.
10. This was despite Lacan's claim that even the Real cannot be grasped without language, that any attempt to go beyond language ends up in the false expectation of prelinguistic and precultural space. Lacan shows that even the most uncanny, the unimaginable, the ineffable—i.e., symbolic categories are, on the one hand, beyond the linguistic or semiotic grip, but, on the other hand, cannot be named or hooked without language. Which means that the non-cultural and non-linguistic Real and the symbolic signifier are intertwined despite being incompatible with each other.

PHILOSOPHIC ONTICS
OF COMMUNISM 231

III
NON-SELF BEING

In Soviet aesthetics, philosophy, and psychology—in works by Evald Ilyenkov, Lev Vygotsky, Alexey Leontiev—we encounter a rather different treatment of both the issue of culture as well as that of language. Language deals with generalizations while having a material form. But what stands behind language is not instinct, drive, or the unconscious—i.e., non-cultural, empirical categories. Quite the contrary, the societally developed means of activity that construct objective reality in all its generality and capacity to be molded into thought is what resides behind language. Thus language is preceded by objective reality and hence by the general, the ideal, the generic, and the universal. Language represents the general form of existence—its traits, relations, and societal practices wrapped in the matter of speech and language. Therefore, meaning is general not because generality resides in the form of language, but because it precedes language in the form of a broader reality. In short, what molds the generality of culture and thought evolves from the generality of labor and societal activity. Thus, what stands behind language is not less general and more empirical than language, but is even more general than language as such.

Traditionally, in the context of the Enlightenment, culture departs from education, *Bildung*. From the Marxist angle, conversely, all practices including culture, thought, education, and economy are grounded by *labor*. Therefore, thought and culture are not abstract or immaterial categories against those that are concrete and empirical. The term "cultural" in this case equals social, labor-based—and vice versa, labor (activity) would inevitably mean cultural. Culture is a sort of labor that resides in the awareness of a collective human contribution to the production of life and its historicity. To sum it up, language is much less abstract and general, and much closer to materiality, than it is posited in post-structuralism. Conversely, material reality, since we as humans have never known any materiality without activity and labor, has always already been an ideated and general phenomenon.

Both Vygotsky and Ilyenkov would definitely admit that language and its denotative role function as *the* tool of generality. Yet importantly, in their conception of language, the conditions of thinking are generated by the inevitability of labor—which is antecedent to concrete language forms, and is preliminary in its generality to the form of language. In other words, labor is "the ideal," "the general," and "the cultural" that precedes language. Language then is merely a means to let the general acquire material articulation.

The cultural paradigm of socialism that follows after the avant-garde is traditionally considered to be predominantly Stalinist. However, the apologetic attitude toward the universal dimension of art and culture, reinterpreted as alter-modern, was already part of Lenin, Trotsky, and Lunacharsky's cultural politics, which was later developed in Lifshitz and Ilyenkov's philosophical texts. For Ilyenkov, the notion of culture was not determined by any cultural difference or aesthetic, stylistic, or regional traits of material fabrication. Culture was something that dealt with the untimely, with the non-local, generic human activity that enabled it to exceed any confrontation between the old and the new. Yet this neutralization of the confrontation between the old and the new does not take place beyond history; it is historically biased and stems from the new social conditions of sublated capitalism. This incessant, traumatic clash between the old (unemancipated) and the new (the emancipated) had to become redundant in communism.

Certain material objects—architecture, art, music, and literature—might be subjected to the judgment of taste and regional habits, yet what is important about something being "culture" is that it implies being an invention for all, in that any material object confirms the generic existence of humanity. In this sense, simple material objects like pincers, plates, or spoons are also cultural. How can this be? Is a plate or a spoon as valuable as the achievement of architecture, as a material artifact dating back to the previous millennium, or the invention of an alphabet?

Ilyenkov has a very elaborate theory on how to construct premises for such cultural universality: culture is something socially and hence collectively grounded; it is embedded in the necessity, incentive, and expediency to produce and create. However, such necessity

is not placed anywhere nominally—either in a concrete object, concrete person, or social group; i.e., culture is nobody's possession or property. It is nowhere, and still elsewhere. The point of departure for such an understanding of culture is the presence of humankind in the world in its non-naturalistic, counter-species, generic dimension.[11]

In his work "On the General," Ilyenkov writes:

> A particular individual represents "man" in the strict and accurate sense of the word in so much as he realizes—precisely through his individuality—a certain sum-total of historically-developed capabilities (especially human ways of vital activity), a particular fragment of culture which has developed prior to, and independently of, himself and which he absorbs through the process of education (self-accomplishment of man). In this sense, the human person can be rightly regarded as the individual embodiment of culture, i.e., the "general" in man. Hence, the general "essence of man" is only real as a culture, as a historically established and evolutionizing aggregate of all specifically human forms of vital activity, as the whole of their ensemble.[12]

Thus, it is not that there is first a human species with its attributes, and then a community emerges constructed out of that species. On the contrary, for the most part, there is historically and diachronically marked living activity, the ensemble of historically developed means of labor (*jiznedeyatel'nost*)—and only after that the condition of a human individual appears as the internalization of such an objective assemblage.[13] The material world of made products bears the imprint of such an ensemble of human labor activities (thought is imprinted in that material activity as well). A human is not reduced to the function of species-being because, as Marx argues, if an animal forms matter

11. Evald Ilyenkov, "On the General" in *Filosofia I Kul'tura* [Philosophy and culture] (Moscow: Politizdat, 1991), 320–339. Available in English: https://www.marxists.org/archive/ilyenkov/works/articles/universal.htm. First published in *Philosophical Investigations in the USSR*, edited by Frederick J. Adelmann (1975), 26–51.
12. Ibid., 333.
13. Ibid.

in accord with the need of the species-being, out of and for its own morphology, a human can produce for the needs of other species-beings as well.[14] In other words, the generic mode lies in producing for others, and in implementing this voluntarily.

The objects and notions that one uses, one owes to others. This mutual owing, need, and usage is general, and happens to be human only by the token of such non-self generality. Thus, what one says or does is not confined to genetic inheritance, or origin. The diachronic and synchronic background of labor and social relations conditioned by the other-determined (non)-self being constructs the generality of the human. In considering this connection, it is important to explain why Evald Ilyenkov grounds his argument about the general not so much on the universality of truth, but on the loss of selfhood—on other-determined self. The general or the common is not an entity understood as the principal invariant of any empirical phenomena. It is not a general attribute for the many. Ilyenkov considers the general as being in and for the other—not only among human beings but even among things as well. For example, two chairs are less general than a chair and table together, or the reader and the book; two atoms of the same kind will not produce a chemical compound. So that generality—commonality—is not a collection of similar, unifiable features, or the imposition of one trait distributed as an invariant for the rest, but rather an interaction of two or more things brought together by their mutual lack, and thus their mutual need. Generality connects by amplifying one's lack in the other.[15] It is not the aggregation of sovereign individual selves, but the ensemble of non-selves in need of other selves.

As Ilyenkov reiterates, if for Kant transcendentality was intrinsic to the form of psyche, its inner mechanism, then Hegel and later Marx understood self-consciousness as a historically and socially developing complex—as something acquired as an external phenomena and independent of the individual's will and personal consciousness. Ilyenkov insists that not only for Marx, but also already for Hegel, the thing is ideal only to the extent of its impact

14. Karl Marx, *Economic and Philosophic Manuscripts of 1844*, trans. Martin Milligan (Amherst, NY: Prometheus Books, 1988), 115–135.
15. Ibid., 332.

on outward societal human culture, in the context of socially orga-
nized human life and activity.

And here the traditional idealist logic according to which some-
thing externally outward is material, and something psychically inward
is abstract and ideal, is overturned. One might think one is speculating
on something inherent and personal, but in fact one de facto thinks by
means of what was provided diachronically, dialectically, historically,
societally, generally, i.e., culturally—and hence ideally.[16]

The ideal, then, as Ilyenkov insists, is merely a product and form
of human labor, of the purposeful (*zelenapravlennogo*) transforma-
tion of natural matter and of social relations accomplished by a social
man, who exerts his activity "in the forms preset for him by the ante-
rior development of humankind."[17]

This brings us to the impossibility of something's self-being
without its non-self being, without being via the other (with "the
other" or for "the other"), i.e., without the thing's other-determined
non-self. Within this logic, even simple, applied objects produced by
labor happen to be culturally (ideally) conceived. Then, even Hegel's
"Geist" is not the spirit superimposed on things, but is rather this
very untimely and non-localized capacity of things to be themselves
through other things and selves, so that something that is itself is
not quite itself; somebody who happens to be a concrete individual
is not quite what s/he is.

Ilyenkov famously illustrates this phenomenon with the follow-
ing example: the form of a jar emerging out of the hands of a potter
is neither in a piece of clay, nor in the organism, body, and physics of
the potter as an individual; but it is molded by the diachronics and his-
tory of making objects by humans for humans, and it is exactly this
outward history and diachronic that makes the potter the transmit-
ter of active forms of societal activity, manifested in the concrete case
of producing. The jar is materially what it is, but at the same time it is
also what is not there nominally in the jar—i.e., the life and labor of the
potter, the skills which the potter learned from the previous potter, the
need, instigation, and exertion in making it, the means of production

16. Ibid., 256.
17. Evald Ilyenkov, "The Materialist Understanding of Thinking," in *Filosofia
/ Kul'tura* [Philosophy and culture] (Moscow, Politizdat, 1991), 212–29.

available, the people who would use it, the efforts that could conceive of a jar as an invention, and many others.

Labor, then is understood not only economically, or sociologically, but also ontically and culturally—i.e., in all its diachronic and synchronic breadth. Such an understanding of activity can never be embodied in anything nominally fixed.[18] As Ilyenkov reminds us, the eye does not see itself; it sees the other, the outward. And even to see itself the eye needs "the mirror"—another object. Culture is exactly the realm that unravels the capacity of the world to exist in the regime of this other-determined non-self, which defines the human condition.

As Robert Wallace notes, the thing is the self-determined self, but it is at the same time the other-determined, non-self: "The domain of other-determination goes beyond itself, rather than being transcended or opposed by something that is simply other than itself." And, as he continues: "So being in itself in order to be a property present in determinate being will necessarily involve being-for-other."[19] In other words, there is nothing that is simply itself. Otherness penetrates the idea of selfhood.

So, returning to our example of a spoon or a plate as something cultural and ideal, we would say that they are cultural (and ideal) not as perfectly produced objects, or in some Platonic sense, as things derived from a true form with an idea behind them, but as the objects created, used, and needed given the diachronics and generic dimension of the mind and of collective human production; as something that was produced by labor's non-biologically biased excessiveness, and that was not codified in a human being's bodily or physiological morphology. A plate was made because it was generally needed. This general necessity makes the plate ideal. The need and capacity to use a plate instead of eating without it leads to the form of plate as the climax of the expediency of labor in the production of a plate. This does not mean that the production of plates as utilitarian or consumer objects or commodities might be ideal as such. What is ideal is the realization of the functionality of the plate as general and generic necessity. This is why a plate or a spoon is no less cultural

18. Ibid., 257.
19. Robert Wallace, *Hegel's Philosophy of Reality, Freedom, and God* (Cambridge, UK: Cambridge University Press, 2005), 67.

PHILOSOPHIC ONTICS
OF COMMUNISM 237

than a poem, or a piece of music.[20] The dimension of the cultural is then a teleological (expedient) correlation with outer reality via labor, which is not programmed biologically, and which is not inscribed in the physiological morphology of a human being.

In his "Materialist Understanding of Thought as the Subject of Logic," Ilyenkov writes: "The Ideal is nothing but the combination of the general forms of human activity about which an individual is conscious, and which define the goal, will, and capacity of individuals to act."[21] We are thus born into the potentiality of social ideality.

A possible argument against Ilyenkov's premise on culture and its generic dimension could be the following: even if we allege that there are phenomena—language, culture, knowledge, material artifacts—existing counter-individually and prior to one's existence, the dimension of the general is not confined to the inevitable previous conditions of the diachronicity of culture, labor, and language, since one transforms them under present conditions of existence, whether individual or collective. The answer to such an argument could be that transformations of the present go without saying. What is at stake in the logical premise of culture and the generic dimension prior to any present existence, however, is that, without it, no present, no individual existence, and no agency or change would be possible.

IV
NON-CULTURAL CULTURE

Postmodernity brought us the attitude that anything can be culturally evaluated and marked. In this sense, in the conditions of metamodernity and contemporaneity, anything is culture—from food traditions to lifestyles, from scientific achievements to commerce. Culture, then, could incorporate anything, without claiming any difference between Warhol's Coke bottle and Michelangelo's Cappella, between a Dickens novel or pulp fiction, except for the

20. For example, one can build a concrete house. But nobody knows who invented the house as a structure in which to live. Such things as a plate, a spoon, or a house are generic cultural acquisitions of humankind.
21. Ibid.

costs of those cultural objects. At first sight, such an all-encompassing attitude might be reminiscent of Ilyenkov's standpoint.

Nevertheless, the difference is drastic here. Warhol's Coke bottle could not have become a phenomenon of culture within the socialist theory of culture, whereas any chair or any table, or even that very can of Coke itself—as an invention of mass production—would. A chair, a can of Coke, and their utility happen to be ideal in their use-value, whereas Warhol's Coke bottle as an art object is not. Why? Because the impact of Warhol's art objects is conditioned by the conceptual, monetary, and symbolic surplus that underlies the artist's conceptual gesture, profaning the Coke bottle as an object in its use-value, but fetishizing it within the sovereign, conceptual artistic gesture. Hence such an artistic gesture conceptualizes the surplus value of a can of Coke, and enhances it as the artistic positing of this object as a readymade. Such a gesture does not pay tribute to the generic dimension of the Coke bottle's production in its non-self being and its untimely presence. On the contrary, it emphasizes the profanity of an object and its susceptibility to monetary exchange.

Socialist ethics and aesthetics ground the universal openness of culture on a completely different premise: within them, even a simple spoon bears the potentiality of one of Shakespeare's tragedies or of philosophical thought, which implies that, on the one hand, culture is the everyday, but on the other, that mundane labor and production are stretched out toward the universal.

CHAPTER 11

ON EVALD ILYENKOV'S COSMOLOGICAL HUMANISM

Nowadays there are two main motivations for claiming the extinguishment of the human condition. The first one stems from an ethical and evolutional dismissal of humankind for all its atrocities in relation to nature, ecology, and society. According to these accusations, anthropocentrism is an obsolete planetary and social paradigm.[1] Another path of post- or in-humanism derives from overhumanism, and goes back to Nietzschean nihilism; its present interpretations can be traced in accelerationism. It grounds the end of man by the incapacities of human beings to exceed cognitive, biological, and social finiteness. This finiteness is caused by individualist, philistine interests that restrict human society from competing with technology, abstract and autonomous knowledge, and to overcome the limits of "folk politics" (Nick Srnicek) or earthly existence. Autonomous knowledge becomes the kernel of speculative realism to claim that knowledge should be liberated from subject-object correlation, and has to be able to provide de-subjectified, mathematized, utterly scientific and "sapient" descriptions of reality, devoid of philosophical mystification (Reza Negarestani).[2]

However, it was exactly in philosophy that the dimensions exceeding human cognition or sensitivity—Kant's Sublime or Hegel's Absolute Spirit—were on the one hand considered as the threshold of human consciousness, but on the other, still retained the universalist, speculative dimension implied at least as a regulative idea if not an acquirable knowledge. Philosophy had already claimed the human condition with the scale of the inhuman as its attribute. So that all the inhuman phenomena were envisaged as extending human capacities—in terms of knowledge, mind, consciousness, invention, and science. But such an extension didn't make the name "human" collapse. On the contrary, it was confirmed by those inhuman extensions.

Marx was probably the first to claim a human had never existed and that the human condition is the project of a communist future. In his *Economic and Philosophic Manuscripts of 1844*, he posits the

1. This direction of research is developed in actor-network theory, cyberfeminism, and geophysical theories of the Anthropocene.
2. Reza Negarestani, "The Labor of the Inhuman, Part I: Human," in *e-flux journal*, no. 52 (February 2014). Available at: www.e-flux.com/journal/52/59920/the-labor-of-the-inhuman-part-i-human/.

Yuri Rost's portrait of Evald Ilyenkov (1979). Photograph. Courtesy of the Estate of Evald Ilyeknov/Elena Evaldovna Illesh.

condition of humanness as yet unaccomplished and unattained until evacuation of private property is abolished and the communist society is realized. Only a human being can "be" not only for oneself but also for others and other species. Marx's possible answer to Latour would be that in order to attain equality between human and non-human agents, one needs precisely human society and human agents.

Sometime later, numerous theories, manifestos, and research results from the Russian avant-garde envisaged a communist society and the construction of conditions of humanness. These often followed in the Marxist vein of achieving the generic dimension of human consciousness under the influence of communist economy and its social conditions.

The Russian avant-garde conducted various experiments in exceeding human finiteness—radical bio-genetic and bio-social transformations of living conditions, of sexuality, of production, technological acceleration, and cosmist utopias. However, in all the experimental theories and practical endeavors of the Russian avant-garde—in Alexander Bogdanov's blood bank for transfusion to rejuvenate the population, in Malevich's idea of the "white humanity," in Andrei Platonov's project of overcoming sexual drives, and earlier in Nikolai Fedorov's idea of resurrecting humans in noosphere—the notion of humanness was kept intact.

Meanwhile the main difference between Russian cosmism or the Soviet socialist philosophy and Kantian critique or Hegel's idealism, or more so, contemporary post-humanist theories, is the following: the issues of the sublime that are simultaneously human and inhuman in German idealism are nevertheless considered to be alien, metaphysical, transcendent. And the human mind is exactly the tool to use to extend oneself to such an uncomfortable, alienated otherness—this was the core issue of philosophy from Kant to Adorno. Speculative realism and accelerationist and object-oriented theories are dispensing with this double-bind construction—of the inhumanness within humanness (of the fake "beyond" within the human mind)—and they are doing so merely by rejecting the fact that the human mind has any capacity at all to grasp what is alien—matter, the real, the cosmological ancestrality of earth, the cosmological dimension. Consequently, what is alien is automatically inhuman. It's no surprise, then, that

gnoseology in new materialisms has to be operated by non-human subjectivities. Such a condition could be related to the way emancipatory politics is understood in accelerationist theories, in which political change or the emancipatory shift is achieved by excelling over alienation, which implies accepting its conditions. How can one win over alienation without entering that very alienation to the full? Only out of technological and cybernetic handling of alienation is it possible to navigate that very alienation.

Yet in the early Soviet experiments in conceiving "the new humankind," radical social, anthropological, or technical emancipation was on the contrary envisaged via a converse procedure—via de-alienation. (Just to repeat, de-alienation is not a claim of any overall or ontological sublation of alienation, but rather of certain political, social, and economic procedures that affect societal infrastructure as de-alienating.) We all know what de-alienation would mean in social and economic terms—the end of the division of labor, of class society, of economics based on surplus value. But on the level of thought its demand would be to cease the separation of the dimensions of the conceptual, cognitive, ideal, and general, on the one hand, and the realm of the empirical, material, and concrete, on the other.

Actually, an amazing thing happens in the Russian avant-garde's neo-humanism as well as in Soviet socialist materialist idealism (e.g. in the works of Evald Ilyenkov). There is nothing in natural, scientific, or anthropogenic transformation that would posit any sublimity, or any futurological imaginary as alien or as detached from human society. It is precisely human society that is to follow any scientific breakthroughs, mutations, or even post-human catastrophes.

One significant feature of such a stance in Soviet thought is the attempt to converge the ideal with the immanent and the real in some sort of dialectical monism. Such an attempt is already obvious in Russian cosmism—in works by Nikolai Fedorov, Konstantin Tsiolkovsky, Vladimir Vernadsky, and later in Alexander Bogdanov's theories of tektology and empiriomonism, or in Andrei Platonov's monist animism.[3] Monism presupposes the convergence of the

3. Alexander Bogdanov, *Tektology*, ed. Peter Dudleys (Hull: University of Hull, 1996); and *Empiriomonism* (Moscow: Respublika, 2003).

PHILOSOPHIC ONTICS
OF COMMUNISM 245

cognitive (abstract) and the material (concrete) phenomena. As argued above, the demand here is the fusion of the matter and the concept, of the empirical and the ideal—against the gap between the nominal, empirical, immanent presences and the idea or the ideal. For example, in Hegel, objective reality in all its negativity is viable but has to be further appropriated by the Absolute Spirit, whereas Ilyenkov, quite in the same vein of Marx, overturns Hegel's scheme. Hegel's Absolute Spirit is the anticipation of a specific form of consciousness that would be able to merely function as a reflection of the generality of societal matter. If an idea can be implemented it is not torn from empirical being. At the same time, thought resides not in the mind of a human subject, but in objective reality, which in its own turn needs an idea and evolves into it.

In his phantasmagoric treatise "Cosmology of the Spirit" (mid-1950s), Evald Ilyenkov goes even further than any radical theories of cosmism.[4] In fact, all those theories envisage a better and more just existence of humanity, initiated by techno-scientific, economic, and social breakthroughs. On the contrary, Ilyenkov's starting point for claiming the human condition in "Cosmology of the Spirit" is the complete extinction of life, of humankind, and even of the solar system altogether. However, in the midst of inevitable entropy and thermal death, Ilyenkov tries to invent the logical turn—to assert the paradox of counter-entropy. Bearing this aim in mind, it is not only the universe that he considers as the "home" of humanity, but he even asserts that the extinction of any existence on earth (or even of the solar system altogether) would not hamper accomplishing the human condition. Ilyenkov provides his treatise with a long subtitle: "an attempt to establish in general terms the objective role of thinking matter in the system of worldly interaction" and further, in brackets: "Philosophic-poetical phantasmagoria, relying on the principles of dialectical materialism."

4. Evald Ilyenkov, "Cosmology of the Spirit," trans. Giuliano Vivaldi, *Stasis* 8 (2017): 164–190. Available at: http://stasisjournal.net/images/Stasis_v05_i02/eng/ stasis_v05_i02_06.pdf. See also Alexei Penzin's "Contingency and Necessity in Ilyenkov's Communist Cosmology," *e-flux journal*, no. 88 (February 2018), and Evald Ilyenkov, "Kosmologia Dukha" [Cosmology of the spirit], in *Filosofia I Kul'tura* [Philosophy and culture] (Moscow: Izdatelstvo Politicheskoy Literaturi, 1991), 415–437.

The Soviet thinker's point of departure is that the solar system, as well as humankind, is sooner or later perishable, even despite technological capacities of resisting its finitude. Hence, the thinking mind as the attribute of matter in that system would also perish. The first stage of the decline of the solar system would be thermal cooling, followed by a thermal explosion turning everything into hot steam and gas. But as Ilyenkov alleges, when the solar system begins to fade away, it will be precisely a thinking human mind that would foster this declining process voluntarily, striving towards explosion and thermal death. During the gradual cooling, the human mind sacrifices itself (self-resigns) to produce excessive energy in this explosion initiated by mind, which will enable the generation of life in another part of the universe. The thinking mind's altruist quest towards an inevitable destruction of life implies an intentional self-awareness about its inevitable eclipse.

However, this is not merely Nietzschean destructionism; but by hastening the end of life in an explosion and further by thermal cooling, the thinking mind facilitates an approximation of matter to its primary, juvenile condition so that new life can emerge from matter in its primariness again. The emergence of this new life could then inevitably imply a new emergence of the thinking mind, since matter cannot but extend into the mind.

As Ilyenkov states, the reason the complete destruction of matter would be impossible in this explosion initiated by the mind and effectuated by means of slow cooling is that the energy that incites destruction releases an excess of energy, i.e., even more energy, than is spent for this destruction. Again, the mind would be destroyed by voluntary self-sacrifice, but it would do so in order that the matter could develop again in some other constellation of the universe. The logic of eternity and infinity here is the following: if mind is ever the attribute of matter, and matter cannot do without thinking, any form of matter will develop into mind, and since the mind is only the human mind, humankind will always be able to be reborn in other galaxies.[5]

5. As Ilyenkov writes, "Therefore death is outlined by this hypothesis of perishability not as senseless and fruitless end but as an act which in its essence is a creative end, as a prelude to a new cycle of life for the Universe." Evald Ilyenkov, "The Cosmology of Mind," trans. J. Vivaldi, *Stasis* 8 (2017): 188.

This remains the same, no matter what the physical and techno-logical parameters of that new humankind would be. What counts is the inevitability of matter to develop dialectically into the mind. In this phantasmagoric text, Ilyenkov wants to prove that even the eclipse he describes is not merely a natural contingency of universal matter, but that it happens with the participation and initiation of a human mind (at the communist stage of its development) and human consciousness.

We thus see how the second law of thermodynamics—about the inevitability of entropy—acquires the impact of surpassing entropy. This is what Ilyenkov writes:

> Dialectical materialism ... is resolving the issue of the "aim" of existence in the category of universal interaction. [Which means that Ilyenkov does not at all endow humanity with a central role in existence.] Humankind, with its thought hooked up to this universal interaction, is engendered within it and is developed and, at some point, disappears within it. The notion of the "highest aim" of human existence is sublated rationally in the understanding of the necessity of its genesis, development and death inside and through the medium of this universal interdependence of all forms of motion of universal matter.[6]

There are a few important consequences of this statement: (1) That human thought and the history of humanity are just part of a bigger cycle of a universal movement of matter. (2) That a subject of thought is not identical with personal consciousness, hence all the moves of a thinking organ are something other than solely knowledge, cogni-tion, consciousness, or the unconscious. Thinking is generic and not dependent on individual will. (3) That the universe is conditioned not only by progress, but also by an inevitable decline; but this condition does not make the role of thinking and the human mind less emanci-patory and meaningful.

In *After Finitude* by Quentin Meillassoux, on the contrary, the end of life in the solar system is the condition to claim that the human

6. Ibid., 172.

history and the pretension of the mind to correlate itself with the universe are senseless.[7] Universalism in the frame of the history of human thought is only a false projection of a finite human mind that is not able to acquire the grip of existence, because reality is absolutely autonomous from man's historical or ethical projections. Moreover, matter does not fit into the notion of death and life, the dead and the living. Thus, the history of humanity, its material culture, and the history of human thought are but tiny episodes in the life of the universe, and any thought then happens to mythologize what pure knowledge could be; knowledge partakes of a human mind, but to be effective it should extract the procedures of cognition and intellect from the human brain and mind, to duly stratify them.

Ilyenkov begins by claiming the unity of matter, thought, and the human being, bringing forth three important premises: (1) That thought is an attribute of matter (a paraphrase of Spinoza's thesis on thought as the attribute of Substance). This means that matter cannot exist without thought, and vice versa, thought needs matter. (2) That thought can only be a human thought and not any extra-human intelligence or competence; human thought is the extension of cosmic and planetary matter. Consequently, a human being is a temporary but indispensable part of matter since thought can find its material realization in him. (3) That the development of the mind needs communist society as its gnoseological breakthrough and paradoxically it is only the communist, altruist mind that is able to initiate the decision of self-resignation. Yet it is important to remember that this self-destruction is cosmologically exerted in the name of future life, not merely the finalization of the universe.

Under this logic, death and destruction are inevitable, but the impossibility of death and destruction is inevitable, too. For Ilyenkov, this anti-egoist consent to one's own eclipse is confirmation of the premise of materialist dialectics, according to which objective matter and reality prevail over consciousness, be it individual or collective. But this does not imply any critique of the correlation of mind with matter, as is the case with speculative realism. On the contrary, a humble and generous awareness of the perishability of human life

7. Quentin Meillassoux, *After Finitude* (London: Continuum, 2009).

and thought, and acceptance of the objective role and supreme role of universal matter by the mind, only confirms the maturity of mind and its indispensability for matter. Human existence here is not a senseless and fruitless ending, but even its destruction is considered to be a creative act that could become a "prelude" for a new cycle of life elsewhere in the universe. In short, the decline of humanity happens to be an act that could be justified and necessary from the point of view of the universal circulation of matter, which develops according to its objective rules. Ilyenkov writes in his treatise:

> Thought remains a historically transitional episode in the development of the Universe, a derivative ("secondary") product of the development of matter, but a product that is absolutely necessary: a consequence that simultaneously becomes the condition for the existence of infinite matter.[8]

The conjecture that there is something more developed for the practice of thought than the thinking human brain would lead to the allegation of religious or other metaphysical reasons for existence, i.e., a form of development extrinsic to a human one. Consequently, all modes of transgressing thinking matter in favor of something exceeding a thinking brain would mean theologizing thought, history, and their dialectical development—no matter whether in favor of finalizing thinking altogether, or excelling above it.

This is why Ilyenkov juxtaposes Kant's sublime reality, incomprehensible for human thought, with Hegel's idealism, in which the overhuman mind remains an allegation, but still a human thought is able to reach its *niveau*—the *niveau* of the worldly objective mind (Absolute reason), and is able thus to acquire a degree of "higher reality."

As mentioned above, matter at some stage of its development cannot but generate thought. Hence instead of the dichotomy of the empirical and the transcendental, or the abstract and the concrete, body and idea, senses and cognition, both components are incorporated by means of a dialectical procedure. Because of this,

8.　Ibid., 188.

in proto-communist social conditions the idea invades the immanence of the living process, rather than being cast into the realm of metaphysics. Then "normal" life and the everyday themselves render the universal and the ideal—be it in material culture or just "banal" communication. So if in Hegel, the general, the Absolute, the idea resides in the human or overhuman spirit that clashes with the otherness (*Andersein*) of objective reality and consequently has to dialectically tune it to fit the Absolute mind (spirit), for Ilyenkov (who is following Marx), reality and its diachronic historicity—as well as its further extinction—presupposes that the general is generated by matter, and resides in it; this means that reality and its objectivity itself produce the idea, thought, and the dimension of the general.

We approach the core issue from which we started. To assert the human condition and communist sociality, Ilyenkov needs to start from the complete ruin of human life in the universe. However, such complete extinction does not terminate the human condition and the sociality of the common good. Although the thinking brain can be made extinct and perish, while it disappears in one spot of infinite space it cannot but appear in another spot of the infinite universe.

At the same time, both the birth of life and its disappearance are not contingent (as is the case in speculative realism), but are part of the awareness of a thinking mind and are inscribed into it from the very beginning as the *supreme eschatology*, which is not pessimistic; it is not pessimistic despite the inevitability of the eclipse, as thinking cannot but reappear somewhere else.

The assumptions made in this treatise disavow the issues that became the kernel of speculative realism—that humanity, alive for just a short while within the span of existence of the solar system and all matter, is unable to claim any capacity to cognize reality in its absolute dimension.

Ilyenkov's radical standpoint quite easily resolves the dilemma brought forward in speculative realism between the ancestrality of the universe and the transitory nature of human history. Human thought cannot die, because in its death it confirms its immortality, because it remains ever to be part of matter, even if ancestrality precedes it or even if some unimaginable futurity is ahead of it.

PHILOSOPHIC ONTICS
OF COMMUNISM

The question is then the following: Would the creatures—in whom the thinking organ might manifest itself again somewhere else in the universe, after going extinct together with the earth— be human? Could it be said that it is not important to whom or to what the thinking mind belongs, when human life is over and thought appears in another cosmic constellation? And if thinking is the supreme realization of a universal matter, what makes thought the chief attribute of humanness at all, if it will belong to other creatures after earthly life is extinct? Why is Ilyenkov insisting that thought realizes the human, but also, that whoever the other thinking creatures might be, this appearance of thinking capacity would be related to humanness anyway, and not to machinic intelligence or extra-natural higher reason?

It seems that the term "human" in this case is just a potentiality to realize the dimension of the general (non-self being) bodily and materially via thought and senses. But still, how would it be possible to claim the human condition or the inevitable potentiality of communism and the common good without human life, or any life whatsoever? The answer that stems from Ilyenkov's work is that what humanity aspires to in its beginning and end will be posited forever by means of universal matter extended into the thinking spirit, regardless of where thinking appears or perishes. Meanwhile a human is not just a natural, or necessarily an earthly human being; it is the performance of aspiration for the general (the common, the communist) and its material implementation. Hence if thought were to derive from matter in other, non-earthly conditions, it would still remain what the human mind had always aspired to—not merely intelligence, but also the common good. Thus to achieve the dimension of the general, of the common good (the stage that will happen to be the dialectical unity of matter and mind), mind (consciousness) has to be aware that it is never the self, that it is always the *other-determined non-self*, destined to generalize itself in the direction of objective reality and social being; the stance due to which social being and daily sociality acquire a cosmological dimension.

This is because human thought is not merely knowledge that is accumulated and shared; hence it's no surprise that Ilyenkov never meant gnoseology as the augmentation of cognition. This capacity

for the general (common, non-self), through which the mind is able to self-resign in the name of new life, is essential for thought on the stage of its communist development; but it exceeds merely intellect and knowledge. In Plato's *Meno*, Socrates claims that knowledge is not just cognition, but is first and foremost a virtue. So thought's enlightening endeavor is not merely about accumulation of knowledge, but it is more about the capacity for self-resignation, about awareness of its own end, bringing the human mind to modesty that does not at all contradict its courage in a cognitive quest or in political activity. Such awareness of self-resignation and of *a non-self being* (as one of the main conditions of the general) is not only cognitively productive, it is also communist in its ethics. So what sustains as the human mind when there will be no humans is exactly the virtue of the general that thought, as matter's extension, will ever bear in itself—in other words, communism inevitably inscribed in matter.

This is why it is essential not to read Ilyenkov's apology for this complete eclipse of life triggered by thought in the Nietzschean context, or as some embodiment of Spinozist *Naturphilosophie*. This is the fallacy that occurs in Žižek's recent interpretation of Ilyenkovs's "Cosmology of the Spirit."[9] He identifies Ilyenkov with de Sade, relying on the passage from book five of de Sade's *Juliette* in which de Sade appeals for a total "orgy of destruction" as the ultimate annihilation of life, which could end the cycle of constant rebirth and decline of human life, and "thus return to Nature her absolute privilege… to cast the dice anew."[10]

Žižek is impressed here by the Soviet Marxist thinker's proximity to such transgressive thinking as de Sade, insofar as both of them, according to Žižek, demand to confirm the climax of the mind and subjectivity by means of the mind's voluntary, entropic eclipse (as the ultimate negativity surpassing simpler negativities such as the finite world and death). Meanwhile, to dispute the aforementioned negativist dystopia as a simplified form of negativity, Žižek

9. Slavoj Žižek, "Evald Ilyenkov's Cosmology: The Point of Madness in Dialectical Materialism," in *The Philosophical Salon*, Dec. 10, 2018. Available at: https://thephilosophicalsalon.com/evald-ilyenkovs-cosmology-the-point-of-madness-of-dialectical-materialism/
10. Ibid.

brings the arguments of Lacan against de Sade's and Ilyenkov's appeal for destruction envisaged as the free, autonomous, and voluntary act of a thinking mind. According to the Lacanian standpoint, total destruction and annihilation ("second death," as Žižek puts it) "does not come at the end of progress," but instead radical negativity is already inscribed in the subject initially and by definition. Total negation (catastrophe) "has always already happened," as Žižek puts it. And therefore, both de Sade and Ilyenkov are premodern in their belief in a self-regulating cosmos with its cycle of progress and regress. This is why Žižek chooses not give the garland for modern cosmology to a Soviet dialectician—this is only to confirm that Soviet materialist dialectics could not be sophisticated enough to truly accept negativity—the reason it remained outside structuralism and post-structuralism.

For Žižek, the merit of most advanced thought is negativity, and unexpectedly coming across Nietzschean destructionism in Soviet materialist dialectics, which he implies is rather associated with a "naïve" reproduction of Hegel and Marx's principal postulates, he precipitates to assume that this negativity in Ilyenkov's cosmology is as pre-modern as de Sade's, hence not "proper" negativity at all. Meanwhile, Žižek happens to miss the role of destruction in Ilyenkov's cosmological narrative. Moreover, his argument overlooks the principal difference in the appeal for destruction between de Sade and Ilyenkov. For de Sade destruction is effectuated as resentment towards the endless cycle of life-reproduction and its senselessness. Whereas, for Ilyenkov, the human mind's decision for self-destruction is motivated by awareness of the inevitability of the end and preemptive *self-resignation in the name of new life and other selves*. In fact, Ilyenkov's message is not at all negatively oriented, or Nietzschean, as Žižek would have it. On the contrary, his extremism is harsher than de Sade's destructionism, or Spinozist substantialism without a Subject. What Ilyenkov endeavors to claim is that even despite total destruction, the mind, hence the dialectical communist subject, and hence the human condition, is infinite and eternal. In terms of logical form, this assumption—that despite entropy, destruction, the eclipse of life, what reigns is only communism and social good—is a sort of theological postulate. But this is not

at all a postulate of a preliminarily established harmony in the midst of the cyclical turnover of nature. Such an attempt to leap over entropic ruptures and the struggle with deep, trans-social contradictions is an impossible, excessive zeal, a sort of *virtus* of communist subjectivity, which is able to transmit any "crack" or "cut" (through which, as Žižek reiterates, existence is inevitably seen), into the infinite potentiality of the universal common good.

To conclude, as Žižek argues, Ilyenkov (quite like the late Lukács) makes three crucial mistakes: 1. He approaches nature without mediation, "whereas the gap that separates the ontic view of reality from the transcendental role of social praxis and the more so from the negativity inscribed in the Subject is unbridgeable … One cannot account for the rise of social praxis in ontic terms."[11] 2. Ilyenkov differentiates, quite in the vein of naive realists of dialectical materialism, the affirmative objectification (where the Subject realizes oneself in Labor), and reification (where the Subject is alienated in Labor). Such an approach brings about, according to Žižek, a fallacious belief in the cosmological, naturalized dimension of social utopia (i.e., it reduces the transcendental difference inherent in an always already cracked Subject to ontics and its objectivity). Apart from that, this approach directly applies objective social circumstances; whereas such circumstances are, according to Žižek, "always mediated by subjectivity even if this mediation amounts to the lack of subjective engagement."[12] 3. Ilyenkov mistakes the unsublatable negativity of a Subject for the necessity of destruction that the thinking mind initiates.

Now, what Žižek overlooks in such an argument are the following postulates: 1. There is no pure unmediated ontics in Ilyenkov's materialist communist absolutism; Ilyenkov's ontics is contaminated and invaded by political-economic, social, and noumenal parameters. In the conditions of abolished private property such retroactive invasion of ontics with transcendental ontology is inevitable. 2. If socioeconomic de-alienation brings about a new, almost totally objectified and socialized Subject, which has lost its sophistications

11. Slavoj Žižek, *Sex and the Failed Absolute* (London: Bloomsbury, 2019), 43.
12. Ibid., 45.

PHILOSOPHIC ONTICS
OF COMMUNISM 255

and cracks, it is only for the benefit of a new, non-capitalist society and its cosmological perspectives. Such naivety, which dispensed with the narcissistic attachment of a Subject to her own alienation, is part and parcel of the sociality of the common good. 3. Ilyenkov does not reproduce the Nietzschean longing for perishing, which makes destruction a necessity for a thinking mind, in order to demonstrate its hubris. The mind that voluntarily perishes does so rather out of philosophic *memento mori*, out of awareness of death as the principal confirmation of the mind's human limits and speculative disabilities. But it is despite those disabilities that the mind uplifts itself to a cosmological scale, and this act in no way contradicts ruptures in modern philosophy—either the Cartesian *cogito*, or Kant's free autonomous act *ex nihilo*.

CHAPTER 12

MATERIALITY OF THE IDEAL:
Evald Ilyenkov's Proofs

Evald Ilyenkov, portrait at the Soviet frontline during World War II (1944). Photographer unknown. Courtesy of the Estate of Evald Ilyeknov/Elena Evaldovna Illesh.

*There is nothing new about the thesis that
the Absolute is identical to this world.*[1]
—Giorgio Agamben

I
THE EPISTEMES OF THE IDEAL

The history of philosophy never stopped to reflect on the dualism of idea and matter, body and mind, the universal and the singular, soul and corporeality, notion (word) and thing, the general and the immanent.

Post-philosophies—such as speculative realism, actor-network theory, cyberfeminist studies, object-oriented ontologies, accelerationist futurisms, not to mention the post-Althusserian wing of post-structuralism out of which emerged the principal Spinozist thinkers of immanence (Deleuze and Guattari, the post-operaists)— all hope to solve the problem of this duality simply by dispensing with the notions of the ideal, the general, and the subject, altogether. They do so because the ideal and the idea are considered an imposition on immanence and matter as a metaphysical supplement. Indeed, the concept of the ideal gets into the realm of mythology, authority, power, or ideology—so long as it is seen as a rejection of the non-reductionist contingency of immanence.

Confining oneself to immanences enables post-structuralism to evade the duality of matter and idea, in that this stance promotes a materialist understanding of reality that would find all metaphysical, spiritual, incorporeal, and ideological complements superfluous.

The post-structuralist treatment of metaphysics in this way (in the work of Deleuze and Guattari in particular) is premised on thought as a semiological and self-generating flow: this process can become an idea, but it has nothing to do with consciousness as such. Thinking is a causal generative process that in its structural

1. Giorgio Agamben, *The Coming Community*, trans. Michael Hardt (Minneapolis: University of Minnesota Press, 1993).

PHILOSOPHIC ONTICS
OF COMMUNISM 259

topology is not disparate from any other processes in nature or the social sphere. (Yet, it should be noted, that despite Deleuze's ardent anti-Hegelianism, his concepts of *transcendental empiricism* and of *supra-being*—or even the theme of "an ideal game" in *Logic of Sense*—posit the necessity of the ideal, albeit in topological terms.) Hence in post-structuralism, often stemming conceptually from Spinozist premises, the incompatibility between the contingency of immanence (the materiality of being) and the mind (ideas, conscious-ness) always remains discreet. Convergence between being and thinking, matter and thought, mind and body in post-structuralism is either *performative*, post-ontological, or anti-dialectical (Deleuze, Butler); it takes place as the result of a semiological equation between signs and things, the signifier and the signified (Derrida).

In the above-mentioned post-philosophies, mind and matter dualism is surpassed via dealing with the immanences of data aggre-gation, no matter whether these elemental hybridities are extracted from speculative or material realms.

Lacanian and post-Lacanian psychoanalysis, by contrast, chose a very different strategy in relation to metaphysics and the ideal. Disputing all the would-be vices of metaphysics, it overturns the logic of the ideal/material by engaging the role of the unconscious for both parameters. As a result, such categories as the mind of the subject, consciousness, ideal—i.e., all the outward sublimities and symbolic qualities that claim to be guiding and controlling the body, psyche, and matter—are preserved. Nevertheless, this comes with an impor-tant reservation. They are sustained only under the condition that they bear a rupture, a disparity, a break, and become empty signifiers. It was the achievement of Lacan to try to prove that sublimities cannot be evacuated from the subject's horizon. However, with the super-session of reality with the unconscious and its organization into the categories of the Real, the Symbolic, and the Imaginary, the uncon-scious became in a way a new form of quasi-metaphysics. The role of the unconscious is then definitely anti-nominalist: it resists techno-bio-physicalism. It retains the category of the sublime, of the ideal, but nonetheless paradoxically supersedes the features of both com-ponents of metaphysical duality—mind and matter. Nevertheless, mind (subject, the sublime, the ideal) is barred and fissured. Whereas

reality—immanence, the objective world—is seen merely as a form of the Imaginary. In this totalizing of the unconscious, Lacanian psychoanalysis insists on the constant impossibility of resolution and teleology, of redemption and effectuation—ontologizing the permanence of negativity. Thus, even ideology and the symbolic appear within the totalizing force of the unconscious as a minimal surplus, as *object petit a*.[2]

<p style="text-align:center">*
* *</p>

Since the 1960s, notions of the general (the universal), the ideal, and culture were considered redundant and obsolete for social analysis in continental philosophy (post-structuralism, passim), or were used only with negative, anti-emancipatory connotations. Yet Soviet Marxist thought (Ilyenkov, Lifshitz) at this time continued to insist precisely on the materialist efficacy and the emancipatory potential of the ideal.

As Ilyenkov claims, the ideal is nothing but the phylogenetic inevitability of the sociality of labor (of activity)—i.e., of inorganic second nature. Indeed, the ideal is the mere purposeful facticity of human activity: its diachronic, non-individual, non-literal character, which surpasses the split between matter and idea, body and concept.

But why label the sociality of labor and its products "the ideal" specifically, when this term traditionally triggered the abovementioned dualism?

2.　Badiou and Žižek's interpretations of Wagner provide good examples of how sublimity and ideality can be treated as evidence of the insurmountable rupture and crack. Musicologists and philosophers have often censured Wagner for his supposed totalitarian aesthetics, claims of redemption and sublimity. For example, the well-known critiques of the composer by Adorno and Laboue-Labarthe take this path. Badiou, nevertheless, overturns these interpretations by insisting that Wagner's music is, in fact, not the idealist Gesamtkunstwerk, but the music of difference and of traumatic deconstruction. In a nutshell: the ideal, the symbolic, the sublime are the zones of a problem, of a crack, rather than any kind of a redemptive attempt to forcefully replenish the gap and the lack. (The same logic works in Žižek's reconsideration of the stereotypical teleological interpretation of Hegel.)

PHILOSOPHIC ONTICS
OF COMMUNISM

What is so indispensable in the term "ideal" for a theory of labor and materialist thought, when the term has historically entailed so many anti-materialist connotations?

Let us begin answering these questions by looking at the main principles of Ilyenkov's philosophy.

Ilyenkov's conceptual opus *Dialectics of the Ideal* appeared in the Soviet Union in the early 1970s, at the peak of interest in cybernetics and neurophysiology. Hence his aim in this work (as well as others such as his last text, *Lenin's Dialectics and the Metaphysics of Positivism* (1980)) was a critique of an attempt to reduce philosophy and materialist dialectics to positivist nominalism, to natural sciences and technology.

In the spirit of Lenin, Ilyenkov calls positivist nominalism a metaphysics or vulgar materialism.

The ideal for Ilyenkov, then, is set as a specific task: to become the key instrument in the demonstration of the deficiencies of positivism and of nominalist immanentism. It, therefore, had to dispute the confinement of thought to neurophysiology and brain-centered theories of psychic life, and, as such, asserts the link between consciousness and the teleological and generic dimension of material processes. The two main premises in this anti-positivist framework of the ideal are (1) the *quid pro quo* principle (the other-determined, non-self being of an object, or of a subject, when its *self* is always confirmed through the *other self*) and (2) expediency (teleology).

Ilyenkov disputes the dichotomy according to which consciousness and the psyche deal with immaterial, ideal phenomena, and that matter, conversely, resides in external reality. In this case what is "in the head," mental, or in the imagination is considered ideal, whereas what is beyond "the head" (beyond the operations of consciousness) is treated as material. However, as Ilyenkov argues, neuroscience demonstrates even a graver fallacy than phenomenology or traditional idealism, when it nominalizes consciousness and mental life, i.e., psychic capacities; that is, when neuroscience brings mental phenomena to a non-dialectical aggregation of an elemental series and then structures and studies this mechanistically as atomized contingent data. Then what is considered to be "the ideal" (the human brain, consciousness) is torn away from the truly material external

world and is reduced to the elemental data of matter—subject to processes of quantitative assembly rather than thinking. This brings us to a situation where immaterial phenomena—a novel, a building, a piece of music—are dissected into conglomerates of hybridized components—sounds, vowels, tones, bricks, particles, etc.—in which materiality is seen in a nominalist way. The same is true the other way around: what is nominal and elemental in matter is then turned into a pure abstraction—data, codes, empty forms, and signs.

Therefore, the goal in defending the ideal was to demonstrate that matter is able to dialectically attain thought and that thought and consciousness, in turn, could only have an objective (material) genesis. Ilyenkov emphasizes that what Kant defined as the transcendental and immanent forms of the psyche is, as Hegel and later Marx claimed, the externally cognized forms of the consciousness of a social (generic) human being. These forms are independent of individual will and of individual consciousness.[3]

As already mentioned, Ilyenkov's interpretation of the ideal was very much influenced by Hegel's notion of *otherness* (*Anderssein*) (the other-determined non-self). This functioned for Hegel as the inevitable objectification of spirit, which brings about the concretion of the material world as the mind's otherness; the spirit cannot be the self, as long as it is "alienated" (objectified, reified) in the world and by the world. So, every "self" is defined through an "other-self," which makes the self not quite its own self. For Hegel the condition of *Anderssein* opens up an expansive field of dialectics between the general (the universal) and the concrete, the speculative and the material, mind and matter. He maintains that this otherness is marked in the negative terms of the alienation of spirit in objects and thinghood. Ilyenkov, on the other hand, in alignment with Marx, translates the "negative" semantics of Hegel's objectification of the mind into affirmative terms, thus shifting the procedure of generalization and non-self being into a materialist dimension. For Ilyenkov, *Anderssein* is the name for the emergence of any mental, conscious,

3. Evald Ilyenkov, "Dialectics of the Ideal" in *Filosofia I Kul'tura* [Philosophy and culture] (Moscow, Politizdat, 1991), 229–270, 250. See in English: *Dialectics of the Ideal: Evald Ilyenkov and Creative Soviet Marxism*, ed. A. Levant and V. Oittinen, 25–81, 51.

PHILOSOPHIC ONTICS
OF COMMUNISM 263

or personified phenomena out of matter and the objective components of being.

In order to demonstrate how "the ideal" and its *quid pro quo* principle functions, Ilyenkov refers to the value form in Marx's critique of political economy. The form of value is the representation of a commodity, of the labor needed for its production, of time and costs. Additionally, value is an expression of the relations of production and the means of production involved in making a commodity. Following Marx, value for Ilyenkov is both an abstract sign and a concrete operation referring to many aspects of social life and production, revealing how the being of non-self is embedded in the objecthood of a product (a commodity), its "self." Thus, the value form simultaneously plays the role of an immaterial sign and pertains to the materiality of production and the concrete constellations of social relations. The value form then is "ideal," insofar as it is the "mirror" of a set of acts and selves, without being itself any "self," and without having any nominal topological identification itself with those acts and other selves of social relations.

Similarly, the sensuous or prosodic form of the word *Peter* is not identical to a real person who bears that name, but it points to him.[4] In other words, the ideal is something that is external to "me," yet at the same time, it constructs me as something *objective*, and even something immanent, which nonetheless exceeds the nominal constraints of my personal will, interests, biography, etc. This objective *non-self* is thus not solely a transcendental construction, but is grounded in the outwardness of being, in the outwardness of generic human activity, making human consciousness something general and a counter-psychic category as well. The capacity of the other-determined non-self is possible for all things, acts, and individuals, since it is facilitated by the presence of humans in nature and objective reality transformed into "inorganic" reality by means of the mediation of labor (activity). Thus the ideal is a universal non-equation and anti-literalness of all objects and subjects, which opens the way to the dialectical configuration of reality and the cosmos in general. In his explication of this notion, we see that

4.　Ibid., 253.

Ilyenkov ardently persists in proving that what is sensuous and has body-form can be general (the universal). On the other hand, what is universal, conceptual, or mental is derived from objective reality by means of, and as the result of, activity (labor) and its purposeful expediency, i.e., the conceptual or mental categories have a material origin.

II
LANGUAGE IS NOT THE IDEAL

Since the 1960s, the critique of the notion of the ideal in continental philosophy has stemmed from the fact that the ideal is identified with idealism, ideology. The ideal then is regarded as either something that is better and more perfect than what is real—something external to imperfect empirical reality. Or, it is seen as something that is immaterial per se—a product of thought, imagination, volition, or abstraction—i.e., a certain intangible outcome of a subject's consciousness or psyche, or some sort of imagined immaterial form of perfection devoid of embodiment or immanence. Language has traditionally been the "location" of abstract, symbolic, alienated, and ideologized modes of representation. If Heidegger ascribes the entirety of being to language, thus ontologizing language, post-structuralism, conversely, attempts to subtract being and the procedures of living from subordination to the Signifier, to language, given that it is abstracted and alienated from life and its activities. In this latter case, language is both the ultimate representation of the ideal—suppressing the immanence of being—and the thing to be deconstructed or even destroyed in order to facilitate access to the eventality of being. As long as traditionally logical categorization and thought have always been understood via linguistic forms, it should come as no surprise that Deleuze, in his *Logic of Sense*, or Guattari, in *The Machinic Unconscious*, did their best to draw logic and the procedures of thinking into the realm of a non-linguistically biased, a-signifying performative semiology.

In Soviet psychology (Vygotsky, Leontiev, Mesheriakov) and later philosophy (Ilyenkov), this tension between language and being, signifier and signified was dealt with in a different way.

Already in the 1920s, Vygotsky claimed that meanings and ideas are generated in language, but, nevertheless, language use is not the principal means of conveying ideas. The concept, or meaning, encloses itself in language, yet it is prior to language itself. According to Vygotsky's well-known motto, "the word is ready when the concept is ready." Following such logic, language simply exerts mediation; it is merely an extension of activity, but it is not an autonomous, self-sufficient repository of established meanings and ideas.

As Alexey Leontiev writes in his *Activity and Consciousness*:

> The vehicle of meaning is language, but language is not the demiurge of meaning. Concealed behind linguistic meanings (values) are socially evolved modes of action (operations), in the process of which people change and cognize objective reality.[5]

Concepts and meanings do not reside *in* language forms; they are formed in objective activity and as a result of labor processes. Hence, Ilyenkov insists on the primary and principal manifestation of the capacity to think already in manual activities—for example, in the production of tools and the hand's haptic abilities. For Ilyenkov—as well as for the proponents of activity theory—complex logical categorizations are embedded in the activity of manual production, in the action of a hand. That is, material and manual activity already engages thought, and as such they are general and ideal in their materiality, even prior to language. Any material activity, then, such as the production of tools and the labor on things, is thought-centered and conceptual.[6] Ilyenkov's position here was certainly influenced by his collaboration with the founders of the Zagorsk experimental school for deaf and blind children—the psychologists and pedagogues Alexander Mesheryakov

5. Alexey Leontiev, *Activity and Consciousness*, 1977, 56. Available at Marxists Internet Archive: https://www.marxists.org/archive/leontev/works/activity-consciousness.pdf.
6. Evald Ilyenkov, *Iskusstvo I Communistichesky Ideal* [Art and the communist ideal] (Moscow: Iskusstvo, 1984), 99.

and Ivan Sokolyanski. Archival footage of medical studies accompanying their pedagogical experiments confirms how the purely haptic, manual, and sensual means of a body—sometimes simply a touch of the hand—can directly translate for the deaf and blind into thinking and the perception of culture and art, communication, and more generally, into a view of the world and of history. Such experiments show how *Bildung* is acquired by means of manual and bodily interaction.[7]

Leontiev adheres to a similar standpoint, arguing that the internal processes of thought are nothing but the result of the interiorization and transformation of external, practical activity. According to Leontiev, the autonomization of logical operations and of thinking is unacceptable for Marxist approaches to consciousness, language, and thinking.[8]

III
THE CONVERGENCE OF MATTER AND THE IDEAL:
Hegelian/Marxian and/or Spinozist Methodologies

The quest for the conflation of matter and thought inevitably brought Ilyenkov to Hegel and Spinoza as the two most eloquent philosophic endeavors in surmounting the dualism of mind and matter. Indeed, Ilyenkov tried to conjoin Hegel and Spinoza, in as much as material being and thinking are inseparable for both philosophers. Yet the question Ilyenkov sought to answer did not lie solely in the conflation of mind and matter, but also in the epistemic methods and outcomes of positing and exerting such a conflation. To start with, then, the principal problem was whether this conflation had to be necessarily dialectical, or it could be accomplished otherwise. Ilyenkov's response was that for the conflation to work, the valency of the dialectical method was indispensable. Consequently, in order to conjoin

7. The footage can be seen in a recent documentary by Emanuel Almborg, *Talking Hands* (2016).
8. Alexey Leontiev, *Activity and Consciousness*, 56–57. Available at: https://www.marxists.org/archive/leontev/works/activity-consciousness.pdf.

Spinoza and Hegel, the goal was to prove that Spinoza's mind-matter monism was implicitly dialectical too.

Ilyenkov attempted to ground the anti-dualist convergence of matter and thought by means of Hegelian and Marxist dialectics, while, conversely, relying on Spinoza's immanentism. In other words, he tried to do something hitherto philosophically unimplementable—reconcile Hegel's dialectics and the performative monist parallelism of Spinozism.

This endeavor is developed in his book *Dialectical Logic* (1974). Hegel is interpreted in it as a thinker who invented the dialectical inseparability of objective reality and the spirit (logic, mind), of consciousness and of history—the inseparability of the ideal and the material.[9] For Hegel, spirit claims consciousness via the material world, even though this "descent" of spirit into the materiality of the world presupposes the spirit's alienation. Yet, in the process of the acquisition of self-consciousness, spirit (reason) struggles with this alienation to encompass the objective world. As Ilyenkov puts it, Hegel's thinking on thinking, that is *thinking for itself* (logic), needs *thinking in itself*—thinking of the world. Before becoming logic, thinking needs to be submerged in sensuous images and sensuous phenomena (*predstavlenija*). All dialectical schemes are the forms of the development of the extrinsic, the objective, which are reverberated (*otrajeno*) in consciousness; whereas the world in its material, natural, and historical versatility remains both independent from thinking, yet reliant on, and needful of, thought. Ilyenkov emphasizes that Hegel included into thinking things that exceed the subjective, individual consciousness. Therefore, history collectively processed by humans—i.e., a process independent of individual human consciousness—is an indispensable component for the formation of that very consciousness, as well as of logic, of thought, and its categories.

Thus, already in Hegel abstract understanding of the idea and the spirit receives an objectivized dimension. Consciousness can form itself only via dialectical reification in objective reality. In other

9. Evald Ilyenkov, "Study 5 (On Hegel)," *Dialectical Logic: Studies in History and Logic* (Moscow: Politizdat, 1984), 109–139. Available in English at Marxists Internet Archive: https://www.marxists.org/archive/ilyenkov/works/essays/essay5.htm.

words, Hegel showed that thinking is impossible without thinking's constitutive relationship to the world and history. Before becoming logic, thought has to immerse itself in the concreteness of sensuous imagery and representations (even though in Hegel's system this means the alienation of spirit).

Nevertheless, as Ilyenkov argues, if for Hegel the life of a human possesses a certain form because a human thinks in a certain way, Marx overturns such a disposition. For him, on the contrary, a human being thinks in a certain way since his life has this or that form.[10] On the contrary, in Hegel's system human activity and the world are raw material for the notion. Hence, for Hegel, the idea (the ideal, reason) still remains in the primary realm of consciousness, albeit reified and objectified.[11] This means that sensuous concreteness is merely the medium for the manifestation of the general; it is subsequent and

10. Evald Ilyenkov, "Dialectics of the Ideal" in *Filosofia I Kul'tura* [Philosophy and culture] (Moscow: Politizdat, 1991), 229–270. 251. See in English: A. Levant and V. Oittinen, eds, *Dialectics of the Ideal: Evald Ilyenkov and Creative Soviet Marxism*, 25–81.

11. What happened in Soviet Marxist philosophy—in the works by Ilyenkov and Lifshitz—is that despite all contradictions and arguments on the dialectics of the ideal (e.g. between Lifshitz and Ilyenkov), the ideal acquired a material trait. This was not the case the other way around—when matter and empirical phenomena in their inferiority have to "ascend" towards the generality of a notion. Ilyenkov interprets the ideal as the potentiality of the generic—as the dimension of exceeding empirical constraints and personal interests and permeating each organic or inorganic singularity with this generality. The ideal implies the expediency and purposefulness of activity. Such activity is outlined by society and its general intellect through history and labor. Lifshitz disputed Ilyenkov's projectivism. He assumed that the ideal must enter into society from somewhere, and this somewhere was an objective reality, which had to include not only society or social consciousness, but all the material world and nature too. (Implicitly this presupposes the tenet of dialectical materialism, according to which the materiality of nature and objective reality already inevitably contain the potentiality of communism.) Lifshitz interpreted the concept of the "ideal" rather as the perfect sample of something. But contrary to Ilyenkov, Lifshitz treated the aspect of perfection, the aspect of the realization of something within objective reality, as the possible condition without any intervention by the transforming activity of consciousness, or of labor. For Lifshitz, perfection is already implied in being and nature regardless of labor or the creative intervention of human beings.

From Lifshitz's perspective, therefore, the further step that Ilyenkov should have taken would have been to say that the dimension of the ideal that manifests itself in culture, labor, society was in fact the reflection of the ideal inherent in the infinite material process that *surpasses* and incorporates

PHILOSOPHIC ONTICS
OF COMMUNISM 269

subordinate to its grandeur, whereas it should be otherwise: *the general, the conceptual should actually be a subsequent attribute and manifestation of any material concreteness, which is always initial. It is at this point that matter itself contains the general as potential and capacity (that is socially and historically grounded by labor and practical activity).*[12]

This focus on materiality and its monism with the idea is the reason Ilyenkov finds Spinoza so important. Yet, as mentioned before, Ilyenkov believed that he could subject the Spinozist premise, according to which thought is the attribute of Substance, to dialectical treatment (thereby allowing post-Cartesian philosophy to solve the problem of dualism and to correlate *res extensa* and *res cogitans*). This was imperative for Ilyenkov, since according to him, no convergence of matter and concept could take place merely contingently, fortuitously, or performatively—it would need a dialectical contradiction to be implemented. And it is here—i.e., in the question of *how* to conflate mind and matter—that problems with Spinoza arise.

The performative and elemental concatenation of the conceptual and the material was not satisfactory for Ilyenkov. This was because the performative and contingent mode of development cannot be part of a dialectical cycle, as it is conditioned by the accumulative power and irreversibility of a concrete *stage* of a cycle; indeed, contingency and accidentality demonstrate neither progress, nor

the social dimension. Thus, for Lifshitz sociality was part of objectivity and not vice versa—objectivity acquired through human activity, labor and social consciousness. For Lifshitz, it is not in a human being that the general is generated, but the human being reflects the generality, given in nature.

This argument between Ilyenkov and Lifshitz, however, should not be exaggerated, as their followers usually do. This is because for both Ilyenkov and Lifshitz an individual consciousness, as well as the collective one, was determined through the external world and its objectivity—the stance that presupposed treating psychological or even phenomenological qualities of consciousness as secondary. Consciousness, no matter whether individual or collective, was an outcome of history, activity, and labor and their ontology and social diachronics. In fact, Lifshitz's disagreement with Ilyenkov was due to the fact that Lifshitz misunderstood to a certain extent the impact of the sociality of consciousness that Ilyenkov developed; as he approached Ilyenkov's adherence to social origin of the ideal as sociological interpretation of consciousness.

12. Ibid.

irreversibility in "ascending." The elements aggregate in their acci-
dentality without acquiring a qualitatively augmented new stage or
"critical mass." As we have noted, for Hegel, dialectics are specula-
tive; whereas accidentality pertains rather to an ordinary discourse
(ratiocination). Thinking accommodates accidents and predicates, but
it always exceeds them: "thinking cannot roam at will, but is impeded
by this weight [of content]."[13] This is one of the principal premises
stated already in the introduction to *The Phenomenology of Spirit*:

> 64. One difficulty which should be avoided comes from
> mixing up the speculative with the ratiocinative methods,
> so that what is said of the Subject at one time signifies
> its Notion, at another time merely its Predicate or acci-
> dental property. The one method interferes with the other,
> and only a philosophical exposition that rigidly excludes
> the usual way of relating the parts of a proposition could
> achieve the goal of plasticity.

And further:

> 65. As a matter of fact, non-speculative thinking also has its
> valid rights, which are disregarded in the speculative way
> of stating a proposition. The sublation of the form of the
> proposition must not happen only in an immediate man-
> ner, through the mere content of the proposition. On the
> contrary, this opposite movement must find explicit expres-
> sion; it must not just be the inward inhibition mentioned
> above. This return of the Notion into itself must be set forth.

13. "Picture-thinking, whose nature it is to run through the Accidents or
Predicates and which, because they are nothing more than Predicates and
Accidents, rightly goes beyond them, is checked in its progress, since that
which has the form of a Predicate in a proposition is the Substance itself. It suf-
fers, as we might put it, a counterthrust. Starting from the Subject as though
this were a permanent ground, it finds that, since the Predicate is really the
Substance, the Subject has passed over into the Predicate, and, by this very
fact, has been sublated; and, since in this way what seems to be the Predicate
has become the whole and the independent mass, thinking cannot roam at
will, but is impeded by this weight." G. W. F. Hegel, *Phenomenology of Spirit*,
trans. A.V. Miller (Oxford: Oxford University Press, 1977), 37.

This movement which constitutes what formerly the proof was supposed to accomplish, is the dialectical movement of the proposition itself. This alone is the speculative in act, and only the expression of this movement is a speculative exposition. As a proposition, the speculative is only the internal inhibition and the *non-existential* return of the essence into itself.[14]

It is important in this case that accidents and their performative contingency are rather seen by Hegel as part of a habitual, discursive *raisonnement*. Not only do they not reach sense, or the truth, but also they even dissipate this content. Lukács expresses similar doubts when he compares the dialectical nature of the mimetic image (which is objective) with the accidentality of magic or religious ritual, which paradoxically happen to be transcendent and detached from reality, although they performatively intervene in it. In his *The Specificity of the Aesthetic*, Lukács emphasizes the paradox: the performative hubris of a shaman invades objective reality, is nominally and even performatively immanent to it, whereas a mimetic image is nominally separated from reality. The [or A] mimetic image is not formally immanent to life. But being hermetic as an artwork, it becomes a "second reality" split from the "first one," and therefore can reflect objective reality in a general sense, can be universal and truthful.[15] By contrast, the performative act of a shaman—despite being nominally part and parcel of reality—joins the transcendent forces, and thus neglects reality. It communicates with the supernatural, with the "gods." The mimetic act, on the contrary, creates a conditional, oblique realm, to deal with reality in all its generalization. The shaman's (ecstatic) performance is then "out of this world." The artist's (aesthetic) treatment and philosopher's (cognizing) treatment of reality are, conversely, *into* this world. They make contact with "human" society. We have already dealt above with this paradox when we touched upon the poetics of realism. However, I need to add that in Hegel's and Lukács's

14. Ibid., 39–40.
15. Georg Lukács, *Die Eigenart des Aesthetischen*, Band 2. Kapitel 5 (Berlin; Weimar: Aufbau Verlag, 1981). Georg Lukács, *Svoeobrazie esteticheskogo*, vol. 2, ch. 5 (Moscow: Progress, 1987), 5–84, 32.

Evald Ilyenkov and Alexander Suvorov, a deaf-blind student, communicating
by means of a tactile alphabet in Ilyenkov's office (c. 1970). Photographer
unknown. Courtesy of the Estate of Evald Ilyeknov/Elena Evaldovna Illesh.

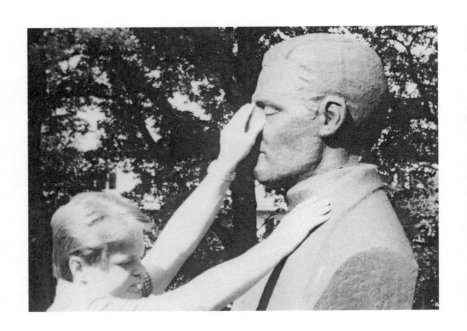

Emanuel Almborg, *Talking Hands* (film still), 2016. 48 min. Courtesy of the artist.

interpretation the nominal and the accidental intervention into reality brings no knowledge of objectivity—and does not allow proper cognition. Magic *performatively* and *accidentally* joins the transcendent through ecstasis: it does not need any cognitive reflection and mirroring of a situation, or sensuous comprehension of it, as it straightforwardly aims at the divine.[16] The work of dialectics, however, is engaged in thought as labor, as activity. This is why Ilyenkov so ardently imposes the modes of dialectics on Spinozist thought.

But is labor, or activity (*deyatel'nost*), not performative or accidental? Certain nominally material or immaterial actions do something or make something that is definitely performative. Yet, the reason labor (human activity in general) is not merely a performance is that it implies more than a separate, *hic et nunc* action of a concrete individual; it implies the fact that labor comprises multilayered and multi-temporarily ramified acts, committed as the superimposition of numerous *non-self* beings, and inscribed in time and history *diachronically* as well as synchronically. It implies a subject, which cannot have a nominal place and location. *Non-self being* is not focused on any special temporal condition; rather, it presupposes the *indiscreetness* of both the self and the non-self.

This is why thought is not a neurophysiological process confined to brain functions located within the skull. Indeed, Ilyenkov goes as far as to insist that physics and other natural sciences or technologies are not directly transmittable into the social sciences and humanities—as Bogdanov claimed.[17] Mere constructivism, structuration, or the instrumental engineering of the social sphere without philosophy and dialectics remain mechanical and empiricist tools for dealing with reality.[18]

The reason Lenin and many other socialist Marxists rejected Bogdanov's positivism was that while they agreed with Bogdanov that natural science had an important function, it could not, they insisted, supersede philosophy. The Marxist premise according to

16.　Ibid., 36.
17.　Evald Ilyenkov, *Leninskaya Dialektica i metaphizika pozitivizma* [Lenin's dialectics and the metaphysics of positivism] (Moscow: Mir Philosophii, 2015).
18.　Ibid., 75

PHILOSOPHIC ONTICS
OF COMMUNISM

which being is independent from and precedes consciousness, pre-supposed a specific philosophic gnoseology. It meant that things and acts are not literal. Biased by Hegel's *Anderssein*, they are other-determined by the non-self being. Referencing Lenin's critique of Bogdanov and empiricism, as Ilyenkov asserted: "hydrogen and electron and the gnoseological issues of cognizing hydrogen and electron are not identical."[19,20]

Mere data cannot be cognized without gnoseological means of generalization—and generalization entails contradiction. Not confined to dealing with data provided by the natural sciences, philosophical generalization involves the dialectical study of the objective material world from various, often contradictory, angles.[21]

Contradiction between the abstract and the concrete cannot be reduced to techno-naturalist isomorphism, between biological, mechanical, and physical laws then applied to social life (as is the case in Bogdanov's tektology).[22] As Ilyenkov writes:

Without dialectical coalescing of the relative and the abso-lute one cannot develop the generality of knowledge, and hence the objectiveness. Objective truth cannot then be distinguished from a subjective picture.[23]

Quite simply, this argument stressed the inability of scientific data to stand for objective truth. Ilyenkov's argument is that pure experience is not objective, but rather subjective. As he insists, the empiricist gnoseology of Bogdanov's tektology as organizational edifice is founded on subjective psychic experience. The data from this subjec-tive experience is merely extrapolated to other realms, such as the economic and the social. Thus for Bogdanov consciousness remains

19. Vladimir Lenin, "Empirio-Criticism and Historical Materialism," in *Materialism and Empirio-Criticism, Lenin Collected Works* (Moscow: Progress, 1972), 17–362. Available in English at Marxists Internet Archive: https://www.marxists.org/archive/ lenin/works/1908/mec/.
20. Evald Ilyenkov, *Leninskaya Dialektica i metaphizika pozitivizma*, 102.
21. Ibid., 109.
22. Alexander Bogdanov, *Tektology*.
23. Evald Ilyenkov, *Leninskaya Dialektica i metaphizika pozitivizma*, 118.

a psychic and sensory phenomenon. Philosophy, on the other hand, deals with things that are not confined to perceived facts.[24] What Bogdanov takes for granted (and Ilyenkov and Lenin vigorously contest) is namely that the social being and social consciousness are identical, co-extensive, and simultaneous. For Ilyenkov the independence of being from consciousness is the kernel not only of philosophic onto-gnoseology, but of social and political practice as well. He does not cherish the illusion of solving ideological contradictions by means of mechanical and physical laws, that is, by means of applying the physicist's principle of equilibrium of energies to societal contexts.[25]

Despite focusing on the Spinozist premise, according to which thinking is an attribute of Substance and hence of nature, Ilyenkov tries to insist that such a convergence of thinking and nature is to be produced dialectically, and not mechanistically, naturally, or merely performatively.

It is true that the conditions of thinking are provided by nature (this Spinozist premise is elaborated as early as in Ilyenkov's *Cosmology of the Spirit* in the mid-1950s). But Ilyenkov emphasizes that what Marx adds to this Spinozist conjecture is that nature is not static and unchangeable in its being Substance. Nature is able to "think" only when it *achieves the stage* when it is transformed; i.e., when things are being produced by means of *labor* by a human being for other humans. In Ilyenkov's *Dialectical Logic*, it is labor then that becomes the irreversible stage in the dialectical development of matter. It is precisely with labor that concept and material realia overlap.

This is the point Hegel touches upon when he claims that "grasping the True" has to take place not only as Substance but "equally as *Subject*."[26] The ontological stage of labor that Ilyenkov argues about in this case is the Subject against mere Substance.

24. Ibid., 119.
25. Ibid. According to Ilyenkov, social relations, which are full of complexities and contradictions, cannot be managed and balanced according to the theory of physicist equilibrium of energies, as Bogdanov would insist.
26. G. W. F. Hegel, *Phenomenology of Spirit*, 10.

PHILOSOPHIC ONTICS
OF COMMUNISM

As such, it is precisely this achievement—labor—that makes possible the production of social life. This is how Ilyenkov ends the chapter on Spinoza in *Dialectical Logic*:

> Of necessity, according to Spinoza, only Substance possesses thought. Thinking is a necessary premise and indispensable condition *(sine qua non) in all nature as a whole*. But that, Marx affirmed, is not enough. According to him, only nature of necessity thinks, nature that has achieved the stage of man socially producing his own life, nature changing and knowing itself in the person of man or of some other creature like him in this respect, universally altering nature, both that outside him and his own. A body of smaller scale and less "structural complexity" will not think. Labor is the process of changing nature by the action of social man, and is the "subject" to which thought belongs as "predicate." But nature, the universal matter of nature, is also its substance. Substance, having become the subject of all its changes in man, the cause of itself *(causa sui)*.[27]

Labor is thus both implemented immanently and dispersed and applied objectively, i.e., generally. If nature realizes itself *(osoznajot)* in human life/labor, this means that it is not the planetary hegemony of the human being that changes nature as some creature alien external to it, as articulated in geophysical and ecological theories of the Anthropocene, but a human being, human presence, its emergence and development, is what nature itself could only have transformed into. Consequently, nature has had to irreversibly transform itself into labor and culture. Or, rather, the necessity of labor in nature, and their co-extensity, is the condition that produces complexity in nature, and therefore enables nature to expand into thought. As Ilyenkov highlights, according to Marx, thinking would be impossible

27. Evald Ilyenkov, in *Dialecticheskaya Logika* [Dialectical logic: studies in history and logic] (Moscow: Politizdat, 1984), 25–55, 54. Available in English at Marxists Internet Archive: https://www.marxists.org/ archive/ilyenkov/works/ essays/essay5.htm.

at a lower level of complexity, i.e., in conditions where labor has not yet emerged, and as such where sociality has not yet emerged.

Let us provide another fragment from Ilyenkov's *Dialectical Logic* to press this point home:

> The forms of thought, too, the categories, were accordingly treated not as simple abstractions from unhistorically understood sensuousness, but primarily as universal forms of social man's sensuous objective activity reflected in consciousness. The real objective equivalent of logical forms was seen not simply in the abstract, general contours of an object (a thing) contemplated by an individual, but in the forms of man's real activity transforming nature in accordance with his own ends: it is precisely *the alteration of nature by men*, not solely nature as such, which is the most essential and immediate basis of human thought, and it is the measure that man has earned to change nature that his intelligence has increased. The subject of thought here already proved to be the individual in the nexus of social relations, the socially determined individual, all the forms of whose life activity were given not by nature, but by history, by the process of the moulding of human culture.[28]

Following this tenet, Ilyenkov claims labor as the subject to which thinking is the extension; it is precisely labor that effectuates the transformation of nature in the "activity of a social human." This premise could have been disputed from the Spinozist standpoint; because, the Spinozist perspective does not allow for a differentiation between a natural object and a produced one, nature and artifact. Moreover, to reiterate, in the Spinozist context, activity is performative, structurally constellated, or seriated and chained, as opposed to a speculative, cyclic, and purposeful procedure. Activity is semiologically and topologically discreet even when *asignifying, or subjectless* (Guattari). For Ilyenkov, activity is ideational even when

28. Ibid., 164–188, 187. Available in English at Marxists Internet Archive: https://www.marxists.org/archive/ilyenkov/works/essays/essay5.htm.

material and social, it is omnipresent and does not adhere to any singular nominal location.

As Leontiev confirms in his "Activity and Human Consciousness,"[29] the main Cartesian divergence of extension, bodily acts, and the internal procedures of consciousness should give way to another differentiation: between the activity of a Subject and objective reality with its forms transformed by the Subject's activity. This would mean that the dissection of activity into two spheres—into material activity and thinking—would be annulled.

Interestingly, Ilyenkov's tenet about the phylogenetic irreversibility of labor disputes the Kantian argument about the inability of perceiving the thing in itself. It also disavows the fear of anthropocentric domination, which has to be dismissed in order to scientifically study the pure physical environment. In Ilyenkov's logic, without a human being and her activity, it would be impossible even to raise the question about matter, objecthood and its purity, and hence about inhumanness. The aporia lies precisely in the fact that any quest for the object's purity or even unmediated materiality can be claimed by the token of a human being present within this very objecthood and materiality.

In his book *Consciousness and Revolution in Soviet Philosophy*, David Bakhurst emphasizes exactly this point, namely, that for Ilyenkov there is no pure physical environment, only a meaningful one since this environment cannot be detached from being marked by human activity.[30]

Thus, to summarize: according to Ilyenkov, the epistemological mediation of labor that is dialectically exerted between nature and production—i.e., between thought and culture—does not discard the Spinozist premise according to which nature (Substance) remains as the source of transformations (a substance), except for one necessary precondition: nature extends onto the stage of human labor, and as such turns into labor as nature's dialectical development. A human being is then an inherent part of nature and mediates

29. Alexey Leontiev, *Activity and Consciousness*, 96–97.
30. David Bakhurst, *Consciousness and Revolution in Soviet Philosophy: From the Bolsheviks to Evald Ilyenkov* (Cambridge, UK: Cambridge University Press, 1991), 187.

nature, inasmuch as nature itself is molded into the process of labor and human activity. In other words, it is not just natural datum in the human being that is able to think naturally in its contact with nature, but a human being already grown into nature as *socium*—a human being of social activity and collectivity.

As Ilyenkov says in relation to Marx:

> It is precisely *the alteration of nature by men*, not solely nature as such, which is the most important and principal foundation of human thought, and the mind of a man has developed according to man learning how to change it. The subject of thought in this case would already be the individual in the nexus of social relations, the socially determined individual, all the forms of whose activity were given not by nature, but already by history, by the process of formation of human culture.[31]

To reiterate, Spinozists would dispute such an intervention of Marxist premises into Spinozist thought, which does not need an ingrowth of attributes or modes between each other, as long as they can be *in concert with each other in their parallelism*. Indeed, one witnesses a contradiction between Ilyenkov's Spinozism and his Marxism. On the one hand, rendering Spinoza's tenets, he emphasizes that there is no such thing as a specificity of human thought as the feature of a human being; he claims that human thought belongs to Substance (nature, i.e., God for Spinoza). On the other hand, Ilyenkov incessantly repeats that it is only the stage of human activity and hence of social consciousness that opens up the path to thinking. Although thinking is thereby a part of nature, it is precisely this irreversible *dialectically acquired* stage in human history that is indispensable for the generation of thought. The latter, then, does not appear from the "outside"; it is part of nature. That said, nature should become unnatural, inorganic, in order to attain the transformative stage of labor and hence reach the level necessary for thought. Nature, accordingly, is

31. Evald Ilyenkov, *Dialecticheskaya Logika* [Dialectical logic], 25–55, 50. Available in English at Marxists Internet Archive: https:// www.marxists.org/ archive/ilyenkov/works/essays/essay2.htm.

PHILOSOPHIC ONTICS
OF COMMUNISM 281

not merely nature, but nature advanced to the evolutionary stage of the laboring body (second inorganic nature), and hence the stage of thinking beings that is able to be general, generic.

IV
THE DIVERGENCES BETWEEN SPINOZA
AND ILYENKOV'S METAPHYSICAL MATERIALISM

Nevertheless, the reason Spinoza is so important for Ilyenkov is that in his counter-Cartesian anti-dualism he evades scholastic mechanicism and crude empiricism to find the unifying measure of both, the material and conceptual dimensions. As Ilyenkov argues, Spinoza's Substance posits the sameness of mind and body, which are simply differently expressed.

The main achievement of Spinoza's monism for Ilyenkov was in that he invented the new logic of coordination between space and thought, proving that there can be no thinking without spacialization and body. Spinoza, as Ilyenkov alleges, discovered a new condition—not simply thought, but a *body that thinks*. Thus Ilyenkov's core interest in Spinoza was not the primacy of affects and the supremacy of the body over consciousness and speculation. Ilyenkov's continuous appeal to Spinoza was in that Spinoza discovered the fantastic capacity of the body: the body that thinks is affected *outwardly* and experiences this affectation in conformity with external objective facts. Hence, it is not the forms of things that cause any shift inside the physicality of the brain—and, by this token, thought is an inward psychic process. On the contrary, thought realizes itself in coordination with externalized spatiality by means of being entangled in outward objecthood. This is why Ilyenkov so often recklessly uses the notion of the "thinking body" instead of Spinoza's Substance. This externalized nature of thought meant for Ilyenkov that thinking is not an internal process evolving inside the brain, but it is the result of external action exerted on objects and things. For Ilyenkov, this is extremely important because it means that thought is material—but its materiality is not confined to elemental micro-changes within the physiology of the brain. Thinking can only function by being placed outside itself,

as the activity enacted in the spacing of *other* things and bodies—according to the schemes and arrangement of external thinghood and not according to its own internal arrangement (formal semiological realization of thinking), or as a result of organic procedures (e.g. brain, neurons, etc.). Consequently, the human being—i.e., a thinking body—can define itself only in accordance with the forms, shapes, and contours of other external bodies, and not in accordance with the construction of "its" own body (its own self).[32] One would think that "thought" is happening inside the head, within the brain, but thought in fact is exerted with external objects and is incited by them.

Spinoza's Substance thus guarantees the equivalence and co-extensity between the thinking body and the external world. And importantly, Substance is not a repository for the world to encompass, but is immanent to both thought and matter as its attributes. This possibility of the equivalence of thought and matter is crucial for Ilyenkov to confirm their interconnectedness.

However, the question here is whether Ilyenkov confused Spinoza's parallelism of mind and extension and their co-extensity as simply an Hegelian *quid pro quo*—determination of something by means of an *other being*, an *other self*. It is true that the material being, which is parallel to thought in Spinoza, is external and "other" in relation to a thinking mind—the stance that is so important for Ilyenkov to argue for the objectivity and materiality of thought. But the *quid pro quo* logic—the way "the other determined non-self" is posited by Hegel—is expressly different from Spinozist parallelism, in that Hegel's *Anderssein* implies dialectical indiscreetness and overlapping of many "other selves," be they mental or material. Whereas Spinoza's externality of being, on the one hand, and thought, on the other, construct parallel chains when each attribute—mental or material—forms its own succession and is not reciprocal with any other, simply because it is already immanent to it. These chains form themselves consequentially in discreet causal connectivity, and not in augmentable convergence and dialectical reciprocity, contradiction and superimposition. Thus the question remains as to whether the principle of *Anderssein*, in its positing things via other selves—e.g. positing the concept dialectically via

32. Ibid.

thinghood—is the same mode of externalization as Spinoza's parallelism and co-extensity of material and conceptual parameters.

Thus, the incompatibility between Spinoza and Ilyenkov's dialectics arises when it comes to the type of mediation between body and mind. The immanence of Spinoza's Substance rests in the positing of its attributes as spatially locatable, topologized, and quantified, even when they are deprived of individuality. In Spinoza, body and mind as two attributes of a substance are mediated performatively given that Substance is immanent to them. Thus, thought is co-extensive with spatial bodies and things as it forms the same performative chain or a set (series) as the things do. But the *chain's* function (episteme) is accidental, performative, and semiological; it does not need a dialectical structure of augmentation grounded in an irreversible and unquantifiable evolutionary process. In other words, it does not require purposefulness or transformation of quantity into quality. For Spinoza, performative and contingent modes of development have no irreversibility determined by the accumulative power of a concrete stage of a cycle; they do not "ascend" into an irreversible stage. The elements aggregate in their accidentality, causally, without acquiring any augmented identity, or a new "critical mass" via dialectical procedure.

In his *Hegel or Spinoza* (1979), Pierre Macherey insightfully emphasizes the same condition in Spinoza; namely that, for him, the real things of being cannot ascend to abstract things or universals. Causal orders of being and of thinking are both of the *same necessity* within Substance, but "between ideas and things there exists no relationship or correspondence that subordinates one to the other, but rather a *causal* identity, that establishes each one of them in necessity of its order."[33] Consequently, Spinoza's system is not evolutionary, unlike that of Ilyenkov's (or of Hegel's and Marx's).

Badiou remarks on the same premise in Spinoza: "Causality organizes in God all finite things in infinite chains. But finite things are only in relation with finite things."[34] The main consequence to this is

33. Pierre Macherey, *Hegel or Spinoza*, trans. Susan M. Ruddick (Minneapolis: University of Minnesota Press, 2011), 64.
34. Alain Badiou, "What Is a Proof in Spinoza's *Ethics*," in *Spinoza Now*, ed. Dimitris Vardoulakis (Minneapolis: University of Minnesota Press, 2011), 39–51, 45.

that the infinite being and the becoming of finite things cannot overlap. They need not overlap simply because infinity is guaranteed by Substance. But precisely such exigency of overlapping and fusion of the finite and the infinite was implied in the concept of the ideal for Ilyenkov. Thus, Spinoza does not say that outward material externality is already capable of producing thought, but that it is just immanent to thought. To embody thought by means of figurated images, the plane of geometry is required.

In his insightful article about Ilyenkov's Spinozism, Vesa Oittinen confirms this incompatibility between the two thinkers. In a way similar to Macherey, Oittinen emphasizes that in Spinoza there is no convergence of material extension and concept. As he states, it is true that for Spinoza, unlike Descartes, thought and matter (extension) are just two parallel attributes of the same Substance, and not two different Substances as they are for Descartes. Nevertheless, these two attributes of the same Substance need not coincide and conflate in Spinoza. Ideas are parallel to matter, but they nevertheless remain incorporeal and different from it. That is why ideas cannot "'reproduce' the corporeal forms of external bodies."[35] Body and thought for Spinoza do not determine or fuse with each other, although they could be performatively concatenated; hence Ilyenkov's term *"myshlyashchee telo"* (the thinking body) is not really Spinozistic, as Oittinen concludes.[36] (Spinoza's term is a "thinking thing" and it is God or Substance, not a human being, or any concrete realization of thought or act).[37]

Given that thought and material extensions are not identical, but merely parallel, these attributes can only be "conceived through their own selves." This is precisely why these two attributes—matter

35. "There cannot be any causal relation between ideas as forms of thought and the external forms of things, and Spinoza says this so clearly that there is no room for any misinterpretations: 'Body cannot determine mind to think. Neither can mind determine body to motion or rest or any state different from these.' This is not possible for the simple reason that the modes of thought have God as their cause insofar he is a thinking thing; '[t]hat, therefore, which determines the mind to thought is a mode of thought and not a mode of extension.'" Vesa Oittinen, "Evald Ilyenkov: The Soviet Spinozist," in *Dialectics of the Ideal: Evald Ilyenkov and Creative Soviet Marxism*, ed. Alex Levant and Vesa Oittinen (Leiden: Brill, 2014), 107–124, 117.
36. Ibid.
37. Ibid., 116.

PHILOSOPHIC ONTICS
OF COMMUNISM

and thought—can be performatively coordinated by Spinoza, since in their discreetness they are already a performative act. Oittinen writes:

> Where Spinoza "sublated" the Cartesian dualism, so in a like manner Hegel "sublates" Kant's dualism. It seems that these dualisms can be removed if it is possible to find some mediating instance between the two extremities. In Spinoza this *tertium datur*, which unites thought and matter was the Substance, in Hegel it was the Spirit, and for Ilyenkov it is the concept of activity [labor]. Ilyenkov writes, for example, that "[t]hinking is not the *product* of action [of the body], but the *action itself*," which amounts to the claim that the action of the body is, considered in itself, apart from its bodily substrate, nothing but thought. Bodily movements thus generate thought, and the action is the mediating link between thought and body, rising above their dualism. This reading does not find support in Spinoza, for whom the *corporis actio* and *mentis actio* were parallel yet clearly different forms of action which did not exert any influence upon one another in the modal world.[38]

This interpretation of Ilyenkov's approach to activity theory is slightly imprecise, mainly because thinking for Ilyenkov is not identical to physical action. If so, he would be Charles Sanders Peirce. For Ilyenkov, body or a body-act is not a thought given directly, and neither is it an act of thought identical with any physical dynamism. Rather, what is meant by thinking-as-action here is the capacity of thought to be constructed, not in accordance with brain procedures or any internal "spiritual" procedures, but through its being formed out of the constellation of outward material things and bodies. Via such a standpoint Ilyenkov asserts that thought is not self-sufficient but can only be conceived due to and by means of *other material beings and other selves*. Similarly, action and matter are not confined to their physical presence; but are able to take on an ideational identity simultaneous to their own materiality. Consequently, both matter/action and thought

38. Ibid., 118.

are conceived and evolve synchronically, as well as diachronically. In these terms, Ilyenkov's conjecture of the simultaneity of many selves and many temporal and spatial sites opens up the dimension of non-self being. This is why thought is impossible without consciousness: consciousness facilitates, as a realm of dialectical processing, the exertion of non-self-ness as such. That is, it facilitates the "fantastic" awareness that anything is at the same time some "other" thing as well. Hence, the syndrome of the dialectical convergence of matter/body and thought is not based on identification and coincidence, but on radical non-identification: if anything can be determined as the other-self, then materiality as a category can be determined by the speculative parameters of thought, and vice versa, speculative, noumenal parameters are not viable without materiality.

Oittinen reminds us that Spinoza applies geometry and imagination to solve the ontic incongruence and parallelism of mind and matter in the same way that Kant uses the representation of noumena by means of a transcendental schema. But Oittinen emphasizes that for Spinoza, geometry, ontically speaking, is not identical with thinghood; it simply serves the goal of bringing ideas to the ocular, ontic valence, and not to ontic identification with thinghood. Thus, according to Oittinen, Spinoza applied the geometric spatialization of the otherwise non-spatial products of mind to use the *imagination* simply as mediation, exactly because thought and matter remain discrete, non-identical, and parallel. Conceptual phenomena have to acquire concrete semiological (geometric) forms of expression and only in this way are they manifested in the guise of the represented phenomena. But spatialization and figuration of the concept into geometry or images, and the usage of representation and imagination for Spinoza, as Oittinen reiterates, does not at all imply any mutation of the conceptual parameters into objecthood, or their mirroring. The idea of a circle or any other geometric figure has no spatial properties, as Oittinen emphasizes. This is why these ideas of geometry need an imaginative, sensuous medium of objectivation. Yet for Spinoza their objectivation and representation is not in any way related to reality or matter. Visual geometry simply represents ideas for "the eyes of mind," but does not identify or mingle with extended things and images. As Oittinen insists, images and

figures then are needed for thought to assist thought as *auxilia intel-lectus* (auxiliary media of thought). The intellect needs the assistance of the medium of imagination and thereby it produces fictitious geo-metric figuration, simply "because mental figures are discernible only in imagination; in pure thought the geometric relations have no parts or distances."[39] Therefore, for Spinoza, imaginative geometric figu-ration is nothing other than mere semiologically mediated thought; it does not in any way prove thought's development from thinghood, or its convergence with the ontic parameters, as Ilyenkov attempted to prove.

Hence, for Spinoza, the use of imagination does not bring about the conflation of mind and matter. Imagination is used as a topological plane for otherwise mental and speculative phenomena, which are transposed there into semiological expression. This act topologizes, singularizes, and semioticizes the idea and puts it in various causal chains (set of series); it geometrically and semiologically marks men-tal phenomena. But such semiotized or geometricized signs do not need to overlap or conflate with material objects, simply because signs of different modi and order are already immanent to each other and equivocal without any convergence. This means that here it is important to keep the self-sufficient *singularity* of the selves in place; everything should be of its own kind, rather than "non-self." If any-thing has its own topological expression and performative evocation, then things can merely concatenate. But they do not need to blur in qualitative convergence, nor be subject to dialectical augmentation.

With the performative principle of chaining each of the two attri-butes, mind and matter, would not need to converge and coincide *ontically*. (Hence the semiological geometric plane of imagination that is applied to make thought discrete.) Even if we look at how Spinozist thought evolves in post-structuralism, we see that there, thinking—despite being inseparable from the material mechanisms by which it is affected—does not need to be identical with those mechanisms themselves. Thought and its semiology are discretely separate from thinghood and objects. This is because thought gen-erates performative effects (expressions to be topologized) in which

39. Ibid., 120.

thought-components and body-components evolve in a discrete, semiological series or its semiological items, rather than growing temporally and spatially into each other, or out of each other. These semiotized or geometricized signs, which Spinoza uses to embody thought, do not need to overlap with material objects simply because signs of different modi and order are already immanent to each other and equivocal without any convergence. To reiterate, if semiological nominalism defines both of the attributes—matter and mind—there is no need for them to converge, simply because both attributes are already immanent and co-extensive to each other without any need of conflation.

If we now refer once more to the filmic studies of the Zagorsk experimental school for the deaf and blind, this footage demonstrates that exactly what at first sight seems affective, sensual—the way the deaf and blind students manually explore the contours of things, the way they communicate via haptic touch—is in fact a process of comprehension, speculation, reflection: i.e., thinking and conceptual procedures. These experiments were confirmation for Ilyenkov that human activity exerts thinking and sociality already on the level of raw materiality.[40] Hence, this case proves that thought is generated even before and without the abovementioned intermediary plane of geometrization and semiologization that for Spinoza is indispensable to transmit thought in the form of ocular abstraction. Even without the ocular parameters of mediation, the *Weltanschauung* and general image of the world still remain possible. Thus, even without the semiological mediation that translates thought, the conceptual, and the general—by means of signs—such universal categories are already at work in human activity in the world. By consequence, signs and language are only a means—complementing the already existing universality and noumenal potentiality of matter. The noumenal potentiality of matter exists irrespective of language.

Interestingly, in his glossary on Spinoza, Gilles Deleuze confirms that Spinoza's modes are topologically biased and their type of mediation is a *composition* of discrete coherences, which defy

40. For interpretations of activity theory in Soviet philosophy see Andrey Maidansky and Vesa Oittinen, eds., *The Practical Essence of Man: "The Activity Approach" in Late Soviet Philosophy* (Chicago: Haymarket Books, 2017).

PHILOSOPHIC ONTICS
OF COMMUNISM 289

any augmentation. Deleuze emphasizes (in a quite similar fashion as Oittinen) that for Spinoza there is no convergence of mind and body. They are autonomous and depend on two different attributes, and "each attribute is being conceived through itself. But there is nevertheless a correspondence between the two, because God, as a single substance possessing all the attributes, does not produce anything without producing it in each attribute according to one and the same order."[41]

Deleuze argues that *this formal identity of order* between bodies and minds correlated in parallelism dates back to Leibniz and is defined by him as *isomorphism*. Already for Leibniz, as Deleuze contends, there is an equal valence between body and thought, a parallelism of order between body and mind—a parallelism of conceptual and material parameters. What Spinoza adds conceptually to this parallelism, according to Deleuze, is the causal correspondence between two attributes—or *isology* (the causal correspondence that was absent in Descartes and in Leibniz). Isology implies that "all that is action in the body is also action in the mind."[42] In other words, this causal correspondence makes it clear that for Spinoza fusion between matter and mind would be unnecessary: because the aforementioned parallelism makes such convergence superfluous. Since the body and mind are isomorphic and isologic—i.e., since they are already equivalent—their convergence or fusion would not bring about any new quality, and would not have any causal valence. The achievement of such semiological discreteness, according to Deleuze, lies in the defiance of the possibility of *eminence* or *superiority* of one attribute or modus emerging over the other, of the "creator" over the "created" body, and of the perfect parameters vanquishing the imperfect ones. Yet it is worth recalling that, despite such equivalence and correspondence, the *ontic* parallelism and discreteness between the body series and mind series remains intact.

This ban of eminence is very important in constructing a proper immanence. Semiology supersedes semantics then: the equal valence and parallelism of the attributes prevents the mind's prevalence over

41. Gilles Deleuze, *Spinoza: Practical Philosophy*, trans. Robert Hurley (San Francisco: City Lights Books, 1988), 87.
42. Ibid., 88.

the body. This is why Deleuze disavows the role of consciousness in relation to an idea and thought. He claims that consciousness is secondary to an idea, since ideas should operate as discrete states. Such a dismissal of consciousness and demand for its disparity with thought and the idea is conditioned by the fact that for Deleuze consciousness functions as the repository of the universal (the general), that is, the irreversibility and indiscreteness of phenomena. Consciousness enables conflation of the body and matter and thereby enacts the generalness (the ideality) of materiality (physicality) and immateriality, which should not be generalized as they have to remain quantifiable, or semiologically literal.

In his essay on Spinoza, Deleuze incessantly repeats the thesis that thought (idea) and body as the attributes of Substance are more extensive than consciousness. Consciousness is nothing but an operation of control and the repository of illusions, and it is here that the divergence with Hegel resides. As Deleuze asserts, in Spinoza's system, mind and body would not need consciousness for mediation. Consciousness merely registers the consequences, but it does not grasp their causes. Causes are determined by combination of coherences, forming the aggregates of living parts, either in correlation with, or in dissociation from, each other. It is this aggregation of causes that constructs nature (mind and matter as its attributes included); but consciousness only retains residual effects and inchoate results of those associations and dissociations. Hence consciousness does not "know" anything about the breadth of the multifarious procedures and the complex composition of the concatenations, associations, and dissociations. Consciousness is thus a "retarded" process of comprehension; it slows cognitive aggregation. That is why Spinoza's *appetit*, *conatus* and desire should be purged from consciousness. On the contrary, consciousness only leads to blurring and falsification of the combinations of causality.[43]

In dialectics, mediation between mind and matter (body) is completely different from such causality and its discrete contingencies. Activity (Ilyenkov's *deyatel'nost*) and the medium of labor permeate every immaterial phenomenon, and vice versa—thought is potentially inscribed in every physical act. So instead of performative

43. Ibid., 18–20.

PHILOSOPHIC ONTICS
OF COMMUNISM 291

expression, instead of Spinoza's *plateau of imagination* added to the attributes of mind and matter as a geometric, semiotic plane of con-catenation, activity and labor exert the *dialectical conflation* of mind and matter by means of an unquantifiable procedure. Labor and activity contain performative elements, but they are not confined to topological presences in separate acts of performance. Labor (activity) becomes the logic of the *ontic* fusion of both thought/act and material objecthood. For Ilyenkov, convergence of the abstract and the concrete is not placeable although it takes place with con-crete functions and outcomes: the spoon is concrete and material, but at the same time it is wholly general in its ideality and its "spoon-ness," which holds the dialectics of its genesis ever open. Matter is *burdened* with idea, and notion or thought, in turn, "burdened with matter" (Oittinen). For a dialectician, then, the immanentist equa-tion of idea and matter by means of geometry and topologization remain merely abstract despite nominalist, *hic et nunc* performa-tivity. This is because such an equation is, to reiterate, semiologic and not semantic. Nevertheless, contamination of objecthood with thought, and of thought with the externality of objective world—i.e., the socialization of the mental—brings about extra-topological universality and its dialectical dimension.

Andrey Maidansky, who also explored the role of Spinozism in Soviet Marxist thought, has to acknowledge (in the same vein as Oittinen) that although for Spinoza "practical action defines human intellect," matter and practice do not create or generate intellect in his system.[44]

Interestingly, Maidansky acknowledges that Vygotsky's appli-cation of Spinozism was quite similar to that of Ilyenkov's in his obsession to prove that body and bodily states were able to gener-ate or transform the human mind (intellect) by means of activity and labor.[45] Unlike Descartes for whom passion is detached from mind and represents a physiological realm, Spinoza reveals how body and mind interact in the regime of relating thought with affect, concept with passion. Yet, as Maidansky confirms, Vygotsky had to admit

44. Andrey Maidansky, "Russian Spinozists," *Studies in East European Thought*, vol. 55, no. 3 (2003): 199–216, 209.
45. Ibid., 204.

that for Spinoza "the forms of imagination do not turn into the forms of intellect or even somehow commingle with them."[46] Intellect and ratiocination process the data delivered from imagination in Spinoza's system, but imaginative acts operate differently from the laws and operations of intellect. For Vygotsky, it was essential to prove the genesis of thought out of external reality—to map how simple affective reactions and emotions become rational ones (i.e., turn into higher mental functions). This goal was extremely difficult to realize, even with the reliance on Spinoza. As Maidansky recalls, Vygotsky's quest was to show (quite similarly to Ilyenkov) that natural forms of perception and imagination *are directly transformable into cultural (intellectual) forms, into higher mental functions*.[47] In both cases, the principal point is the finite, ontic, material characteristics of the ideal, the finiteness of the universal parameters (*finiteness of the infinite*). The same is true the other way around: the possibility of ideality and infiniteness operating materially as mundane objecthood. This leads to a specific dialectics of the finite and infinite—when infinity is posited as finite materiality, materiality in its own turn becomes noumenal and eidetic, i.e., is seen as timeless and eternal.

This is why Ilyenkov was unable to solve the problem of the *finite* form of the ideal (of the *general*, the *infinite*) in the context of Spinozism—his main preoccupation in the framework of his theory of the materialist ideal. The Spinozist condition was that finite things a priori have an infinite God as their immanent cause; hence, the finite and the infinite need not converge. Finite things can only be created by finite things and be connected to other finite things. Infinity under such conditions is possible only as the infinity of the chain of finite things in infinite chains. This infinity of immanence suffices to claim infinity as such.[48] But Ilyenkov's "fantastic" discovery—his insistence on claiming the *ontic* (factual, material) dimension of the ideal—was that finite things operate as infinite not only in the framework of a deep cosmic time. On the contrary, physical things simultaneously with their nominal finiteness

46. Ibid., 206.
47. Ibid., 207.
48. See Badiou, "What is a Proof in Spinoza's Ethics," 39-51.

PHILOSOPHIC ONTICS
 OF COMMUNISM 293

function as noumenal, eternal, ideal, extra-physical. And vice versa: the parameters of the ideal are ontic and object-based. The trigger for such dialectics of matter and mind convergence is the politico-economic conditions of communism.

When an object ceases to be a commodity, or is extracted from the economy of libidinality, its material ontic parameters change too. Thus what seemed to be natural qualities in the existence of a thing turn out to be the outcomes of political economy. Consequently, change in political economy can transmit the functioning of an object into a different ontic field. Not only does sociality change with non-libidinal economy, but also the conditions of materiality—the very physics and phenomenology of matter.

Under the conditions of abolished private property and surplus economics, material and finite objects are able to acquire a noumenal (infinite) dimension. On the other hand, idealities are able to function as objective, finite, and material social aspects of the everyday. In short, elementary material objects become speculative—metaphysical. This presupposes a "fantastic" condition, where the ontic becomes ontology and is superseded by it, speculation then resides right in the frame of nominal materiality. In other words, the ontic becomes ontological, ideal, whereas ontology (the ideal) in its own turn operates and functions in the ontic regime.

Following such logic, the ideal is already present and operating in the world of finite objects and only due to this can it be developed and evolved into thought.

Such complexities in reconciling materialism of the ideal with Spinoza's studies of Substance reside in the task that Ilyenkov sets himself, conjoining Hegelian and Marxian dialectics and Spinoza's anti-idealist immanentism. The task can be regarded as unaccomplished, because both Hegel's and Marx's dialectics rely on the principle of development and augmentation. Dialectics as a procedure surpasses discrete particulars—the accidentalities, contingencies, and topologies—thus making the arrival at certain stages of labor and history irreversible. On the other hand, Ilyenkov's dialectical theory of the materiality of the ideal cannot be fully identified with Marx either. Although Marx insists on embodying the social ideal in the politico-economic infrastructure, he has no need for the

metaphysical lexicon in order to posit the new condition of materiality and of ontics when grounding his gnoseology. Thus what is new in Ilyenkov's gnoseology in comparison to Marx is exactly the mutated ontics of historical socialism in which the aforementioned twist between ontics and ontology took place. In this gnoseology, for the first time in the history of humanity, thinking is colonized, as Ilyenkov puts it, by the revolutionary outcomes of sociality and political economy, which "define the criteria, basis and goal of being and cognition." By consequence, concrete daily sociality is permeated by the modes of philosophic ideation.

V
THE ABNORMALITY OF SOCIALISM

That Soviet philosophy so insistently clings to the notion of the ideal lies in the fact that the society of historical communism represents a societal construction that, however paradoxical it sounds, has come closest to the societal "ideal" of the communist abolishment of capitalist relations. The problem of historical socialism has always been posited in terms of its flaws: the still un-sublated elements of state capitalism, the shadow economy, and the hegemony of the party nomenklatura. However, the paradox is that the abnormality of Soviet socialism was concealed in the opposite condition. It resided in the prematurely attained proto-communist traits of socialism. I have already mentioned the advancement of the relations of production over the productive forces in previous chapters, which created the *casus* of attained socialism in the conditions of immature productive forces and their inefficiencies. It should be noted that Ilyenkov's gnoseology stems from such "abnormal" social conditions—the very conditions in which Soviet thinkers found themselves.

As Ilyenkov tacitly infers in his text on "Marx and the Western World" (1965), socialism should not merely be a crude form of communism, as Marx argued in his critique of vulgar communism, but already a transition from the purely formal socialization of property and wealth (characteristic of "vulgar" communism) to the appropriation of that wealth through the de-alienation of the productive

forces, which are traditionally alienated under private property.[49] On the other hand, paradoxical as it may seem, while insisting on the conscientious sublation of surplus economics and private property, Ilyenkov nevertheless acknowledges the inevitability of undergoing the stage of the "vulgar" and coercive abolition of private property in order to guarantee the subsequent socialization of such a condition. Soviet socialism, as he infers, was already a transition away from the crude form of the socialization of property. Yet the mutation, which was not obvious for contemporaries of the socialist era and which revealed itself later in the post-socialist phase, contained the following paradoxical fact: precisely the true achievements that led to communism became an unsolvable obstacle to communism. The development of socialism into communism was blocked not only because of the remainders of capitalist society—the rudiments of private property, surplus value, alienation, authoritarian and patriarchal components in its institutional infrastructure, bureaucratic and state control, and partocracy; i.e., socialism mutated not only as insufficient and false communism; it emphatically declined into individual repulsion toward the common good and social equality. Rather than simply owing to the initial faults of socialism and its infrastructure, socialism declined precisely due to the eminence of communist features in socialist society, which became unbearable and began to be treated as an abnormality. The reason for such a decline was of course in the libidinal construction of human subjectivity, which the non-libidinal political economy did not manage to fully dismiss.

Under capitalism, the sublation of alienation functions as a regulative idea motivating the ongoing emancipatory struggle, but it cannot form and construct political economy and social relations. Capitalism's economic and social basis is grounded first and foremost in the extraction of a surplus from production and from the market economy as the primary and insurmountable condition of such extraction. Consequently, critical thought has to accept "evil" (capitalism) as its point of departure. Reality is malicious. Sociality, then, is always marked negatively, and, therefore, it inscribes into

49. Evald Ilyenkov, "Marx I Zapadniy Mir," in *Voprosi Filosofi*, no. 10 (1988). Available, in Russian, at: http://caute.tk/ilyenkov/texts/phc/marxww.html.

itself various forms of emancipation in the mode of resistance. The social sphere is first a construct of the subjugating apparatuses and only afterwards is it a space in which one can performatively build militant subjectivities institute practices, critical bodies, and activities able to subvert subjugation from within.

In Soviet socialist society the point of departure was the opposite: evil (capitalism) was not completely expelled, but was still considered sublated. Notions such as labor, culture, the general, and the idea were already evaluated without the subsuming contexts and effects that they acquire in the unequal, non-socialist society. For Ilyenkov, as for a thinker living in socialism, a post-capitalist social infrastructure is not a remote and regulative imaginary, but, in fact, a present state of affairs—even despite certain deviations from it. This is because the socialist, proto-communist society already claims to have carried out its principal task: capitalism's sublation—even without empirical confirmation of this task's completion. The social virtue is already there, even if in *certain cases* of production, social life, or economy, it is still unaccomplished; inequality, surplus value, and the consumption-oriented economy are abolished and one finds oneself in the realm of the "attained" common good.

Yet, the trick with socialist society is that its inhabitants are doomed to exert the social subjectivities of equality even before such subjectivities invade their individual lives or personal needs. Commonality and generalness as imperatives for each individual consciousness begin functioning *prior* to people's self-conscious realization of what they are exerting and why. This is because the already existing communist political economy started to function before individual consciousness matured to the level of the communist economy. This also relates to the question of de-alienation in economy and production. De-alienation becomes the logic of the post-surplus economy and it occupies being; but this inscription happens prior to the stage when individuals, in their living conditions, would feel or need to be utterly non-alienated. In this case, communist infrastructure precedes concrete individual readiness for communism.

We can bring a theological comparison to this disposition. Let us imagine that utopia is paradoxically already accomplished before it is duly projected and organized. Let us infer that we get

into paradise abruptly, despite our sins, and before our sins are atoned, i.e., even before we have prepared ourselves for paradise and regardless of whether we would like to be there at all. In that case paradise would seem like torture. In patristics hell does not exist. God did not create hell or evil. They have no ontology. God gave freedom to human beings (including freedom to sin) merely because it was by means of freedom that a human being's likeness to God could be confirmed. Thus hell has no specific location and it is not meant as any special punishment for sinners. Hell is simply that the incapacity to sin when being in paradise makes sinning empirically impossible. This is why patristics claims the necessity to dispense with the desire to sin ahead of death and the afterlife, so that in the afterlife these desires, without the possibility of being accomplished due to the absence of matter and body, do not become one's ordeal as un-accomplishable desires. If the desires for certain sinful actions that the sinner practiced are sustained in the afterlife where they cannot be realized, then merely getting into the afterlife—and more so, into paradise, where those desires cannot be practiced and embodied—become unbearable for the sinner. This unbearableness is exactly the punishment and torture experienced as hell. Thus, the person who gets into paradise would have no option but to strive to realize certain desired physical acts, but such need and desire to commit those acts are precisely un-implementable in the afterlife. In order to turn the afterlife into paradise, one would need to get rid of the desire to commit such acts, whereas a poignant wish to carry them out would turn the afterlife into torture. It is then the impossibility for the sinner to sin in paradise that makes such a paradise a hell. When getting into paradise (the site of the afterlife with sublated desires) precedes readiness to remain there, the struggle to exist in such a place would be in fitting in and striving towards the already attained paradise. The difficulty would be in unlearning sinning—in getting rid of the desire to sin.

Something similar happens in already existing socialism or communism. Let us imagine that one is already forced to live a flawless communist life ontically, in a body that is inscribed into the communist life-world. Yet one cannot stand this precisely because

one's desires (on an imaginary and phantasmatic level) are still with capitalism, with "sin." In this case, sin (capitalism) still exists only as a personal longing despite being already in paradise (social-ism/communism)—a condition that turns paradise into torture. Consequently, it makes no sense to criticize or resist "the nightmare of paradise," if it is just the sinner's imperfection that makes this paradise a hell. Suffering would not be alleviated through "one's" critique of "one's" individual sin—only the termination of desiring certain things and acts or fleeing from paradise or simply abolishing it could alleviate the suffering of the sinner. In this way, the sinner could manage to embody desires and phantasms in a new "non-communist" (non-paradise) reality.

In a situation where the ideal is a social and even material fact, where it is immanent to reality, one is permanently under the threat of almost never fitting into the already existing social ideal, which, even if unbearable, has already become a fact of everyday existence. Hence the obsession in Soviet art, literature, culture and philosophy with developing the ability to fit into the laws of communist society, as opposed to evading them. Evading communism, evading the general, is a *natural* inborn *status quo* condition of the "natural" individual. Hence, a revolutionary act in that case would consist of stretching towards the social commons, in practicing adequacy to it, rather than fleeing from the societal structure by considering it a power, an authority, or an apparatus. This is because, paradoxically, the socialist system contained more "communism" than did the "people's" personal aspirations.

This is why political resistance within this "paradise" either incessantly stretches toward the already attained common good, in order to be adequate to the demands of communist virtue, or deserts such a "paradise."

VI
NOUMENALIZATION OF ONTICS

In his book *The Fragile Absolute*, Slavoj Žižek quite involuntarily con-firms the condition of historical socialism I have described above. Due to a prevailing common wealth ideology, the acceleration of production and the forces of production are slowed down, so that, consequently, the criteria for social excellence are no longer based on the augmentation of techne—that is, these criteria cease to be technologically conditioned. Žižek criticizes Marx for his overesti-mation of production and productivism. His rebuke to Marx in this respect implies that keeping production as the core element of social development in communist society made it impossible to overcome capitalism. Marx did not heed to this condition. As Žižek argues, Marx thought that if the crisis components of production in capitalism were removed, the spiral of productivity would facilitate the construction of a society of justice and equality, etc.[50] In other words, for Marx, the fallacy hampering socialism lay in the collapse and drawback of production; productivity was, for him, from time to time, undermined and annulled by social-economic crises. Thus, if the contradictions hampering capitalist production could be surpassed, this would bring production to its heightened social(ist) efficiency. Žižek disputes Marx's expectation here. He insists that it is precisely capitalism's syndrome of periodic crisis that keeps productivity productive. His point is that if the repeated economic crisis of capitalist production were removed, then the drive for increased productivity would, in fact, cease rather than continue. Drawing on this argument, Žižek infers that it was exactly the syndrome of productivism (i.e., ground-ing sociality on the correlation between the productive forces and the relations of production) that prevented socialist societies from fully achieving the anti-capitalist condition. This is because, as Žižek claims, communism grounded in the drive for efficient productiv-ism is nothing other than a fantasy about capitalism transgressing

50. Slavoj Žižek, *The Fragile Absolute* (London; New York: Verso, 2001), 16–21.

its own self. Thus, according to Žižek's assumption here, socialism failed because it was a modified variant of capitalism, which was only able to sublate capitalism ideologically, preserving nonetheless capitalism's crucial dynamic—the goal of efficacy in productivity. At the end of his argument, Žižek comes to the conclusion that such an obsession with the efficacy of production resides in the insurmountable libidinality of production; and hence its growth and proliferation is inevitably grounded in the extraction of surplus value and cannot develop otherwise.

But slowdowns in Soviet productivism are precisely what were crucial in the anti-capitalist condition of Soviet communist ontics. The decline of surplus value and private property in socialist societies de facto brought about the condition that Žižek finds utterly anti-capitalist: the slowing down and inefficiency of the Soviet non-surplus economy, as a break with capitalist techne and its continual refinement. As I mentioned above, the aporia is that socialist relations of production, when attained, do not facilitate the equivalent development of productive forces. If such inefficiency can become the main trait of anti-capitalism, then the Soviet social infrastructure really reached the condition of the common good (wealth), without first achieving the advanced excellence in technology envisaged by post-industrial economics. Žižek overlooks that precisely the flaws of production in the case of historical Soviet socialism were in contradiction to the productivist interpretation of Marx. Moreover, it was exactly this trait—shortages of goods in the conditions of their overproduction—that was unbearable for normal human daily consumer life, bringing societies to an almost ascetic materiality of the everyday that became, in turn, the cause of the decomposition of the societies of historical socialism as the result of their economic limitations and technical deceleration. This trait of Soviet political economy—on the one hand overfullfilment of planned production (*perevipolnenie plana*), abundance of produced retail goods, and on the other hand, the poignant *shortage of the desired ones*—is the outcome of the aforementioned paradox. It subsisted in the fact that the de-privatized relations of production facilitated the due production of the items of basic need but could not instigate the technical acceleration of productive forces that would fit global

technical progress. It is not surprising, that in the conditions of radical de-commercialization, the function of technology changes its semantics and impact.

Interestingly, it is exactly at this point that numerous orthodox Marxists find fault with Soviet socialist production. In this respect, the most frequent accusation is that historical communism failed, because without the advanced development of technology in productive forces (that by the end of 1960s began to decelerate in the Soviet socialist societies), the achievements of the common good could not actually be transmitted into the social superstructure.

To recall one of Marx's claims from the "Introduction to a Contribution to the Critique of Political Economy":

> At a certain stage of development, the material productive forces of society come into conflict with the existing relations of production or—this merely expresses the same thing in legal terms—with the property relations within the framework of which they have operated hitherto. From forms of development of the productive forces these relations turn into their fetters. Then begins an era of social revolution.[51]

This means that even if Marx asserts that the productive forces cannot duly develop without the de-privatization of the relations of production (i.e., that social equality is primary to technology), in this passage he explicitly appeals to the necessity of the advancement of productive forces for social emancipation.

We can only guess what Ilyenkov's attitude would have been in this case. Whatever that may have been, he would not have completely disregarded the role of production or define it as the rudiment of capitalism, as Žižek does.

Nevertheless, in *The Abstract and the Concrete*, Ilyenkov's thought reaches the point where socialist political economy clearly contradicts Marx's theses about the productive forces being

51. Karl Marx, *A Contribution to the Critique of Political Economy*, trans. Nahum Issac Stone (Chicago: Charles H. Kerr & Company, 1904), 11–12.

essential for social emancipation. As Ilyenkov asserts, the forces of production may manifest themselves as the result and outcome of the relations of production. Indeed, he states that inside the relations of production one can trace the outcomes that are able to retroactively affect the forces of production and change the function they played hitherto.[52] This allegation is important and radical. According to Ilyenkov's argument, the cause and incentive of social emancipation—productive forces—become a consequence.

What does Ilyenkov's argument lead to? It reveals that Ilyenkov in fact confirms that Marx's postulate about the importance of the productive forces *can be modified and even reconsidered under the ethics and labor conditions of the non-capitalist society*. It means that the social construction of the anti-capitalist society and its historical context can devalue the hegemonic role of production and stop seeing progress in terms of accelerated technology. The outcome of this is that the historically formed system of the relations of production in new socialist conditions can be a self-sufficient organism, retroactively influencing its base—the set of the productive forces—therefore able to acquire "a relative independence with the regard to the productive forces themselves."

As Ilyenkov argues:

Any new accretion of productive forces does not automatically create the economic relation, or the socioeconomic forms directly corresponding to them; but this accretion determines the direction in which the already existing historically formed system of economic relations evolves. And the situation is not affected by the fact that this already formed system of economic relations is in its turn, from beginning to end the product of the entire preceding development of the productive forces.

A concrete and historically formed system of economy is always a relatively independent organism producing a

52. Evald Ilyenkov, "The Spiral-Like Character of the Development of Reality," in *Dialectics of the Abstract and the Concrete in Marx's "Capital."* (Moscow: Urss, 2011), 97. Available in English at Marxists Internet Archive: https://www.marxists.org/archive/ilyenkov/works/abstract/abstra2.htm#2c01.

reverse effect on its own basis—the sum total of produc-
tive forces, and refracting any effect of the latter through
its own specific nature.[53]

In fact, what Ilyenkov claims here is quite applicable to Žižek's argu-
ment. Socialism evolves from the logic of capitalism's development
and self-sublation, but its conditions retroactively demolish the
necessity of the dominant role of the productive forces in socialism.
This is because the logic in which the socialist society, its labor eth-
ics, economy, and culture evolve acquires historical irreversibility
and becomes relatively independent from the bondage by which the
capitalist utopias are tied to technical and economic "excellence."

<div align="center">*</div>
<div align="center">* *</div>

We thus see that the ideal in Soviet socialist thought can be
approached as a certain kind of *syndrome* that asserts itself as some-
thing a priori accomplished and already functioning ideologically,
logically, and socioeconomically (i.e., materially), even before it is
fully mastered institutionally or technologically. As I have repeatedly
analyzed in this volume, socialism permeates not merely sociality, but
invades and transforms *ontics*, crude objecthood, and daily experi-
ence. But it penetrates it so thoroughly that objecthood and physical
existence are burdened by the noumenal—the ideational and the
general (the generalized, common). This condition, nevertheless, is
anomalous: it makes the regime of noumenal procedures construct
practical life and its forms. It is the documentation of this syndrome
that becomes Ilyenkov's philosophic task in tracing the dialectics of the
ideal in objecthood—the condition relevant only in post-revolutionary
society, and thus new even in relation to Marx's work.

In *The Communist Postscript*, Boris Groys emphasizes precisely
this noumenal character of communist material culture. As he argues,
matter and objecthood are identical in such a society with "the lan-
guage." "The language" in this case is the category of semantics, of

53. Ibid.

the general and the conceptual, as opposed to the capitalist condition where the semantic impact of a language is superseded by circulating signs and exchange values. A society in which private property has collapsed is philosophical even on the level of its everyday maintenance, as long as the empirical needs of such a society are noumenalized to the extent that matter equals a noumen. The latter is not something transcendental or sublime, but operates in the things that are materially and ontically constructing the everyday.

The *noumenalization of objecthood* in the Soviet everyday manifests the expediency (teleology) of the material ideal as the regime inevitable in communism. But, on the other hand, it shows that in historical socialism the role of the ideal revealed itself as a paradoxical construct: something that is far from the ideal from the point of view of techne is nevertheless completely ideal politically, socially, ethically, existentially, and ontically. That said, the socialist masses had to accept this noumenal dimension of material life not because they were brainwashed by communist ideology but, rather, because the principal merit of a material thing in a de-privatized economy is its *eidetic, generalized, generic, basic* function and value. And hence it is this *eidetic* basis—for example, the fact that scissors cut, or that bread feeds and plates are used for food—that constructs both the material telos of objecthood as well as its conceptual expediency. This view considers objects of use, the things of the material world, as non-finite *epiphenomena*, rather than as commodities and objects of consumption. It is no surprise, therefore, that the produced objects can be perceived as being "bad" from the point of view of commodity logic; but they are at the same time socially ideal. The plainest pen is the only pen worth using, because one does not imagine or desire any other pen. There can be no better pen, because "this" pen is already the proper one. Then even things deemed inefficient from the point of view of attractive design or technical innovativeness are seen as fully accomplished; yet these very things might be full of drawbacks if one looks at them from the point of view of consumption and design appeal and beyond the aureole of the deprivatized political economy.

When materiality itself is determined and applied in noumenal terms, it becomes redundant to transpose the common good into technical and empirical terms and incarnate it into consumption,

production, exchange, or trade. Noumenalized materiality is not in need of parameters considered efficient in the economics of consumption and commerce. This is because the desires that could instigate a person towards the empirical and consumptive perfection of appearances are missing in this case.

Things are inventions: there cannot be a more commodified form of a spade, or of a car, or of any other object, if these objects are needed merely as invented common necessities. Ontically, such a stance brings to materiality a minimalism and modesty, manifested as "poverty"—one possesses merely a spade-as-a spade, or one type of plate, or one type of spoon, or one kind of food product—e.g. only one basic type of cheese. But it is such a "poverty" that makes things precise and inapt for any further diversification or refinement, which implies that they already achieved the dimension of being general and ideal. Such effects and functions of material objects are the consequence of a form of production that aspires to use value.

CONCLUSION

To conclude, Ilyenkov's dialectics of the ideal splits into (1) a field of philosophical research, contextualized in Hegel, Spinoza, Marx, and the history of philosophy in a broad sense; and (2) the regime of noumenalization of materiality that permeates Soviet society and its everyday life due to the radical de-privatization of the economy.

Soviet thinkers' concern in the 1960s and 70s with the necessity of the notion of the ideal was thus triggered by socialist political economy. However, most Soviet residents were not brought to a full awareness of this noumenalized and "philosophized" materiality of Soviet reality, with all its mutations. Indeed, it was only in the late 1970s that the artists of Moscow Conceptualism managed to critically reflect and analyze this noumenalized materiality. Unlike other intellectuals and cultural workers, the Moscow Conceptualists developed an analytical distance from Soviet material reality, insofar as they managed to study the construction of the Soviet social texture as a created artistic project (see, e.g., Boris Groys's writing of the Moscow Conceptualists).

It is important to emphasize that by his obsession with installing the ideal in the everyday, Ilyenkov was in fact reacting to his concrete social and existential environment without straightforwardly mentioning its socioeconomic traits, but implicitly reproducing them. In short, the treatment of the notions of the general and the ideal by Soviet thinkers should be considered in the socioeconomic context on Soviet de-privatized materiality.

In the way each of the concepts touched upon here—the general, culture, labor, the Ideal, language, consciousness, the unconscious, desire, pleasure—functioned in Soviet thought, one can discern to what extent the experimental impact of the socialist infrastructure and economy influenced the philosophic semantics and epistemologies of those notions. In capitalist conditions, Ilyenkov's assumptions about the generic impact of labor, culture, and the ideal would not be relevant. These assumptions had to rely on a proto-communist condition *hic and nunc*—e.g., *the concrete realization* of de-privatized sociality.

By emphasizing the *ontical* correlation of the Soviet socialist economy with specific philosophic and aesthetic ideas featured in historical socialism, I have tried to map how the political economy

of de-privatization managed to transform the very factuality of existence, the thinghood of things itself.

In the beginning of Chapter 1, I noted Žižek's strategic logic: in post-Lacanian psychoanalysis, the fully-achieved, the sublime, and the ideal preserved their logic and their functional places, but were forever seen as deficient and lacking. Transcendence itself is always devoid of completion, as it is, in fact, the site of lack and deficiency.

Under an emancipatory communist ontics, however, the opposite is the case: the very things that we, capitalist subjects, see as cracks, inefficiencies, deteriorations, and failures, are perceived, experienced, and assessed by the socialist gaze as elements of an acquired plenitude. When surplus value and the libidinal undercurrents triggering it are abolished, progressive and emancipatory movements are not motivated by any yearning or desiring—even desiring a better future or a utopian society. The emancipatory zeal then is much more about *voluntary restraint and self-resignation* in favor of the already achieved and materially functioning social ideal. This is the paradox of the material ideal as it evolved in the conditions of the Soviet socialist non-surplus economy.

*

* *

In the four parts of this book—(1) Political Economy; (2) Sexuality; (3) Aesthetics; (4) Philosophy—I traced the highlights of Soviet socialist thought, aesthetics, social theory, ethics, and cultural production that question the foundation of the anti-capitalist theories of emancipation in continental thought and critical theory that have emerged since the 1960s. Anti-capitalist thought and theory in capitalist countries after the disillusion of the Stalinist period dismissed any attempt to regard the socialist experience as viable for continental counter-capitalist critique. Disappointment in the Soviet socialist experiment eliminated all aspirations for a critical theory that would posit radical anti-capitalist measures—abolition of private property, complete socialization of education, equalization of the remuneration of labor, cultural cosmopolitanism, and universality—as emancipatory; instead such measures were treated as coercive, immature, and totalitarian.

As a result, most of the philosophic, aesthetic, politico-economic, and social theories in the history of continental that thought coordinated themselves with the realization of common good remained in the past, well before the 1950s, until they reemerged much later in the thought of Alain Badiou, Slavoj Žižek, or Boris Groys. Thus, by means of revisiting historical socialism, I approached the "outside" from which one can discern how anti-capitalist critique in the conditions of capitalism overlooks numerous modes of its own inevitable entanglement in the logic of capital. Looking "outside" of historical socialism enables us to see how the exigencies of the common good do not become closer to the societies of developed, post-industrial capitalism, since they are dismissed as repressive and false even in the counter-capitalist critiques of these societies.

By reconsidering the emancipatory concepts that "traditionally" undermine power and metaphysics—*sexuality*, *freedom*, *enjoyment*, *desire*, *unconsciousness*, *subversion*, *performativity*, etc.—I call the liberating potential of such concepts into question. On the other hand, by revisiting notions regarded as metaphysical—such as *the ideal*, *the universal* (*the general*), *the classical*, *metanoia*, *realism*, *culture*, *non-self being*, and *self-resignation*—I trace their transformation into materialist social tools in the conditions of a non-surplus economy.

By comparing the functions of the abovementioned notions in capitalist and non-capitalist societies respectively, I reveal the hidden capitalist core in the very subjectivity of anti-capitalist critique.

BIBLIOGRAPHY

Adorno, Theodor W. *Aesthetic Theory*. Translated by Robert Hullot-Kentor. London: Continuum, 1997.

Adorno, Theodor W., and Max Horkheimer. *The Dialectic of Enlightenment*. Translated by Edmund Jephcott. Stanford: Stanford University Press, 2002.

Agamben, Giorgio. *The Coming Community*. Translated by Michael Hardt. Minneapolis: University of Minnesota Press, 2003.
———. *Homo Sacer: Sovereign Power and Bare Life*. Translated by Daniel Heller-Roazen. Stanford: Stanford University Press, 1998.

Althusser, Louis. *Essays in Self-Criticism*. Translated by Grahame Lock. London: New Left Books, 1976.
———. "Ideology and Ideological State Apparatuses." In *Lenin and Philosophy and Other Essays*, 127–188. Translated by Ben Brewster. London: New Left Books, 1971.

Aronson, Oleg. "Sovetskoe: trud obraza" [The Soviet: labor of the image]. In *Communicative Image*, 315–350. Moscow: New Literary Review, 2007.

Arvatov, Boris. *Art and Production*, edited by John Roberts and Alexei Penzin. London: Plutopress, 2017.

Badiou, Alain. *The Communist Hypothesis*. London and New York: Verso, 2015.
———. *Five Lessons on Wagner*. Translated by Susan Spitzer. London and New York: Verso, 2010.
———. "What is a Proof in Spinoza's Ethics." In *Spinoza Now*, edited by Dimitris Vardoulakis, 39–51. Minneapolis: University of Minnesota Press, 2011.

Bakhurst, David. *Consciousness and Revolution in Soviet Philosophy: From the Bolsheviks to Evald Ilyenkov*. Cambridge, UK: Cambridge University Press, 1991.

Balibar, Étienne. "Althusser and 'Communism.'" *Crisis and Critique* 2, no. 2 (November 2015): 8–23.
———. *On the Dictatorship of Proletariat*. Translated by Grahame Lock. London: New Left Books, 1977.

Balina, Marina, Evgeny Dobrenko, and Yuri Murashov, eds. *Sovetskoe Bpgatstvo: Statji o Kulture, Literature, Kino* [Soviet wealth: articles on culture, literature, cinema]. Saint Petersburg: Academicheski project, 2002.

Balzer, Harley D. *Soviet Science on the Edge of Reform*. Boulder, Colorado: Westview Press, 1989.

Bastani, Aaron. *Fully Automated Luxury Communism*. London and New York: Verso, 2019.

Benjamin, Walter. "The Work of Art in the Age of its Technical Reproducibility." In *The Work of Art in the Age of its Technical Reproducibility and Other Writings on Media*, edited by Michael W. Jennings, Brigid Doherty, and Thomas Y. Levin, 19–55. Translated by Edmund Jephcott and Harry Zohn. Cambridge, MA and London: Belknap Press, 2008.

Bogdanov, Alexander. *Empiriomonism*. Moscow: Respublika, 2003.
———. *Tektology*, edited by Peter Dudely. Hull: University of Hull, 1996.

Buck-Morss, Susan. *Dreamworld and Catastrophe*. Cambridge, MA: MIT Press, 2000.

Bourdieu. Pierre. "The Social Space and the Genesis of Groups." *Theory and Society* 14, no. 6 (November, 1985): 723-744.

Boym, Svetlana. *Common Places*. Moscow: New Literary Observer, 2002.

Butler, Judith. *Gender Trouble*. New York and London: Routledge, 2007.
———. *Psychic Life of Power*. Stanford, CA: Stanford University Press, 1997.

Buzgalin, Alexander, and Vladimir Mironov, eds. *Sotsializm-XXI. 14 tekstov postsovetskoy shkoly kriticheskogo marksizma* [14 texts on the post-soviet school of the critical marxism]. Moscow: Cultural Revolution, 2009.

Castoriadis, Cornelius. *The Imaginary Institution of Society*. Translated by Kathleen Blamey. Cambridge, UK and Malden, MA: Polity Press, 1987.

Chalmaev, Viktor Andreevich. *Andrey Platonov: K Sokrovennomu Cheloveku* [Andrei Platonov: towards the innermost in the human being]. Moscow: Soviet Writer, 1989.

Charchordin, Oleg. *The Collective and the Individual in Russia*. Berkeley: University of California Press, 1999.

Chubarov, Igor. "Sexuelle Transgression vs. Grenzlosigkeit der Arbeit. Bataille und Platonov." *Russkaja Pochta: Journal on Russian art and literature* (2008): 157–166.

Clark, Katerina. *The Soviet Novel: History as Ritual*. Bloomington: Indiana University Press, 2000.

Chukhrov, Keti. "Epistemological Gaps between the Former Soviet East and the 'Democratic' West." In *Primary Documents. Art and Theory of Post-1989 Central and Eastern Europe: A Critical Anthology*, edited by Ana Janevski, Roxana Marcoci, and Ksenia Nouril, 375–378. New York: MoMA; Durham, North Carolina: Duke University Press, 2018. Previously published as "Epistemological Gaps between the Former Soviet East and the 'Democratic' West." *e-flux journal*, no. 41 (January 2013). https://www.e-flux.com/journal/41/60226/epistemological-gaps-between-the-former-soviet-east-and-the-democratic-west/.
———. "In the Trap of Utopia's Sublime. Between Ideology and Subversion." In *Gender Check Reader: Art and Theory in Eastern Europe*, edited by Bojana Pejic, 32–38. Cologne: Verlag der Buchhandlung Walther König, 2009.

Davydov, Yuri. *Trud I Iskusstvo* [Labor and art]. Moscow: Astrel, 2008.

Degot, Ekaterina. *Bor'ba za Znamja, Sovetskoye Iskusstvo mejdu Trotskim I Stalinim* [Battle for the banner, soviet art between Trotsky and Stalin]. Moscow: Moscow Museum of Contemporary Art, 2008.
———. "The Death of Art and the Birth of the Creative Activity: The Dialectical Modernity in USSR and Russia." In *Back from the Future: East European Culture of Post-communism*, edited by Boris Groys, Anne von der Heiden, and Peter Weibel, 539–565. Berlin: Suhrkamp Verlag, 2005.
———. "Moscow Communist Conceptualism." In *Moscow Conceptualism*, edited by Ekaterina Degot and Vadmin Zakharov, 7–11. Moscow: WAM, 2005.

———. "Ot Tovara k Tovarishu" [From commodity to comrade]. *Logos* 5, no. 50 (2005): 201-10.

Deleuze, Gilles and Félix Guattari. *A Thousand Plateaus*. Minneapolis: University of Minnesota Press. 2005.

Deleuze, Gilles. *Spinoza: Practical Philosophy*. Translated by Robert Hurley. San Francisco: City Lights Books, 1988.

Dimitrijević, Branislav and Branislava Andjelković. "The Body, Ideology, Masculinity, and Some Blind Spots in Post-Communism." In *Gender Check Reader: Art and Theory in Eastern Europe*, edited by Bojana Pejic, 233–245. Cologne: Verlag der Buchhandlung Walther König, 2009.

Dolar, Mladen. "Beyond Interpellation." *Qui Parle* 6, no. 2 (Spring/Summer 1993): 75-96.

Fedorov, Nikolay. "Filosofia Obshego Dela" [Philosophy of the common task]. In *Sobraniya sochineniy* [Collected works in 4 volumes], vol. 1, edited by Anastasia Gacheva and Svetlana Semenova. Moscow: Progress, 1995.

Foucault, Michel. *The Will to Knowledge: The History of Sexuality, Volume 1*. Translated by Robert Hurley. Penguin, 1976.

Freud, Sigmund. "Civilization and Its Discontents." In *The Standard Edition of the Complete Psychological Works of Sigmund Freud*, vol. 21, edited by James Strachey. London: Hogarth Press, 1961.
———. "Beyond the Pleasure Principle." In *The Standard Edition of the Complete Psychological Works of Sigmund Freud*, vol. 18, edited by James Strachey. London: Hogarth Press, 1960.
———. "Introductory Lecture on Psycho-Analysis." In *The Standard Edition of the Complete Psychological Works of Sigmund Freud*, vol. 22, edited by James Strachey. London: Hogarth Press, 1966.
———. "Mourning and Melancholia." In *The Standard Edition of the Complete Psychological Works of Sigmund Freud*, vol. 18, edited by James Strachey. London: Hogarth Press, 1960.

Friche, Vladimir. *Soziologia Iskusstva* [The sociology of art]. Moscow: Urss, 2010.

Geller, Mikhail and Alexandr M. Nekrich. *Utopiya u vlasti: istoriya Sovetskogo Soyuza s 1917 goda do nashikh dney* [Utopia at power: the history of the soviet union since 1917 to the present]. London: Overseas Publications Interchange LTD, 1982.

Godelier, Maurice. *The Mental and the Material: Thought, Economy and Society*. London and New York: Verso, 1986.

Graham, Loren R. *Science, Philosophy, and Human Behavior in the Soviet Union*. New York: Columbia University Press, 1987.

Grotowski, Jerzy. *Towards the Poor Theatre*, edited by Eugenio Barba. New York and London: Routledge, 2002.

Groys, Boris. *The Communist Postscript*. Translated by Thomas Ford. London and New York: Verso, 2010.
———. "Poesia, Kultura I Smert' V Gorode Moskve" [Poetry, culture, and death in the city of Moscow]. In *Rannie Texti: 1976–1990* [Early texts: 1976–1990], edited by Natalia Nikitina, 107–125. Moscow: Ad Marginem Press, 2017.
———. "Posledovatelni Ateism Delaet Nevozmojnoi Zhalobu" [Consistent atheism makes complaint impossible]. In *Raznoglasiya: Zhurnal obshchestvennoy i khudozhestvennoy kritiki* [Dissent: the journal of social and artistic critique], no. 6 (July 27, 2016). http://www.colta.ru/articles/raznoglasiya/11644.

"Romantic Conceptualism." In *Total Enlightenment: Conceptualist Art in Moscow. 1960–1990*, edited by Boris Groys, 316–22. Frankfurt: Schirn Kunsthalle Frankfurt; Berlin: Hatje Cantz Verlag. 2008.
———. "Under the Gaze of Theory." *e-flux journal*, no. 35 (May 2012). www.e-flux.com/journal/under-the-gaze-of-theory/.

Groys, Boris, ed. *Russian Cosmism*. Cambridge, MA: The MIT Press, 2018.

Groys, Boris, Peter Weibel, and Anne von der Heiden, eds. *Zurück aus der Zukunft: Osteuropäische Kulturen im Zeitalter des Postkommunismus* [Back from the future: the Eastern European culture of postcommunism]. Frankfurt, Germany: Zuhrkamp, 2005.

Guattari, Félix. *Chaosmosis: An Ethico-Aesthetic Paradigm*. Translated by Paul Bains and Julian Pefanis. Bloomington: Indiana University Press, 1995.

————. *The Machinic Unconscious*. Translated by Taylor Adkins. Los Angeles, CA: Semiotext(e), 2011.

Habermas, Jürgen. *The Philosophical Discourse of Modernity: Twelve Lectures*. Translated by Frederick Lawrence. Cambridge, UK and Malden, MA: Polity, 2015.
————. *Structural Transformation of the Public Sphere: Inquiry into the Category of Bourgeois Society*. Cambridge, MA: MIT Press, 1989.

Halfin, Igal. *From Darkness to Light: Class, Consciousness, and Salvation in Revolutionary Russia*. Pittsburgh: University of Pittsburgh Press, 2000.

Halfin, Igal, and Jochen Hellbeck. "Analis Praktik Subjektivazii Sovetskogo Gosudarstva" [Analysis of subjectivation practices in the soviet state]. *Ab Imperio*, no. 3 (2002): 217–260.

Hegel, Georg Wilhelm Friedrich. *Hegel's Aesthetics: Lectures on Fine Art*, Vol. 1. Translated by T. M. Knox. Oxford: Clarendon Press, 1988.
————. *Phenomenology of Spirit*. Translated by A.V. Miller. Oxford: Oxford University Press, 1977.

Hensgen, Sabina, and Hans Gunter, eds. *Sovetskaya Vlast' I Media* [*Soviet power and media*]. Saint Petersburg: Academic Project, 2006.

Ilyenkov, Evald. *Iskusstvo I Communistichesky Ideal* [Art and the communist ideal]. Moscow: Iskusstvo, 1984.
————. *Dialectics of the Abstract and the Concrete in Marx's Capital*. [*Dialektica abstraktnogo i konkretnogo v nauchno-teoreticheskov mishlenii*]. Moscow: Philosophy Institute of Academy of Sciences,1960. English translation edited by Andy Blunden available at: https://www.marxists.org/archive/ilyenkov/works/abstract/index.htm.
————. "The Cosmology of the Spirit." Translated by J. Vivaldi. *Stasis* 5, no. 2 (2017): 164–90.
————. *Dialectical Logic: Studies in History and Logic*. Moscow: Politizdat, 1984. English translation available at: https://www.marxists.org/archive/ilyenkov/works/essays/essay5.htm.
————. "Dialectics of the Ideal." In *Evald Ilyenkov and Creative Soviet Marxism*, edited by A. Levant and V. Oittinen, 25–81. Leiden; Boston: Brill, 2014.

——. *Leninskaya Dialektica i metaphizika pozitivizma* [Lenin's dialectics and the metaphysics of positivism]. Moscow: Mir Philosophii, 2015.

——. "Marx I Zapadniy Mir" [Marx and the western world]. Accessed September 1, 2019. http://caute.tk/ilyenkov/texts/phc/marxww.html.

——. "Materialisticheskoye Ponimanie Mishlenia" [The materialist understanding of thinking]. In *Filosofia I Kul'tura* [Philosophy and culture], 212–29. Moscow: Politizdat, 1991.

——. "On the Coincidence of Logic with Dialectics and Theory of Knowledge of Materialism." *Monthly Review*, New York, January 1, 2020.

——. *Ob Idolakh I Idealakh* [*On Idols and Ideals*]. Kiev: Chas-Krok, 2006

——. "O Vseobshem" [On the universal]. In *Filosofia I Kul'tura* [Philosophy and culture], 320-339. Moscow, Politizdat, 1991. First published in *Philosophical Investigations in the USSR*, edited by Frederick J. Adelmann, 26–51. Chestnut Hill: Boston College, 1975. English translation available at: https://www.marxists.org/archive/ilyenkov/works/articles/universal.htm.

——. "Otkuda Beriotsa Um" [Where does the mind come from]. In *Filosofia I Kul'tura* [Philosophy and culture]. Moscow: Political Literature Publishers, 1991.

Jameson, Frederic. "The Aesthetics of Singularity." *New Left Review*, no. 92 (March–April 2015): 101–132.

Jerebkina, Irina. *Gendernie 1990-e, ili Falosa ne suchestvuet* [Gender in the 1990s, or the phallus does not exist]. Saint Petersburg: Aleteia, 2003.

Yurchak, Alexei. *Everything was Forever, Until It Was No More*. Princeton: Princeton University Press, 2005.

Kabakov, Ilya. *60-e, 70-e zapiski o neofizialnoy jizni v Moskve* [1960s and 1970s: Notes on the unofficial life in Moscow]. Moscow: NLO, 2008.

Kharkhordin, Oleg. *Oblichat' I Lizemerit'* [To denounce and display hypocrisy]. Saint Petersburg: European University Press, 2002.

Kiaer, Christina. *Imagine No Possessions: The Socialist Objects of Russian Constructivism*. Cambridge, MA: MIT Press, 2005.

———. "Rodchenko in Paris." In *October* 75 (Winter 1996): 3–35.

Kolganov, Andrei. *Chto takoe Socialism: Marxistskaya Versia* [What is socialism: the Marxist version]. Moscow: Librocom, 2011.

Kollontai, Alexandra. *Radikalniy proekt Jenskoi Emansipazii* [Radical project of women's emancipation]. Tver: Folium, 2001.
———. "Sexual Relations and the Class Struggle." In *Selected Writings of Alexandra Kollontai*. Translated by Alix Holt. New York: W.W. Norton, 1977.

Krauss, Rosalind. *The Optical Unconscious*. Cambridge, MA: MIT Press, 1993.
———. *The Originality of the Avant-Garde and Other Modernist Myths*. Cambridge, MA: MIT Press, 1985.

Lacan, Jacques. "Ja v Teorii Freuda i v Technike Psychoanalysa" [The ego in Freud's theory and in the technique of psychoanalysis]. *Seminars*, Vol 2, 155–162. Trans. Alexander Chernoglazov. Moscow: Gnosis, 2009.
———. "Réposes à des étudiants en philosophie." In *Autres Écrits*, 203–213. Paris: Editions de Seuils, 2001.

Lacoue-Labarthe, Philipp. *Musica Ficta (Figures of Wagner)*. Translated by Felicia McCarren. Stanford University Press, 1994.
———. *The Subject of Philosophy*. Edited by Thomas Tresize. Minneapolis: University of Minnesota Press, 1993.

Latour, Bruno. *We Have Never Been Modern*. Cambridge, MA: Harvard University Press, 2004.

Leontyev, Alexei. *Dejatelnost, Soznanie, Lichnost* [Activity and Consciousness]. Moscow: Politizdat, 1975. English translation available at: https://www.marxists.org/archive/leontev/works/activity-consciousness.pdf.

Lenin, Vladimir. "The Impending Catastrophe and How to Combat it", In *Polnoe Sobranie sochineniy* [Complete Works], 5th edition, v. 34. Moscow: Gospolitizdat, 1969.
———. *Materialism and Empirio-Criticism*. In *Lenin Collected Works*, vol 14, 17-362. Moscow: Progress Publishers, 1972. Available at: https://www.marxists.org/archive/lenin/works/1908/mec/.
———. "The State and Revolution." Available at: https://www.marxists.org/archive/lenin/works/1917/staterev/.

Lepecki, André. *Exhausting Dance*. New York and London: Routledge, 2006.

Lifshitz, Mikhail. *Chto Takoe Klassika* [What is the classical]. Moscow: Iskusstvo XXI, 2004.
———. "Drevniy Mir, Mifologia, Esteticheskoe Vospitanie"[Ancient world, mythology, aesthetic edifice]. In *Mifologia Drevnjaa I Sovremennaya* [Ancient and contemporary mythology], 122–27. Moscow, 1980.

"Estetika Gegelja I Sovremennost" [Aesthetics of Hegel and contemporaneity]. In *On Hegel*, 185–249. Moscow: Grundrisse, 2012. Iskusstvo XXI, 2007.
———. "Spori o Realizme" [On the arguments on realism]. In *Mifologia Drevnjaa I Sovremennaya* [Ancient and contemporary mythology], 498–545. Moscow: Iskusstvo, 1980.

Lordon, Frederic. *Willing Slaves of Capital: Spinoza and Marx on Desire*. Translated by Gabriel Ash. London and New York: Verso, 2014.

Lukács, Georg. *Die Eigenart des Aesthetischen*. Volume 2, chapter 5. Berlin; Weimar: Aufbau Verlag, 1981.
———. *History and Class Consciousness*. Translated by Rodney Livingstone. Cambridge, MA: The MIT Press, 1971.

Lyotard, Jean-François. *The Inhuman: Reflections on Time*. Translated by Geoffrey Bennington and Rachel Bowlby. Cambridge, UK and Malden, MA: Polity Press, 1991.
———. *Libidinal Economy*. Translated by Iain Hamilton Grant. London and New York: Continuum, 2005.

Lock, Grahame. Introduction to *Essays on Self-Criticism*. In Louis Althusser's *Essays on Self-Criticism*, 1–33. Translated by Grahame Lock. London: New Left Books, 1976.

Macherey, Pierre. *Hegel or Spinoza*. Translated by Susan M. Ruddick. Minneapolis: University of Minnesota Press, 2011.

Maidansky, Andrey. "Russian Spinozists." *Studies in East European Thought* 55 (2003): 199-216.

Maidansky, Andrey, and Vesa Oittinen, eds. *The Practical Essence of Man: 'The Activity Approach' in Late Soviet Philosophy*. London: Haymarket Books, 2017.

Malabou, Catherine. *The Future of Hegel: Plasticity, Temporality and Dialectic*. Translated by Lisabeth During. London and New York: Routledge, 2005.

Mamardashvili, Merab. "Analis soznaniya v rabotakh Marxa" [Analysis of consciousness in works by Marx]. *Voprosi Filosofii*, no. 6 (1968): 14-25.
———. "Converted Forms: On the Need for Irrational Expression." *Stasis* 5, no. 2 (2017): 204-217.

Marx, Karl. *A Contribution to the Critique of Political Economy*. Translated by N.I. Stone. Chicago: Charles H. Kerr Publishing Company, 1904.
———. *Economic and Philosophic Manuscripts of 1844*. Translated by Martin Milligan. Amherst, NY: Prometheus Books, 1988.
———. *Theories of Surplus Value*, vol. 1 [1861–63], edited by S. Ryazanskaya. Translated by Renate Simpson. London: Lawrence & Wishart, 1969.

Marx, Karl and Friedrich Engels. *Collected Works*, vol 4. London: Lawrence & Wishart, 1975.

Mazzucato, Mariana. *The Entrepreneurial State: Debunking Public vs. Private Myths*. London: Anthem Press, 2013.

Meillassoux, Quentin. *After Finitude: An Essay on the Necessity of Contingency*. London: Continuum, 2008.

Mejuev, Vadim. "Socialism kak Prostranstvo Kulturi" [Socialism as the terrain of culture]. In *14 tekstov postsovetskoy shkoly kriticheskogo marksizma* [14 texts on the post-soviet school of the critical marxism], edited by Alexander Buzgalin and Vladimir Mironov, 113-164. Moscow: Cultural Revolution 2009.

Metzinger, Thomas. *Being No One: The Self-Model Theory of Subjectivity*. Cambridge, MA: The MIT Press, 2003.

Mikhailov, Boris. *Suzi et Cetera*. Cologne: Walther Koenig. 2007.

Monastyrski, Andrey. "Earthworks" (Zemlyanie Raboti). Accessed Janurary 1, 2020. http://conceptualism.letov.ru/Andrey-Monastyrsky-earthworks.html.

Negri, Antonio. "Soviet: Within and Beyond the 'Short Century.'" *South Atlantic Quarterly* 116, no. 4 (October, 2017): 835–849.

Pasolini, Pier Paolo. *Theorem*. Translated by Stuart Hood. London: Quartet Books, 1992.

Pejic, Bojana, ed. *Gender Check Reader: Art and Theory in Eastern Europe*. Cologne: Verla der Buchhandlung Walther König, 2009.
Penzin, Alexei. "Contingency and Necessity in Evald Ilyenkov's Communist Cosmology." *e-flux journal*, no. 88, (February 2018). https://www.e-flux.com/journal/88/174178/contingency-and-necessity-in-evald-ilyenkov-s-communist-cosmology/.

Peirce, Charles Sanders. "How to Make Our Ideas Clear." In *Popular Science Monthly*, no. 12 (January 1878): 286–302. http://www.peirce.org/writings/p119.html.

Platonov, Andrey. "The Anti-Sexus." Translated by Anne O. Fisher. *Cabinet*, no. 51, (Fall 2013): 48–53.
——. *The Foundation Pit*, trans. Robert Chandler, Elizabeth Chandler, and Olga Meerson New York: New York Review Books Classics, 2009, 4.
——. *The Foundation Pit*. Translated by Thomas P. Whitney. Ann Arbor: Ardis Publishers, 1973.
——. *Happy Moscow*. Translated by Robert and Elizabeth Chandler. New York: New York Review Books Classics, 2012.
——. "No Odna Dusha u Cheloveka" ["But a man has one soul"]. In *Gosudartvenny Zitel* [The state resident], 531–533. Moscow: Sovetsky Pisatel, 1988.
——. "The River Potudan." In *Soul and Other Stories*. Translated by Robert and Elizabeth Chandler, with Katia Grigoruk, Angela Livingstone, Olga Meerson, and Eric Naiman. New York: New York Review Books Classics, 2008.

Podoroga, Valery. *Kairos: A Crucial Moment*. (Kairos, Kriticheskiy Moment). Moscow, Grundrisse, 2013.
——. *Anthropogrammes*. Saint Petersburg: European University, 2017.

Pound, Ezra. *Guide to Kulchur*. New York: New Directions, 1970.

Read, Jason. *The Politics of Transindividuality*. Leiden; Boston: Brill, 2016.

Roberts, John. *Revolutionary Time and the Avant-Garde*. New York and London: Verso, 2015.

Simondon, Gilbert. *On the Mode of Existence of Technical Objects*. Translated by Cecile Malaspina and John Rogove. Minneapolis: Univocal Publishing, 2017.

Ryklin, Michail. *Communism as Religion* (Kommunism kak Religia). Moscow: New Literary Observer, 2009.

Schuster, Aaron. "Sex and Antisex." *Cabinet*, no. 51 (2013).

Spinoza, Benedict de. *The Ethics*. Translated by R.H. M. Elwes. Mocking Bird Classics Publishing, 2014.

Schoellhammer, Georg, ed. *Sweet Sixties. Specters and Spirits of a Parallel Avant-Garde*. Berlin: Press, 2011.

Sweezy, Paul. *The Theory of Capitalist Development*. New York: Monthly Review Press, 1968.

Timofeeva, Oxana. "We Have Never Had Sex." *Stasis* 4, no. 1. (2016): 144–161.

Tomšič, Samo. *The Capitalist Unconscious*. London and New York: Verso, 2015
———. *The Labour of the Enjoyment: Towards a Critique of Libidinal Economy*. Berlin: August Verlag, 2019.

Van der Linden, Marcel. *Western Marxism and the Soviet Union*. Leiden and London: Brill, 2007.

Vygotsky, Lev. *Thought and Language*. Translated by Alex Kozulin. Cambridge, MA: The MIT Press, 1986.

Vygotsky, Lev, and Alexander Luria. "Foreword to Freud's 'Beyond Pleasure Principle.'" In Sigmund Freud, *Psychology of the Unconscious (Psikhologia Bessoznatel'nogo)*, 29-37. Moscow: Prosveshenie, 1990.

Vygotsky, Lev. "The History of the Development of Higher Mental Functions." In Lev Vygotsky, *The Collected Works*, edited by Robert W. Rieber, 10-245. Boston, MA: Springer Science and Business Media, 2012.

Virno, Paolo. *Multitude. Between Innovation and Negation*. Semiotext(e), 2008.

Voloshinov, Valentin. *Freudianism: A Marxist Critique*, edited by I. R. Titunik and Neal H. Bruss. Translated by I. R. Titunik. New York: Academic Press, 1976.
———. *Marxism and the Philosophy of Language*. Translated by Ladislav Matejka and I.R. Titunik. NY and London: Seminar Press, 1973.
Lev Vygotsky, *Thought and Language*, trans. Eugenia Hanfmann and Gertrude Vakar, ed. Alex Kozulin. Cambridge, MA: MIT Press, 1986.

Wagner, Richard. "Art and Revolution." Translated by W.A. Ellis. In *Richard Wagner's Prose Works in 8 volumes*, Vol. 1, 21–215. London: Truebner & Co: 1892.
———. "Art Work of the Future." Translated by W.A. Ellis. In *Richard Wagner's Prose Works in 8 volumes*, Vol. 1, 21–215. London: Truebner & Co: 1892.

Wallace, Robert. *Hegel's Philosophy of Reality, Freedom, and God*. Cambridge, UK: Cambridge University Press, 2005.

Webern, Anton. *Lekzii o Musike* [Lectures on Music]. Translated by V.G. Shnitke. Moscow: Muzika, 1975

Zakharov, Vadim, and Ekaterina Degot, eds. *Moskovskij Koncepualizm* [Moscow conceptualism]. Moscow: WAM, 2005.

Žižek, Slavoj. "Evald Ilyenkov's Cosmology. The Point of Madness in Dialectical Materialism." In *The Philosophical Salon*, Dec. 10, 2018. https://thephilosophicalsalon.com/evald-ilyenkovs-cosmology-the-point-of-madness-of-dialectical-materialism/.
———. *The Fragile Absolute*. London and New York: Verso, 2001.

Zinoviev, Alexander. *Kommunism kak Realnost* [Communism as Reality]. Moscow: Astrel, 2008.

INDEX

ACKNOWLEDGEMENTS

The publication of this book has only been possible with the support and advice of numerous colleagues and comrades at different stages of its writing and production.

I am grateful to Anton Vidokle, who encouraged my interest in writing this book as early as in 2012 and supported my efforts all the way through. I thank the e-flux team, Kaye Cain-Nielsen, Brian Kuan Wood, Andreas Petrossiants, and Colin Beckett for a most productive collaboration and editing process. Nathaniel Boyd's scientific editing deserves high praise and special thanks.

I am indebted to Boris Groys for carefully reading parts of the book and for the opportunity to rely on the tremendous work that he had done inspecting the philosophy of communism.

I owe much to John Roberts, who hosted and supervised my research during a Marie Curie Fellowship at Wolverhampton University (2017-2019) and often helped with comradely advice, as well as to Francesco Paradiso and Amrit Chodda, who facilitated so many events in the frame of this research.

There were invitations to conferences and collaborative seminars between 2012 and 2019 that were crucial in shaping the goals and approaches that crystalized in the book. For these I thank Georg Schoellhammer (Transit, Springerin), the PATTERNS lecture series at WUS Austria, the Art History Faculty of the Russian State University for Humanities (Moscow), WHW (Zagreb, Vienna), Oleksiy Radinsky and Sergey Klimko (VCRC, Kiev), Dmitry Gutov, Samo Tomšič, David Cunningham (University of Westminster), Meena Dhanda (Wolverhampton University), Angela Dimitrakaki (University of Edinburgh), Alberto Toscano (Goldsmiths College), and Michal Murawski and Maria Mileeva (UCL, London).

I thank Catherine Malabou and Mladen Dolar for their trust and benevolence, and Agon Hamza for his shrewd recommendations with the manuscript.

I feel deep gratitude to my comrades and colleagues—Artemy Magun, Oxana Timofeeva, Alexey Penzin, and Maria Chehonadskih—whose mutual collaboration endowed my work with the proper context and ideas.

COLOPHON

PRACTICING THE GOOD:
DESIRE AND BOREDOM
IN SOVIET SOCIALISM
Keti Chukhrov

ISBN 978-1-5179-0960-4 (hc)
ISBN 978-1-5179-0955-0 (pb)

A Cataloging-in-Publication record for
this book is available from the Library
of Congress.

e-flux

Published by e-flux
www.e-flux.com
journal@e-flux.com

Printed and Distributed by the
University of Minnesota Press
111 Third Avenue South
Suite 290
Minneapolis, MN 55401
www.upress.edu

Results incorporated in this publication
have received funding from the European
Union's Horizon 2020 research and
innovation programme under the Marie
Sklodowska-Curie grant agreement
No. 752417

"Gender and Its Social Paradigms"
originally appeared in the editor's
introduction to the section on "Gender"
in *Primary Documents: Art and Theory of
Post–1989 Central and Eastern Europe:
A Critical Anthology*, edited by R. Marcocci,
A. Janevski (Duke University Press and
MoMA, 2018), 200–204.

"Sexuality in a Non-Libidinal Economy"
originally appeared in *e-flux journal*,
no. 54 (April 2014) and in *What's [Love]
Got to Do with It*, edited by J. Aranda,
K. Cain-Nielsen, B. K. Wood, A. Vidokle.
(Sternberg Press and e-flux, 2017), 298–317.

"The Cost of Sexuality" originally appeared
in *Stasis*, no. 1., vol 4, (2016): 114–128.

"Three Components of Realism:
Sensuousness, De-alienation, Humane
Resignation" originally appeared in
Springerin, no. 21, vol. 2 (April 2015): 25–32.

"On Evald Ilyenkov's Cosmological
Humanism" was originally published
under the title "Why Preserve the Name
'Human'?" in *e-flux journal*, no. 56 (June
2014) and in *Supercommunity: Diabolical
Togetherness Beyond Contemporary Art*,
edited by J. Aranda, B.K. Wood, A. Vidokle
(Verso and e-flux, 2017), 403–413.

SERIES EDITORS
Julieta Aranda
Kaye Cain-Nielsen
Brian Kuan Wood
Anton Vidokle

MANUSCRIPT EDITOR
Dr. Nathaniel Boyd
Associate Fellow
Department of Politics
University of York

DESIGN
Noah Venezia

COPY EDITING
Ames Gerould

PROOFREADER
Steven Zultanski

ADDITIONAL PROOFREADING
Andreas Petrossiants
Rachel Ichniowski

KETI CHUKHROV is associate professor of cultural theory at the National Research University Higher School of Economics. She is the author of *To Be—To Perform: "Theatre" in Philosophic Critique of Art* and *Pound & £.*